American Decorative Wall Painting
1700-1850

American Decorative Wall Painting

1700-1850

New Enlarged Edition

NINA FLETCHER LITTLE

A Dutton **dep** *Paperback*

E. P. DUTTON NEW YORK

This paperback edition of American Decorative Wall Painting 1700–1850 *first published
in 1989 by E. P. Dutton*

Copyright 1952, © 1972 by Nina Fletcher Little

*Published in the United States by E. P. Dutton,
a division of NAL Penguin Inc.,
2 Park Avenue, New York, N.Y. 10016.*

Published simultaneously in Canada by Fitzhenry and Whiteside, Limited, Toronto.

Library of Congress Catalog Card Number: 88-51316

ISBN: 0-525-48221-0

1 3 5 7 9 10 8 6 4 2

In affectionate memory of

ESTHER STEVENS BRAZER

whose knowledge and enthusiasm encouraged
my first interest in the architectural use of paint

Contents

Part I - *Painted Woodwork*

Illustrations

Color Plates (following page 44)

Black-and-white Plates

WOODWORK PAINTING

PLASTER PAINTING

Freehand Repeat Patterns

Stenciled Patterns

Preface to New Enlarged Edition

When *American Decorative Wall Painting 1700–1850* first appeared in October, 1952, the investigation of painted decoration on early woodwork and walls was only in the pioneering stage. Many owners of old houses in which this type of decoration was discovered were either disinterested or uninformed, and consequently refinishing of woodwork and resurfacing of plaster walls often obliterated valuable examples of the work of itinerant painters. It was the scholarly appreciation of this material, coupled with a firm belief in its growing importance, that persuaded Old Sturbridge Village to undertake publication of the first edition of this book at a time when popular appeal was largely limited to special students in the field of American decorative arts. Today, however, interest in the architectural use of paint is greater than ever before, resulting in the study and preservation of both existing and newly discovered examples. This interest has prompted the publication of a second edition, containing the original text and illustrations, with additional black-and-white and full-color pictures and a new chapter covering discoveries recorded since 1952.

Many of the illustrations for the first and second editions present the visual appearance of overmantels and painted walls as found in their original positions. It is fortunate that both local and amateur photographers, often working under adverse conditions of limited space, inadequate lighting facilities, and badly obscured paint surfaces, were able to produce a creditable record of wall decorations as they appeared before cleaning, restoration, or repainting. Some have already changed hands or been lost sight of through remodeling, even since the making of the current notes and photographs on which Chapter XI is based.

An added group of overmantels is included to bring the former list up to date, and Chapter XI has been separately indexed for easier reference to the new material and illustrations contained therein.

Nina Fletcher Little

Brookline, Massachusetts
March, 1972

Foreword

By Marshall B. Davidson

THERE PROBABLY NEVER HAS BEEN A TIME in all the known history of man when he has not tried, in one way or another and for one purpose or another, to relieve the bare walls of home and public place with painted decorations. The tradition can be traced far back toward the beginnings of human development. On the walls of dark caves at Altimira, Lascaux, and elsewhere, images of astonishing force were painted for occult purposes long before man had evolved either an architecture or a written language. From ancient Crete and ancient Egypt, from classical Greece and imperial Rome, from medieval England and renaissance Italy, and from colonial America—from everywhere in time and place—examples of mural painting have survived that testify to the continuity of this old and entirely human practice.

For the most part we can only guess how common the practice may have been at any one point in time or place, for only an unknown fraction of what went on the walls has been recovered and recorded. The fraction is no doubt a very small one. Yet at times it seems miraculous that so much of this highly perishable evidence has been spotted by indefatigable scholars in the field and preserved for the interest and pleasure it holds.

Ironically, thanks to one of the accidents of history, until recently we knew more of what went on the walls of ancient Pompeii than what went on the walls of American buildings a few centuries ago. There were no active volcanoes within the continental United States of America to serve the archaeologist. Rather, there were for centuries after the first settlements, forests on a scale Europe had not known in historic times. There was wood to burn, and burn it often did even after it had been converted into frame dwellings. A sad proportion of America's architectural heritage—painted decoration and all—has gone up in flames, thanks to the prevailing use of wood in building. The wrecker's tool has been responsible for as much more destruction, purposefully here, in the name of progress.

But America has had its own indefatigable scholars, who have salvaged from fire and wreckage, and who have recovered from neglect and ignorance, a surprising body of evidence about the ways in which our ancestors painted their houses and public buildings. Among those scholars I know of no one more tireless, no one who has contributed more through her field work and research, than Nina Fletcher Little. The following pages represent only a modest part of her total findings about old houses and old painters and what they have to tell us. But on the particular subject of decorative painting in early American structures what follows is, in itself, a sizeable and important contribution.

To those who have not thought about the matter Mrs. Little's story will be a revelation. I am thinking now of those who picture our ancestors in terms of Hawthorne's somber romances, all done in mouse-colored grays, grim blacks, chaste whites—and only occasional lurid scarlets. One of our eminent historians has more accurately observed that our Puritan ancestors may have disliked extravagance, but they appreciated comeliness in a house as in a ship—or in a woman; and they loved bright colored paint on houses as on ships—if not on women. As antiquarians have been pointing out for quite a few years, although it is still not common knowledge, bright-colored homes are an old tradition in America.

For those better instructed along these lines, on the other hand, Mrs. Little has reduced to fact and actual survey, and brought into focus, a solid lot of material which has not before been available between two covers. Here she provides a body of fresh information, gathered with uncommon skill and energy, that will be

of lasting service to others in their search for a broader understanding of American civilization and of American art.

The latter, I believe, is a point of special importance. The evidence Mrs. Little has brought together is not concerned with the occasional rare genius and the creation of masterpieces, but with something much closer to the common and to the communal experience of the times of which she writes. Yet, it is neither sensible nor possible to draw a line across the field of study and claim that everything on one side represents the fine art of painting, that everything on the other side belongs to the craft of the decorator. There is a continuity, occasionally observable in the work of a single individual, that runs unbroken from one form of expression to another. That sort of continuity is by no means peculiar to America, but it has been more apparent here where conditions did not favor the intensive specialization practiced in older societies.

It would be hard to determine to just what extent the talents of these painters whose work Mrs. Little describes fed the main currents of American art. But it is a question implicit in her book and one, possibly, with important ramifications. It may surprise many, for instance, that although most existing books on American painting have minimized the importance of landscape painting in this country before the 19th century—some have ignored it altogether—Mrs. Little finds enough evidence on these wooden panels and plaster walls to suggest that from well back in the 18th century, landscape painting was a far more common practice than has been generally realized. And, of course, she adds corroborative evidence from documentary records of the time to broaden the sense of her findings in the field. I think she would be the last to insist that these early panels represent the true beginnings of a school of landscape painting in America. But those who write about such matters in the future will, in view of her findings, want to explore that possibility.

The Metropolitan Museum of Art
March 11, 1952

Preface

Τ HIS BOOK is not offered in the belief that it comprises a complete or final survey of all the wall painting in this country. Examples are known which I have been unable to see, and others will continue to appear as old houses are renovated or restored. The material has been gathered during a personal investigation carried on over a period of years, during which many obscure houses have been visited, and their woodwork and walls examined and photographed. Museums, historical societies, dealers, and private collectors have also generously placed their examples at my disposal. Books, articles, and source material have been consulted when available, although relatively little information on the subject as a whole will be found in print. Special mention should be made, however, of two pioneer books in this field to which any student must constantly refer: Edward B. Allen's *Early American Wall Paintings,* and Janet Waring's *Early American Stencils on Walls and Furniture.* Also indispensable are three books dealing with early Arts and Crafts, edited by Rita Susswein Gottesman, Alfred Coxe Prime, and George Francis Dow. From these compilations of eighteenth century newspaper advertisements comes a great deal of the documentary evidence which is cited as background material.

Believing that the "house, sign, and fancy painters" were one of the most important groups of early American craftsmen, and that they deserve individual recognition and study, I have tried to identify these men by means of their work. This quest has proved even more baffling than anticipated. Their brush strokes still remain, but their personalities have vanished from memory, and old accounts do not record names of wandering artists who seemed to come from nowhere, and to depart for an equally mysterious destination.

I have made an effort not to burden the text with unessential details, but notes at the end of each chapter will amplify the contents for those who desire further information. In the Appendix will be found biographical accounts of woodwork and plaster painters, and a descriptive check list of pictorial overmantel panels.

Such a survey as this could not have been accomplished without the enthusiastic assistance of countless friends. Of all those who have so generously helped me I should like to mention in particular the following, who have spared no effort to provide me with valuable information: Miss Mary Allis, Mrs. Charles M. Auer, Mrs. Samuel Cabot, Mr. and Mrs. Henry N. Flynt, Charles F. Montgomery, Harry Shaw Newman, Frank O. Spinney, William L. Warren, Winsor White, and Miss Alice Winchester. Especial appreciation is also due to Charles D. Childs, Abbott Lowell Cummings, Elmer D. Keith, and Mrs. Jean Lipman who have read parts of the manuscript and made many constructive suggestions; and finally to my husband, Bertram K. Little, who has given me unfailing assistance and advice during many busy years. To the numerous other persons who were unknown to me until they kindly proffered information, and to the various owners who have so courteously allowed me to trace, photograph, and describe their walls, the value of this book will be in great part due.

NINA FLETCHER LITTLE

Brookline, Massachusetts
March, 1952

Introduction

THE INFLUENCE of the traveling decorator on the early homes of rural America can hardly be over-estimated. It was the itinerant painter who, for a modest sum, could provide the woodwork and walls of the simplest interior with pattern and color. What a house might lack in the way of fine paneling, or wall hangings, could be simulated by the use of paint, if cleverly applied by an ingenious country craftsman. Paneled wainscot could be imitated to enrich a plain plaster wall; painted door casings could be supplied to "dress up" a wood-sheathed entry; gold-framed pictures could be "hung" in the best parlor; and wallpaper could be so artfully reproduced that the owner might enjoy at least a visual effect of luxury.

The provincial artist working during the eighteenth and first half of the nineteenth centuries did not specialize in one branch only of his trade. He combined all types of painting from which he might gain added recompense. In 1785 we find Abraham Delanoy of New Haven advertising in the *Connecticut Journal:* "Likenesses painted on canvas, carriages painted, ornamented, gilt and varnished. Signs of all kinds. Plain house and ship painting carried on . . . Paints mixt at short notice." In the *Connecticut Courant* in 1801 Luther Allen of Enfield announced: "Portrait painting in oil of all sizes from busts to full figures. Painting with pastels or crayons, miniature painting, hair work etc." For the ornamental trade he did "carriage painting embellished with gildings and drawing, sign painting, lettering with gold leaf, and smalting."

Although the rudiments of painting were doubtless picked up by many a young man from his father, the apprenticeship system was responsible for training most of the boys who wished to learn a trade. Usually apprenticed for a period of seven years, from fourteen to twenty-one years of age (although sometimes for a shorter time), these lads received a general education at the hands of their masters, which consisted of basic instruction in the three R's, as well as really proficient training in the craft of their choice.

Painting and glazing was a basic trade which included coach and sign painting, gilding, lettering, drawing of coats-of-arms, and fancy ship painting if the painter lived in a seaport town. Added to these were a number of specialties among which were included the decorating of furniture, clock faces, window blinds, screens, fire buckets, floor cloths, and many other items unknown to present-day life. Fancy architectural painting, especially that on interior woodwork, walls, and floors, was advertised to a degree which indicates that this type of decoration was far more prevalent than we have heretofore realized. Often the house painter was called upon to disguise the native pine with an imitation of walnut, oak, or cedar, or to make "wood into artificial stone." Mock paneling, pictures in simulated frames, and painting to represent stucco, fret, or carved work, enhanced the plaster walls of homes from Connecticut to Maryland, and must have presented a novel appearance. Traveling artists were also employed to decorate rooms with scenic panoramas or repeat patterns in lieu of wallpaper, or to fill an architectural panel with a land or seascape.

The subjects used by these country painters were often stylized expressions of what they felt or remembered as well as what they actually saw, and therefore they found no objection to including in one picture completely dissimilar elements, or of adding figures or buildings which appear to us to bear no relation to the rest of the composition. The result is apt to be a refreshing freedom of design which is often lacking in the academic work of the period. The landscape artist of the late eighteenth century was above all an individual, and it is his personal approach to his subject, and his original execution of it, which form the basic difference between him and the artist trained in a formal manner. Although it is primarily the decorative work of the ornamental painters which will be treated in the following pages, we shall see also examples of marine, landscape, and figure painting by these men, which prove the vitality and versatility of the early American craft tradition.

Heretofore students of architectural painting have

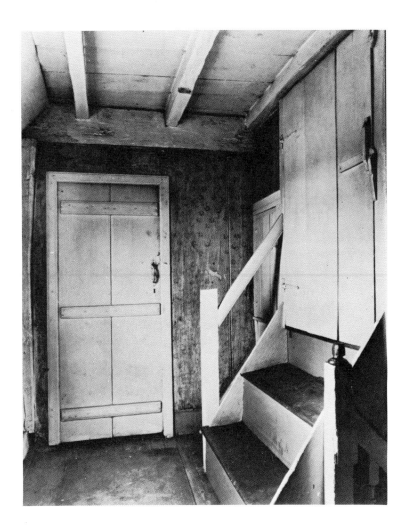

FIG. 1. Upper Front Entry "SCOTCH"-BOARD-
MAN HOUSE, *Saugus, Massachusetts,* 1651.
The original sheathing is sponge-
painted in black on gray.
*Society for the Preservation of New England
Antiquities,* Boston, Mass.

been inclined to draw rather a sharp line between the work of the freehand painter, the stenciler, and the grainer, feeling that each branch was especially practiced to the exclusion of the others. Many people still feel that any man who was capable of executing a freehand design on a wall would never have bothered with the meticulous and mechanical process of stenciling. It has been interesting, therefore, to analyze the various types of work seen throughout New England and to find that stenciled borders, buildings, and figures sometimes appear in conjunction with landscape frescoes, and that examples are known where stenciled and freehand designs in conventional patterns are to be found on the same wall. Further, I have learned that where one type of "fancy painting" is found there is a good chance of discovering other evidences of the same decorator's hand. Grained woodwork, a marbled floor, or a scenic fireboard were frequent companions to painted plaster walls, and a search for several types of ornamen-

tation in one house will often prove rewarding. The old-time decorator remained in one neighborhood as long as he could find employment, and houses containing similar decoration are apt to be found within a few miles of one another.

It is my belief that architectural painting of the sort described herein was used equally in New England and in the South, the largest amount of documentary evidence in the form of advertisements being found in the newspapers of Philadelphia, Baltimore, and Charleston. A somewhat lesser amount appears in the New York City press, and relatively little is discoverable in New England newspapers of the late eighteenth century, although examples of all types of wall painting abound in this region. The larger part of the documents quoted, therefore, will be of necessity from the advertisements of southern artists, while the illustrations shown will be primarily from New England.

Chapter I

House Painting
"In all Sorts of Shining Colours"

To trace and verify the paint colors used on the exteriors of buildings in colonial America would require many years of patient study and investigation. Countless spring rains, followed by summer suns and driving winter snows, have washed many of the old clapboards bare so many times that scraping on exposed surfaces often yields little information. In a prosperous town such as Salem, Massachusetts, most of the newer houses were painted by the middle of the eighteenth century. James Birket writing in 1750 says: "Salem is a large Town well built, many genteel large houses (which tho' of wood) are all . . . pland & Painted."[1] Many exteriors were never painted until the early nineteenth century, and the Reverend Timothy Dwight wrote of Dover, New Hampshire, in 1797: "The buildings are substantial and decent, but formed with very little taste or beauty. A small number of them only are painted, and most of these with a dull, disagreeable colour. There is nothing sprightly in the appearance of the town, except the activity of its inhabitants."[2]

We may assume from contemporary evidence that red and pumpkin yellow were favorites during the eighteenth century. Specifications for the Market House at Annapolis, Maryland, printed in the *Maryland Gazette* for July 30, 1752, call for the weather boarding to be of featheredged yellow poplar plank "to be painted Red with Oil Colour." Those who have thought of "Indian red" as referring to an early American formula having some connection with the local aborigines may be surprised to learn that this term was in use in eighteenth century England, and that it had no connection with the American red man. The following information may be found in *The Handmaid to the Arts*, printed in London in 1758: "The common Indian red, meant here, is of an hue verging to the scarlet: but the true Indian red, . . . is greatly inclining to the purple: among which colours it may well be classed. This common kind has been introduced as a counterfeit or substitute for the real kind brought from the East-Indies. . . ."[3]

In Pomfret, Connecticut, in 1762, it was voted "that the new meeting-house be colored on the outside of an orange color—the doors and bottom boards of a chocolate color—the windows, jets [cornices], corner boards and weather boards, colored white." These contrasting hues seem to have met with considerable favor, since five years later, in 1767, the villagers of Thompson, Connecticut, voted to paint their new house of worship "the same as Pomfret."[4]

Definite distinctions were made, even in the eighteenth century, between paints suitable for inside and outside work. John Baldwin advertised in New York City in 1766 that he purified and strengthened the oil especially for outside work "being the Sun is so penetrating."[5] Frequent reference is heard today to early paints made with skimmed milk, but genuine old formulas for these presumably simple concoctions are now hard to find. Such well-known facts were seldom written down and more rarely committed to print. The contents of such a book, however, entitled "Paints and receipts for wooden work," bearing the date 1801, have been published in the *Bulletin of the Connecticut Historical Society* for January, 1943. This article deals chiefly with furniture painting but includes one sentence of interest to the house painter: "for Laying on of your Coloring. for outdore work it must be mixt with linsid oil, but for indore work it may be mixt with Strong Beer or Milk."

During the early nineteenth century there was considerable controversy over the subject of the efficacy of milk paint, and various methods were published, enlarged upon, and refuted. In 1815 *The Dyer's Companion*, published in New York by Elijah Bemis, contained an article "On a method of Painting with Milk" by

A. A. Cadet de Vaux. This recipe was included in a somewhat shortened form in *The Domestic Encyclopedia* by A. F. M. Willich which appeared in Philadelphia in 1821,[6] and it was again published with slight changes in *The New England Farmer* in 1828.[7] The ingredients of the 1815 recipe consisted of 2 quarts of skimmed milk, 6 ounces of fresh slacked lime, 4 ounces of caraway, linseed or nut oil, and 5 ounces of Spanish white. The lime and enough milk to make a smooth mixture were to be combined, the oil added by degrees, then the remainder of the milk, and finally the Spanish white. The milk might be curdled but should never be sour. The Spanish white must be crumbled and spread upon the surface of the liquid, and when it sank it must be stirred with a stick. This paint was used on plaster walls, and could be colored with charcoal, yellow ochre, etc. A rule for "Resinous Painting in Milk" for outside work, also taken from *The New England Farmer*, calls for adding to the above 2 ounces each of slacked lime, oil, and white turpentine.

Apparently, skimmed milk paint was not considered satisfactory by some who tried to follow these directions, as a week after the recipe came out in *The New England Farmer* a disturbed correspondent wrote to the editor disputing its success. He referred to a pamphlet published as early as 1808 in Connecticut giving directions for the "then new process" and saying that on trial milk paint had proved thoroughly unsatisfactory.[8] These difficulties might have been mitigated in some degree if the readers of the *Farmer* had followed advice published in 1823 recommending that houses be painted in the late autumn when the cold would form the ingredients into a "hard cement on the surface," and the oil would not penetrate as in the heat of the summer.[9]

Mural painting of the period, in the form of overmantel landscapes and frescoed walls, offers pictorial corroboration that exterior colors used by the early house painters are still in use today. In fact these shades have probably changed less over the years than have the interior colors. Red, yellow, white, and gray are the hues that predominate on houses in landscape pictures which date before 1825, and are followed in less degree by brown, buff, green, and pink, the last probably intended to be a simulation of brick. When the Reverend Timothy Dwight traveled through the Connecticut Valley in 1797 he made the following observation about the homes in Suffield: "The houses on both sides of the street are built in a handsome style; and, being painted white (the common colour of houses in New-England), and in the midst of lots universally covered with a rich verdure, and adorned with flourishing orchards, exhibit a scene uncommonly cheerful."[10]

Concerning the color and durability of white exterior paint *The New England Farmer* made this observation on November 9, 1827: "Earthy paints are more durable when exposed to the air than the metallic paints. White lead, in particular, by a small mixture of yellow ochre, produces a more pleasing as well as a lasting colour than white lead alone, which decomposes in a year or two, in the air. The colour it assumes is a cream colour, and it has a full and rich appearance. It has been very extensively tried with success in Philadelphia."[11]

Old houses are still occasionally seen of which the back, usually the north side, is painted a different color from the rest of the building. This is an old custom, but it is interesting to find it mentioned in a set of specifications pertaining to the Jonathan Sweet house in Deerfield, New York, which is owned by a descendant of the first owner. This detailed agreement entered into by Bernice West, builder, and Jonathan Sweet, owner, on December 9, 1822 says in part: "The back side of the building to be painted red, and the front and sides to be painted white." The roof was "to be well shingled and stained with lamp oil black and Spanish brown."[12]

As Spanish brown was widely used during the eighteenth century both in England and the Colonies, and its exact color is sometimes in question, the following description, which appeared in 1701, may be of interest: "Spanish Brown, is a dark, dull red, of a Horseflesh Colour, 'tis an Earth, it being dug out of the ground, but there is some of it of a very good Colour . . . 'tis of great use among Painters, being generally used as the first or priming Colour, that they lay on upon any kind of work, being cheap and plentiful. . . ."[13]

There is abundant evidence, both pictorial and documentary, that many roofs were painted in the early days. A 1720 entry in the Journals of the House of Burgesses, Williamsburg, Virginia, mentions "450 yards of painting on the Roof of the [Governor's] House."[14] On September 10, 1771 Henry Pelham in Boston wrote to John Singleton Copley, then residing in New York, concerning details of work being done on Copley's houses on Beacon Hill. Among his questions is the following: "Would it not be best to give one good coat of paint, to the Roofs of the Houses? it appears to me as well as to others, that it would be a great benefit, much more than the expence."[15] In the Chebacco Parish of Ipswich, Massachusetts, now Essex, the sum of $3.50 was charged in 1807 "for painting the roof of the house."[16] Red seems to have been a favorite shade, and many wall paintings show houses with roofs of this color, with a few also in brown and green. Doors appear in black, red, green, and blue.

Documentary evidence regarding the details of house painting is rather scarce in pre-Revolutionary New Eng-

land. There are indications, however, that several English painting instruction books were used in this country, one at least of which, *Valuable Secrets Concerning Arts and Trades,* was published in Norwich, Connecticut, in 1795 after an earlier appearance in London.[17] *The Art of Painting in Oyl* by John Smith, an eminent mezzotint engraver, first appeared in London in 1676 and went through nine editions, the last appearing in 1788. Some of his instructions, adapted to American use, will be referred to later in this chapter.

Building trim as shown in the early murals was almost invariably white, and this practice is verified as follows in *The Art of Painting in Oyl:* "Window-Frames are laid in White, if the Building be new, but if not, then they generally are laid in Lead Colour, or Indico and White, and the Bars with Red-Lead. Indigo is a dark Blue if workt by itself, to remedy which, whites are usually mixt, and then it makes but a very faint Blue."[18] Apparently something new in the painting of windows was noted by Copley in 1771, by which means the heavy bars or muntins of the period were minimized to give the slender effect which was to become an architectural feature of the early nineteenth century. From New York Copley wrote to Henry Pelham: "If it is not two late I should like to Direct how to make the Sashes somthing differant from what is usual with you." To which Pelham replied: "The Window Sashes are made much as you would have them, narrow but very deep. I have observed the Windows of several Houses, lately painted, in a manner that I greatly like, and which makes the Glass look much Larger, and the Bars appear very slender. it is by painting the putty, with a dark Colour, nearly approaching to Black."[19] Window blinds are never depicted on houses in the mural paintings, which strengthens the surmise that they are a late feature. Nevertheless, a mineral green, with strong body and brilliant color, was made especially for window blinds in Roxbury, Massachusetts, in 1825 and advertised in *The New England Farmer* in November of that year.

Interior Paint Before 1725

There is little evidence of paint in New England interiors during the seventeenth and early years of the eighteenth centuries, although in 1697 when the old Boston Town House was "altered and fitted up so as to make it more convenient and comfortable," Samuel Sewall wrote in his diary: "The Governour and Council first meet in the Council-Chamber, as it is now fitted with cieling, Glazing, Painting, new Floor. . . ."[20] There was also painting of special interest in Sewall's own home, the old house which his wife had inherited from her father, John Hull, in 1683, which stood on what is now Washington Street in Boston. In March,

1692/3 a part of the kitchen burned, and repairs and enlargement of the original structure were begun which were not completed for several years. On September 18th, 1695, there occurs in Sewall's diary a most tantalizing reference, the full meaning of which remains obscure: "This day Mr. Torrey and his wife, Mr. Willard and his wife, and Cous. Quinsey dine with us; 'tis the first time has been at our house with his new wife; was much pleas'd with our painted shutters; in pleasancy said he thought he had been got into Paradise. . . ."[21] The shutters were obviously unusual enough to cause comment among Sewall's friends, but whether because they were the only features of the room to be painted or because they were actually decorated in some unexpected manner, such as simulated japan, tortoiseshell, or marble in the newest English taste, must remain a matter of surmise.[22]

Four ceilings, each exhibiting a similar pattern and technique, still survive from the seventeenth century and are recorded here because they represent what is believed to be some of the earliest examples of decorative painting in this region.

On the "hall" or kitchen ceiling of the "Scotch" Boardman house, built in Saugus, Massachusetts, in 1651 and owned by the Society for the Preservation of New England Antiquities, crude painted decoration in the form of black spots was uncovered some years ago. This treatment, on a slate-gray background, is found also on the early beaded sheathing of the stairway and upper front entry (Fig. 1). In the east chamber, under an outer coat of blue, is a gray-green slate color with decoration of short curved black lines.[23] Another spotted ceiling was found under later plaster in the lean-to kitchen of the seventeenth century Blaney house, when it was demolished in Swampscott, Massachusetts, in April, 1914. At that time a portion of the painted boarding was obtained, and may be seen in the Society's Museum at 141 Cambridge Street, Boston. A third ceiling of this general type still remains in the kitchen of the Isaac Winslow House, 1699, in Marshfield, Massachusetts, owned by the Historic Winslow House Association. In nearby Hingham the Cushing house, built about 1685, has white sponge painting on a black background, which reverses the decorative effect.[24] Some old notes deposited in the library of the Society for the Preservation of New England Antiquities presumably refer to the Province House in Boston, erected in 1679 and for many years the home of the provincial governors. Included in the notes is the following entry: "1737, whitewashing and spotting kitchen, 17 shillings." Apparently, this process was repeated each year, as similar entries are recorded for 1738 and 1739. In the latter year the price had risen to 1 pound, 6 shillings.

A different type of ornamental painting was found

under later construction in the Haskell house which stands on Lincoln Street, West Gloucester, Massachusetts. In 1627 Richard Winslow, official "joiner," arrived from England in the ship *Vanitie,* and sometime thereafter built this house which he sold to William Haskell in 1652. On the chamfered edges of the huge hand-hewn girts in the lower southeast room are the remains of a narrow band of bright vermilion, which must have provided an unusual and charming accent against the dark timbering and whitewashed walls of this early dwelling.

Over the parlor fireplace of the seventeenth century Hart house, built in Ipswich, Massachusetts, and now installed in the American Wing of the Metropolitan Museum of Art, runs a band consisting of a double row of dentils cut from a molded board. Before renovation some years ago, these dentils showed traces of color, being painted alternately red and black in what is believed to have been a very early use of painted decoration.[25]

One other building, the Conant house in Townsend Harbor, Massachusetts, built about 1720, exhibits on the bevel and bead sheathing over the southeast chamber fireplace a unique design made up of wavy brown lines forming crude diamonds on the original slate-blue paint. In the center of each diamond is a circular motif in dull red and black similar to those found on contemporary furniture.

Although it is now impossible to say with certainty when any of this painting was actually done, it all apparently occurs on original woodwork or ceilings of buildings erected before 1725. Fragmentary as these designs are, they are to be treasured as fast disappearing evidence of very early architectural painting in the New England colonies.

Interior Paint, 18th Century

Until approximately 1725, we are safe in assuming that the greater part of the houses in New England and elsewhere were unpainted both within and without. Linseed oil was scarce, and pigments were expensive and hard to obtain except in coastal cities. Imports of "Painter's Colours" were advertised in Boston, however, as early as 1710,[26] and the use of paint began gradually to increase until by 1750 most city houses, and the "best rooms" of many in outlying communities, had brightly colored woodwork. Nevertheless, some country interiors, particularly back entries, kitchens, and unfinished chambers, remained without benefit of paint until well into the nineteenth century, and a few rare examples still remain. The Boston *News-Letter* of May 13/20, 1731, advertised "A new handsome well Built House" for sale, of which the rooms were "all nicely Painted."[27] In 1734 the *New England Journal*

carried the following announcement: "To be Sold, a large Fashionable Dwelling-House, Consisting of Eight Fine Rooms, Two of which with Entries are very beautifully Wainscotted and laid in Oyl, and Four handsomely Painted."[28] Careful restoration work with especial emphasis on original colors has resulted in paints prepared in correct colonial shades, but this is not an innovation of our modern age! In 1736 Richard Marten, house, sign, and ship painter, advertised in the *South Carolina Gazette:* "Gentlemen in the Country may be furnished with all sorts of Colours ready mixt and directions how to use them."[29]

Careful investigation of all layers of paint remaining on old woodwork should be undertaken as a routine part of the restoration of an early building. This is important because so much of our heritage of color and design has already disappeared through the mistaken belief that the woodwork of any old house, regardless of period, should be returned to natural pine. The most satisfactory way of removing layers of pigment varies according to the circumstances, but one of three methods is usually employed. One may chip, scrape, or wash with some type of solvent. Chipping is the speediest and most successful method if conditions warrant its use. If the second layer of paint has not firmly adhered to the first coat, a small amount of pressure applied to the outer edges of a small scar or blister will sometimes result in all subsequent layers chipping off together, and leaving patches of the original paint easily exposed. Unfortunately, this is not often the case, and it may be necessary to scrape each succeeding layer, taking care to leave a good sample of each layer in some unobtrusive place, to show the progression of colors. Scraping should be done slowly and with care, using a tool sharp enough to remove the surface, but not sufficiently sharp to scratch through layers not yet reached. A broad putty knife with a good edge is recommended for this work, or a razor blade if used with care. Most of those experienced in the investigation of paint feel that the use of a solvent is not as satisfactory as chipping or scraping, as the color of the original coat may be altered by the ingredients of the remover. Nevertheless, paint remover, if used carefully and lifted off with a blunt scraper as soon as the pigment has been rendered sufficiently soft, can sometimes be used with success even by the amateur. Denatured alcohol is a safer agent than paint remover as it acts less quickly and there is not the same danger of too thorough removal. To reassure the inexperienced, however, it should be noted that the first layer of paint which is next to old wood is usually extremely hard and durable, and almost impervious to solvents carefully applied. The newer the paint the more easily it may be dissolved or scraped.

Occasionally one has the good fortune to find an early

journal or day book which contains homemade recipes for old paints and stains. The names of the ingredients will sound strange, and some of the procedures equally so, but their lasting quality has proved their sturdy composition. A small, leather-bound book owned by the author chronicles the itinerant transactions of one Braverter Gray, born in Hillsborough, New Hampshire, in 1785. According to an entry on the last page, he became apprenticed to Jonathan Webster when he was sixteen years of age, and "came from aprentiship October 15, 1804." Thereafter he married, eventually became the father of seven sons, and evidently followed several trades. His interest in paints is evinced by two sets of recipes, one of which, in a fine eighteenth century hand, was obviously written in the center of the book before Gray began to use it for his accounts. Entitled "A Catalogue of Colours Used in painting with Oil," some of these directions appear to be original, while others are copies or adaptations from *The Art of Painting in Oyl*, which shows that English precedent was closely followed even in rural America. Because these recipes are brief, and contain specific information of considerable interest concerning certain colors used in house, carriage, and furniture painting, we quote a few of them from the Gray day book:

YELLOW. Yellow oker is of two sorts, one called Oker, the other spruce yellow. Those colours are much used to paint houses with, you can make them lighter by mixing white lead with it.
REDS. Vermillion is the most delicate of all reds. Red lead is what we commonly paint the better sort of sleighs with. Spanish brown is a dark dull red, we paint common sleighs with it. It is much used to prime with and is a cheap colour. by mixing red lead with it is very useful to paint tables etc.
BLUE. Prussian blue, this is what we paint sleighs with. We grind it with white lead to make it of a lighter colour, as it would be too dark. It is sold from three, to three and six pence, per ounce which will paint 2 sleighs.
BLACKS. Ivory black, Lamp, or candle black. Lamp black is what we use, you must put in it a little red lead which will make it dry soon. This is an Entire Secret.

It is evident from a study of original paint, both in New England and in the South, that eighteenth century colors were for the most part strong, and inclined to be dark, featuring Indian red, yellow ochre, blue, green, and gray. A valuable study of the original colors found in four pre-Revolutionary mansions in Virginia has been made by Herbert A. Claiborne and published in *The Walpole Society Note Book* for 1948. These houses, Stratford, Mount Vernon, Wilton, and Brandon, exhibit a wide range of shades in four main colors, greens being the most prevalent, followed by blues, grays, and varying shades of buff.[30] In 1749 Peter Kalm, a Swedish traveler in the American Colonies, had this to say concerning the houses which he visited in New York City:

"The alcoves and all the woodwork were painted with a bluish-gray colour."[31] Gray of various shades seems to have been a favorite for woodwork over a long period of time. Braverter Gray mentions it in his account book as follows: "Ash colour is made of white lead and lam[p] black. You may make this colour dark or light as you please, and it is a pretty colour for a common room." Although white was not widely used until the Adam period, it was employed to some extent at an earlier date. An interesting proof of this fact is contained in an advertisement in the New York *Mercury* for March 10, 1766: "John Baldwin, Begs Leave to acquaint the Public, that he will perform House painting, gilding, glazing, &c. after the most accurate Method now followed in London, Viz. Dead White, and all Sorts of shining Colours."[32]

The use of the words "shining colours" emphasizes one of the most important points with reference to the composition and application of early paints. During the eighteenth and early nineteenth centuries it was common practice to cover the finish coat with varnish, or to apply a transparent glaze. The colors themselves came in powder or paste form to be ground in oil, and when this was done with certain pigments there resulted a glaze which transmitted the tone of the undercoat. An eighteenth century definition which makes clear the different uses of opaque and transparent colors is quoted here in full because of its obvious importance as a contemporary explanation:

The most considerable of the more general properties of colours after purity and durableness . . . are transparency and opacity: for according to their condition, with respect to these qualities, they are fitted to answer very different kinds of purposes. Colours which become transparent in oil, such as lake, Prussian blue, and brown pink, are frequently used without the admixture of white, or any other opake pigment; by which means, the teint of the ground on which they are laid retains in some degree its force; and the real colour, produced in the painting, is the combined effect of both. This is called Glazing, and the pigments indued with such property of becoming transparent in oil, are called *glazing colours.* . . . The property of *glazing* . . . is of so much importance, . . . that no other method can equally well produce the same effect in many cases, either with regard to the force, beauty, or softness of the colouring. . . . Colours which have no transparency, such as vermillion, King's yellow, etc. are said to Cover.[33]

There is no doubt that glazing gave a depth, softness, and brilliance to the old finishes that are totally unobtainable today by the use of flat, opaque, modern paint. This conclusion was borne out by experience gained in recreating old-time effects during the restoration of the Campbell-Whittlesey House in Rochester, New York. Writing of the difficulties inherent in attempting to duplicate old finishes with modern paint, Marjorie Ward Selden states in a booklet published in 1949:

Unfortunately, experiments demonstrated that modern, ready-mixed commercial paints, no matter how blended, could never be made to duplicate the original colors and surface quality. . . . After numerous trials, and as many failures, it became obvious that if the original effects were to be duplicated, it would be necessary to acquire a thorough knowledge of pigments, how they were made, and how they were used prior to 1836.[34]

John Smith also stressed the use of glossy paint when he observed:

Take Notice, That all simple Colours used in House-Painting, appear much more beautiful and lustrous, when they appear as if glazed over with a Varnish, to which both the drying Oyl before-mentioned contributes very much. . . . Experience teaches, that some good clear Turpentine, . . . before it be mixt with the Oyl-Colours, shall make those Colours shine when dry, and preserve their beauty beyond all other things, drying with an extream glasey surface, and much more smooth than Oyl alone.[35]

In the Gray account book are recipes for the varnish and drying oil referred to above, which may be of interest to those who wish to know the original ingredients of genuine early formulas:

Receipt to Make Drying Oil. Boil 1 pound of red lead, quarter of a pound of lithereige [litharge] with three quarts of linseed oil until it will be as thick as syrup, and when cold and well settled pour the clearest into a bottle. This should be used one quart to three of raw oil.

A Varnish For All Sorts Of Colours. Take of gum annimiac [ammoniac] 1 ounce, of mastic and gum sanderac of each 2 ounces. Reduce them to a fine powder, put them into a glass vessel and pour a pint of the spirits of wine over them; hang them in the sun or set it by the fire till it is disolved; then strain it through a clean cloth and keep it in a vial well corked; and then mix your paints with it.

A number of interesting paint recipes are given in the American editions of *Valuable Secrets Concerning Arts and Trades,* many of the ingredients of which are of course unobtainable today in their original forms. A knowledge of the basic elements, however, is necessary if one wishes to simulate the correct early finishes. Directions for preparing the four main transparent colors, quoted below, can be adapted to present use by anyone familiar with the components of modern paint:

To Make Transparent Colours.
For The Green. Put in very strong vinegar, verdigrise, rue-juice, and gum-arabic. Set this in the sun for a fortnight, or, if you have no sun, boil it on the fire. Strain it, bottle and stop it.—Shake it well before using.
For The Red. Make a lye with salt of tartar. In it, put to infuse for one night, some India wood, with a little alum. Boil all, and reduce to one third. Run it through a linen cloth, and mix some gum-arabic with it.—With more or less alum, you make it of a higher or paler hue.
For The Yellow. Bruise Avignon seed, which we, in this country, call *French Berries,* and put it in a lye of salt of

tartar to boil on the fire, to the reduction of two thirds. Run it, and boil it one bubble more. Then bottle and cork it.— . . . A small addition of saffron renders it more lively.
For The Blue. Soak in chamber-lye, for one night, a certain quantity of German *Palma Christi.* Take it out and grind it with a little quick lime.—More or less quick lime will raise or lower it in hue. And nothing more is required to dilute it than chamber-lye and gum-arabic.[36]

House painting in the eighteenth century was paid for by area and not by time. Hence the charges were computed by the number of square yards which had been covered rather than by the time it took the artisan to accomplish the work. In *The Art of Painting in Oyl* is the following illuminating admonition to the unwary: "Take notice of the fraud and deceit of common Painters, who commonly agree to do work by the Yard at a certain Price, and the Work to be coloured three times over, which they commonly paint with such thin Colour . . . that all three times doing over is not so substantial as one time would be, if the Colour had a thick and substantial Body."[37]

From before the Revolution until 1793, the Boston firm of Rea and Johnston, house and fancy painters, charged seven to ten pence per square yard for interior painting. In that year dollars began to replace pounds, shillings, and pence in the ledgers, and thereafter the rate in American money was twenty cents per square yard. In the Orne family papers, deposited in the Essex Institute, Salem, Massachusetts, is a bill dated 1808 from Philip and A. Chase to Captain Josiah Orne in the amount of $9.00 for "painting a chamber blue." A minimum quantity of white paint must have been used, as this item cost the owner only 20¢. According to an account book kept by Allen Holcomb, now owned by the Metropolitan Museum, house painting in Otsego County, New York, cost the modest sum of $1.50 per day in the year 1816. In Ipswich, Massachusetts, outside painting cost 33¢ per hour in 1807, or $1.25 a day.[38]

Graining and Marbleizing

Not all paint used in the colonies prior to the Revolution was a one-tone finish. Many houses and public buildings were treated with all manner of variegated effects intended to be decorative simulations of wood, marble, and stucco. Hewn stone was sometimes imitated by applying plaster to the outer wood covering.[39] We wonder today at a fashion which called for painting wood to resemble itself, but by this means the humble pine could be effectively disguised as cedar, mahogany, oak, or maple, and one nineteenth century observer stated that graining gave an "elegance to the wood."[40] Another writer in 1833 had this to say on the subject: "Recommended that all woodwork if possible be grained in imitation of some natural wood, not with a

view of having the imitation mistaken for the original, but rather to create an allusion to it, and by a diversity of lines to produce a kind of variety and intricacy which affords more pleasure to the eye than a flat shade of colour."[41]

This type of decoration was not confined to ornamental painting. European porcelain and faience of the mid eighteenth century was both marbleized and painted to simulate wood, while wall papers with marbleized backgrounds became fashionable in America after the Revolution. One imported French paper, made in 1785, with a large design on a marbled background may be seen at the Cooper Union Museum, New York City, and two early nineteenth century marbleized wall-paper panels are illustrated in *Historic Wall Papers* by Nancy McClelland.[42]

Although "imitation-painting" was fashionable in England during the last quarter of the seventeenth century, it did not appear to any extent in this country until after 1725. A very early reference, however, relating to the Capitol at Williamsburg, Virginia, is contained in the Journals of the House of Burgesses for the year 1705: "Resolved . . . that the wanscote and other Wooden work on the first and second floor in that part of the Building where the General Court is, be painted like marble."[43] Williamsburg, during the eighteenth century, was the capital and metropolis of the Virginia colony, and the Capitol was one of the most important buildings in colonial America. It is not surprising, therefore, to find the interior of the principal seat of government painted in the newest European fashion. As the eighteenth century progressed, variegated painting was widely used in many different forms, retaining its popularity through the nineteenth century, and the period of ubiquitous golden oak, to the early years of the present era.

A few interesting references to early "grainers" exist in newspaper advertisements of the eighteenth century, and indicate that certain house painters were equipped to execute this specialized branch of the trade. Richard Marten of Charleston, South Carolina, advertised in 1736 that he could do imitations of marble, walnut, oak, and cedar at five shillings per yard. In 1760 "a convict servant man named John Winters" in Charles County, Maryland, ran away from his master, who advertised for his return in the *Maryland Gazette,* describing him as "a very compleat House Painter; he can imitate marble or mahogany very exactly." The notice included also this intriguing bit of information: "The last work he did was a house for Col. Washington near Alexandria. He must be pretty well known there, having work'd at his business several months in Town."[44] Documentary evidence in New England consists principally in the form of *For Sale* notices printed in the Boston

newspapers. In 1753 the house of George Tilley was offered by trustees representing his creditors. This building was described in the *Boston Gazette* of September 18th as an eight-room house handsomely painted throughout. The colors enumerated are of particular interest: "One of the Rooms is painted Green, another Blue, one Cedar and one Marble; the other four a Lead colour."[45]

Judging from remaining examples, cedar and mahogany were the two most popular grained finishes during the eighteenth century. The William Pepperrell house in Kittery, Maine, has mahogany crotch-graining in a bold pattern which has never been repainted, and as the house is said to have been redecorated about 1740, this may suggest a date for the painting. A similar finish has been found in the hall of the Jonathan Cogswell house, Essex, Massachusetts, and also in the Richard Mansfield house, Ansonia, Connecticut, now owned by the Connecticut Antiquarian and Landmarks Society. The painting in the two latter houses was restored by the late Esther Stevens Brazer.

Cedar, richest in color of all the variegated finishes, consisted of a ground coat of transparent pink which had been laid over a thick, smooth priming coat of a darker color, often gray or olive drab. The graining was drawn over the pink with sweeping brush strokes of deep rose-red, and simulated the richness of cedar wood to a marked degree. In the Gray account book is the only recipe for this type of finish which I have happened to see: "Cedar. Take a white lead and India Red, Brown, or Red pink, and make dark for the Nots and Grain. Add a little white vitrol and make it dry. The Nots and Grain to be put on as soon as the ground, so that the colours may mix together a little." The last line provides an important clue to the artistic success of the eighteenth century graining. The overtones were skilfully blended into the ground colors, giving thereby an effect of soft but vibrant color. Graining of the nineteenth century was smaller in pattern and harsher in blending.

Cedar combined with green marbleizing was found under layers of later paint in the southwest chamber of the Jonathan Cogswell house in 1938 (Pl. 1). Here the raised-panel surfaces of doors and overmantel are grained, while the large molding around the fireplace and the cornice moldings show only the pink undercoat. Stiles and rails are marbleized in dark green, and the quarter round moldings of the panels are picked out in light tan. The painting was probably done before 1750, and the plaster exhibits many layers of whitewash, the dead white of the walls making a striking contrast to the brilliance of the four-toned woodwork. Two other houses in this vicinity have similar painting. In Gloucester the ancient White-Ellery house, now owned

by the Cape Ann Scientific, Literary and Historical Association, has cedar graining on the original sheathing in the upper front entry and west chamber. This is one of the rare examples which has never been repainted, and it has turned in the course of years to a deep, rich mahogany red. The Richard Derby house in Salem, built in 1762, exhibits traces of cedar graining so like that in the Cogswell and Ellery houses that the same decorator may well have been responsible for much of this type of decoration in Essex County. It so happens that we know the name of one man who was doing exactly this sort of work in Salem during the mid eighteenth century.

Anyone who has a liking for old New England churchyards must have paused with interest to study the carvings which embellish the stones that mark these ancient graves. The early stonecutters were men of many parts. This occupation alone would not have provided adequate support in the small communities in which they lived, and early records list their other vocations as mason, slater, builder, cordwainer, and surveyor. In the familiar vines and scrolls which border their stones, in the rosettes and other devices which filled the corners, and in the stylized portraits which served as personal memorials to the dead, we sense an unmistakable affinity to the work of the folk painter. Were the carver and the decorator sometimes one and the same, creating their designs as occasion demanded in paint, or wood, or stone? No ready answer can yet be made while so many examples in both fields remain anonymous, but one such name does stand forth, that of John Holliman, gravestone cutter and painter-grainer of Salem, Massachusetts.

Holliman was one of the most popular stonecutters of Essex County. In 1746 he was paid 10 pounds for making gravestones by the estate of John Conant of Marblehead, but the gravestone of Joanna Herrick, Beverly, 1738, is said perhaps to be his masterpiece. Of the stones of his own children, in the Charter Street Burying Ground, Salem, Harriette M. Forbes says in *Gravestones of Early New England:* "His round heads with flat noses are amusing, and a peculiarity of his is fine chisel marks both around his design and on his backgrounds."[46]

In the same burying ground may be seen the grave of Dudley Woodbridge, for whose grandfather Holliman painted so distinguished a room that it was recorded many years afterward by that famous diarist the Reverend William Bentley, who by his description of a visit made in June of 1816 unwittingly preserved for posterity a name which otherwise might have been lost in oblivion. "Visited the Woodbridge house, said to be 140 years old, to view Holliman's painting. He died about 1744. The great southeast room is pannelled on the north side around the fireplace. The ground is variegated white & black shaded. The pannels brown framed in white. Above in the chamber the ground white & red variegated shades, frame & pannel as below. One beam till lately covered by a closet exhibits all the beauty of this man's colouring."[47] In 1742 "John Holliman of Salem mason and painter" bought land on Beacon Hill which he immediately mortgaged for the entire amount of the purchase price.[48] Bentley believed that he died in 1744, but there is no record of his demise in Salem, and an unexpected coincidence has recently proved that far from going to his heavenly rest, Holliman moved instead to the "Hub of the Universe."

Living in Boston during the third quarter of the eighteenth century was a close-knit group of artisans engaged in various branches of the painting trade. John Gore of Roxbury (father of Governor Christopher Gore), his son Samuel, and son-in-law Thomas Crafts, carried on extensive ornamental painting businesses. John was the proprietor of the shop "Sign of the Painter's Arms" on Queen Street where he imported and sold a large assortment of colors, oils, and painters' supplies. One of his apprentices, David Mason, opened his own shop in 1758 where he did expert japanning, gilding, and varnishing in addition to the drawing of family coats-of-arms. Mason studied portrait painting under John Greenwood and worked with Thomas Johnston, engraver and japanner, whose son John became in 1773 a partner in the firm of Rea and Johnston, decorative painters to the Boston aristocracy. To join this active group of craftsmen came John Holliman who forthwith joined the Brattle Square Church, where many of his colleagues worshipped. In the records of the Church for 1743-44, two lines below the name of John Gore, may be found this entry which solves the mystery of his disappearance from his native town: "John Holliman, from Chh. in Salem."[49]

The patterns of eighteenth century graining differ from those of the nineteenth but can be recognized after some observation and study. In general, the early designs were done by means of a brush with large, sweeping strokes which produced free, uncomplicated patterns. Imitation of the actual woods was merely suggested, and the resulting effects were colorful and decorative rather than purely imitative. With the first half of the nineteenth century came the literal simulations of various woods by means of paint, and the large, free-flowing designs began to disappear. Curly and bird's-eye maple were carefully reproduced with a fidelity which might easily deceive the eye, and fine, meticulous patterns, achieved by the graining comb rather than the brush, appeared on furniture and woodwork. As the century progressed the designs became more cramped and mechanical, until by the late Vic-

torian era graining had lost all its early vigor and charm. Rufus Porter, a versatile decorative painter, published in 1825 a small book entitled *A Select Collection of Valuable and Curious Arts and Interesting Experiments* in which is included detailed directions "To Paint in Imitation of Mahogany and Maple."[50] For those interested in contemporary methods of doing this work, these instructions have been reprinted in *Early American Decoration*, by Esther Stevens Brazer.[51] A more detailed discussion of the subject of "Imitation Painting" was published by Porter in the *Scientific American*, of which he was founder, in 1846.[52]

While the choicest of timber was still obtainable from American forests, clear white pine free from knots was considered the most desirable material for interior paneling. Specifications for building a tavern on Lynn Common, Massachusetts, appeared in the Salem *Gazette* on February 1, 1803, as follows: "The inside work of the two lower stories of the main building and the wings (except the kitchen) are to be finished with clear stuff."[53] If by chance a knot crept in, its presence had to be effectively concealed by whatever means were at hand. Proof of this fact is found in the advertisements of two painters who apparently thought it worthwhile to make known their abilities in this particular field. John Baldwin of New York City announced in the New York *Mercury* in 1766 that his method of house painting "destroys the knots that defects the painting."[54] In 1768 Thomas Booth, Coach, Sign, and House Painter from London had this to say about the problem: "Pine Knots are known to be very destructive in House-Painting, he therefore will obligate himself to stop them from weeping, in such a Manner that the Pannel though ever so full of them, shall not be the least perceptible though finished with the lightest of colours."[55] While the eighteenth century decorator suggested the grain of the wood by the use of his brush, he did not draw the knots in so uncompromising a fashion as did his early nineteenth century follower.

The Ebenezer Waters house in Sutton, Massachusetts, illustrates this technique (Fig. 2). The overmantel panel is believed to have been painted by Winthrop Chandler before 1790, but it seems probable that the "knotty pine" painting was done at a slightly later date. This premise is strengthened by the fact that other decorative painting of nineteenth century type was found there, including a stenciled floor. Samuel Waters, brother of Ebenezer, had a carriage painting shop in Sutton in the 1820's, and it is possible that he or one of his workmen might have been the decorator. In *Old-Time New England* there is an article on the Maria Mitchell house in Nantucket, Massachusetts, in which are two excellent illustrations of a knotty-pine grained kitchen.[56] The color is various shades of purple-pink,

and the painting covers all walls and woodwork, even including the pump! William Mitchell built the kitchen ell in 1818, and he is believed to have been responsible for the painting sometime between that date and 1838, when he sold the property to his brother Peleg.

In conjunction with graining, a great deal of marbleizing was used both on woodwork and accessories. The most usual procedure was to grain the panels of a room-end, but to marbleize the pilasters and fireplace moldings in either matching or contrasting colors. A superb room in the Seth Wetmore house in Middletown, Connecticut, built in 1742, has original dark cedar graining on panels, cornice, and summer beam, while the fluted pilasters which flank the fireplace are marbleized in grayish-green with olive green veining, and the molding which surrounds the fireplace opening is painted a still darker green (Fig. 3). The MacPhaedris-Warner house, built in Portsmouth, New Hampshire, in 1716 retains in the present dining room a section of original marbleizing which was revealed in 1932. This finish was found behind a large breakfront bookcase which has stood in its place since well before 1800. When the rest of the room was subsequently repainted the wall behind the bookcase could not be conveniently reached, and it is thanks to this fortunate circumstance that a portion of this fine painting has been preserved in original condition, making possible the restoration of the remaining woodwork in 1939. Veining in black and dark cream is superimposed on a brown background to form the raised section of the panels, while the bevels and outer moldings are grained in brown. On the rails and stiles graceful scrolls are painted freehand in a running pattern. The cornice, door frames, and baseboards are veined like the panels. The date of this decoration is unknown, but the pre-Revolutionary period is likely, and the presence also of striking wall paintings on the plaster of the adjoining hallway suggests that a versatile decorator, and perhaps more than one, worked on the interior of this house. In Marblehead, Massachusetts, the 1768 Jeremiah Lee mansion, now owned by the Marblehead Historical Society, is said to have been one of the most expensive private dwellings built in colonial America. It contains two sets of wallpaper painted in England expressly for the house, and the design of its elaborate carved oak chimney breast in the Banquet Room was taken from Plate 51 of Swan's *British Architect* of 1745. This room has retained its original grained finish and is said to have contained an overmantel of the biblical scene Esther before Ahasuerus.

The woodwork from Marmion, King George County, Virginia, which is installed in the American Wing of the Metropolitan Museum, proves that painted decoration of sophisticated design was not confined to man-

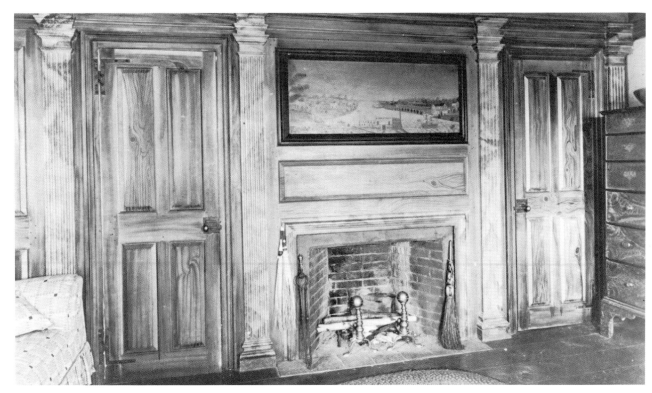

FIG. 2. EBENEZER WATERS HOUSE, *Sutton, Massachusetts*
Grained and marbleized woodwork in light buff and brown. Now
painted over. Overmantel panel view of a river by Winthrop Chandler.
Courtesy Mrs. Gordon Wood

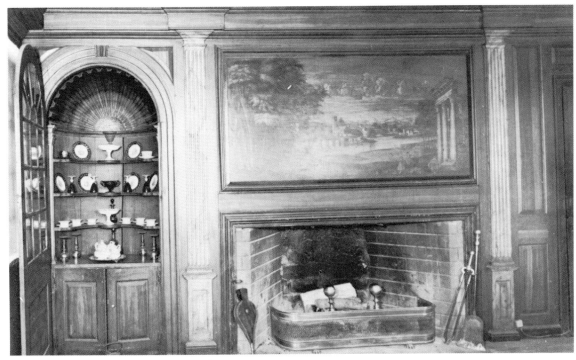

FIG. 3. SETH WETMORE HOUSE, *Middletown, Connecticut*
Room-end cedar-grained, with pilasters and fireplace molding
marbleized in green. Overmantel panel of an Italian landscape.
Courtesy Samuel M. Green

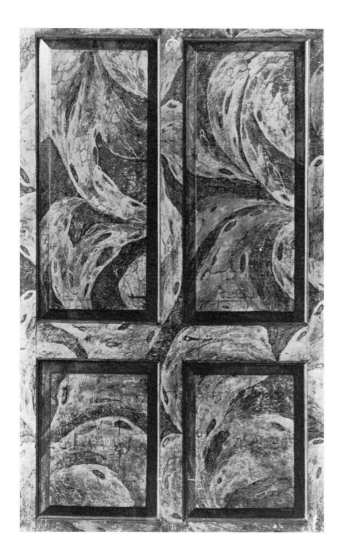

.

sions in cities or large towns. This outstanding room was taken from a house that stood on an estate first owned by the Fitzhugh family, located in the comparative isolation of the peninsula formed by the Potomac and Rappahannock Rivers, some twenty-five miles south of Mount Vernon. The raised surfaces of some of the panels are decorated with landscapes after the French taste, others with bits of rococo details, such as vases, cornucopias, and garlands. The heavily dentiled cornice, pilasters, and dado are marbleized on a background of grayish-green. Woodwork from the Colonel Joseph Pitkin house, East Hartford (deposited in the Wadsworth Atheneum, Hartford, Connecticut) (Fig. 4), from the Coombs house, in Sakonet, Rhode Island (illustrated in *Early American Decoration*), and from

.

FIG. 5. HOLLY HILL, FRIENDSHIP, *Anne Arundel County, Maryland*
Marbleizing in blue and cream. Overmantel panel of a lake on the shore of which stands a castle flying the British flag.
Courtesy Captain and Mrs. Hugh P. LeClair

FIG. 4. Paneling from the JOSEPH PITKIN HOUSE, *East Hartford, Connecticut*
Now demolished. Panels marbleized in gray and cream with black veining. Stiles and rails in shades of cedar-rose and cream.
Collection Wadsworth Atheneum, Hartford, Conn.

Holly Hill, Friendship, Maryland (Fig. 5) are other striking examples of unrestored eighteenth century marbleizing.

A fine veined pattern in dark bluish-gray on an off-white ground was apparently the type of marbleizing in most common use over a long period of time. Variations of this pattern appear on floors, furniture, and paneling with no essential change of technique from 1750 to 1850, its popularity seeming to have persisted after the more complex patterns had gone out of fashion. Directions for marbleizing are given by Rufus Porter in the *Scientific American* for 1846 as follows: "Imitations of marble are produced on white, or light slate colored grounds, and the shading colors,—which are ground in oil—are applied immediately to the ground color, and blended therewith before the former begins to dry. The shading used on light marbles is generally a mixture of blue, black, and white, though occasionally green, red and yellow are used; In imitating the Egyptian marble, the ground is painted nearly black, and the graining or clouding is formed with various lighter colors."[57]

There remain two very interesting references to early exterior marbling, and undoubtedly much of this has now disappeared, the effect of the elements on its delicate patterns making it unsuitable for outside exposure. Yet how striking it must have been when used to enhance the ornamentation of a handsome colonial façade. In 1750 James Birket, whose account of his travels affords some valuable sidelights on manners and customs of the period, was taken to see Captain Mal-

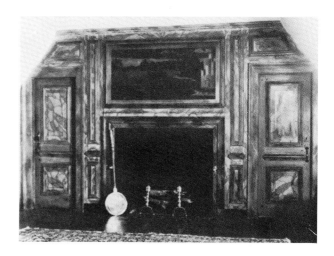

.

.

.

.

bone's country house which stood just outside Newport, Rhode Island. He saw an imposing mansion, built of stone, with corners and window frames painted to simulate marble.[58] In Farmington, Connecticut, the seventeenth century Samuel Cowles house received an elaborate face lifting about the time of the Revolution, at which date the front door was flanked by columns which supported a pedimented entablature incorporating a palladian window. That these columns were marbleized at one time is proved by a letter written in 1800 by Julia Cowles, daughter of the family: "Our house is now painting white, we have had three men to work at it, the Pillars are painted in imitation of marble, I dont think I shall like the color as well as white."[59]

Meeting Houses with Decorated Woodwork

Scattered throughout New England are a number of eighteenth century meeting houses which still retain original interior paint. Graining and marbleizing were considered especially suitable for the decoration of public buildings of this type, and a few, with their box pews and wine glass pulpits, have fortunately been preserved, and are well worth seeing.

The meeting house in colonial New England was usually owned and supported by the town, and was built by taxes levied on the entire community. In the meeting house all public assemblies of importance were held, including those of church, town meeting, and sometimes school. Often placed on a hill in order to occupy a commanding situation, its location occasionally caused bitter dispute, especially in larger townships. The early structures were usually built without steeples, being rectangular in shape with a door in the center of the side. A gallery supported by columns surrounded three sides of the interior, which was lighted by many large windows with multiple small panes.

One of the finest examples still stands at Sandown, New Hampshire, a few miles from Exeter. The large, two-story building has capped windows, a dentiled cornice, and three doors with Georgian pediments. The interior has changed but little from the time of its erection in 1774, on July 4th of which year a vote was entered in the town records: "To color the meeting house the color of Chester meeting house."[60] Although the pews are natural pine, the paneled pulpit and gallery fronts are cedar-grained, and their extraordinary similarity, in both pattern and color, to examples already mentioned in Essex County, should be noted. Two sets of pilasters on the pulpit and the columns which support the galleries are veined in dark blue on an oyster-white ground (Fig. 6).

In 1760 the township of Hawke, New Hampshire (now Danville), was incorporated in honor of the British admiral of the same name, and in a grassy field, overlooking its ancient graveyard, stands the meeting house erected the same year. The base and panels of what is said to be the oldest high pulpit in New Hampshire are finely grained in a soft rose stain, with the top rail pink. The gallery fronts and columns are now white, with pews in unpainted pine. In nearby Fremont the meeting house is characterized by a two-story porch at either end containing stairs to the gallery. Although this building is of a slightly later period than the others, not having been raised until 1800, the front of the pulpit and the rail before it are mahogany crotch-grained, and the risers of the stairs are marbled in gray-blue on white. In Washington, New Hampshire, the 1789 meeting house stands on the north side of a long village green, the dominant unit in a group of early white-painted buildings. The Asher Benjamin steeple was a later addition, and the east end was used at one time to accommodate the old academy. The woodwork is now painted gray, with white plaster walls, but one suspects that more decoration may once have existed. A trip up the winding stairway to the gallery, where a floor has been inserted which did away with the original high pulpit, reveals the old-fashioned church benches still "clouded" in bluish-gray.

Maine can boast of two venerable decorated meeting houses, one of which stands on a hilltop in Alna township, a few miles inland from Wiscasset. Erected in 1786, the woodwork is a warm gray, with contrasting panels of brown mahogany crotch-graining on pew doors, pulpit, and gallery panels. At Walpole stands a shingled building raised by the inhabitants of the town of Bristol in 1772, in which the lower part of the pulpit and pilasters behind it are mottled in green to simulate Italian marble, while the gallery columns are marbled in gray.

"Rocky Hill" in Amesbury, Massachusetts, built in 1785, has an exceptionally fine interior in original condition. Here also the reeded pilasters in the rear of the pulpit and the gallery supports are marbled in the usual manner. Evidence of decoration in the First Parish Church in Gloucester remains in the form of a portrait of the Reverend Eli Forbes, executed by Christian Gullager about 1787, in which he exhorts his flock from the paneled, grain-painted pulpit.[61]

Architectural Japanning

There was one other type of decorative painting widely practiced during the eighteenth century. This was the art of "japanning" which derived from the process of lacquering as practiced in the Orient since before the Christian era. In *Handmaid to the Arts* there is this definition: "The art of covering bodies by grounds of opake colours in varnish; which may be either afterwards decorated by paintings or gilding, or left in a

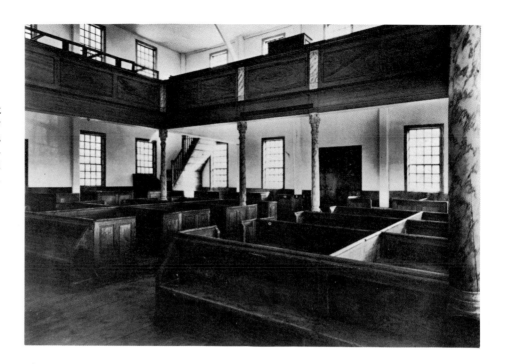

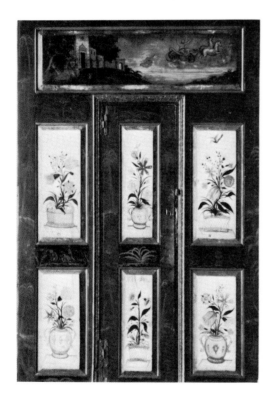

FIG. 7. DOOR AND SURROUNDING Paneling from a House at *Belle Mead, New Jersey*

Panels cream color with baskets and vases of flowers in naturalistic colors. Bevels painted to simulate wood graining, with door casing painted to simulate tortoiseshell. Rails and stiles decorated in imitation of Chinese lacquer.

Courtesy Metropolitan Museum of Art, New York City, N. Y.

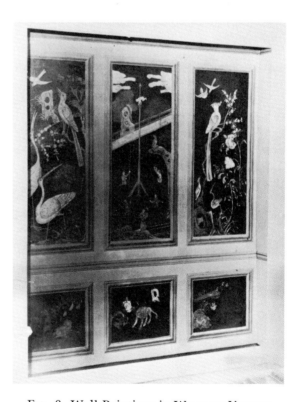

FIG. 8. Wall Paintings in WILLIAM VERNON HOUSE, *Newport, Rhode Island*

Chinoiserie panels on plaster found under wood paneling in the northwest parlor. Painted in imitation of Chinese lacquer, surrounded by painted bolection moldings. Rails and stiles marbleized in buff and brown.

Family Service Society, Newport, R. I.;
Photograph courtesy The Magazine Antiques

plain state."[62] Certain gums dissolved in alcohol produced the colored varnishes with which the ground color was laid. Furniture which was to receive the successive coats of varnish was first to be covered with a smooth, hard surface composed of glue and whiting. This procedure had some disadvantages in the drying, and consequent chipping, of the undercoat, and was therefore sometimes dispensed with in favor of the more lasting method of japanning directly on the surface of the wood. The relief ornaments were then built up with a mixture of gum arabic and whiting, and these might be gilded, silvered, or touched with color. Sometimes raised figures were not used, but the pattern executed in flat metallic colors. This type of work will often be found on the sides of chests, clock cases, and less important surfaces.

New England was the stronghold of the japanner whose advertisements appear in the Boston papers from the early years of the eighteenth century. This branch of the decorating business was carried on by a number of men who combined with it the usual occupations of house, ship, and carriage painting. It was even considered a genteel and desirable accomplishment for young ladies of the period, as witness the following announcement made by John Waghorne in the *Boston Gazette* for May 19/26, 1740: "Whereas John Waghorne, has lately Receiv'd a fresh parcel of materials for the new Method of Japaning, which was Invented in France, for the Amusement and Benefit of the Ladies, and is now practised by most of the Quality and Gentry in Great-Britain, with the greatest Satisfaction . . . he designs a School at Five Pounds for each Scholar."[63] Many kinds of japanned furniture were made during the mid eighteenth century, including highboys, lowboys, clock cases, picture frames, mirrors, and corner cupboards. In view of its widespread popularity, does it not seem likely that some adventurous craftsman would have experimented with using this fashionable "Chinoiserie" as a finish for interior woodwork? As far as I know this interesting possibility has never been investigated, yet there is some evidence, both factual and documentary, which indicates that architectural japanning was occasionally attempted.

In 1688 George Parker published in London an illuminating dissertation, the authenticity of which has been questioned, although his general directions were considered genuine by Mrs. Brazer. He called it *"A Treatise of Japaning and Varnishing*, Being a Compleat Discovery of those Arts. With the best way of making all sorts of Varnish for Japan. . . . Also rules for counterfeiting tortoiseshell, and marble, and for staining or dying wood. . . ." Concerning japanned woodwork, the following paragraph, which occurs in the preface, is of considerable interest:

Well then, as Painting has made an honourable provision for our Bodies, (in preserving portraits that are true to life) so Japanning has taught us a method, no way inferior to it, for the splendor and preservation of our Furniture and Houses. These Buildings, like our Bodies, continually tending to ruin and dissolution, are still in want of fresh supplies and reparations: On the one hand they are assaulted with unexpected mischances, on the other with the injuries of time and weather; but the Art of Japanning has made them almost impregnable against both . . . what can be more surprizing, than to have our Chambers overlaid with Varnish more glossy and reflecting than polish't Marble?[54]

In the *Magazine Antiques,* July, 1937, is a short article describing a notebook containing miscellaneous jottings kept by one John Cruger, of New York City, between the years 1798 and 1812. Cruger was a descendant of a well-known New York family, and much of the contents of the notebook deals with the equipment and furnishing of the house at No. 87 Greenwich Street which he maintained for his family in conjunction with other estates at Mill Brook and in the village of Cruger, near Peekskill. On July 19th, 1803, the luxury of Manhattan water was brought into the Greenwich Street establishment at a cost of $31.00, and just a month later appears a receipt in the sum of $58.54 given by William Mooney for "Japaning 2 Rooms." No further details are given, and we know only that Mooney, an upholsterer, was associated from 1802 to 1807 with Daniel Mooney, painter and glazier, who was probably responsible for this particular decoration.[65] Speculation as to the finish of these two intriguing apartments brings us to the inevitable question, do any walls still exist of which the decoration shows the influence of japanned technique?

A section of paneling from a house in Belle Mead, New Jersey, about nine miles from Princeton, has been owned and exhibited for some years by the Metropolitan Museum in New York City. This is a unique example of painted decoration of mid eighteenth century type, which shows evidences of both Dutch and Chinese influence (Fig. 7). In describing this acquisition, Charles O. Cornelius wrote as follows in the *Bulletin* of the Metropolitan Museum for January, 1926: "The stiles and rails are painted a very dark green, almost a black. On this are traces, which in some spots have almost disappeared, of fanciful decoration in yellow, the subjects and treatment of which are suggestive of Chinese lacquer, which undoubtedly formed the inspiration for this cruder attempt."[66] Here without doubt is an example of so-called japanned woodwork, which may have been similar to that referred to in the Cruger notebook. It is also worth noting that the bevels of the Belle Mead panels are grained in brown on a dull salmon-pink base, and that the applied molding which frames the door is painted to imitate tortoiseshell. Per-

haps the painter who did this room had access to Mr. Parker's Treatise, with "Rules for counterfeiting tortoiseshell and for staining or dying wood."

The Vernon house, which belongs to the Family Service Society in Newport, Rhode Island, should be noted as containing further examples of architectural japanning, which occur on a door in a third floor chamber, and on the plaster of the outer walls in the lower northwest parlor. In the spring of 1937 repairs necessitated the removal of paneling which covered the four sides of this room, beneath which were found what appeared to be the original plaster walls, the paneling having evidently been installed at a later date. On the fireplace wall, and on that next to the hall, no decoration was found, but on the north and west walls appear Chinese scenes arranged in panels framed in simulated bolection moldings which are painted in shades of brown. The space between the panels was originally expertly marbled in ochre and brown (Fig. 8).

The late Miss Ruth Ralston, formerly Associate Curator of the American Wing of the Metropolitan Museum of Art, was making a definitive study of these paintings at the time of her death. The following discussion of technique is taken from her preliminary notes which have been made available through the courtesy of the *Magazine Antiques*:

Underneath the painting is an undercoating of pink of what Mr. Bresnahan [who assisted in the restoration] calls 'lacquer.' I think it may be pigment and size. The painting on the wood panel on the third floor also shows a pink under coat (almost red). The technique of all the painting on the walls is what Mr. Bresnahan calls lacquer, and which he describes as pigment mixed with varnish and thinned enough to apply with a brush. It also appears to me to be lacquer, or, more correctly, japanning technique. The background is black throughout, very thick, and continues under the figures. On the black background the figures were drawn and filled in with colored pigments in 'lacquer.' The colors are green, umbers and reds. The figures have no gesso build-up and there is no gilding anywhere and no shadowing. The color was applied smoothly with a wide brush. Fine black lines are used to indicate the feathers on the birds and scales on the monsters, and to point up the rocks. There are large clusters of red dots like the decorations on oriental lacquer screens. In some cases the figures do not have oriental features.

The north half of the building is thought to be of seventeenth century date, and was owned in the early years of the eighteenth century by William Gibbs. It is interesting to note in passing that he was a painter,

and the wall decorations were probably done during his family's occupancy, and before the installation of the paneling by Metcalf Bowler after his purchase of the property in 1759. Overhead, in the northwest chamber, a West Indies scene was painted on the plaster over the fireplace. This was taken out some years ago and has now disappeared.

So far no similar work has been found in the vicinity of Newport or elsewhere in America, but precedent for this type of wall decoration may be found in the painted wallpaper panels which were made in China during the early eighteenth century and sent to England, a few coming directly to the colonies. Examples of several types may be seen in *Historic Wall-Papers*. Even closer in feeling to the Newport panels, however, are the wall decorations of leather painted in color with Chinese scenes which adorn a room in Honington Hall, Warwickshire, England, built in 1670.[67] These decorations with their handsome bolection frames are so similar in design and arrangement to those in the Vernon house that one must conclude that the local artist had access either to them or to corresponding examples in England. It should be further noted that whereas the English panels were fashioned from imported leather, and embellished with fine wooden moldings made especially to fit their size, the colonial artist contrived the same rich and decorative effect entirely by the use of paint, superimposed on a plain plaster surface.

Because of the nature of the raised decoration, and the expert work required to apply the smooth background and metallic ornamentation, it seems obvious that japanning, as applied to furniture, could never have been a practical finish for woodwork or walls. Nor is there at present evidence that the use of japanning in America was anything more than incidental, since it appears to have been limited to the use of flat surfaces with backgrounds and figures which may be said to derive from the Oriental lacquer tradition.

In closing, we may conclude from the evidence at hand that there was an increasing use of paint, both exterior and interior, in the American colonies beginning soon after the year 1700. Strong shades were popular until the pastel Adam period after the Revolution. Variegated finishes consisting of graining, marbleing, and other decorative effects followed European fashions, making the eighteenth century home rich with pattern and color.

[1] James Birket, *Some Cursory Remarks Made by James Birket in his Voyage to North America, 1750-1751* (New Haven, 1916), p. 15. Hereafter cited as Birket, *Some Cursory Remarks.*

[2] Timothy Dwight, *Travels in New-England and New-York* (London, 1823), I, 384. Hereafter cited as Dwight, *Travels in New-England.*

[3] [Robert Dossie], *The Handmaid to the Arts . . .* (London, 1758), p. 50. The 2nd edition of 1764 may be seen at the New York Public Library. Hereafter cited as Dossie, *Handmaid to the Arts.*

[4] *The 150th Anniversary of the Organization of the First Church of Christ in Pomfret, Conn. . . .* (Danielsonville, Conn., 1866), pp. 43-44. Owned by the Boston Athenaeum.

[5] Rita Susswein Gottesman, ed., *The Arts and Crafts in New York, 1726-1776; Collections of the New York Historical Society,* LXIX (New York, 1938), 348. Hereafter cited as Gottesman, *The Arts and Crafts in New York.*

[6] These recipes have been reprinted for the Seminars on American Culture, New York State Historical Assoc., Cooperstown, New York.

[7] Thomas G. Fessenden, ed., *The New England Farmer,* VII, 8 (Sept. 12, 1828). A file of this newspaper is owned by the Boston Athenaeum.

[8] *Ibid.,* VII, 9 (Sept. 19, 1828).

[9] *Ibid.,* I, 40 (May 3, 1823).

[10] Dwight, *Travels in New-England,* I, 270-271.

[11] *New England Farmer,* VI, 16 (Nov. 9, 1827), 126.

[12] A copy of these specifications containing entire details of construction may be seen at the Society for the Preservation of New England Antiquities, Boston.

[13] John Smith, *The Art of Painting in Oyl* (London, 1701), p. 22.

[14] Entry for Dec. 12, 1720. H. R. McIlwaine, ed., *Journals of the House of Burgesses of Virginia, 1712-1726* (Richmond, Va., 1912), p. 297.

[15] *Letters & Papers of John Singleton Copley and Henry Pelham, 1739-1776.* Massachusetts Historical Society, *Collections,* LXXI (Boston, 1914), 156. Hereafter cited as *Copley-Pelham Letters.*

[16] Account book of Amos Burnham of Ipswich, Mass. Owned by the author.

[17] *Valuable Secrets Concerning Arts and Trades* (London, 1775). American editions appeared in Norwich, Conn. 1795; Boston, Mass. 1798; New York, 1809 and 1816.
The edition of 1798 is owned by the Boston Athenaeum.

[18] Smith, *Painting in Oyl;* pp. 52-53 and 26.

[19] *Copley-Pelham Letters,* pp. 130 and 146.

[20] Samuel Sewall, *Diary of Samuel Sewall 1674-1729,* Vol. I; *Collections of the Massachusetts Historical Society,* V (Boston, 1878), 458.

[21] *Ibid.,* p. 413.

[22] Directions how to accomplish these and many other painted effects were published in great detail in *A Treatise of Japaning and Varnishing* (London, 1688). This book may be seen in the Print Department, Metropolitan Museum of Art, New York City.

[23] William Sumner Appleton, "The 'Scotch'-Boardman House, Saugus, Mass. 1651" *Old-Time New England,* XII, 4 (April, 1922), 167.

[24] This ceiling is pictured in Esther Stevens Brazer's *Early American Decoration . . .* (Springfield, Mass., 1940), facing p. 169. Hereafter cited as Brazer, *Early American Decoration.*

[25] R.T.H. Halsey and Charles O. Cornelius, *A Handbook of the American Wing* (New York, 1926), p. 80. Hereafter cited as Halsey and Cornelius, *Handbook of the American Wing.*

[26] George Francis Dow, ed., *The Arts & Crafts in New England, 1704-1775 . . .* (Topsfield, Mass., 1927), p. 237. Hereafter cited as Dow, *Arts & Crafts in New England.*

[27] *Ibid.,* pp. 208-209.

[28] *Ibid.,* p. 210.

[29] Alfred Coxe Prime, *The Arts & Crafts in Philadelphia, Maryland and South Carolina 1721-1785* (The Walpole Society, 1929), p. 299. Hereafter cited as Prime, *Arts and Crafts, 1721-1785.*

[30] *Walpole Society Note Book,* 1948, pp. 61-76.

[31] Peter Kalm, *Travels into North America . . .* (2nd ed., London, 1772), I, 457.

[32] Gottesman, *The Arts and Crafts in New York,* p. 348.

[33] Dossie, *Handmaid to the Arts,* p. 5.

[34] Marjorie Ward Selden, *The Interior Paint of the Campbell-Whittlesey House, 1835-1836* (Rochester, New York, 1949), p. 11. Hereafter cited as Selden, *Interior Paint of the Campbell-Whittlesey House.*

[35] Smith, *Art of Painting in Oyl,* p. 41.

[36] *Valuable Secrets,* pp. 68, 69.

[37] Smith, *Art of Painting in Oyl,* pp. 37-38.

[38] Account Book of Amos Burnham.

[39] Birket, *Some Cursory Remarks,* p. 15.

[40] Nathaniel Whittock, quoted in Selden, *Interior Paint of the Campbell-Whittlesey House,* p. 22.

[41] Margaret Jourdain, *English Interior Decoration* (London, 1950), p. 68.

[42] Nancy McClelland, *Historic Wall-Papers From Their Inception to the Introduction of Machinery* (Philadelphia and London, 1924), p. 221. Hereafter cited as McClelland, *Historic Wall-Papers.*

[43] *A Handbook for the Exhibition Buildings of Colonial Williamsburg* (Williamsburg, 1936), p. 23.

[44] Prime, *Arts and Crafts, 1721-1785,* p. 300.

[45] Dow, *Arts and Crafts in New England,* p. 215.

[46] Harriet M. Forbes, *Gravestones of Early New England and the Men Who Made Them, 1653-1800* (Boston, 1927), p. 89. Hereafter cited as Forbes, *Gravestones of Early New England.*

[47] The Rev. William Bentley, *The Diary of William Bentley,* IV (Salem, 1914), 392. Hereafter cited as Bentley, *Diary.*

[48] Forbes, *Gravestones of Early New England,* p. 89.

[49] *Records of the Church in Brattle Square, Boston, . . . 1699-1872* (Boston, 1902), p. 101.

[50] Rufus Porter, *Select Collections . . . ,* p. 34.

[51] Brazer, *Early American Decoration,* p. 258.

[52] Rufus Porter, "Imitation Painting," *Scientific American,* 17, I (Jan. 8, 1846).

[53] Fiske Kimball, *Mr. Samuel McIntire, Carver; The Architect of Salem* (Portland, Maine, 1940), p. 104. Hereafter cited as Kimball, *Mr. Samuel McIntire, Carver.*

[54] Gottesman, *The Arts and Crafts in New York,* p. 348.

[55] Prime, *Arts and Crafts, . . . 1721-1785,* p. 302.

[56] Lydia S. Hinchman, "The Maria Mitchell House and Memorial, Nantucket, Mass.," *Old-Time New England,* XVI, 3 (Jan. 1926), 112, 113.

[57] Porter, "Imitation Painting," *Scientific American* XVII, 1 (Jan. 8, 1846).

[58] Birket, *Some Cursory Remarks,* p. 27.

[59] Bertha Chadwick Trowbridge, ed., *Old Houses of Connecticut . . .* (New Haven, 1923), p. 62. The facade of the house is illustrated.

[60] Alice Winchester, "The Meeting House at Sandown," *Magazine Antiques,* XLVIII, 6 (Dec., 1945), 336.

[61] Louisa Dresser, "Christian Gullager, An Introduction to His Life and Some Representative Examples of His Work," *Art in America,* XXXVII, 3 (July, 1949), 139. The portrait is discussed and illustrated.

[62] Dossie, *Handmaid to the Arts,* p. 406.

[63] Dow, *Arts & Crafts in New England,* pp. 266-267.

[64] George Parker, *A Treatise of Japaning and Varnishing . . .* (Oxford, 1688), no page.

[65] "A Notebook and a Quest," *Magazine Antiques,* XXXII, 1 (July, 1937), 8-9.

[66] Charles O. Cornelius, "Colonial Painted Paneling," *Bulletin of the Metropolitan Museum of Art,* XXI, 1 (Jan., 1926), 6-7.

[67] Nathaniel Lloyd, *A History of the English House from Primitive Times to the Victorian Period* (London, 1931), Fig. 706 and p. 409. Hereafter cited as Lloyd, *History of the English House.*

Chapter II

Woodwork with Landscape Decoration
"Either from Nature or Fancy"

BEFORE THE MIDDLE OF THE EIGHTEENTH CENTURY landscapes and subject pieces were being painted in the colonies, and were being advertised in the local newspapers to an extent which suggests their undoubted popularity. Unfortunately, the greater part of these have now disappeared, leaving the impression that portraits were the sole output of the colonial artist. Recently, however, it has been discovered that a large body of new material exists in the form of pictorial panels. A study of these has revealed that many artists were executing well painted American landscapes some years before Ralph Earl introduced the Connecticut countryside into his portrait backgrounds, or accepted commissions to paint his views near Sharon and Worcester in the closing years of the eighteenth century.

The introduction of pictorial panels into colonial America was not a surprising development, since landscape painting as an integral part of room decoration was much in vogue in England during the late seventeenth and early eighteenth centuries. In the diary of Celia Fiennes is the following reference to the house of Sir Thomas Cooke at Epsom, near London: "Very good Pictures in all ye roomes over Chimneys and doores, all fix'd into ye wanscoate."[1] Most of these pictures were painted on canvas and set into the woodwork, some were on wood panels, and still others were executed directly on the plaster walls and framed by architectural moldings.[2] Isaac Ware in *A Complete Body of Architecture . . .*, published in 1756, has this to say of the chimneypiece: "A principal compartment should be raised over it to receive a picture." In *The City and Country Builder's and Workman's Treasury of Designs,* issued by Batty Langley in London during the same year, is the contemporary name for the architectural enframement: "Designs for Chimney-Pieces and their Ornaments, Containing great Variety of Tabernacle Frames. . . ."[3]

The fashion for pictorial wall panels reached the col-onies by way of the many English artists who came to the southern cities during the second quarter of the eighteenth century. Bishop Roberts advertised portrait painting, engraving, heraldry, and house painting in Charleston in 1735, and a water color drawing of the harbor and waterfront done by him is illustrated in Flexner's *American Painting, First Flowers of Our Wilderness.*[4] Two years later he inserted this notice in the *South Carolina Gazette* for July 23: "Gentlemen may be supplied with Land-scapes for Chimney Pieces of all Sizes." In 1750 John Kieff, "lately arrived from London" and living in Williamsburg, advertised landscape painting of all sorts, and in 1776 one Warwell, also from London, announced the painting of landscapes and sea pieces in Charleston, South Carolina.[5]

On April 15, 1757, George Washington sent an order to a distant relative in London for certain items in connection with the remodelling of Mount Vernon. These included: "A Neat Landscape after Claude Lorrain . . . £ 3.15.6." The picture which is now in place over the mantel of the west parlor is painted on canvas, coincides exactly with the dimensions which were included in the above order, and is believed to be the original placed there by Washington in 1758.[6]

In 1769 Alexander Stewart, who had been bred in the Academy of Painting in Glasgow and had later studied in Edinburgh, advertised in Philadelphia: "Those gentlemen, either in town or country, who have picture pannels over their chimney pieces, or on the sides of their rooms, standing empty, may now have an opportunity of getting them filled with pictures, at a very moderate rate."[7] As late as 1792 a notice in the *Maryland Journal* announced: "Many things relating to the Decorations of elegant Rooms—such as Fancy Pattern-Cloths for Floors and Passages, transparent Blinds for Windows, Flowers, and rural Scene-Pieces for Chimney. . . ."[8]

Advertisements for decorative painting of this sort

are infrequent in New England newspapers; yet the large number of panels which have been found here prove that a great deal of such painting was done, house painters being responsible for most of the panel landscapes. An amusing commentary on those who did "chimney paintings" is contained in an auction notice which appeared in the *American Herald,* Boston, on January 2, 1786: "To Be Sold on Thursday, 12th Inst. At one o'clock, at the Bunch of Grapes, in State-Street, Two Jack Asses, Lately imported from Europe for improving the Breed of Mules—Three Chimney Paintings in gilt Frames, one representing Ships in a Calm, two representing Country Seats, well executed by a Genuine Painter." A subtle distinction is here suggested between the overmantels done by the ordinary house painter and framed canvases intended to serve the same purpose, but executed by one who evidently moved in higher artistic circles!

The artists who came to Baltimore and Charleston directly from England probably did many of their overmantels on canvas which were then set into handsome "tabernacle frames" similar to that at Mount Vernon. This custom was not generally followed in New England where the woodwork in the majority of houses consisted of simple paneled room-ends which the native painters used as backgrounds for their "rural scene pieces." An exception to this rule was Oak Hill, Peabody, Massachusetts, two rooms of which (now in the Museum of Fine Arts, Boston) have canvas overmantel paintings attributed to the Italian artist Michele Felice Cornè (Fig. 39).

Many pictures intended to be framed and hung on a wall were painted on wood, and these are sometimes mistaken for overmantel decorations. The overmantel woodwork was a fixed part of the architectural structure and was constructed either of one very wide board, or of two so skillfully fastened together that the joining is not apparent without careful examination. The raised panel with beveled edge slipped into a groove behind the bead on the edge of the stiles and rails. When a panel is removed from its original position nail holes will sometimes be apparent along the edges. If the painting was done after the panel was set in place, as appears usually to have been the case, a narrow unpainted band will be left where the molding covered the edge of the bevel. If the bevel has been removed, traces of recent cutting should be apparent. In woodwork of the late eighteenth and early nineteenth centuries flat panels with no bevel came into use, held in place by a raised applied molding. Here also, however, the line of the original molding will be clearly seen, although the paint may go to the edge of the wood if the work was done before the paneling was set in place. The backs of many old wooden pictures were primed with a flat color as an aid in preventing warping, but paneling seems seldom if ever to have been so treated. On the back of structural woodwork may often be seen either the grooves of an old-fashioned plane (Fig. 9), or the marks of a cross-cut saw (Fig. 10).

As age and smoke darkened the ornamental pictures, repeated coats of varnish were applied, in an attempt to brighten the surface. Therefore most panels when found in a house will present a dark brown surface through which it is often difficult to see the design. In most instances the varnish has preserved the old surface so that careful cleaning will reveal the original colors in good condition. This work, however, should not be undertaken by the amateur, but should be entrusted only to an experienced restorer having reliable knowledge of solvents and modern cleaning methods.

From investigation of the woodwork surrounding many overmantels it is evident that graining was often used, no doubt the work of the same decorator. Although in most cases the paneling has been many times repainted, a few examples of original colors still remain. The Wetmore house in Middletown, Connecticut (Fig. 3), and the room from Marmion, Virginia, in the Metropolitan Museum are two examples having original variegated finishes. In other instances a plain surrounding color was used, usually in a shade calculated to enhance the landscape. Indian red, blue, and ochre have been found. Sometimes the bevels of the panels were painted to match the adjoining woodwork; at other times they were toned in with the picture itself.

By far the larger number of pictorial decorations were painted over the fireplaces, but in rare cases other wall panels were embellished with scenes. An overdoor landscape is found at Holly Hill, Maryland. An example by Cornè is now in the Peabody Museum, Salem, and one from New Jersey is illustrated in Fig. 7. The large surfaces of early two-paneled doors also served as good backgrounds. Two very interesting designs from Hingham, Massachusetts, most effectively executed in gray monochrome with bevel in soft rose, give the impression of having been drawn with a brush rather than painted (Fig. 11).

Not all decorative painting was scenic; occasionally still life motifs were used with charming effect. In the paneling from Belle Mead each raised surface is filled by a vase or basket of flowers drawn on an ivory background in shades of green, pink, blue, yellow, brown, and black. The combination of the overdoor panel, the Chinoiserie stiles and rails, grained bevels, and tortoiseshell moldings makes this one of the most important remaining examples of American painted decoration. From Wallingford, Connecticut, comes a section of woodwork with a dish of cucumbers naïvely painted on an upper panel (Fig. 12). Other sections show dishes of

FIG. 9. OLD PLANE MARKS on the Back of an
Overmantel Panel
The front of this panel is illustrated in FIG. 45
Author's collection

FIG. 10. MARKS OF A CROSS-CUT SAW on the back of an
Overmantel Panel
The front of this panel is illustrated in FIG. 23
Courtesy Edward Atkinson

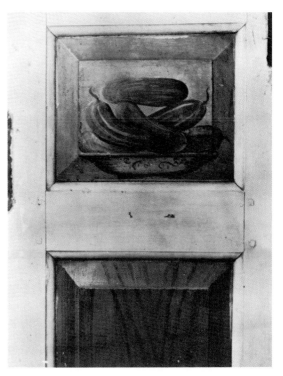

FIG. 12. DISH OF CUCUMBERS on Paneling from
a House in *Wallingford, Connecticut*
Lower panel grained in two shades of red
*Courtesy Mrs. J. Watson Webb; Photograph Na-
tional Gallery of Art, Index of American Design
Photograph by Henry Shaeczko*

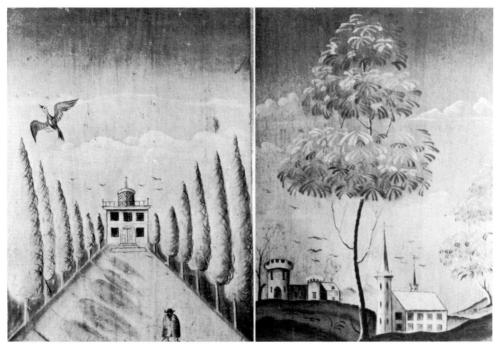

FIG. 11. Door Panels from THAXTER-LINCOLN HOUSE, *Hingham, Massachusetts*
Now demolished. Painted in gray monochrome with bevels in pink.
Courtesy Francis H. Lincoln

fruit, entwined grapevines, and a large pineapple surmounted by a dove carrying an olive branch. The lower panels are grained and the reeded pilasters are marbleized.

Shell-top cupboards were frequently the objects of special attention by the decorator. Of those which still retain their original finish, one is to be found in the drawing room of The Lindens, built in Danvers, Massachusetts, in 1754, and now re-erected in Washington, D. C. This cupboard is marbleized, probably by the same artist who did the handsomely decorated floors of the hallways and chambers. A cupboard door originally in the Bray House, Kittery Point, Maine, had a carved and painted cherub head and wings which may have been done at the same time as the overmantel in the parlor. A pine-paneled room from the Bliss house in Springfield, Massachusetts, now installed in the National Museum in Washington, D. C., has a "beaufat" with an unusual stenciled interior (Fig. 13). On a deep yellow background vines of leaves and tendrils in red and green are painted above the shelves, while similarly colored swags decorate the upper edge of the curved dome. A similar vine appears beneath the landscape fresco in the hall of the Knowlton house in Winthrop, Maine, which is signed A. N. Gilbert, and dates from about 1830. One of the finest painted cupboards extant is in the parlor of the Seth Wetmore house in Middletown, Connecticut (Fig. 14). The walls are a clear, strong blue, the shelves are cedar-grained to match the woodwork of the room, the center sunburst is embellished with a scroll design, and the shell top is shaded in bands from reddish-orange through light green, back to a deep bluish-green.

As a general rule definite names have not been handed down in connection with architectural painters, but certain attributions are widespread and persistent, although corroborating historical evidence is lacking in every case. These legends concern the transitory visits of British and French soldiers at the time of the Revolution, of Hessian prisoners and American army deserters, of British spies during the War of 1812, and of wandering foreigners of uncertain origin and intemperate habits. The legend concerning foreigners is often repeated, and may have more truth in it than some of the other accounts. These stories, although now romanticized out of all recognition, probably contained originally some basis in fact. They also provide an invaluable clue to the attitude which the ordinary citizen had toward the traveling artist, who seemed to him a sort of mysterious vagrant, appearing and disappearing at will from, and to, an unannounced destination. No doubt the men to whom this wandering life appealed were odd characters at best, and it is not surprising that rumors of spies and deserters followed them at the time,

and have persisted through the years.

Before the middle of the eighteenth century it became fashionable to own a picture of one's country home, and in the south artists were offering to gentlemen "draughts of their houses in colors or India ink." In 1752 A. Pooley of Culvert County, Maryland, advertised "Views of their own Houses and Estates," and in 1769 "perspective views of gentlemen's country seats" were offered in the *Pennsylvania Journal*.[9] Considering the popularity of this type of picture, one would expect to find many of them still in existence, but seldom does the mansion in an overmantel panel prove to be the house from which the painting actually came.

The most unusual rendering of the owner's estate which I have happened to see is the "perspective view" of Holly Hill, Anne Arundel County, Maryland, and its surrounding terrain (Fig. 15). This chart was found secured to a wall in the hallway by two wrought iron supports when the house was purchased by the present owners in 1936. It is on canvas, 36 by 42 inches, and is contained in a heavy molding which appears to be the original frame. Entitled "Samuel Harrison's Land Near Herring Bay," it shows the house and adjacent property in great detail with further notes interpolated along the margins. Samuel Harrison owned this estate between the time of his inheriting it in 1716 and his death in 1733, and it seems fair to presume that the chart was painted to his order sometime between these two dates.

A panel from Worcester, Massachusetts, is one of the few which shows a well drawn view of the house from which it came. It was originally placed over the fireplace in the north parlor of the home of the Reverend Joseph Wheeler, which stood on the east side of Main Street opposite the First Unitarian Church, until its demolition about the year 1882. The square, hipped-roof mansion, with its fine doorway and quoined corners, is shown in the center of the panel (Fig. 20), and its identity is proved by an old photograph of the Wheeler house owned by a descendant of the family (Fig. 21). Also on Main Street stood in Revolutionary times the mansion of Gardiner Chandler which was described by Timothy Dwight in his *Travels* as "one of the handsomest which I have met with in the interior of this country." In the 1784 appraisal of Chandler's estate appears an item, especially interesting because it may refer specifically to a picture panel, which gives the current value: "Situation of the Mansion House, 6 shillings."

The interest in this type of view apparently lasted well into the first quarter of the nineteenth century, as one of the rare advertisements of a New England house and fancy painter appears as follows in *The Franklin Herald and Public Advertiser*, Greenfield, Massachu-

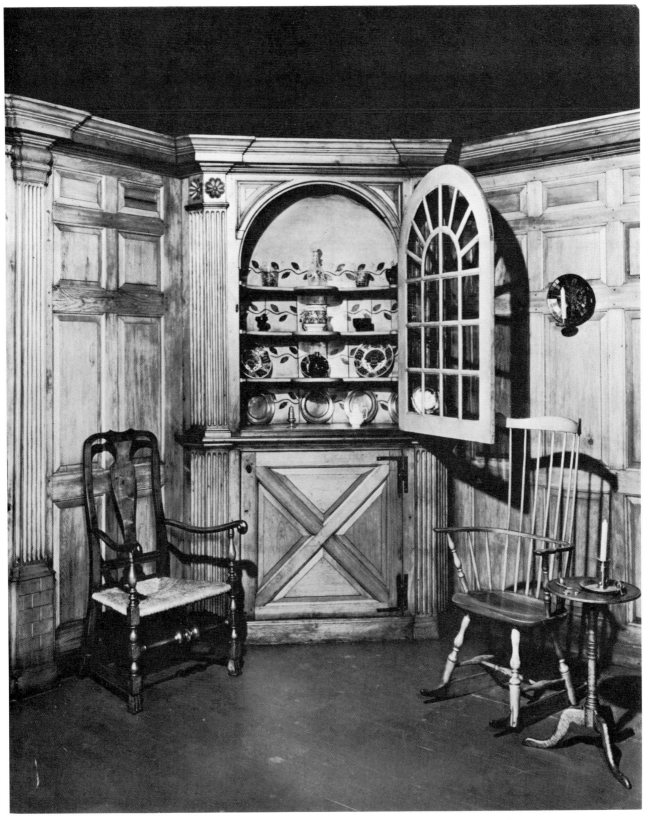

FIG. 13. Interior from the REUBEN BLISS HOUSE, *Springfield, Massachusetts*
Corner cupboard is stenciled in red and green on a bright yellow background.
Smithsonian Institution, Washington, D. C.

·21·

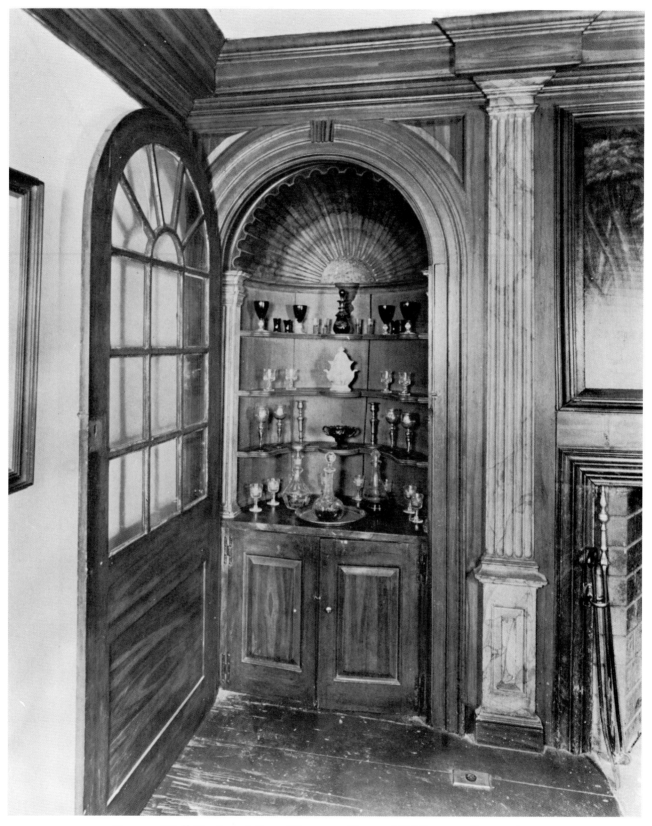

FIG. 14. Wall Cupboard, SETH WETMORE HOUSE, *Middletown, Connecticut*
The interior wall is blue. The shell top is painted in bands which shade from red, to light green, to dark green.
Courtesy Samuel M. Green

setts, in 1823: "House painting, sign and ornamental painting in all their branches . . . Landscape Painting and views of gentlemen's country seats if required. . . ."

In examining the subject matter of the overmantel panels one must ask the inevitable question: where did the artist get his inspiration? Were his designs original conceptions, or did he borrow and reuse certain details from already available sources? Taking the group as a whole, we find that the scenes are amazingly fresh and non-derivative. There is no doubt that by far the greater part were decorative compositions painted to fill a given architectural space, although it is often hard to believe that they were not really factual views. These country-bred artists did not romanticize the landscape as their nineteenth-century followers were to do. Instead they

took elements of contemporary life with which they were familiar and used them in varying realistic combinations, creating what is today a valuable record of the eighteenth century American scene. James L. Walker, for instance, advertised in Baltimore in 1792: "Landscapes, either from Nature or Fancy."[10] Despite the fact that these painters did manage to achieve results which were strongly individual, a few of their motifs were definitely adapted from outside sources to which the artists had access. Although this may not be readily apparent, careful comparison of a number of examples will indicate the following three main sources from which details may be recognized: engravings (sometimes through the medium of needlework pictures), imported wallpapers, and English builders' design books.

One has only to glance at the newspaper advertise-

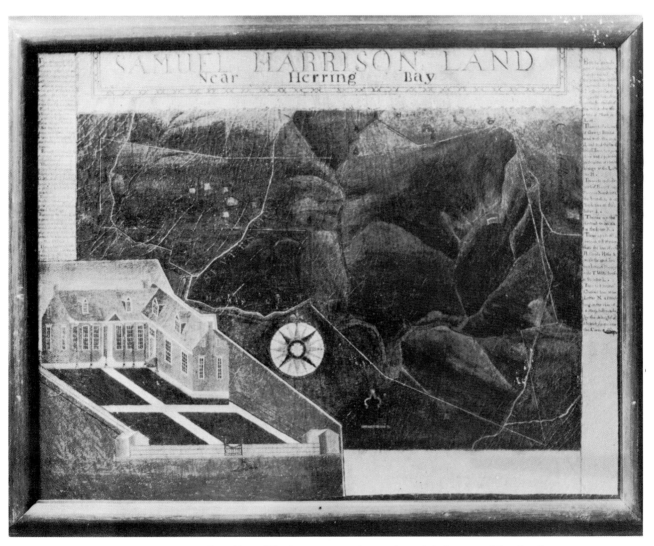

FIG. 15. Chart of Holly Hill, FRIENDSHIP, *Anne Arundel County, Maryland*
Painted on canvas with original frame. Shows the house and land between 1716 and 1733.
Courtesy Captain and Mrs. Hugh P. LeClair

· 23 ·

ments in any of the coastal cities during the eighteenth century to realize how many engravings were imported and sold in the colonies. Likewise individual inventories list large numbers of "Landskips" many of which undoubtedly were prints. During the mid eighteenth century young ladies were embroidering needlework pictures from designs based on English and European engravings, the patterns for which were supplied at embroidery schools of the type carried on by Mrs. Condy "near the Old North Meeting House." Here she supplied to the gentlewomen of Boston patterns for "all sorts of beautiful Figures on Canvas, Screens, Pocket Books Pictures etc."[11] Needlework pictures, oblong in shape and appropriately enclosed in handsome walnut and gold frames, sometimes embellished with candle brackets, were made by the young girls, and provided decoration similar to that of the overmantel panels. One such picture owned by the Museum of Fine Arts, Boston, is known as the Bourne heirloom (Fig. 24). It is referred to in the will of Mrs. Mercy Bourne of Barnstable, Massachusetts, dated July 10, 1781, in which she left "to her granddaughter Abigail Gallison, her mother's work, called a chimney-piece."[12] Mrs. Condy also used the term "Chimney-Piece" in an advertisement in the Boston *Evening Post* for March, 1742. In 1738 she announced: "The patterns [are] from London, but drawn by her much cheaper than English drawing."

Extensive research on the subject of engravings as sources for embroideries has been done by Nancy Graves Cabot, and it now appears that certain details in a few of the panels may be traced to the same printed source as those in the contemporary embroideries. In some cases the artist probably had access to the actual engravings, while in others he may have seen the patterns or the finished needlework pictures, which must have been fairly prevalent even in rural New England. As might be expected, several of the hunting panels show close affinity to English sporting prints. One is actually a copy, with minor variations, of a print after a painting by James Seymour (Figs. 31 and 32). Other panels include small groups of figures taken out of engravings and inserted into compositions of the artist's own making. These and other source motifs will be discussed further in Chapters III and IV in connection with the panels in which they appear.

Wallpaper was a prolific source of design for all types of architectural painting. Repeat patterns, classic ruins, marbleized backgrounds, and scenic panoramas all appeared in contemporary imports and were eagerly seized upon by the wall painter as inspiration for his facile brush. Even the subjects intended for paper bandboxes could be successfully adapted to produce a panel of unusual design! (Figs. 23, 25, 33, 34).

English builders' design books must have played some part in the architectural compositions of the panel painters. We know from a comparison of architectural details that these volumes were in the hands of many colonial housewrights who adapted English building traditions to local American taste. In such books the mural painter might see the square mansions with long dependent wings terminating in pavillions which he sometimes reproduced in his pictures.[13] Such houses were infrequent in New England. It seems fair to presume, however, that the local artists admired these buildings in handbooks of which John Crunden's *Convenient and Ornamental Architecture*, published in London in 1770, was a popular example. Here are various drawings for "villas" which incorporate kitchen and washhouse in flanking wings. In Pain's *British Palladio or The Builder's General Assistant*, which was issued in London in 1793, Plate 24 bears the following inscription: "Plan and elevation of a Gentleman's Country House with a pavillion at each end, one for steward's and house keeper's apartments, and the other for kitchen, scullery etc."

REFERENCES

[1] Celia Fiennes, *Through England on a Side Saddle in the Time of William and Mary* (London, 1888), p. 298.

[2] Lloyd, *History of the English House*, Fig. 647, p. 381. Argyll House, Chelsea, London, 1723, has an overmantel landscape on panel exactly like those appearing in America during the third quarter of the eighteenth century.

[3] Batty Langley, *The City and Country Builder's and Workman's Treasury of Designs* (London, 1756), p. 23.

[4] James Thomas Flexner, *American Painting: First Flowers of Our Wilderness* (Boston, 1947), p. 157.

[5] Prime, *Arts and Crafts, 1721-1785*, p. 8.

[6] For information concerning this overmantel I am indebted to Worth Bailey, Curator of Woodlawn Plantation, Mount Vernon, Virginia.

[7] Prime, *Arts and Crafts, 1721-1785*, p. 9.

[8] Prime, *Arts and Crafts, 1786-1800*, p. 302.

[9] Prime, *Arts and Crafts, 1721-1785*, pp. 7, 9.

[10] Prime, *Arts and Crafts, 1786-1800*, p. 306.

[11] Boston *Newsletter*, April 1738 and Boston *Evening Post*, March 1742. Quoted by Nancy Graves Cabot in "Engraving and Embroideries," *Magazine Antiques*, XL, 6 (Dec., 1941), 368.

[12] For further discussion and illustrations of needlework chimney-pieces see Nancy Graves Cabot, "The Fishing Lady and Boston Common," *Magazine Antiques*, XL, 1 (July, 1941), 28-31.

[13] Such a house may be seen in a panel from Canterbury, Connecticut, illustrated in Edward B. Allen, *Early American Wall Paintings, 1710-1850* (New Haven, 1926), p. 17. Hereafter cited as Allen, *Early American Wall Paintings*.

Chapter III

Overmantel Panels from Massachusetts and Northern New England

"Rural Scene-pieces for Chimneys"

Central Massachusetts

UP TO THE PRESENT TIME, the largest group of land-scape panels to be found in New England comes from Massachusetts. This perhaps is not surprising in view of the numerous thriving seaports which dotted the coastline and the many prosperous towns in the central part of that state during the late eighteenth and early nineteenth centuries. Many itinerant painters plied their craft in isolated communities, leaving no record except their "landskips." An interesting group of sixteen panels from central Massachusetts varies to such a degree that the panels now appear to be the work of at least ten different decorators.

The John Ammidown house on West Dudley Road, Southbridge, said to have been built in 1796, contained at one time several evidences of decorative painting. On the plaster wall of an upper room were portraits of George and Martha Washington.[1] One chamber floor and the stairway were stenciled with a small black figure, and the "chair-mouldings, corner-posts, and frieze were painted a light color clouded with blue."[2] Over the fireplace in the southwest parlor may still be seen a panel landscape which was moved from a similar position in the east room when the house was modernized (Fig. 16). A panel from the Damon Nichols house, which stood off the Worcester road near the Sturbridge-Charlton line, is very similar in composition and coloring (Fig. 17), as is one from the Bliss house in Springfield,[3] and all three were probably done by the same artist.

Other overmantels have been found in Sturbridge and vicinity but the style of painting is quite different from the three mentioned above, and they are undoubtedly by another hand. Old Sturbridge Village owns a landscape contained in the original chimney breast which came from the Perez Walker house at Walker Pond, in the northern part of the town. It shows a large group of closely-built houses, with shipping in the distance. The round-topped black doors are worthy of notice, as they seem to be characteristic of this man's work. Two pairs of figures in late eighteenth century costume, a white horse, four cows, and a group of sheep enliven the composition.

The Worcester Historical Society owns a long narrow panel from the Joshua Merriam house in North Oxford which is obviously by the same hand, as will be seen in the detail shown in Fig. 18. The figures, again in costumes of the late 1790's, are of unusual interest, particularly the darky peddler with stick and shoulder pack accompanied by his dog. Many "transient persons" of various types were on the road at this period, and they appear in a number of the panels.

Another panel from Oxford is owned by the Worcester Art Museum (Fig. 19). On the bank of a broad river is a church surrounded by a colorful group of houses painted brown, yellow, red, and green, their windows accentuated in contrasting colors. Ladies and gentlemen wearing 1795 hats and gowns feed swans on the opposite bank. This group may be based on an English engraving, as it bears a surprising resemblance to the figures in a panel from Lansdale, Pennsylvania (Fig. 63).

Also from Southbridge, but completely unlike any of the others from this vicinity, is the portrait panel in Pl. III which was over the fireplace in the lower southeast room of the Moses Marcy house, and is now owned by Old Sturbridge Village. Moses Marcy was born in Woodstock, Connecticut, in 1702, and in 1732 moved his family to what is now Southbridge, but was then part of the town of Oxford. He soon rose to a position of prominence in town affairs, and was given the first pew allotment in the First Church, a significant mark of esteem. He held the rank of Lieutenant-Colonel in the local military company, and this regiment marched to the relief of Fort William Henry in 1759. It has been surmised that this picture shows Moses Marcy in his

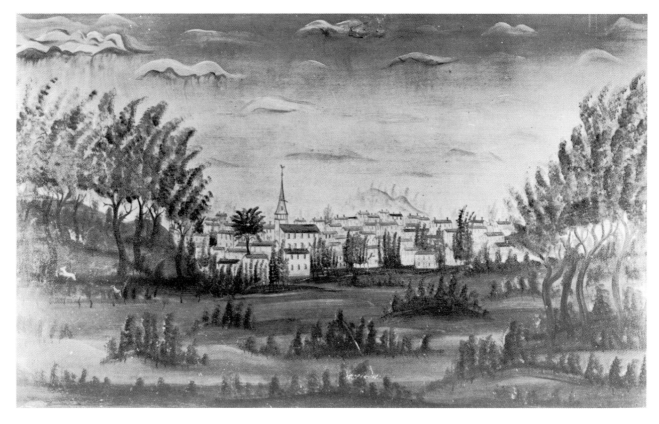

FIG. 16. Overmantel from the JOHN AMMIDOWN HOUSE, *Southbridge, Massachusetts*
Courtesy Frank Brissette

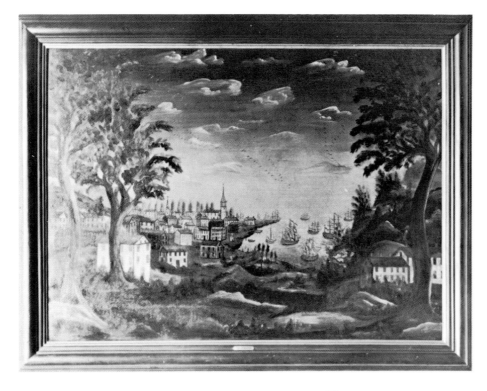

FIG. 17. Overmantel from the DAMON NICHOLS HOUSE, *Sturbridge, Massachusetts* This house, now demolished, stood close to the Charlton-Sturbridge line.
Author's collection

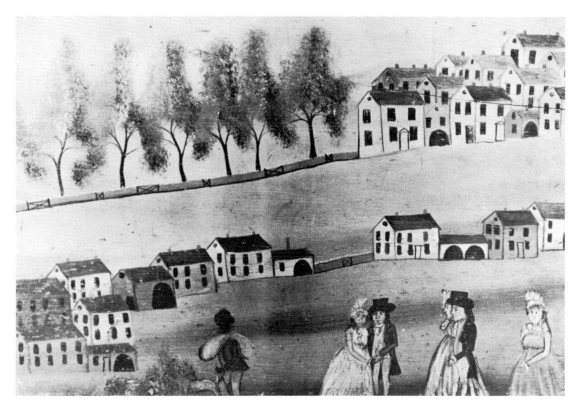

FIG. 18. Detail of Overmantel from JOSHUA MERRIAM, SENIOR, HOUSE, *North Oxford, Mass.*
Houses painted white, brown, and red, with black windows and doors.
Worcester Historical Society, Worcester, Mass.

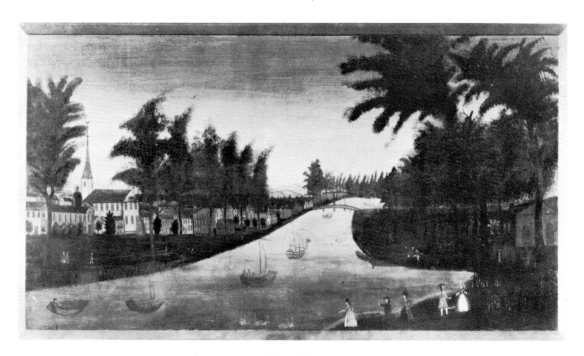

FIG. 19. OVERMANTEL from an Unidentified House in *Oxford, Massachusetts*
Houses are painted brown, yellow, red, and green. The church has quoined corners.
Worcester Art Museum, Worcester, Mass.

militia uniform, his tricorn hat edged with gold braid, a red sash from shoulder to hip, and his hand on his sword belt. From a tall-stemmed glass he drinks a toast contained in a creamware punch bowl, while his dog lies under the table, and a gigantic bird perches on a nearby branch. The gambrel roofed house, painted light buff with white trim and red door, does not resemble the descriptions of the old Marcy home from which the panel came, nor would the Quinabaug River permit the passage of a full-rigged ship of such proportions as the one which lies offshore. Whatever its significance may have been, the painting seems quite certainly to be pre-Revolutionary in date, and its subject matter makes it one of the most outstanding panels thus far found.

In nearby West Sutton, in the old Waters house, are two panels by Winthrop Chandler, a Connecticut artist whose work will be considered in detail in Chapter IV (Fig. 2). The house was built in 1767 by Ebenezer Waters, whose father Richard had come from Salem and was one of the first settlers of Sutton. Here in the southwest parlor in 1837 Henry Ward Beecher was married to Eunice Bullard. The overmantels in the lower and upper southwest rooms may have been done as early as 1779, for between April and November of that year Chandler painted in Sutton portraits of Samuel Waters (brother of Ebenezer) and his wife Prudence. In any case the panels were certainly executed before 1790, the year in which the artist died.[4]

Shortly before the Revolution the Reverend Joseph Wheeler came from Harvard, Massachusetts, to Worcester, bringing with him, it is said, part of the lumber with which to build his first home. He served as Register of Probate from 1776 until his death in 1793, and in 1780 he erected a mansion house, making the first little structure into a store which served as such for many years. His large house stood on the east side of Main Street, opposite Court Hill, and sheltered five generations of the Wheeler family before its demolition in 1882. Over the fireplace in the north front parlor was a painting by an unknown artist which shows the Wheeler house with adjacent store and neighboring houses, all sheltered by a long row of trees which resemble palms, and are certainly of a species unknown in New England (Fig. 20). Nevertheless, this view is not purely fanciful, as an old photo of the house proves that the pedimented door, dentiled cornice, and quoined corners were carefully copied in the painting (Fig. 21). This panel has unusually delightful coloring. The mansion house is deep cream, with front door of a gay vermilion. The windows of all the buildings are blocked in with blue, and the sides of the outbuildings are drawn with black lines to indicate vertical boarding. The houses at the extreme right are painted vermilion, blue, brown, pink, and gray with brown doors. It almost seems as if the artist must have seen a copy of a quaint little book entitled *Art's Treasury of Rarities: and Curious Inventions*. My copy bears on its fly leaf the revelatory inscription, "William Carter, June 15, 1815. One quarter part of W. R. Danforth's Library." Under the heading "How to Colour Buildings" is the following helpful advice to the "landskip" artist: "In colouring Buildings, you must use much Variety, the better to set them off; yet not so as they may appear extravagantly adorned, or contrary to the Use of this kind; . . . if a Brickhouse, use red Lead and white, and where the Houses stand thick together there use sundry Colours suitable to the occasion."[5]

On the old road which connects Brookfield with the present town of Fiskdale stands the Banister house, a fine example of foursquare country Georgian architecture. Placed high in a commanding location, its dentiled cornice and two handsome pedimented doorways proclaim its prosperous past. The road now winds close to a corner of the building, but an overmantel which remained until recently in the old ballroom probably shows the house as it looked many years ago. Long sheds having four arched doorways were pumpkin color, the small barn was gray, and the house itself was light yellow (Fig. 22). The execution of this scene proclaims the painter to have been almost completely unskilled in the rudiments of art, but his panel, with its comical animals and great attention to detail, is decidedly appealing in spite of its artistic shortcomings. The figures in the foreground are really unusual. At the left two gentlemen in red coats and white knee breeches play a cello and a flute under the shade of sheltering trees. The detail of the flute player appears in identical pose in a needlework picture from Maine of the mid eighteenth century, and is found also in French engravings of the period. In the center a lady and gentleman sit on a rock holding hands, while at the extreme right a man holds out his hand to receive a bird which is perched on the wrist of his lady friend. The costumes of the men, and the high plumed hats of the women, suggest a late eighteenth century date.

From Westborough comes a panel which shows a majestic stag being pursued by riders and dogs across the park lands of a country estate, the owners of which stand unconcernedly in the path of the onrushing hunt. From the vicinity of Enfield, a town now covered by the waters of the Quabbin Reservoir, an overmantel of a prim yellow house was fortunately saved. Winthrop Chandler traveled north to Petersham probably in the 1780's to embellish the best chamber of his cousin John Chandler with a view of a river town. In Framingham a compact little village still nestles amidst

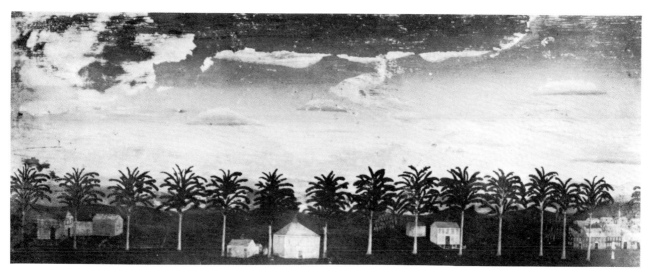

FIG. 20. Overmantel from the REVEREND JOSEPH WHEELER HOUSE, *Worcester, Massachusetts*

At the left of the mansion is the first small house which was later used for many years as a store. The large house is deep cream. Houses in the group at right are painted red, blue, brown, pink, and gray. Doors are brown and vermilion.

Courtesy Charles Aiken

FIG. 21. Old Photograph of the REVEREND JOSEPH WHEELER HOUSE, *Worcester, Massachusetts*

The round topped door, quoined corners, and dentiled cornice are shown in the overmantel.

Courtesy Charles Aiken

· 29 ·

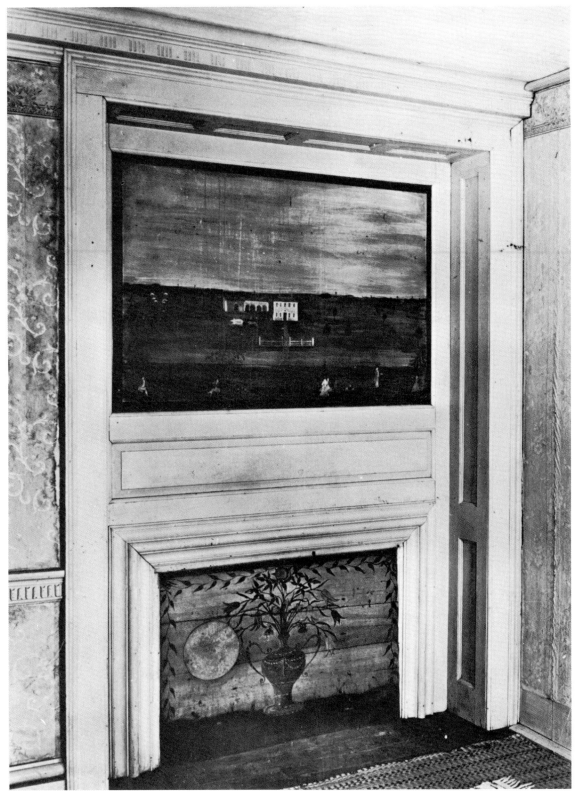

FIG. 22. Overmantel and fireboard from the BANISTER HOUSE, *Brookfield, Massachusetts*
In original position in the ballroom, before removal.
Author's collection
Photograph Historic American Buildings Survey, Library of Congress, Washington, D. C.

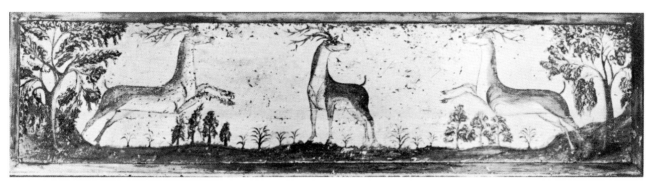

FIG. 23. OVERMANTEL from an Unidentified House in *Framingham, Massachusetts*
Now demolished. Said to have been painted by an Indian in the late 1700s.
Courtesy Edward Atkinson

surrounding hills over the parlor mantel of the Peter Clayes house on Salem End Road.

Also from Framingham comes a unique panel consisting of a spirited rendition of three stags silhouetted against the skyline, a magnificently stylized composition extraordinary for its simplicity and sense of motion (Fig. 23). It was taken from its original setting about the year 1840 and was at one time covered with wallpaper, the removal of which, by dry scraping, caused the small gouges which now appear upon its surface. (Marks of a crosscut saw on the back of this panel are shown in Fig. 10.) Its date is ascribed to the late eighteenth century, and its authorship is credited by family tradition to a local Indian, one Wamscoun, said to have been a descendant of one of Eliot's "Praying Indians" at South Natick. This is an excellent example of the stag motif which appears so frequently in American needlework pictures of a slightly earlier period, and which in turn derived from English sporting prints (Fig. 24). Wallpaper makers also utilized the hunt design, and we find the stag and hounds used to decorate a bandbox made by Hannah Davis of Jaffrey, New Hampshire, about 1825[6] (Fig. 25).

Although the stag hunt as portrayed in these panels is probably a stylized version taken originally from an English source, there were actually large numbers of wild stags in the forests of Pennsylvania in the mid eighteenth century. Peter Kalm relates that they were sold in Philadelphia for twenty-five to forty shillings apiece. After particularly cold and snowy winters they were found dead in the snow in great numbers, in the country thereabouts. "All aged persons asserted, that formerly this country abounded more with stags than it does at present. It was formerly not uncommon to see 30 or 40 of them in a flock together. The reason of their decrease is chiefly owing to the increase of population, the destruction of the woods, and the number of people who kill and frighten the stags at present.

However, high up in the country, in great forests and deserts, there are yet great numbers of them."[7]

Panels from Vicinity of Boston

In Boston, where eighteenth century homes were decorated in the handsomest fashion, few houses of the pre-Revolutionary period survive, and whatever examples of fancy architectural painting there may once have been, have now disappeared.

One famous mansion, known as the Clark-Frankland house, stood on the corner of Garden Court and Prince Street, near the old North Square. Because of its handsome interior, with inlaid floors and painted decoration, various descriptions of it have been handed down, and several panels from its magnificent drawing room have fortunately been preserved. The land was bought in 1711 by William Clark, a wealthy merchant and member of the Governor's Council, who built the house the following year. After his death in 1742 his son-in-law, Thomas Greenough, sold the property to Sir Henry Frankland who was Collector of the Port of Boston under Governor Shirley. The following description of the interior is taken from an article by Henry Lee which was printed in the *Massachusetts Historical Society Proceedings* for 1881:

Opposite the door [of the north parlor] was the ample fireplace . . . the other three walls were divided into compartments by fluted pilasters of the Corinthian order, which supported the entablature with its dentilled cornice. The flutings and capitals of the pilasters, the dentils of the cornice, the vault and shelves of the buffet, were all heavily gilded. . . . The peculiar decoration consisted of a series of raised panels, filling these compartments, reaching from surbase to frieze, eleven in all, each embellished with a romantic landscape painted in oil colors, the four panels opposite the windows being further enriched by the emblazoned escutcheons of the Clarks, Saltonstalls, and other allied families. . . . The twelfth painting was a view of the house upon a horizontal panel over the mantel, and beneath this panel,

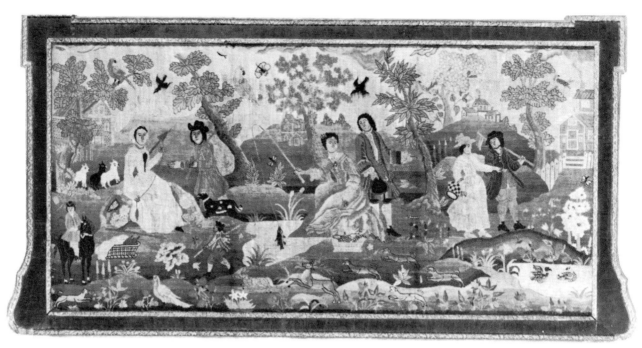

FIG. 24. BOURNE HEIRLOOM Needlework Picture
Called a *chimney-piece*. Stag hunt in foreground. Horse and rider at far left are copied in reverse from the painting *The Going out in the Morning* by John Wootton. This figure appears in an overmantel owned by the Marblehead Historical Society. The huntsman with pole in left center is taken, in reverse, from *The Chase,* by John Wootton.
Courtesy Museum of Fine Arts, Boston, Mass.

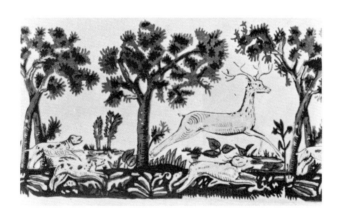

FIG. 25. WALL PAPER on a Bandbox made by Hannah Davis of *Jaffrey, New Hampshire*
Stag hunt similar to designs which appear in needlework and painting.
Photograph National Gallery of Art
Index of American Design Rendering by Martin Partyka

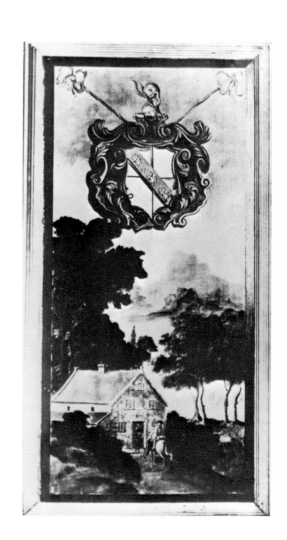

FIG. 26. Wall Panel from CLARK-FRANKLAND HOUSE, *Boston, Massachusetts*
Hubbard family arms
Maine Historical Society, Portland, Maine.

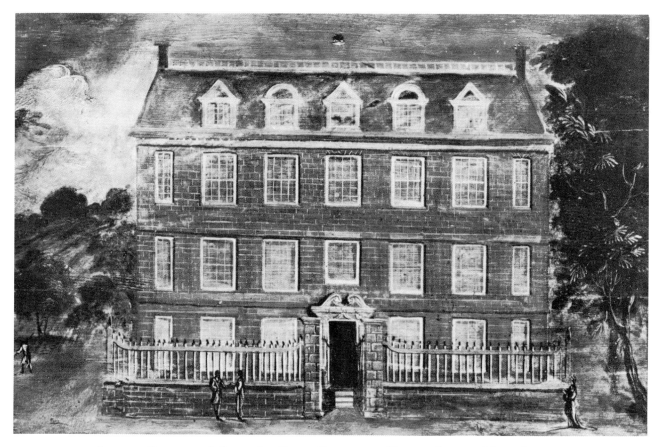

FIG. 27. Overmantel from the CLARK-FRANKLAND HOUSE, *Boston, Massachusetts*
A view of the mansion probably painted
before the death of William Clark in 1742.
Bostonian Society, Boston, Mass.

inscribed in an oval, was the monogram of the builder, W. C. At the base of the gilded and fluted vault of the buffet was a painted dove.

After the death of Frankland in 1768 the house was owned by his wife, the romantic Agnes Surriage, until her death in 1782. Thereafter the property passed through many ownerships, and the mansion was finally demolished in 1833. At that time five panels from the north parlor were saved, two of which descended in the Gay family of Boston.[8] Two others were bequeathed to the Maine Historical Society by the Reverend Daniel Austin of Kittery, and the fifth panel, a view of the house itself, which surmounted the fireplace, was willed in 1931 to the Bostonian Society by Frederick W. Hassam, who had inherited it from a descendant of a one-time occupant of the house.

The four wall panels are painted, as one would expect, in the English romantic tradition. Bold escutcheons, Jacobean in type, greatly enhance the decorative effect (Fig. 26). Although the figures in the overmantel are very similar to those which appear in the other panels, the façade of the house itself is treated quite differently from the purely decorative approach of the rest of the views, and this fact leads to the surmise that it was not painted by the same artist.[9] The three-story red brick edifice has white trim and a green pedimented door (Fig. 27). The end-chimneys and ornamental dormer windows were unusual features at this date, and the panel is of great historical value as a contemporary document which illustrates one of Boston's finest colonial mansions.

Whether the paintings were executed at the time the house was built in 1712, or at some later date is unknown, but they were certainly painted before the death of William Clark in 1742, as the Clark armorial bearings, a ragged staff in bend between three roundels, appeared on one of the panels, and his initials W. C. were beneath the overmantel. The Clark arms were also inlaid in variegated woods in the floor of the reception room to the right of the entrance hall. They may likewise be seen on William Clark's tomb in Copps Hill Burying Ground, the tomb and arms being

· 33 ·

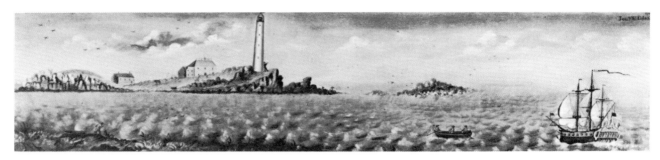

FIG. 29. OVERMANTEL from an Unidentified House in *Revere, Massachusetts*
Boston Light, with a pilot being rowed out to an incoming vessel.
Signed *Jona. W. Edes, 1789*
Author's collection

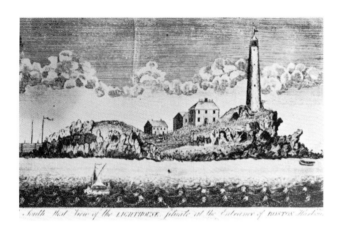

FIG. 28. VIEW OF BOSTON LIGHT at the Entrance
of Boston Harbor
From an illustration in the *Massachusetts Magazine*
of February, 1789. Engraved by S. Hill after J. Edes.
Author's collection

supplied by the stonecutter Codner, to whom the estate paid forty pounds.[10]

There has been considerable speculation as to the authorship of these paintings. The possibility has been suggested that an English artist, one R. Robinson, may have been commissioned to do the decorating in this house.[11] In the *Third Annual Volume of the Walpole Society*, London, is illustrated woodwork from a house erected in London in 1669. It consisted of a room finished with thirty-three panels arranged above and below a chair rail. On each of these was painted a lively and colorful scene intended to represent life in the East Indies as visualized in England of the seventeenth century. On one of these panels appears this inscription: "R. Robinson 1696." It should be noted that in this case the decoration was evidently done seventeen years after the building of the house. Unfortunately there is little biographical information available about R. Robinson. A decorative painter of

apparent ability, he was a contemporary of John Smith, 1654-1720, the most eminent engraver of mezzotint of his time, for whom Robinson designed a still life group entitled "Vanitas." Smith was also the author of *The Art of Painting*, London, 1676, which, under the title *The Art of Painting in Oyl*, reached a sixth edition in 1753 and is a basic book from which we have frequently quoted. An unpublished manuscript in the British Museum refers to Robinson as "a painter of portraits, landscapes, and subjects of natural history, who was also practised in the art of engraving mezzotint."[12]

The technique and subject matter of the English panels bear only a general resemblance to those in the Clark-Frankland house, and this similarity is accounted for by the style and taste of the period. Although it is possible that the Clark paintings were done by an Englishman from English prototypes (as were also the plaster wall panels in the Vernon house, Newport), they do not, in my opinion, agree in the essential details which would indicate that they were done by the same artist. We may, however, consider Robinson as one of the English predecessors of the American wall painters of the eighteenth century, and the Clark-Frankland panels as the earliest presently

FIG. 30. SIGNATURE on Overmantel of Boston Light
This occurs on the upper right
corner of the face of the panel.

known examples of the English school of architectural landscape painting in the New England colonies.

One other interesting possibility should be mentioned here. It is not unlikely that the bold escutcheons were not the work of the man who did the romantic landscapes, but rather of some ornamental painter such as Thomas Johnston, the well known engraver, japanner, and heraldry painter. Johnston was born in 1708, was active in Boston until his death in 1767, and we know that he was actually employed to do some heraldic painting in the Clark house. In the administrator's accounts already referred to[10] appears this significant item which could refer to the wall panels: "Pd Johnson for Escutcheon and Coat of Arms and Stock [ditto] for House, 57—[pounds]."

Another panel which has unusual historic interest shows a view of Boston Light, the oldest lighthouse in the United States. On November 5, 1714, the Court passed an order that "a Light-House be Erected at the Charge of this Province at the Entrance of the Harbor of Boston." The first keeper was engaged in 1716 for the sum of fifty pounds per year which was substantially increased by his fees as one of the pilots of Boston harbor, and the island continued to be the headquarters for harbor pilots for many years thereafter. Expenses of the lighthouse were supplied by a duty on vessels which passed by it. This was called "light money" and was reckoned at one shilling per ton on foreign vessels and two pence one halfpenny on American ships. Pilots waiting to conduct boats into the harbor were always on hand prepared to respond to a signal.

In February, 1789, an article appeared in the *Massachusetts Magazine* entitled "Boston Light House, An account of the Light House, at the entrance of Boston Harbour—Embellished with an Engraving, representing a South West View of the Light House, and of the Island on which it is situate." This piece was written by the keeper, Thomas Knox, "branch pilot for the Port of Boston." The illustration which accompanied the article showed the island with keeper's house, and the light itself with one of the pilots looking through a spy glass out to sea (Fig. 28). This view was signed by S. Hill as delineator, and by J. Edes as the artist of the original drawing from which the engraving was made.[13] Samuel Hill was a well-known engraver of the period who did all the illustrations for the *Massachusetts Magazine,* but about J. Edes there has been no information readily available.

Investigation has proved, however, that Edes was not unknown as a painter in Revolutionary Boston. In 1772 his mother, "Rebecca Edes Senior" deeded to her twenty-one year old son Jonathan Welch Edes, Painter, pew 67 in the New North Church.[14] From 1798 until 1803 his name appears with the designation of Painter in the Boston Directories. In the same year in which his view of Boston Light was published in the *Massachusetts Magazine,* Edes executed a larger and more extensive version of the same scene which he painted in oil on an overmantel in a house on Beach Street in Revere, which was then a part of the town of Chelsea (Fig. 29). This panel he signed in the upper right-hand corner, "Jona. W. Edes. pinct. 1789" (Fig. 30).

There is a possibility that Edes may have executed still a third view of Boston Light. Late in October of 1789 President Washington made an official visit to Boston, at which time he was given a grand public reception. There was a procession made up of representative groups of local merchants, shopkeepers, and tradesmen. An account of this colorful event, with a list of the groups that marched, may be found in *The Essex Journal and New Hampshire Packet* for October 28, 1789.[15] Each division was preceded by a leader, and carried on a seven foot staff a flag one yard square which was symbolic of its craft or trade. The Marine Society, led by Captain Dunn, carried a banner with "ship passing the lighthouse, and a boat going off to her." As this description exactly fits the two views of Boston Light which Edes did that same year, one cannot help wondering whether he may not also have been retained to paint the Marine Society banner.

There is documentary evidence indicating that Edes painted at least two overmantels in the town of Waltham, where he was apparently living in the 1790's. Two articles which appeared in the *Waltham Free Press* under dates of September 13th and 27th, 1864,[16] refer to another engraving drawn by him, entitled "Eden Vale in Waltham" which appeared in the *Massachusetts Magazine* for April, 1793. This view was described as being John Boyce's paper manufactory on the Charles River, in Waltham. Concerning the artist, the newspaper article observes that about seventy-five years before (about 1789) Edes painted a picture on the panel over the fireplace in the parlor of Josiah Sanderson of Piety Corner. He afterwards began the outlines of another overmantel in the town. This work was never finished and was eventually painted over, but he offered to paper the walls without charge if he should consider the pattern sufficiently handsome! Josiah Sanderson purchased the house from his father in 1771. He subsequently built a large addition onto the easterly end, and perhaps at that time commissioned Edes to do the painting. Was the overmantel in the Sanderson house the original of the "Eden Vale" engraving? We shall probably never know, as the old building was taken down in 1894.

At the present time nothing more is known of the work of Jonathan Welch Edes, but the finding of a

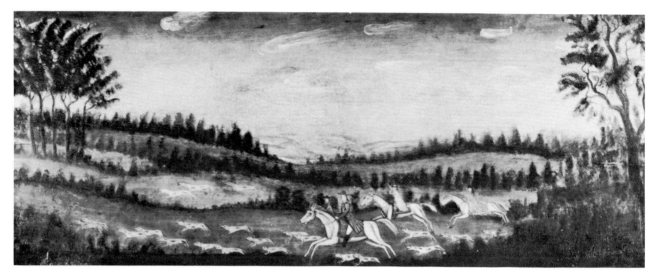

FIG. 31. Overmantel from MAKEPEACE-RAY HOUSE, *Franklin, Massachusetts*
This panel is a copy of an English engraving after a painting by James Seymour
Author's collection

signature on an overmantel is unique, and adds the name of another eighteenth century panel painter to the gradually growing list. He must have been well thought of as an artist to have had two of his sketches reproduced in the *Massachusetts Magazine,* as the preface to the first number indicates: "To please the generous patrons of this infant attempt, no pains nor expense have been spared to procure copperplate delineations on domestick subjects, as being more agreeable to the citizens of this new Empire, than copying sketches from European masters."[17]

Panels South of Boston

A number of panels have been found in towns south of Boston. From a house belonging at one time to the

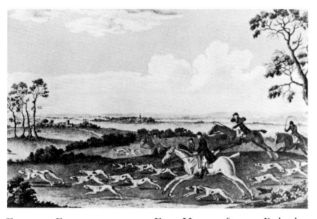

FIG. 32. ENGRAVING OF A FOX HUNT after a Painting
By James Seymour
This was the source of design for panel in Fig. 31.
Photograph courtesy Nancy Graves Cabot

Ray family near Franklin came three landscapes (probably inspired by engravings) which show country life on a gentleman's estate in the late eighteenth century, where hunting, shooting, and group conversation seem to have been the chief pastimes.[18] Fig. 31 shows one of these panels, a hunt in full cry with four horsemen and a pack of hounds racing over the rolling countryside. The figures in this scene derive quite directly from an engraving after James Seymour, 1702-1752, the English sporting painter. Although the American artist has altered the background to suit his own taste it is one of the few panels which is a close copy of an engraved source (Fig. 32). A similar picture on glass, entitled "The Chase", is illustrated in the *Mazagine Antiques* for February, 1928, being a colored transfer of one of four fox hunting prints engraved by Thomas Burford and published in 1766.[19]

From the old Porter Inn, which stood on the south side of Taunton Green and was demolished about one hundred years ago, comes one of the most interesting historical panels which has been preserved. It shows in seemingly accurate detail the houses which stood on the north side of the Green in the late eighteenth century. Unfortunately too dim from an accumulation of old varnish to be satisfactorily illustrated, the panel may be seen at the Old Colony Historical Society in Taunton, where all the buildings (which include the 1772 Court House and two early stores) have been identified.

Proceeding easterly toward the seacoast brings us to Duxbury, once a busy seaport where prosperous merchants could afford to decorate their homes in the newest taste. That they did so is proved by the exam-

ples of painted walls and woodwork which still exist in several of the old homes in the town.

A number of portraits, miniatures, and at least one landscape on canvas, are the work of a local artist, Rufus Hatheway, who married the daughter of a prominent ship owner in 1795. Hatheway was also a physician, which profession family tradition avers he embarked upon at the instigation of his father-in-law, Joshua Winsor, who did not regard "limning" as a suitable occupation for his daughter's husband. Hatheway painted at least one overmantel and probably more. It is possible that the view of Taunton Green may be by him, as it resembles his work to a considerable degree, and he is also known to have painted portraits in the neighboring town of Middleboro. The pair of peacocks in Fig. 33 is a stylized subject which is entirely different from anything we have seen elsewhere. The panel originally came from the old John Peterson house on Powder Point, Duxbury, long since disappeared. The birds, with their bright red wing feathers, are effectively silhouetted against a background of soft bluish-green.[20] An interesting comparison in design is furnished by an early nineteenth century bandbox (Fig. 34) which is fashioned from a block printed paper and shows a pair of American grouse in a somewhat similar pose.

North of Duxbury, in the seacoast town of Hingham, are remains of painted decoration of particular interest and merit. These consist of a number of panels from each of two early Thaxter houses which stood facing one another in the center of the town. One of these houses was owned by Elisha Leavitt, a bitter Tory during the Revolution. It was owned later by the Lincoln family and was torn down in 1865. The other was purchased by the Wampatuck Club in 1900 and still stands on its original site. The fireplace wall of the principal room in each house consisted of multiple raised panels, upon the surface of each of which was painted a landscape scene. When the Thaxter-Lincoln house was taken down a number of the panels were saved. One of these hangs in the Hingham Historical Society, several are locally owned, and still another is illustrated in Fig. 35. In the Wampatuck Club the entire chimney wall incorporates seventeen panels, each decorated with a different view (Fig. 36). They are well painted in a style more competent than that of the usual travelling decorator. The subjects bear no resemblance to American scenery but might be either English or Continental. However, the British Jack flies over the turreted castle which surmounts the fireplace.

Probably because of the foreign character of these subjects their authorship was many years ago credited to John Hazlitt, a portrait and miniature painter who lived in nearby Weymouth during the 1780's. He was the son of an English clergyman who had favored the colonies during the Revolution, and a brother of William Hazlitt, the well known essayist. The Hazlitt family arrived in New York from Ireland in 1783, and came to Massachusetts in 1784, where they remained until they sailed back to England in 1787. During 1785 the Reverend William Hazlitt went frequently to Salem to preach for the Rev. Mr. Barnes, taking with him his young son. John was only eighteen years of age at this time, but he was already proficient in the media of miniature, pastel, and oil. In an unpublished manuscript written in 1835-1838 by Margaret Hazlitt, sister of the artist, she speaks of her brother's portraits but makes no mention of landscape painting of any kind.[21] Were the Hingham panels done by Hazlitt? There appears to be no evidence to support this attribution except the facts that he was painting portraits in the town between 1784 and 1787, that he was a competent artist, that the panels are unusually well executed, and that the subject matter appears to be European rather than American. If Hazlitt did indulge in a bit of architectural painting it must have been as a sideline from his regular occupation of portrait painter.

Several door panels, also from the Thaxter-Lincoln house, are in existence and have been attributed to "Madam Derby," the founder of Derby Academy in Hingham in 1784. There seems to be no evidence that she did other decorative work, and painting was not included in the curriculum of the school as she planned it before her death. Nevertheless these panels and those attributed to Hazlitt are not by the same artist. The paintings in Fig. 11 are charmingly executed in gray monochrome with bevels in soft coral-pink. The designs appear to be drawn rather than painted, and while the execution betrays an inexperienced hand, they have great decorative quality, with the Oriental feeling which one sees in some of the early fireplace tiles. The reverse of some of these door panels is grained in bird's-eye maple.

Panels from North of Boston

Ornamental Painters of Salem

It is not surprising that Salem, one of the most prosperous coastal towns, contained numerous artists who did portraits, landscapes, seascapes, port scenes, coats-of-arms, and many other types of ornamental work. In fact there was so much varied activity in the painting trade from 1775 to 1850 that it is now impossible fully to clarify the situation. Many names of artists whose work is unrecognized, and a considerable number of unattributed paintings, have yet to be connected by

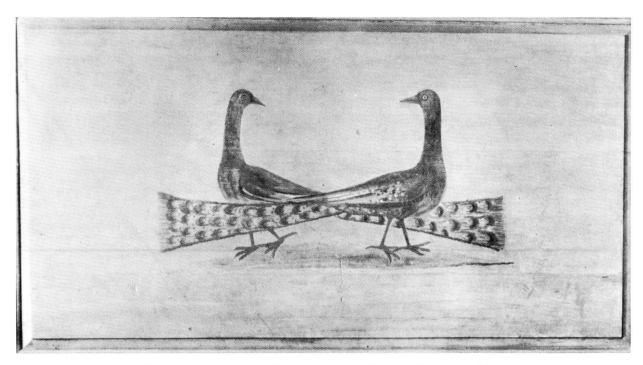

FIG. 33. Overmantel from the JOHN PETERSON HOUSE, *Duxbury, Massachusetts*
Now demolished. Panel painted by Dr. Rufus Hatheway
of Duxbury, who also painted portraits and landscapes.
Courtesy Dr. Abbot Peterson

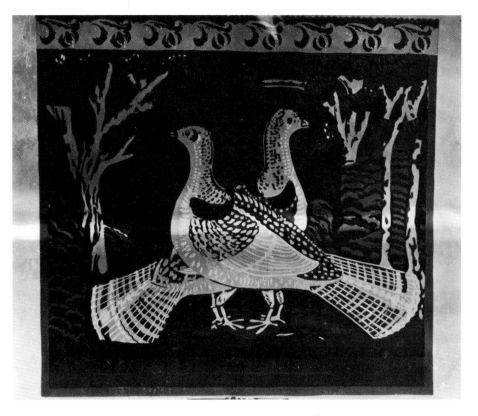

FIG. 34. WALL PAPER on an
Early Nineteenth Century
Bandbox
American grouse, similar in
pose to the peacocks in Fig. 33.
*Photograph National Gallery
of Art, Index of American
Design; Rendering by
Harold Merriam*

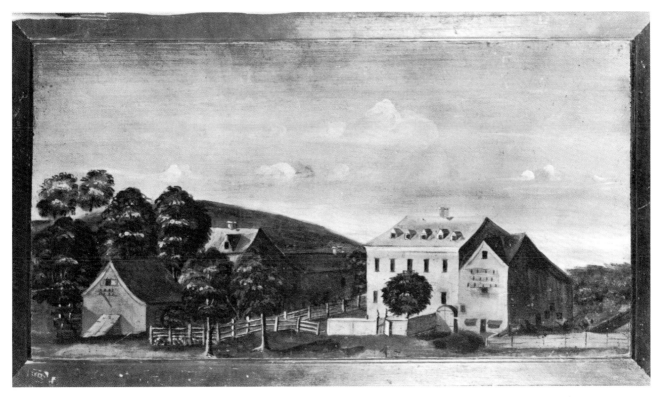

FIG. 35. Wall Panel from the THAXTER-LINCOLN HOUSE, *Hingham, Massachusetts*
Now demolished. Attributed locally to John Hazlitt, an Englishman who lived in Weymouth during 1785 and 1786.
Author's collection

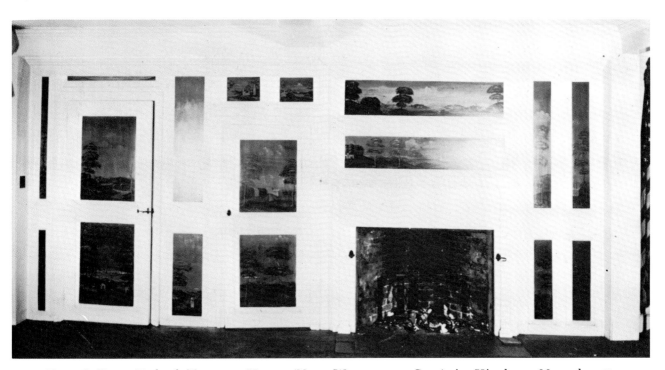

FIG. 36. Room-End of THAXTER HOUSE (NOW WAMPATUCK CLUB) *in Hingham, Massachusetts*
Each raised panel bears a different scene, apparently English in character
Attributed locally to John Hazlitt, working in Hingham 1784-1787.
Wampatuck Club, Hingham, Mass.

factual evidence. The purpose of this section, therefore, is to set down what information I have been able to piece together about a few of the ornamental painters of Salem, and to discuss some of the painted decoration which has been found there.

We have already mentioned John Hazlitt in connection with the panels in the two Thaxter houses in Hingham. He travelled to Salem with his father on a number of occasions and while there stayed, according to Margaret Hazlitt's reminiscences, "with Mr. Derby, a merchant, and the son of an acquaintance at Hingham." Elias Hasket Derby, with whom the Hazlitts stayed, was the son of Richard Derby, who had married as his second wife in 1771 Mrs. Sarah Langlee Hersey of Hingham. After her husband's death in 1783 she returned to Hingham and became known as "Madam Derby."

On June 14th, 1785, young Hazlitt inserted the following notice in the Salem *Gazette:* "Portrait Painting, John Hazlitt informs the public that he intends portrait painting in all sizes at Salem upon reasonable terms. For portraits inquire at Mrs. Elkins, opposite the east Meeting House." Two references to Hazlitt are made in *The Diary of William Bentley.* On October 7, 1802, he records having dined at Mr. B. Ward's, where several portraits were examined and Mr. Hazlitt's miniatures were considered excellent.[22] Again, in describing the decorations of the East Meeting House for the celebration of Independence Day, 1804, Bentley describes the front of the pulpit as being decorated with a bust of Governor Winthrop "cut by Mr. Macintire, . . . and a likeness taken by Hazlitt."[23]

"Madam Derby," wife of Richard Derby of Salem, has also been mentioned as the possible artist of door panels in Hingham, but no trace of her as a decorative painter while she lived in Salem has been found. If distinctive landscapes of the two types found in Hingham should ever be found in Salem (where both Hazlitt and "Madam Derby" lived for a time during the 1780's), it would constitute the best proof that those in the Thaxter houses were also done by them.

An old label pasted on the back of a small wood panel provides the name of another artist who was executing decorative landscapes in Salem in the 1780's. William Northey, Junior, son of William Northey the goldsmith, died on December 2nd, 1788, in his twenty-second year. The only known record of him as a painter consists of two sketches in oil. One of these is labelled "Winter Island," now a part of Salem Willows (Fig. 37). These views, which measure only 7 x 9 inches, may well have been preliminary studies for full sized overmantels, as they exhibit all the characteristics of larger compositions of this type.

An overmantel showing what is probably an enlarged view of the same scene came originally from the George Hodges house on Essex Street (Fig. 38). This was done on canvas and set into the woodwork over the mantel, presumably in 1798 at the time of the marriage of Captain Hodges and Hannah Phippen. If this traditional date is correct, it would place the painting of this picture ten years after Northey's death, but similarities of composition and technique suggest an affinity which might be more than coincidental.

One of the most intriguing names in the roster of Salem decorators is that of Robert Cowan. Cowan was an ornamental painter who was born in Scotland in 1762, married and raised a family in Salem, and died there in 1846. He lived in a seventeenth century house on the corner of Essex and Beckford Streets from 1791 to 1837; a few years later the street was widened and the old house disappeared.[24] The Derby family papers in the Essex Institute contain enough references to his work to make us wish that some of his landscapes could be identified. For one of these on a fireboard he billed John Derby 1 pound, 9 shillings and 7 pence in 1791.[25] For Derby in 1799 he painted "the body and top of a sley" at $1.75, and gilded a picture frame two years later.[26] In 1803 he polished and varnished a Pembroke table made by Sanderson, and painted and gilded twelve chairs at 10 shillings each.[27] He worked also for the great merchant Elias Hasket Derby in 1796 and did the ornamental painting on the "sturn" of his famous ship, the second Grand Turk.[28] At the present time not a single example of Cowan's work can be recognized. A well-executed water color rendering of the Stewart coat of arms (which was his wife's family name) might be by him, and also any of the fireboards in Figs. 66, 68, 79, and 80, which are all from Salem. Cowan, however, was undoubtedly responsible for much of the painting of Salem furniture, accessories, and interior decoration which is still unattributed.

John Holliman has already been identified in Chapter II as an expert "grainer" and stone cutter of Salem during the mid eighteenth century. Just how early he began his painting career, and what other types of decorating he may have done, we do not know, but he married in 1722 and appears to have lived and worked in Salem from that time until his removal to Boston in 1744. It would be surprising if he did not paint overmantel landscapes in conjunction with his graining, and his name should be kept in mind as the possible artist of early panels in Essex County.

The names of a few other eighteenth century house and fancy painters may be found in Salem records and the fragmentary references are given here for what they may be worth. In 1786 alterations to the pulpit of the East Meeting House were undertaken. The carpentry work was done by Mr. Ward, "& the Painting by Mr.

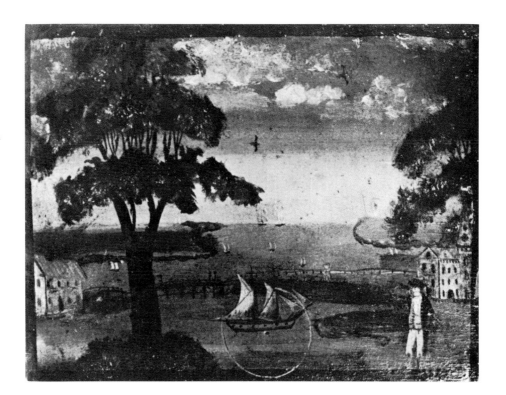

FIG. 37. SMALL PAINTING on
Wood from *Salem,
Massachusetts*
View of *Winter Island* by
William Northey, Junior.
Painted prior to 1788.
Author's collection

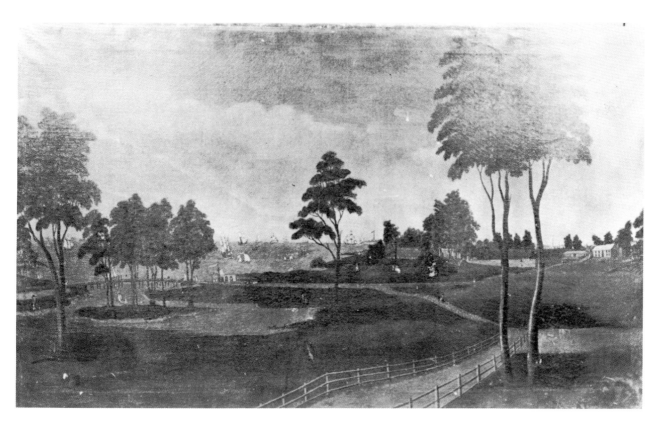

FIG. 38. Overmantel on Canvas from the GEORGE HODGES HOUSE, *Salem, Massachusetts*
Now demolished. Probably a view of *Winter Island.*
Courtesy George Hodges Shattuck

Liscombe."[29] This name was also spelled "Luscombe." Bentley also mentions "Sampson Augustus, a negro and painter by trade," who died in 1811.[30] William Gray, Painter, worked for Henry Appleton of Salem in 1794 and 1795, and charged 7 shillings for painting "firebuckets and bagg."[31] Samuel Blyth did gilding, house painting, "carpet stamping," and furniture decorating for Elias Hasket Derby in 1782.[32] During a severe cold spell in January of 1810 there occurred a tragedy which involved a Salem man and which the indefatigable Dr. Bentley recorded as follows: "Two young men named Brookes perished in the Cold at Woburn & poor Douglas the Painter, a man of wit & intemperance, on his way from Salem to Manchester. Alas for poor Douglas."[33]

Salem's most versatile decorative painter, however, was a Neapolitan by the name of Michele Felice Cornè who was brought to Salem by Elias Haskett Derby in his ship *Mount Vernon* in 1799, and introduced to local society by the Derby family, and by the ubiquitous Dr. Bentley. He copied with varying success portraits of such notables as Governor Endicott, Governor Leverett, and George Curwin, and of such local citizens as Captain Thomas West, Captain James Cook, and others. It is for his marines, however, that he is justly famous, and many of his fine water colors of Salem vessels, dating between 1802 and 1804, are preserved in the Peabody Museum in Salem.

Although Dr. Bentley was often critical of Cornè's ability as a portraitist, he approved of his painting of local ships. Under date of October 7, 1802 he makes this cautious observation in his diary: "Mr. Cornè as a painter of ships has great excellence. Some of his paintings of portraits are good." Again in 1804 he says: "Cornè continues to enjoy his reputation as a painter of Ships. In every house we see the ships of our harbour delineated for those who have navigated them."[34]

During the War of 1812 Cornè painted for exhibition in Boston a large seascape of the battle between the Constitution and the Guerrière, which he followed by pictures of naval engagements. In 1816 Abel Bowen, a Boston engraver, published an account of these engagements under the title, *The Naval Monument containing official and other accounts of all Battles fought between the Navies of the United States and Great Britain during the late War*. This was illustrated by woodcuts and engravings, most of which were based on sketches by the Italian artist.

Cornè tried his hand at silhouette cutting, traveling as far afield as Nova Scotia, where he was apparently more successful than in Salem. This trip may have been in company with the Salem silhouettist and cabinet maker, William King, whose journeyings have been chronicled by Alice Van Leer Carrick in the *Magazine Antiques* for August, 1925.[35] In February, 1807, King showed in Washington Hall, Salem, a tremendous panorama measuring 10 by 60 feet of the Siege of Tripoli, the ships in which were painted by Cornè. The exhibition was more popular in Marblehead than in Salem where it was said to have been in need of some improvement! Two years later Cornè exhibited both in Salem and Boston his own panorama of the Bay of Naples. This was not favorably received by the candid Dr. Bentley who went to see it with several young female friends and found it to be "without one stroke of originality . . . and yet it is said to have had unbounded admiration in Boston & is exhibited in Salem at ¼ D. [25 cents] It is about 10 by 8 feet probably, & as the Keeper says looks best at a distance."[36]

In 1804 the Salem East India Marine Society, which had been founded in 1799, was moved to a new building erected by Colonel Benjamin Pickman for the Salem Bank, rooms in which had been especially prepared for the Society. For this new headquarters Cornè was commissioned to paint landscapes, marines, fireboards, and a panel. On June 11, 1804, Dr. Bentley noted this event with a particularly interesting reference to the work of Cornè: "Spent the morning in the newly arranged Museum of the East India Society in the New Room. They have spared no pains to supply & to decorate it. On one Chimney is painted the landing of Plymouth & on another the launching of the Essex with devices. There is a delineation of the Cape of Good Hope, & of Wampum in China. . . . They have a painting of Capt. Cook done at the expence of the Society by Mr. Cornè."[37]

"The Landing of Plymouth," painted on canvas, may still be seen at the Peabody Museum, as may also the portrait of Captain James Cook. The original receipt for this picture, dated Salem, May 10, 1803, lists the price of the portrait at 13 pounds and the frame at 5 pounds.[38] Unfortunately, the whereabouts of the "launching of the Essex with devices" is at present unknown. The delineations of the "Cape of Good Hope" and "Wampum" (Whampoa) were on fireboards ordered expressly to fit the fireplaces of the new rooms (Fig. 67). These boards are still in place and will be mentioned again in Chapter V. For the space over the entrance door he painted a panel of Salem Harbor which is signed: "M. Cornè pinxit 1805." This shows Salem Neck with a ship in the foreground and a figure of a woman seated at the left. A scroll lettered "East India Marine Society" was added about 1825 when the Society moved again to the new East India Marine Hall.

At the time that Cornè arrived in America Samuel McIntire, the great carver, designer, and architect was

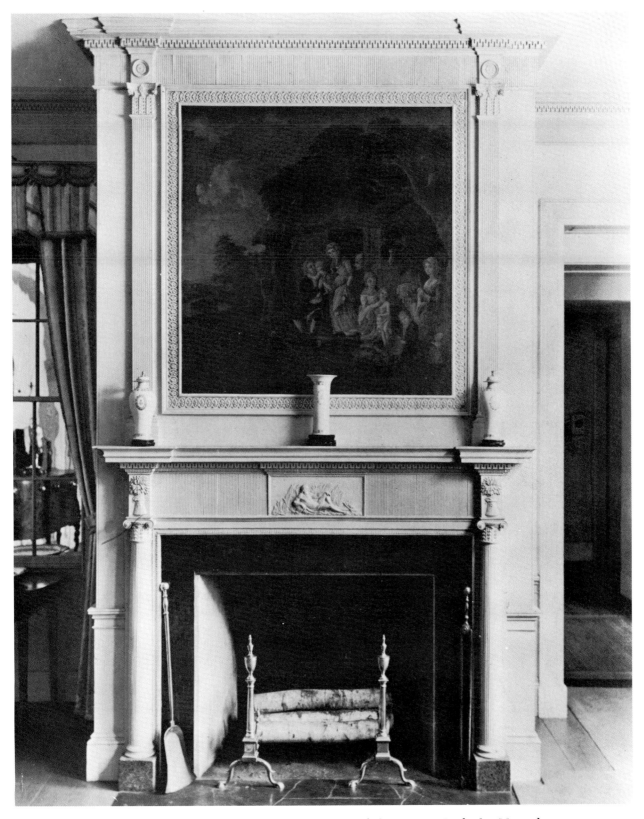

FIG. 39. Chimney breast from the Dining Room of OAK HILL, *Peabody, Massachusetts*
Woodwork by Samuel McIntire, overmantel on canvas by Michele Felice Cornè
The subject is *Saturday Evening* after a painting by William Redmore Bigg, R. A.
Courtesy Museum of Fine Arts, Boston, Mass.

at the height of his career. As Cornè was certainly the most competent ornamental painter in Salem during the early years of the nineteenth century, it is not surprising to find his paintings in mansions where McIntire had been retained to do the finest of carvings. Cornè's work had a sureness of touch, a brilliance of color, and a decorative Italian flair which set it apart from the more primitive American wall paintings of the period. For the hall of the Timothy Lindall house, and for the ceiling of the Benjamin Pickman cupola, he executed scenic frescoes (Fig. 133), and in the mansion of Simon Forrester on Derby Street, and at Oak Hill in Peabody, overmantels of unusual merit are attributed to him.

Elias Hasket Derby bought Oak Hill in 1789 and bequeathed it to his eldest daughter, Elizabeth, wife of Nathaniel West, in 1799. This house contained some of McIntire's finest work, the interiors of the dining and drawing rooms being now installed in the Museum of Fine Arts, Boston. The two overmantel pictures are on canvas, framed in delicate composition moldings, in a style seldom seen in New England. The one in the dining room, entitled "Saturday Evening" is after a painting by William Redmore Bigg, R.A., which was exhibited in London at the Royal Academy in 1792 (Fig. 39). In the drawing room the companion piece is "Sunday Morning."

Four overmantel panels, three of which are known to have come from Salem houses, are of foreign scenes which may also be attributed to Cornè, although no documentary proof of their authorship has as yet come to light. Use of color, of light and shadow, of subject matter, and of figure painting technique, all bear a great resemblance to his other known work in oil and fresco. Two of these landscapes also originated in a house with McIntire woodwork. In 1767 Simon Forrester, a young man of nineteen years who was born in Killeenach, Ireland, came to Salem in the schooner Salisbury, owned by Captain Daniel Hawthorne. By 1775 he was commanding ships, and laying the foundation of a fortune which Dr. Bentley says eventually reached the sum of fourteen thousand dollars. Early in 1791 Forrester purchased from Captain Jonathan Ingersoll a large unfinished house which still stands at 120 Derby Street. For this mansion McIntire did some very fine carving, including a chimney breast which contained an over-mantel landscape that is now preserved in the Essex Institute. Also from this house came a second overmantel, somewhat similar to the first in composition, but having on its outer edge a most unusual border of roses and leaves very beautifully executed in free-hand painting (Fig. 40). An examination of Simon Forrester's will, inventory, and administrator's accounts, in the Essex County Court

House, reveals no mention of these paintings in connection with his property, nor do the Forrester papers at the Essex Institute contain the name of Cornè. This is not surprising, however, as architectural paintings were considered a part of the interior decoration, and are seldom referred to in documents pertaining to an estate.

Two other overmantels, obviously by the same hand, are very similar to those from the Forrester house. One is known to have come from Salem (Fig. 41). The other is said to be a view of Port Louis, Isle of France (Mauritius), but if so must be a highly romanticised version, judging from a print of the harbor which is in the McPherson Collection at the Peabody Museum (Fig. 42).

One other humorous collaboration is recorded between McIntire and Cornè. Under date of September 25, 1807, Bentley records: "Saw an imitation of a wonderful pear, which grew in Ipswich. It was carved by Macintire & painted by Cornè & was said to be an exact imitation. It might be easily mistaken except its size might make suspicion." Shortly thereafter Cornè left Salem, and he is listed in the Boston Directory of 1810 as a limner at 61 Middle Street. In 1822 he retired to Newport, Rhode Island, where he lived on the proceeds of an annuity from the Massachusetts Hospital Life Insurance Company until his death on July 10, 1845.

Cornè had several pupils, the best known being George Ropes. Born in 1788, a son of Captain George Ropes, George, Jr., was deaf and dumb from birth. He began to study under Cornè when he was thirteen years old, and a fireboard by him in Cornè's Italian style is illustrated in Samuel Chamberlain's *Salem Interiors*. After his father's death in 1807 he became the sole support of his mother and eight children. In addition to ship portraits Ropes did several interesting views of old Salem, including "Salem Common on Training Day" and a long panel of Crowninshield's Wharf showing a number of local ships in port. He was also a general ornamental painter, and in writing of his funeral in 1819 Bentley says: "He began by drawing ships, landscapes, & then continued the trade of Chaise & sign & other such paintings."[39]

Other Panels from Essex County

A panel believed to have come from a house in Marblehead is now at Beauport in East Gloucester.[40] The scene is an unusually lively one, the street being crowded with vehicles and people, while sailors signal to the ships lying in the harbor (Fig. 43). An unusual feature is the fact that the clock never had painted hands, but a small hole in the center of the face suggests that it had real hands which could be moved by

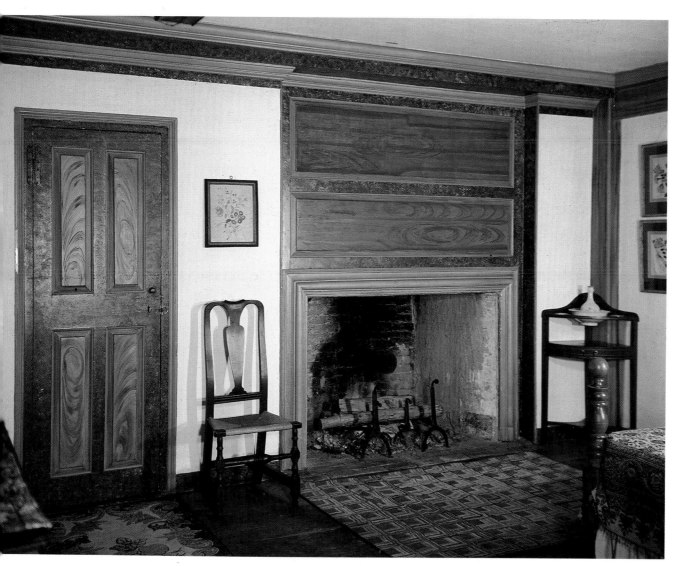

PLATE 1. JONATHAN COGSWELL HOUSE, *Essex, Massachusetts*
Panels in cedar-graining framed by marbleizing in black and green. See page 7.
Mr. and Mrs. Bertram K. Little

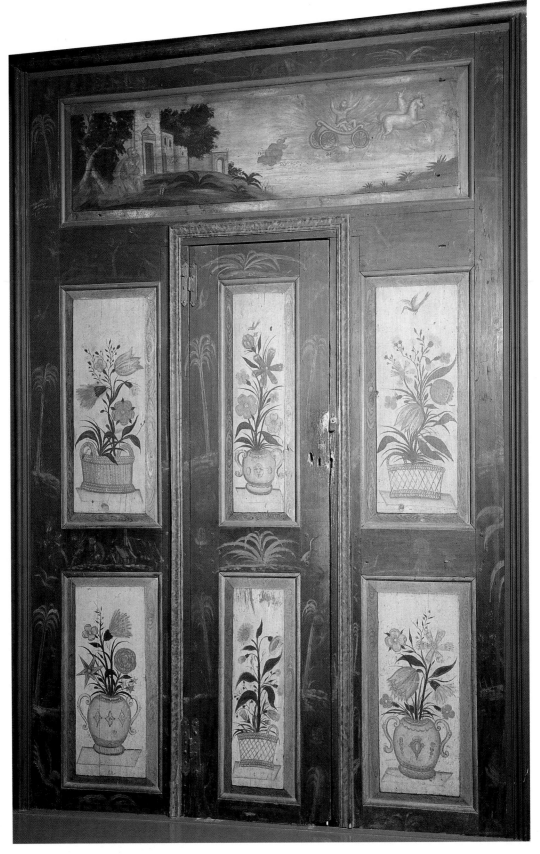

PLATE II. DOOR AND SURROUNDING PANELING from a house at *Belle Mead, New Jersey*
Bevels painted to simulate wood graining, with door casing painted to simulate
tortoiseshell. Rails and stiles decorated in imitation of Chinese lacquer. See page 14.
Courtesy The Metropolitan Museum of Art, New York, N.Y.

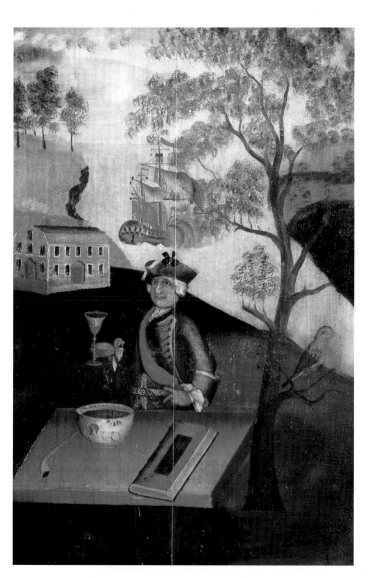

PLATE III. OVERMANTEL from
the MOSES MARCY HOUSE,
Southbridge, Massachusetts
The house no longer stands, but does not seem to
have resembled that in the panel. See page 25.
Old Sturbridge Village, Sturbridge, Mass.

PLATE IV. OVERMANTEL from the
ELISHA HURLBUT HOUSE, *Scotland, Connecticut*
By Winthrop Chandler of Woodstock, Con-
necticut. Painted before 1790. See page 53.
Author's collection

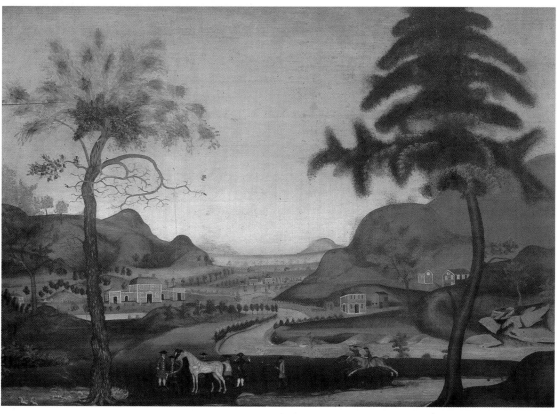

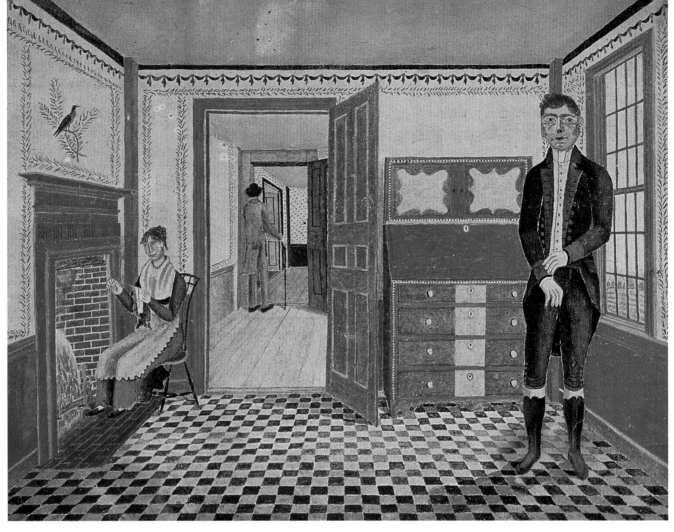

PLATE V. INTERIOR of JOHN LEAVITT'S TAVERN, *Chichester, New Hampshire*, 1824
Watercolor by Joseph Warren Leavitt. Contemporary view of a stenciled room with painted floor. See page 101.
Author's collection

PLATE VI. OVERMANTEL from the PETER CLAYS HOUSE,
Framingham, Massachusetts. See page 137.
Author's collection

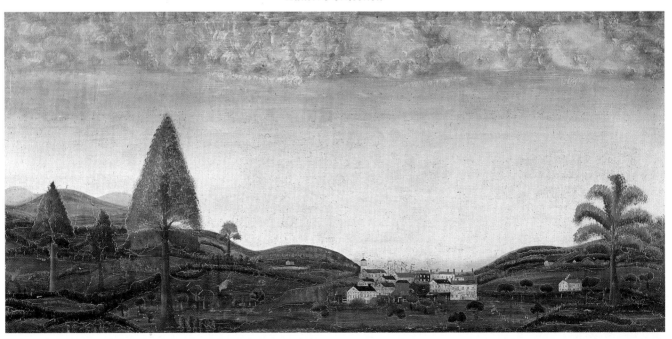

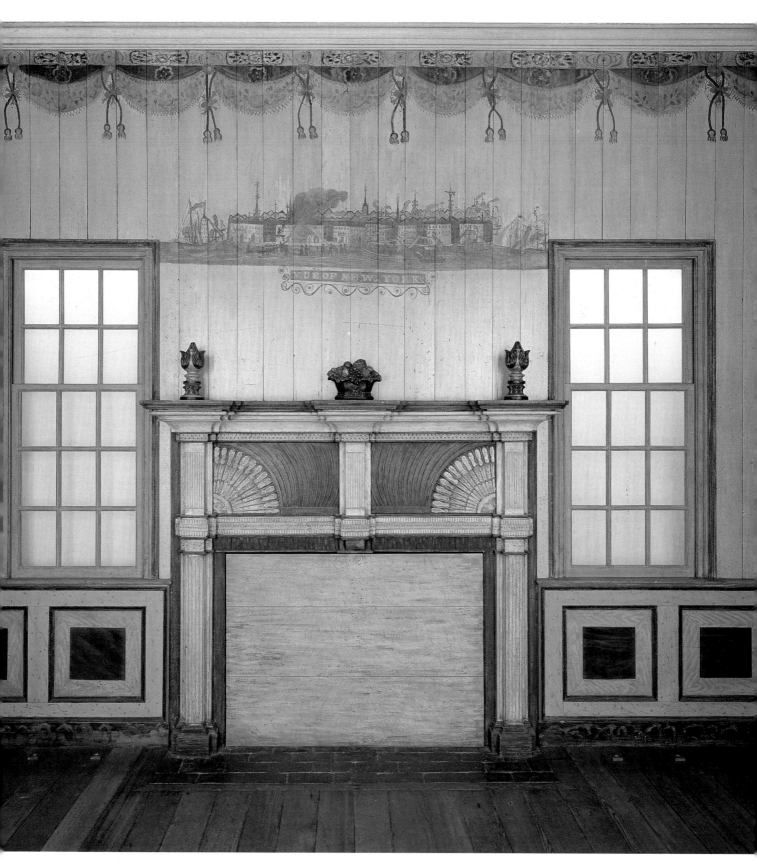

PLATE VII. ROOM-END from the ALEXANDER SHAW HOUSE, *Wagram, North Carolina*
Signed and dated *"I. Scott. August 17, 1836."* See page 137.
Abby Aldrich Rockefeller Folk Art Collection, Williamsburg, Va.

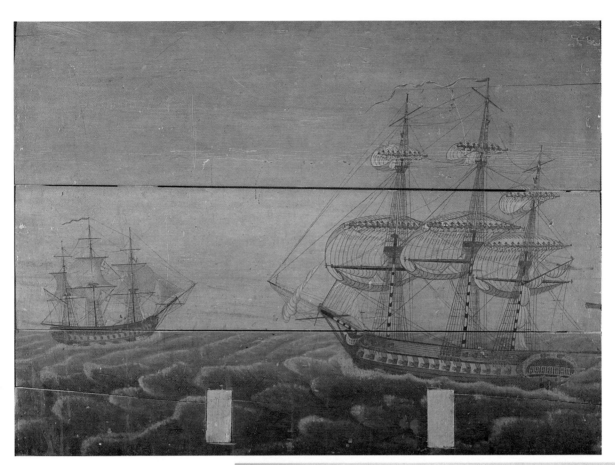

PLATE VIII. FIREBOARD
of Two Frigates
Close inspection reveals that
the black dots on the yard-
arms are seamen furling sails.
See page 138.
Author's collection

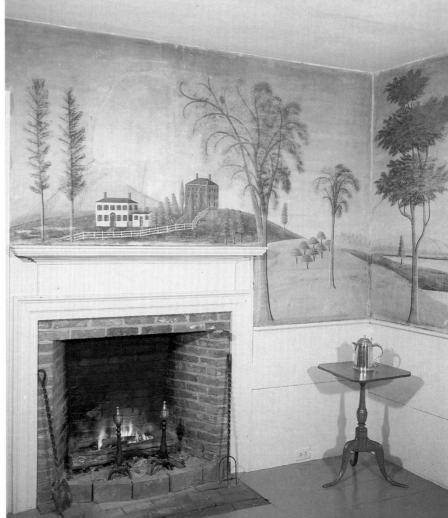

PLATE IX. FRESCO by Rufus Porter
(c. 1825), in the HOLSEART HOUSE,
Hancock, New Hampshire.
See page 147.
*Photograph Historical Society of
Early American Decoration*

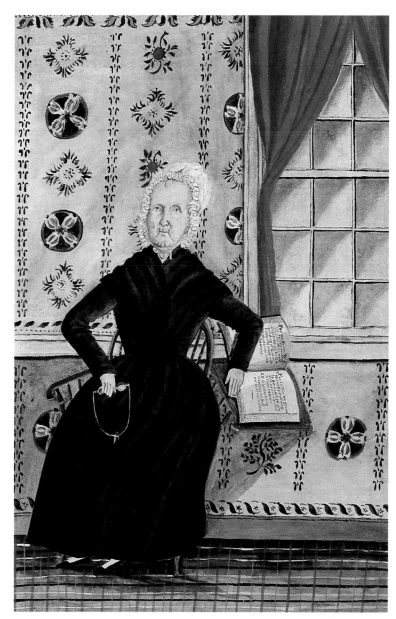

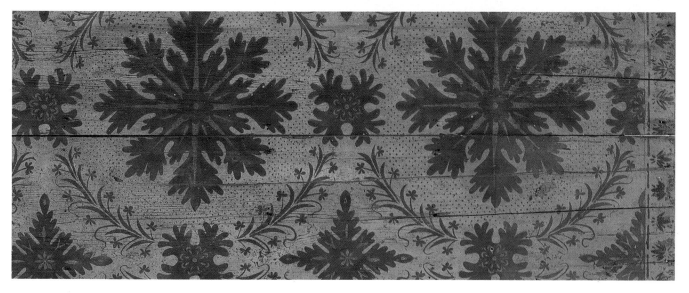

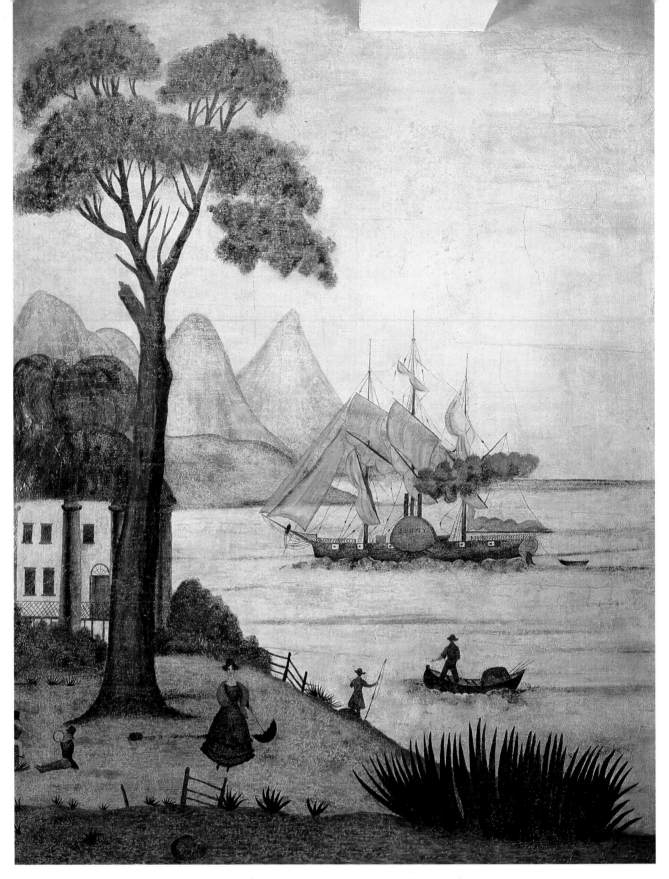

PLATE XII. LOWER HALL of the CARROLL HOUSE, *Springfield, New York*
Signed and dated "*William Price 1831.*" See page 149.
Henry Francis du Pont Winterthur Museum, Winterthur, Del.

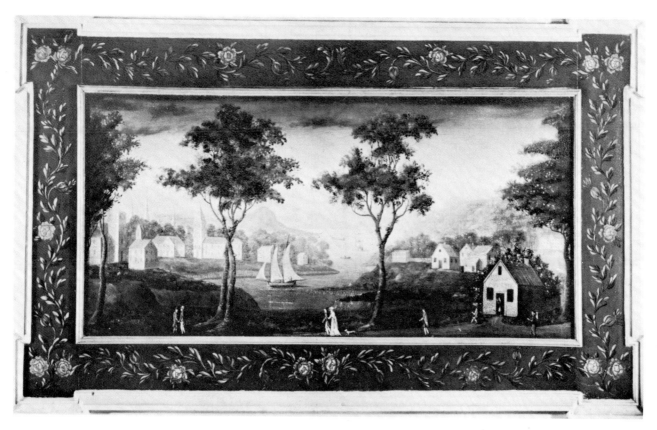

FIG. 40. Overmantel from the SIMON FORRESTER HOUSE, *Salem, Massachusetts*
Attributed to Michele Felice Cornè. This panel
has an unusually fine free-hand painted border.
Courtesy Mrs. Francis B. Crowninshield

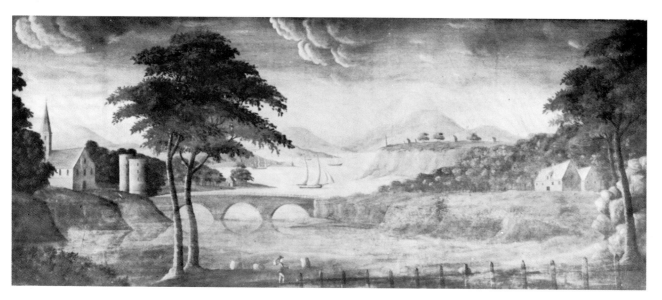

FIG. 41. OVERMANTEL from an Unidentified House in *Salem, Massachusetts*
Attributed to Michele Felice Cornè.
Author's collection

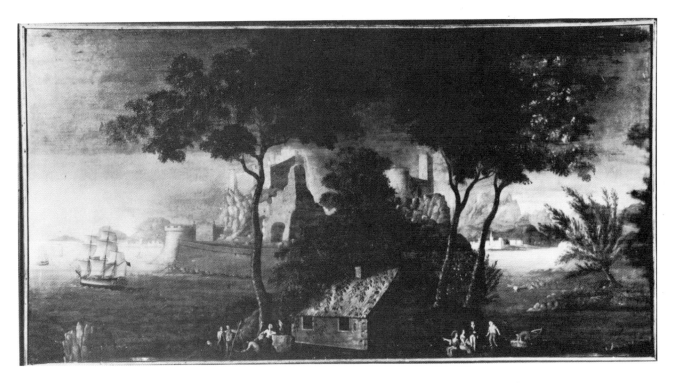

FIG. 42. OVERMANTEL from an Unidentified House in *New England*
Supposed to be a fanciful rendering of Port Louis, Isle
of France (Mauritius). Attributed to Michele Felice Cornè.
Courtesy Mr. and Mrs. Lammot du Pont Copeland

the spectator. Hanging in the Jeremiah Lee House, headquarters of the Marblehead Historical Society, may be seen a large panel which is a close copy of an engraving by B. Baron after the English painting by John Wootton entitled "The Going out in the Morning." Although the composition is slightly simplified as regards the number of dogs, the five riders are carefully reproduced, and the positions of many of the dogs are the same. This makes the second hunting panel to be identified as deriving from an English engraving.[41]

From the old Caldwell house, which stood near the Town Wharf in Ipswich, came a panel which is now owned by the Ipswich Historical Society. Thinly painted and dark from smoke and old varnish, it is an actual view of the fishing station which flourished for more than a hundred years in the cove on the shore of Great Neck, where stages were erected for the drying of fish at least as early as 1696. A British flag on one of the boats lying at anchor indicates a pre-Revolutionary date for this picture.

One of the earliest panels we have seen came from the home of the Reverend John Lowell, great-grandfather of James Russell Lowell (Fig. 44). It was removed about 1850 from the old home in Newburyport and taken to Elmwood, home of James Russell Lowell

in Cambridge, where it is now incorporated as part of the woodwork over the fireplace in the rear study. What event occasioned the painting of this piece is not now known, but the date would appear to be mid eighteenth century, and the Reverend John Lowell is presumed to be sitting at the head of the table, in company with six visiting clergymen. The table accessories also are of unusual interest.[42] The frontispiece for the July, 1936, number of the *Magazine Antiques* illustrates a rather similar German painting entitled "The Tobacco Parliament," which is dated 1739. This also shows a number of bewigged gentlemen sitting around a long table on which may be seen candlesticks, clay pipes, and other culminating features of a sociable repast. As an unusual commentary on manners and customs in the old world and the new, a comparison of these two pictures is recommended.

The exact origin of the panel in Fig. 45 is unfortunately unknown, but it may well come from this general vicinity. The style of painting, however, suggests an artist who had received at least some training in the English landscape school. An interesting inscription on the reverse bears out this assumption, and also indicates that the picture was painted over for some years: "Painted by an Englishman near the year 1776, afterwards being covered with white paint, was gently

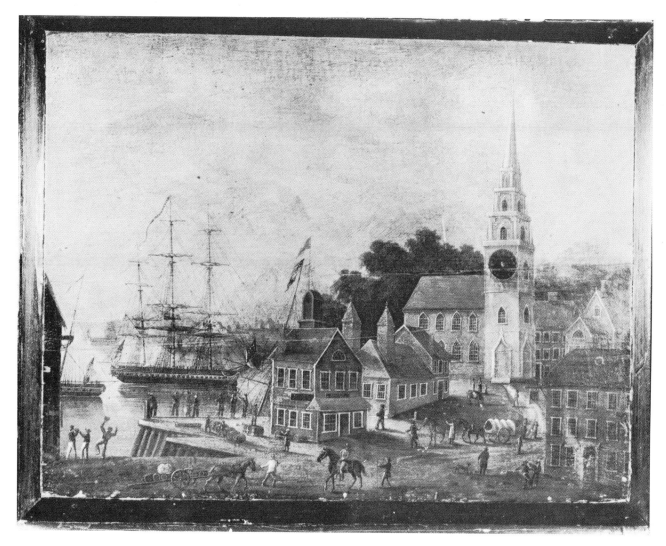

FIG. 43. OVERMANTEL from an Unidentified House, possibly in *Marblehead, Massachusetts*

Despite its apparent reality this is probably a fanci-
ful scene. Now installed at *Beauport,* former home
of Henry D. Sleeper, Gloucester, Massachusetts.
Society for the Preservation of New England Antiquities, Boston, Mass.

removed by L.W.B. and Mary H. Hughes. 1854-1857."
The plane marks on the back of this panel are shown
in Fig. 9.

Panels from Maine, New Hampshire, and Vermont

Relatively few panels have been found in Maine,
New Hampshire, and Vermont; painted decoration in
the northern states seems to have taken the slightly
later form of stenciled and frescoed plaster walls. In
the vicinity of the seacoast, however, a few examples
of pictorial woodwork have been found. When the
Captain Robert Parker house on Islington Street in
Portsmouth was recently demolished, a good over-

mantel panel showing a house beside a river was for-
tunately saved. Across the Piscataqua River, in Kittery
Point, Maine, the old Bray house contains a panel
also by an unknown artist. Because Sir William Pep-
perrell's mother was the daughter of John Bray, it
has been surmised that the picture was intended to
represent the scene of the Battle of Louisburg, Nova
Scotia, whose fortress was captured by Sir William
Pepperrell, commander-in-chief of the New England
forces in 1745. It is more likely, however, that like
other overmantels of its period, it was a decorative
composition.

From the Gardiner Gilman house in Exeter, New

FIG. 44. Overmantel from the home of the REVEREND JOHN LOWELL, *Newburyport, Massachusetts*
An unusually interesting painting of an eighteenth century group of clergymen.
Courtesy Mrs. A. Kingsley Porter

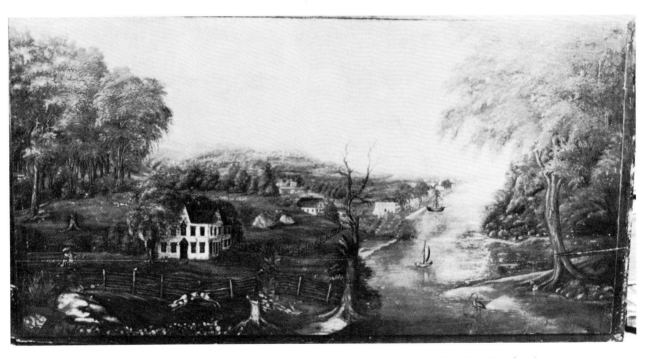

FIG. 45. OVERMANTEL from an unidentified house, probably *New England*
Inscription on the back indicates that this was painted by an Englishman in 1776.
Author's collection

Hampshire, came the panel shown in Fig. 46, which is now preserved in the Gilman Garrison house. This is a scene which undoubtedly told a story or memorialized an event long since forgotten. A barge, presumably from the ship in the bay, is preparing to land, while the sailors stand at attention with oars held erect. Down the main street of the town comes a large party of ladies and gentlemen preparing to descend the steps of the wharf to embark in the cutter, en route, we presume, to a formal visit on the nearby vessel. The houses in this typical New England setting are painted white, red, and gray, and the two taverns with signboards hanging on brackets are an especial point of interest.

While speaking of painting in the vicinity of Exeter mention should be made of John Dow, farmer, hunter, and craftsman of Kensington, New Hampshire. Dow was born in 1770, in the old house which still stands on Quaker Farm, South Road. Here he lived his entire life and died at the age of ninety-two. Dow painted domestic animals, wild life, and hunting scenes on both wood and plaster in many houses along the South Road, and some of his original creations have been recorded by the Reverend Roland D. Sawyer of Kensington. On the large barn doors of his farm he painted a pair of great red oxen with long yellow horns, and on the smaller doors he put a horse and a cow. On the long panel over the kitchen fireplace he attached, in a sort of decoupage, figures of men, horses, and dogs carrying game from a hunt. The design once stretched across the entire panel and the figures were accented with color, but after recent "refinishing" only one end of the procession now remains. He was fond of painting the wild fowl seen in the neighborhood, and in the Lovering house at the foot of the hill near his home, he painted on the plaster wall beside the fireplace a wild goose against a pink background.[43]

Owned by Old Sturbridge Village is an overmantel panel which is said to have come from a house in Exeter. An eagle with shield and seven stars is flanked by two large sponge-painted trees, against a background of soft grayish-blue. The absence of a bevel, and the square corner designs, suggest that this was originally set in a molding with crossetted corners (Fig. 47). Although patriotic emblems appear quite frequently in easel pictures of the post-Revolutionary period, they do not seem to have been popular in architectural decoration. Three eagles which appear on overmantels in New Hampshire and Vermont, and one found on a plaster wall in Massachusetts (Fig. 128), are the only ones which have so far come to my attention. Above the fireplace in the parlor of the Ocean-Born Mary house in Henniker, New Hampshire, is depicted the United States Seal with eagle, shield, and laurel wreath surmounted by sixteen stars.[44] This painting and the stenciling in the same room were restored some years ago by the owner, Mr. L. M. Roy.

A hunting scene whose origin is unknown but which is said to have come from New Hampshire, and a village scene from a house facing the Connecticut River near Plainfield, are the only other New Hampshire panels which are recorded, but many more must have been painted and others will undoubtedly be found.

Near Jericho, Vermont, stands the Chittenden house, built by the first governor as a wedding gift for his second son, Martin. In the northwest parlor, concealed behind a later painting, was found an eagle similar to that in Henniker (Fig. 48). Here other patriotic devices include the flag with sixteen stars, the liberty cap, and the cow and three sheaves of wheat which still appear in the Vermont State Seal. Although the number of stars found on the flag is a notably unreliable indication of date, it may have some basis in fact in this case, as Tennessee was the sixteenth state admitted to the Union in 1796, and Governor Chittenden died in 1797. The fine woodwork of the chimney breast, including the unusual rope-carved molding, should be especially noted.

A search for other panels in Vermont has proved unfruitful. Herbert Wheaton Congdon, author of *Old Vermont Houses*, knows of only one other which is in the old Rich Tavern in North Montpelier. This shows a primitive group of public buildings now become black and almost indistinguishable owing to the unfortunate use of floor varnish as a preservative!

In closing this chapter I should like to suggest the name of Christian Gullager as a possible panel painter who, although now known primarily for his portraits, was also a versatile decorator who traveled from Newburyport to Philadelphia and was active in New England for about ten years. In 1786 he married in Newburyport Mary Selman, who was born in Marblehead, and five portraits of Newburyport residents have been attributed to him, as well as others painted in Portsmouth and Worcester. He was acquainted with the technique of landscape, having taken "2 perspective views" in Newtown in 1789, and followed these with theatrical scene painting in Boston and New York. In 1797 he advertised "Decorations for Public and Private Buildings," and in 1798 "Ornamental Painting, Signs, Buckets, Cornices &c. &c. executed in stile . . ." He also specialized in representations of the American eagle. No definite evidence connects his name with overmantel painting but it seems unlikely that he would not have tried his hand at this most popular branch of the decorating trade.[45]

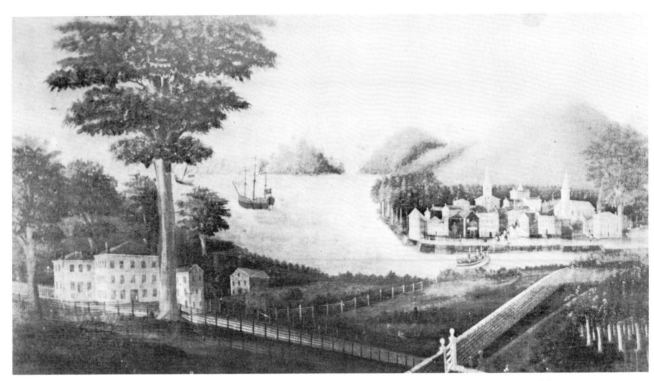

FIG. 46. Overmantel from the GARDINER-GILMAN HOUSE, *Exeter, New Hampshire*
Now installed in the Gilman Garrison house, Exeter.
Courtesy William P. Dudley

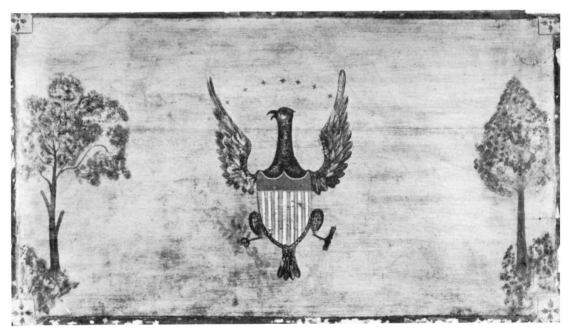

FIG. 47. OVERMANTEL from an Unidentified House in *Exeter, New Hampshire*
Only three patriotic overmantels have so far been found in New England.
Old Sturbridge Village, Sturbridge, Mass.

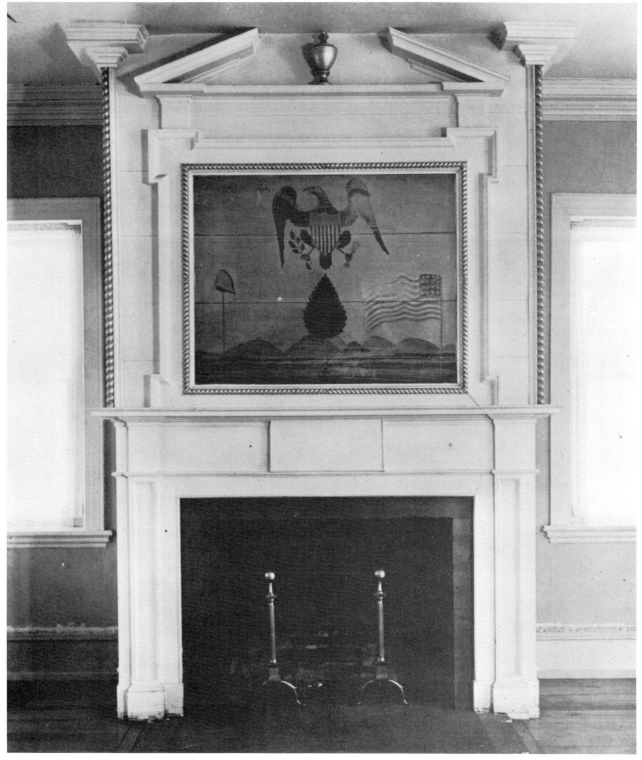

FIG. 48. Overmantel in CHITTENDEN-CHAPIN HOUSE, *Jericho, Vermont*
Built by Vermont's first Governor as a wedding present for his son Martin about 1796
Courtesy C. P. Hasbrouk; Photograph copyright 1940 by Herbert Wheaton Congdon

[1] Information from the owner, Frank Brissette.

[2] *Leaflets of the Quinabaug Historical Society*, I, 3 (Southbridge, Mass.), 31.

[3] The room from the Bliss house which contains the overmantel is now installed in the National Museum, Washington, D. C.

[4] For full description and illustrations of these panels see Nina Fletcher Little, "Recently Discovered Paintings by Winthrop Chandler," *Art in America*, XXXV, 2 (April, 1948), 81-82, 92-95.

[5] J. White, *Art's Treasury of Rarities: and Curious Inventions* 5th edition (London, 1770), p. 62. Owned by the author.

[6] Bandboxes with this design may be seen in the Brooklyn (New York) Museum, and in the Wadsworth Atheneum, Hartford, Conn.

[7] Kalm, *Travels into North America*, II, 566.

[8] For descriptions and illustrations of these panels see Allen, *Early American Wall Paintings*, pp. 3-7.

[9] The painting of the house is referred to in the preceding account by Henry Lee as having been "upon a horizontal panel over the mantel." It should be noted, however, that there is no bevel apparent on the panel as it exists today, and it is thinner and lighter than one would expect from its mid eighteenth century date. Possibly the picture was painted on a wooden background of suitable size and then inserted in the chimneybreast at a slightly later period than were the surrounding wall panels.

[10] Estate of William Clark, Administrator's Accounts, 1744. Docket 7784. Suffolk County Probate Court, Boston.

[11] Halsey and Cornelius, *Handbook of the American Wing*, p. 180.

[12] A. J. Finberg, editor, *Third Annual Volume of the Walpole Society, 1913-1914* (Oxford, 1914), p. 75.

[13] *The Massachusetts Magazine: or, Monthly Museum of Knowledge and National Entertainment . . .* , I (Feb., 1789), 66-69. Hereafter referred to as *Massachusetts Magazine*.

[14] Descendants of John Edes of Charlestown, Henry Herbert Edes, New England Historic Genealogical Society, Boston.

[15] This newspaper may be seen in the library of the Essex Institute, Salem, Mass.

[16] Files of this newspaper are owned by the Waltham (Mass.) Public Library.

[17] *Massachusetts Magazine*, I (Jan., 1789), preface, p. 2.

[18] Investigation suggests that these three panels may have come out of the old William Makepeace house in Unionville, near Franklin. Col. Joseph Ray came to Unionville in 1839; his son, Francis B. Ray, married Susan Bailey, and they lived in the old Makepeace house.

[19] Harold G. Clarke, "Old English Glass Pictures," *Magazine Antiques*, XIII, 2 (Feb., 1928), 120.

[20] For the history and attribution of this panel I am indebted to the Reverend Abbott Peterson of Duxbury.

[21] Exerpts from the reminiscences of Margaret Hazlitt appeared in the *Antiquary Magazine* for Sept. and Oct., 1884. These were made available to me through the courtesy of the late Francis H. Lincoln. Hazlitt's portrait of Dr. Ebenezer Gay is illustrated in the *History of the Town of Hingham* (Hingham, 1893), and a miniature by him of his father is owned by the Wampatuck Club.

[22] Bentley, *Diary*, II, 452.

[23] *Ibid.*, III, 96.

[24] Sidney Perley, *The History of Salem Massachusetts*, III, *1671-1716* (Salem, 1928), 139.

[25] Bill from Robert Cowan to John Derby, Dec. 7, 1791, Derby Family Papers, XXXI, 47. Essex Institute, Salem, Mass. Reprinted in *Essex Institute Historical Collections*, LXXXII (Jan., 1946), 94.

[26] Derby Family Papers, XXXII, 48, 56.

[27] *Ibid.*, p. 64.

[28] *Ibid.*, XXXI, 51.

[29] Bentley, *Diary*, I, 49.

[30] *Ibid.*, IV, 73.

[31] Appleton Family Papers, Essex Institute.

[32] From entry in Derby accounts, quoted in Kimball, *Mr. Samuel McIntire, Carver*, p. 63.

[33] Bentley, *Diary*, III, 494.

[34] *Ibid.*, II, 452; III, 68.

[35] Alice Van Leer Carrick, "Silhouettes, The Hollow-Cut Type," *Magazine Antiques*, VIII, 2 (Aug., 1925), 85-89.

[36] Bentley, *Diary*, III, 275-276, 481.

[37] *Ibid.*, p. 93.

[38] Mabel M. Swan and Louise Karr, "Early Marine Painters of Salem," *Magazine Antiques*, XXXVIII, 2 (Aug., 1940), 63.

[39] Bentley, *Diary*, IV, 573.

[40] Beauport is the former home of the late Henry Sleeper, and is now open to the public during the summer months.

[41] Wootton was a close contemporary of James Seymour. The engraved source of this panel, and of that in Fig. 31, were both called to my attention by Nancy Graves Cabot.

[42] This panel has been fully discussed by Louise Karr, "A Council of Ministers," *Magazine Antiques*, XI, 1 (Jan. 1927), 45-46. Also by Alan Burroughs, "An Early Overmantel," *Art in America*, XXIX, 45 (Oct. 1941).

[43] When the Lovering house was taken down, the section of plaster wall with the painting of the goose upon it was saved by Carroll B. Hills of Ipswich. With Mr. Hills and the Reverend Mr. Sawyer I visited the home of John Dow, and am indebted to them for the information presented here.

[44] This panel is illustrated in John Mead Howell's *The Architectural Heritage of the Merrimac* (New York, 1941).

[45] These notes are taken from Louisa Dresser's "Christian Gullager, An Introduction to His Life and Some Representative Examples of His Work," *Art in America*, 3, XXXVII (July, 1949), *passim*.

Chapter IV

Panels from Southern New England and from Other States

Painted by sundry "Transient Persons"

Connecticut

NEXT TO MASSACHUSETTS the largest number of overmantel landscapes has been found in Connecticut. In general they are similar to those found further north. Some have unfortunately disappeared through repainting, fire, and other hazards, while others have been removed from their original locations and their whereabouts lost sight of. The work of a number of different painters is apparent, with no present clue to their identity. It seems fair to suppose, however, that Ralph Earl painted overmantels (at least it would be strange if he did not) either before his departure for England in 1778, or after his return in 1785. Until his death in 1801 he spent much time traveling through the Connecticut countryside where he often stayed in the homes of his sitters or preferred "finding his own support," as expressed in the Litchfield *Weekly Monitor* of 1796.[1] His Revolutionary "View of the Town of Concord" bears great similarity to Winthrop Chandler's "Battle of Bunker Hill" (Fig. 70). Even Earl's later views, such as "Landscape Near Sharon," are composed in the overmantel manner, with large trees and abrupt hills framing distant panoramas, but these show the influence of his English experience and lack the fine decorative flair exhibited by many of his American contemporaries.

Two groups of similar panels have been found in Windham County, the artist of one being known, the other still unidentifiable. The same painter was probably responsible for those which once adorned several houses in the town of Brooklyn, Connecticut. One of these, which is illustrated in *Early American Wall Paintings,* was in the parlor of the Allen house, on the top of Allen's Hill, and represented a forest scene with many wild animals. This house was destroyed by fire some years ago. Another home on the village green contained a panel which has been removed, and another

panel which was reported as having been in the Israel Putnam house cannot now be located, but an overmantel from the old Coles-Searle Tavern is owned by the Metropolitan Museum and exhibited in its American Wing (Fig. 49).

In Woodstock lived a decorative painter about whom we have many details; a survey of his known panels forms an excellent basis for the study and comparison of the work of his contemporaries. Winthrop Chandler was born in Woodstock in 1747, and is a typical example of the country craftsman of the second half of the eighteenth century. Beginning his career as a house painter, at which time he is said to have had a small shop on Woodstock Green, he also did carving, gilding, illustrating, and drafting, as well as painting portraits of his family and acquaintances in neighboring towns. Still preserved in houses originally owned by Chandler relatives or friends, in both Massachusetts and Connecticut, is a group of overmantels which has been traditionally ascribed to him, and which on stylistic evidence also may be accepted as his work. With one exception (a still life depicting a shelf of books), all his panels are of landscapes which possess fine color, effective composition, and tremendous decorative quality.

In January 1772 Chandler received what must have been an important commission to paint five portraits of the family of Judge Ebenezer Devotion of Scotland, Connecticut. Probably at this time, or possibly at a later date, he executed one of his finest overmantels for the lower northeast parlor of the Elisha Hurlbut house which faces the village green (Fig. 50). The sharply rising hills, winding river, and large trees in the foreground show his feeling for decorative composition, while the houses carefully painted with white trim and black doors betray the house painter's knowledge of architectural detail. Houses painted in exactly the same manner appear in all his panels and are one of the dis-

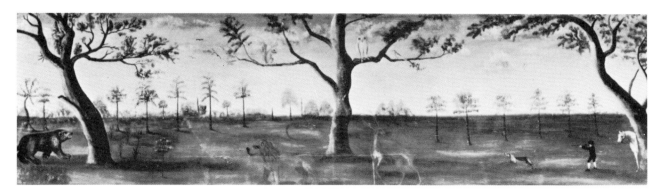

FIG. 49. Overmantel from COLES-SEARLE TAVERN, *Brooklyn, Connecticut*
Several other panels probably by the same artist have been found in Brooklyn.
Courtesy Metropolitan Museum of Art, New York City, N. Y.

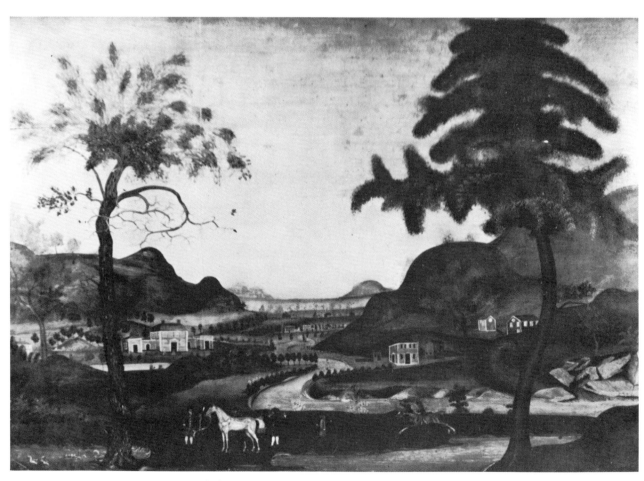

FIG. 50. Overmantel from the ELISHA HURLBUT HOUSE, *Scotland, Connecticut*
By Winthrop Chandler of Woodstock, Connecticut. Painted before
1790. The large house is painted gray, house in center red, that on
right dark gray. All have white trim and front doors in black or red.
Author's collection

tinguishing features of his work. He also frequently included interesting groups of eighteenth century figures, of which a detail is shown in Fig. 51. From the vicinity of Pomfret came the panel in Fig. 52, and another, presumably from a house in Woodstock, is now owned in Hampton.

During the summer of 1785, partly owing to financial stress, Chandler moved his wife and children to Worcester, Massachusetts. There he carried on house and fancy painting until early 1790, when he moved back to Connecticut and died in Thompson on July 29 of that year. While he was in Worcester he may have painted the two panels in Sutton which were mentioned in the previous chapter (Fig. 2), and also one in the John Chandler house in Petersham, Massachusetts. A total of thirty-one portraits and seven overmantels are ascribed to Winthrop Chandler, which for quality and interest rank among the best. Yet he died impoverished and apparently unsuccessful, his pictures scattered and unrecognized until *Art in America* and the Worcester Art Museum memorialized the two hundredth anniversary of his birth by making possible an exhibition of his work in 1947.[2]

In Canterbury appears a fanciful scene of a mansion house with dependent wings which is framed by dark draperies looped at the ends with a tasselled cord, a unique and effective device.

In Suffield a fine panorama of the surrounding countryside still remains in the Alexander King house, which fronts the broad main street (Fig. 53). This is undoubtedly intended to represent the fertile meadows and low, rolling hills of the Connecticut River Valley, but the exact location of the view cannot easily be identified. An amusing touch of realism is introduced by means of the large puffs of smoke which appear in the top left corner of the picture, apparently rising from some distant and unseen forest fire.

In the South Farms district of Middletown was discovered some years ago, under layers of whitewash and wallpaper, the remains of what must have been a very unusual decorated room (Fig. 54). The walls were originally unplastered, and on the inside of the outer boarding were painted two rows of landscapes and marines, the ships flying American flags. These pictures were evidently surrounded by moldings, with a chair rail separating the upper and lower groups of paintings. Unfortunately the room is now again covered with wallpaper.[3]

Also in Middletown, on the old Meriden Road, stands the Seth Wetmore house which contains a room which is unique in its preservation of eighteenth century painted decoration (Fig. 3). The paneled room-end, doors, and cornice are all grained in a rich shade of cedar rose, with stripes of a deep maple-yellow for contrast, quite different in pattern from the cedar graining noted in Essex County, Massachusetts (Plate 1). This house was built in 1742 and the painting may be contemporary or somewhat later, although it appears quite definitely to be of eighteenth century character. The cupboard is handsomely painted (Fig. 14) and the overmantel, framed in a bold molding, shows an Italian scene with classic ruin in the foreground (Fig. 55). Although obviously based on a foreign source, after the manner of Claude Lorrain, the architectural details are not accurate, and a certain naïveté of manner leads one to suspect the hand of an American provincial decorator rather than that of a foreign-trained artist. Wallpaper designs which included Roman ruins were brought out in England by Jackson of Battersea about 1750, and such a source, rather than a more obvious derivation, may have been the inspiration for panels such as this.[4]

In the seaport towns, and adjacent to the coast, one also finds some fancy painting in Connecticut. The parlor of the Waid-Tinker house in Old Lyme was at one time decorated with freehand designs on the walls, and with a panel landscape attributed to Jared Jessup, who was working in the Warham Williams house in Northford in 1809 (Fig. 56). Jessup did a number of walls in Connecticut and Massachusetts with plaster overmantels of a distinctive pattern in which no perspective is attempted, the buildings being set on horizontal planes accentuated by rows of trees and shrubbery (Figs. 101 and 110). Several names were painted on the buildings in the Waid-Tinker panel which included Amen Street, Jin Shop and S L Inn in front of which hung a tavern sign. Because of smoke damage caused by a fire a few years since, the woodwork and walls of this room have been entirely painted over. Another panel by the same artist (Fig. 100) came from the Burk Tavern in Bernardston, Massachusetts. The most conspicuous building is the local inn identified by its signboard on which is lettered "Hotel Tenny, 1813" which is presumed to indicate the date of the painting. Jessup's obvious interest in local taverns might seem to indicate the bibulous proclivity which has always been associated with the personality of the itinerant painter![5]

Slightly north of Old Lyme, on the opposite side of the Connecticut River, an old house in Deep River once contained a panel showing a harbor scene with unusual detail of men chopping and piling wood preparatory to loading it onto an ox-drawn cart. Many coats of old varnish make illustration unfeasible, but the style of painting is quite different from anything seen elsewhere.

In Northford a small square panel which came from the Tyler-Harrison house has been moved to a modern home nearby by a descendant of the original owner (Fig. 57). The heavy dark trees remind one of some

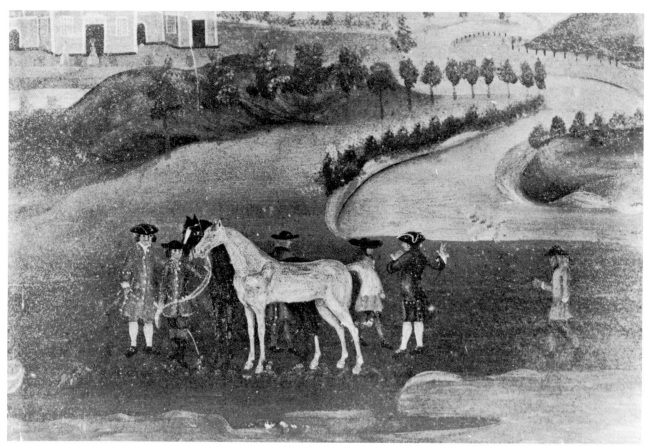

FIG. 51. Detail of Overmantel from HURLBUT HOUSE, *Scotland, Connecticut*
A particularly well painted group of eighteenth century figures.

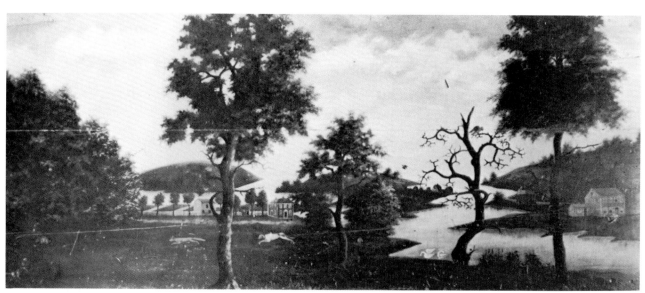

FIG. 52. OVERMANTEL from an Unidentified House in the vicinity of *Pomfret, Connecticut*
Attributed to Winthrop Chandler.
The Pomfret School, Pomfret, Connecticut.

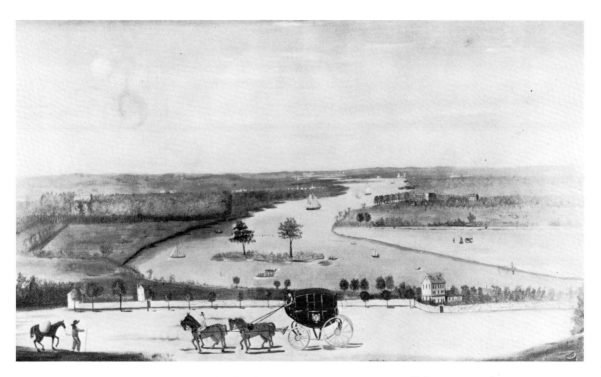

FIG. 53. Overmantel in the ALEXANDER KING HOUSE, *Suffield, Connecticut*
Probably intended to be a view of the Connecticut River.
Courtesy Samuel Spencer

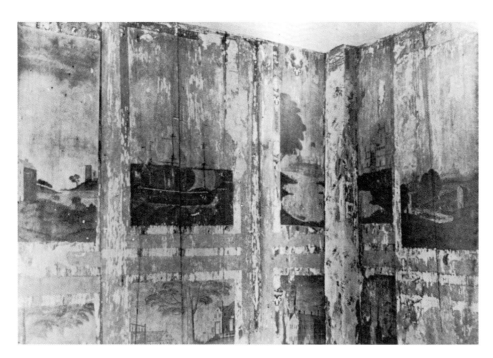

FIG. 54. INTERIOR OF A ROOM in a House in *South Farms District of Middletown, Connecticut*
Pictures occur on the inner side of the outer board-
ing, and were originally surrounded by moldings.
Photograph courtesy Newton C. Brainard

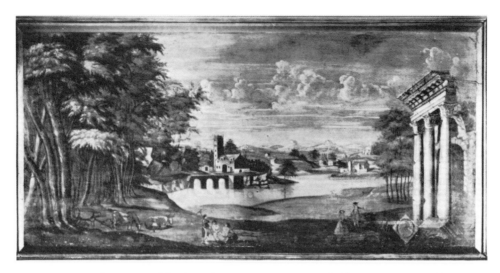

FIG. 55. Overmantel in SETH WETMORE HOUSE, *Middletown, Connecticut*
A classic scene obviously derived from a European source.
Courtesy Samuel M. Green

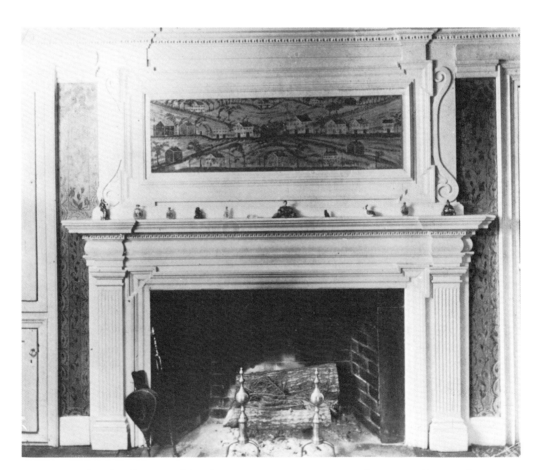

FIG. 56. Fireplace Wall in the WAID-TINKER HOUSE, *Old Lyme, Connecticut*
Overmantel and free-hand painting on plaster
attributed to Jared Jessup. Now painted over.
*Courtesy Walter McGee; Photograph, Society for the
Preservation of New England Antiquities, Boston, Mass.*

of the plaster wall paintings of the early nineteenth century. The small figures which are almost indistinguishable in the photograph, and the prim houses painted in pleasing shades of blue, buff, gray, and cream, with red roofs and doors, make this an unusually charming and colorful composition.

Hanging in the Cheshire Public Library is a panel removed from the Rufus Hitchcock house which stands nearby on the green. It is said to represent an early view of the town and to have been painted by a native of Wallingford, one Sylvester Hall, born there in 1774. Although this ascription is purely traditional, it is a fact that Hall advertised as a general decorator in New Haven in 1804[6] and may well have included overmantels in his repertory, although they are not specifically mentioned. A second panel, owned by the Fairfield Historical Society, bears enough similarity to that in Cheshire to suggest the work of the same artist (Fig. 58). According to the records of the Society this panel, when given in 1904, was said to have come from the residence of Elisha T. Mills, and to picture a house on Main Street, Fairfield, in the 1790's. This view has the appearance of actuality and it is a pity that its definite history is obscure.

Rhode Island

Only a few overmantel landscapes have so far been located in Rhode Island, although some are known to have existed which have now disappeared.

Over what was originally the kitchen fireplace of the Rowland Robinson house in Saunderstown appears a spirited hunting scene (Fig. 59). Five large trees are effectively outlined against a rose and blue sky, and the huntsman and groom follow a pack of hounds which are hard on the heels of a magnificent stag. When the present owners purchased this property, they found the panel taken out and standing against a wall, while a new wooden board with hole cut for a stovepipe had fortunately replaced it over the fireplace.

One would expect to find handsome decoration in Newport, during the eighteenth century one of the most wealthy and prosperous towns of the Rhode Island colony. When James Birket visited there in 1750 he recorded in his journal the following incident which refers to what must have been an extraordinary house, even for Newport: "In the afternoon I went with my fellow travelers to See Captain Molbons Country house. It Stands upon a tolerable Advantageous Scituation About a mile out of the Town And makes a good Appearance at a distance. . . . It is Built of Hewn Stone and all the Corners and Sides of the windows are all painted to represent Marble . . . this house & Garden is reckond the wonder of that part of the Country not being Such another in this Government."[7] A few weeks later he gives us a general impression of the houses in the town itself: "Newport . . . is in the General well built And all of wood (Except the Statehouse and one of Capt. Molbons which are of Brick) [this refers to Malbone's town house] the houses in general make a good Appearance . . . many of the rooms being hung with printed Canvas and paper &c which looks very neat Others are well wainscoted and painted as in other places."[8] Although many of the fine houses have been demolished and from others architectural details have disappeared, evidence still remains that Newport has had a rich decorative heritage, the existing examples of which indicate its quality and scope. Mention has already been made in Chapter I of the unique Chinoiserie wall paintings in the Vernon house (Fig. 8), and on the subject of overmantel decorations another visitor to Newport, one Dr. Alexander Hamilton, made this mystifying observation in 1744: "It is customary here to adorn their chimney pannells with birds' wings, peacock feathers and butterflies."[9]

One of the few topographical panels comes from Newport and is a valuable historical record as it shows a panorama of the harbor and town taken from Goat Island, the present torpedo station, showing Fort George in the foreground (Fig. 60). The painting is executed in the manner of an engraving, although it apparently was not based on any previous source, the Newell lithograph which resembles it not having been issued until after 1850. Many of the old buildings may be recognized, including the Colony House at left center, and the famous Stone Tower just to the right of the righthand church. Concerning its origin the following reference appeared in the *Annals of the Redwood Library* for September 27, 1871: "Colonel T. Bailey Myers, of New York, has lately left in the Library an old painting of Newport, purchased by him of Mr. James Phillips, which has for nearly one hundred years remained in position as a panel over the mantelpiece, in his house in Mill Street. . . . [It] was placed in the Mill Street house during its occupancy by Joseph Clarke, the (colonial) General Treasurer in the room occupied by him as an office."[10] Because of architectural details a date of 1740 has been ascribed to the painting in recent years. Another painting on wood of the old Stone Tower, Newport, is said to have come from the Cottrell-Mumford-Watts-Phillips house, it having been discovered when modern wallpaper was removed from the front parlor during remodeling in 1886.[11]

Several other panels which depicted harbor and battle scenes are rumored to have existed in Newport, in a house razed about 1925, but these panels were privately purchased at that time and are unlocated at present writing.[12] There was, however, a harbor view in the small lower southwest room of the "Quaker Tom"

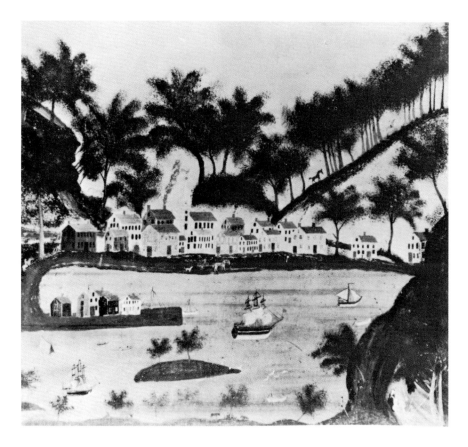

FIG. 57. Overmantel from the TYLER-HARRISON HOUSE, *Northford, Connecticut*

The houses are painted blue, buff, dark gray, and cream. Roofs and many of the doors are red.

Courtesy Miss Ethel Wellman, Gaylord Wellman

FIG. 58. Overmantel said to have come from the ELISHA T. MILLS HOUSE, *Fairfield, Connecticut*

Supposed to represent a house on Main Street, Fairfield, in the 1790's. The house is painted gray with white trim. The front door is blue and the barns are red.

Fairfield Historical Society, Fairfield, Conn.
Photograph courtesy Mary Allis

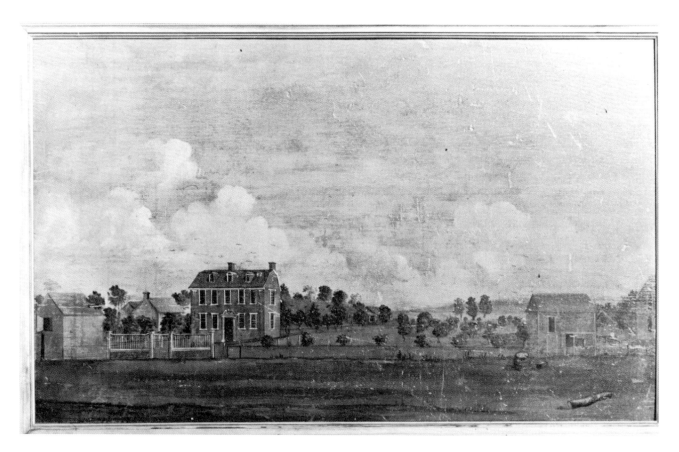

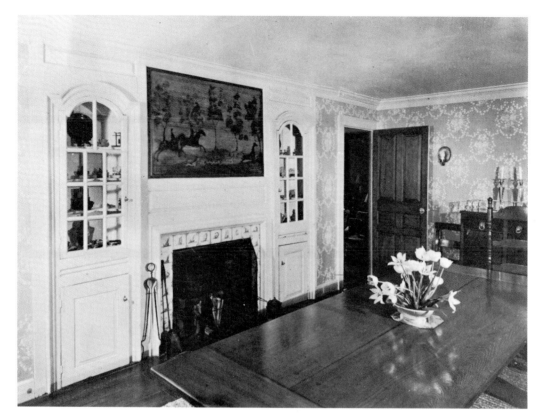

FIG. 59. Overmantel in the ROWLAND ROBINSON HOUSE, *Saunderstown, Rhode Island*
Two riders engaged in a stag hunt.
Courtesy Mr. and Mrs. Frederick Hazard
Photograph, The Museum of Art, Providence, Rhode Island

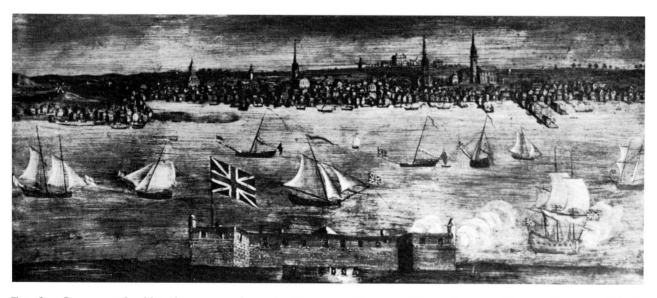

FIG. 60. Overmantel said to have come from the COTTRELL-MUMFORD-WATTS-PHILLIPS HOUSE, *Newport, Rhode Island*
View of Newport from Goat Island. The Colony House may be seen in left center.
Courtesy Lewis G. Morris; Photograph courtesy William King Covell

Robinson house, which apparently has a good deal of decoration that is still covered by modern paint. Investigation in an upper chamber, which is still incomplete, has revealed a continuous landscape pattern on the eight panels surrounding the fireplace, and on the large two-paneled doors. The design seems to consist of a wavy horizon line as a basis for greenish-gray trees of varying sizes placed against a sky which has stripes of red and green. The rails and stiles of the paneling appear to be variegated in green, and two red fires smoke at either end of the chimney breast. The whole effect must have been primitive, both in coloring and design, and gives the impression of a plaster panorama rather than the finite composition of a panel painter.

Entirely different in style, and executed by an accomplished workman, was the painted decoration of the beautiful northeast parlor of the Nichols-Hunter house on Washington Street. Judging from the evidence of color uncovered before the removal of the paint, the marbleizing of the various architectural elements, the painting of the shell-top cupboards, and the polychroming of the cherub figures combined to make this one of the most outstanding rooms yet recorded. Recent investigation has also revealed original mahogany and cedar graining in the southeast and southwest rooms respectively. Behind woodwork and whitewash of a later alteration cedar graining has been discovered on the plaster walls of a small rear room. This unusual procedure appears to have been for the purpose of matching the finish to the paneling of the adjoining room.

Another example of "fancy painting" exists in the Wanton-Lyman-Hazard house at 17 Broadway (Fig. 61). In the upper south chamber, the fireplace wall is sheathed with fine early boards which have been crudely painted to simulate rail and stile paneling. The outer edges are grained with a swirled design in gray and black, the "mock panels" are outlined with a red stripe, and the inner surface is grained in red, gray, and buff.

Other examples of painted decoration exist here and there in Rhode Island, among them the keeping room and chamber of the Joseph Reynolds house in Bristol which is handsomely marbleized.[13] The Coombs house near Little Compton has marbled fireplace panels, freehand painted ceiling beams, and a door painted with a large tree and a ship flying the Union Jack.[14] From "Mowbra Castle" in Belleville, ten miles north of Narragansett Pier, came three handsomely grained rooms which have never been repainted.[15] The north end of the house is said to have been built in 1709 by a Newport man named Phillips whose son Christopher added the south end and "embellished the estate" after 1748. Probably at this time the large kitchen fireplace was

filled in with an unusual arrangement of cupboards, panels, and drawers surrounding a smaller aperture. The woodwork in the entire room including the ceiling beams was then cedar-grained, with panel bevels variegated in blackish-green, and moldings in light buff (Fig. 62). In the upper southeast chamber the raised panel surfaces were marbled in black on a variegated green background. These panels were surrounded by bevels and moldings in pink, with stiles and rails marbleized in black on gray. The upper southwest chamber had a dark red base coat with pinkish-buff over-design in knots and swirls. Here the bevels were a soft gray, the stiles and rails green marbled. These rooms with their unusual patterns and soft but vibrant colors show the work of the eighteenth century decorator at his best.

Some Panels Outside New England

There seems little doubt that graining, marbleizing, and panel painting was as prevalent in the South and perhaps even handsomer than in New England. In fact, much of the documentary evidence, as we have seen, is to be found in southern newspapers of the second half of the eighteenth century. The decoration itself, however, has survived in much greater quantity in the north, although systematic investigation in the states south of New England would probably reveal unsuspected riches.

One overmantel has been noted in New York State. The Daniel Burt house, built in 1764 in Warwick, has a room-end composed of thirteen small panels, five of which form the central decoration over the fireplace. The center panel of this group, which measures only thirteen by thirty inches, is painted with a scene in which two hills topped with rows of trees slope down to the waters of a bay. A man in knee breeches is fishing, a ship lies offshore, and men are rowing a skiff toward a whale which disports itself nearby. The most astonishing feature of the composition, however, is a large eagle dominating the top of a cliff which rises in the left foreground. A significant note about this panel is the fact that the family who built the house came from Connecticut, where overmantels were a popular decorative feature.[16]

Pennsylvania, the home of so much gaily painted furniture and other colorful folk art, seems to have yielded surprisingly little architectural decoration, although much probably yet remains to be recorded. The Metropolitan Museum shows in the American Wing a painted chimney breast from Lebanon County which contains a panel with a strange view that is almost an exact copy, greatly enlarged, of Plate XXI in William Salmon's *Polygraphice*, published in London in 1685. This is the only instance known to me where an over-

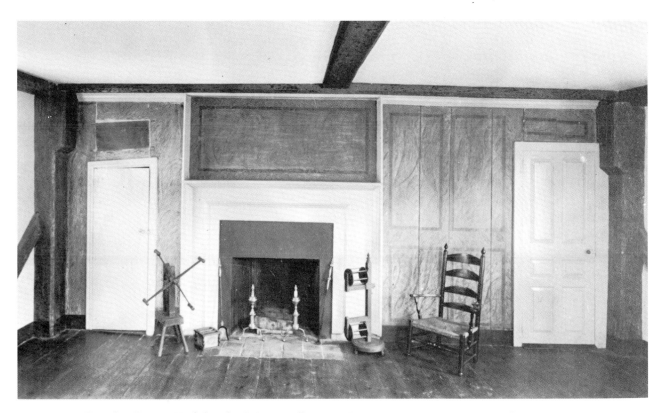

FIG. 61. Room End in the WANTON-LYMAN-HAZARD HOUSE, *Newport, Rhode Island*
Mock paneling and graining in the upper south chamber.
Newport Historical Society, Newport, Rhode Island
Photograph, Historic American Buildings Survey, Library of Congress, Washington, D. C.

FIG. 62. MOWBRA CASTLE,
Belleville, Rhode Island

The woodwork of three rooms is now installed in Scarsdale, New York. This woodwork is cedar-grained, and probably dates from the middle of the eighteenth century when the original large fireplace was filled in by this unusual arrangement of cupboards.

Courtesy Ralph E. Carpenter, Jr.

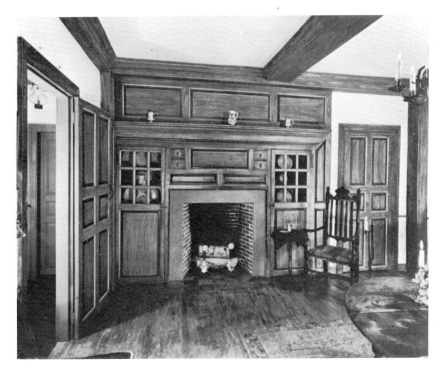

mantel has been copied in exact detail from so early a published source.

From the vicinity of Lansdale comes a romantic scene which is of particular merit because of the unusual group of figures in mid eighteenth century costume (Fig. 63). The old gentleman rests his gouty leg on a carrying bench, while his companions chat and feed the swans.

Holly Hill, Anne Arundel County, Maryland, for generations the home of the Harrison family, is a seventeenth century plantation house to which was added a large addition sometime between 1716 and 1733. In a chamber on the second floor the paneled room-end is marbleized in blue and cream. The stiles and rails of the doors are in soft blue, with door frames and panel moldings in brown veined in cream, an unusually attractive combination of colors. A landscape over the fireplace is framed in a raised bolection molding, and shows a fanciful view with castle and English flag which is typical of the pre-Revolutionary type of decorative painting (Fig. 5). There are two other smaller panels, one above a doorway and the other over the fireplace in the dining room, which are in the same manner.

Also from Maryland comes a long overmantel, likewise pre-Revolutionary, which is thought to be an actual view of shipbuilding on Gray's Inn Creek on the westerly side of Chester River, below Rock Hall. Now owned by the Maryland Historical Society it originally was placed over a fireplace in Spencer Hall, Yarmouth, Kent County. This busy scene shows a wooded shoreline with building and two ships on the ways in process of construction. There are many vessels in the river and seven British flags are prominently displayed. Small figures may be descried, including one man with a spy glass. The bevel of this panel appears to be cedar-grained under a coat of later gray paint.

Mention has been made in Chapter II of the canvas overmantel at Mount Vernon, and a seascape on panel has recently been found during the restoration of nearby Woodlawn Plantation, the land of which was given by Washington in 1799 as a wedding gift to Nellie Custis, his adopted daughter, on her marriage to his nephew Lawrence Lewis. The house, designed by William Thornton, architect of the Capitol, was completed in 1805. The panel was set below the window which lights the stairway and upper hall.

The handsomely painted room from Marmion, King George County, Virginia, now installed in the Metropolitan Museum, has already been referred to as a fine example of decorative painting in the English and Continental manner. The panels and details, painted to imitate ormolu, are reminiscent of the French rococo taste, and were probably done between 1770 and 1780.[17] Morattico, Richmond County, Virginia, built by Charles Grymes probably before 1717, was destroyed about 1927 through erosion of the banks of the Rappahannock River. The fine drawing room in Queen Anne style with original flock wallpaper was fortunately saved and now forms part of the Henry Francis du Pont Winterthur Museum. Three large panels on the chimney breast are framed in marbleized moldings. One depicts an elaborate mansion, with huntsman and dog, having a river and town in the background. The smaller panels show exotic birds in full color (Fig. 64). The source of such decoration is not hard to find. One instance of similar pictorial paneling framed in gray-green marbling is to be found in Wilsley House, Cranbrook, Kent, England, built in 1690.[18]

REFERENCES

[1] William Sawitzky, *Ralph Earl 1751-1801, Catalogue by Whitney Museum of American Art*, New York, Oct. 16—Nov. 21, 1945.
[2] For complete details of the life and work of Chandler see Nina Fletcher Little, "Winthrop Chandler," *Art in America*, XXXV, 2 (April 1947). This monograph was used as the catalogue of the exhibition of his work which was held at the Worcester Art Museum during May, 1947.
[3] Mr. Newton C. Brainard of Hartford very kindly supplied me with this photograph and information.
[4] A wallpaper of classic type, owned by the Metropolitan Museum, is illustrated in McClelland, *Historic Wall-Papers*, p. 161. A set of Piranesi's views of Roman ruins by Jackson are still in place in the second floor drawing room of the Jeremiah Lee mansion in Marblehead, Mass.
[5] A full account of Jessup's plaster painting will be found in Chapter VII.
[6] This advertisement is quoted in full in Chapter VII.
[7] Birket, *Some Cursory Remarks*, p. 27.
[8] *Ibid.*, p. 28.
[9] Dr. Alexander Hamilton, *Gentleman's Progress* (Chapel Hill, 1948), p. 157.
[10] George Champlin Mason, *Annals of the Redwood Library and Athenaeum*, Newport, R. I. (Newport, 1891), p. 308.
[11] Philip A. Means, *Newport Tower* (New York, 1942), p. 136.
[12] Information from John Perkins Brown.
[13] Illustrated in Antoinette Forrester Downing, *Early Homes of Rhode Island* (Richmond, 1937), pp. 72, 73.
[14] Illustrated in Brazer, *Early American Decoration*, facing p. 169.
[15] The three painted rooms here described have been removed from Mowbra Castle and installed in the home of Ralph E. Carpenter, Jr., in Scarsdale, N. Y.
[16] I learned of this panel from Mrs. Charles Slaughter of Warwick, and through her kindness was able to see it.
[17] Thomas Tileston Waterman, *The Mansions of Virginia 1706-1776* (Chapel Hill, 1945), p. 76.
[18] Lloyd, *History of the English House*, p. 407, Fig. 704.

FIG. 63. OVERMANTEL from Vicinity of *Lansdale, Pennsylvania*
A fanciful scene particularly interesting for the group of figures which includes an elderly gentleman resting his leg on a carrying bench.
Author's collection

FIG. 64. MORATTICO, *Richmond County, Virginia*
This room is now installed in the Henry Francis du Pont Winterthur Museum. It still retains its original paint. Marbleized moldings surround pictorial panels of a mansion house and exotic birds.

Henry Francis du Pont Winterthur Museum,
Winterthur, Del.

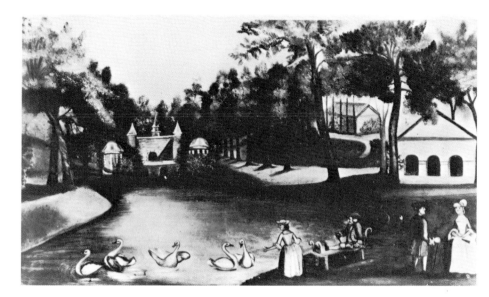

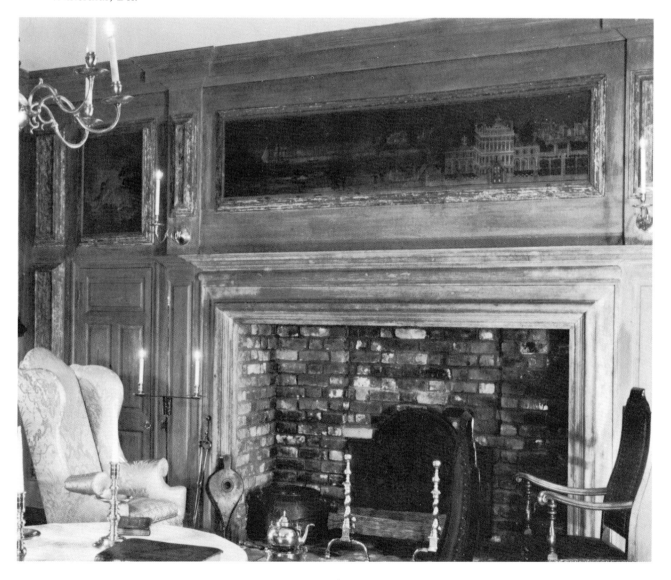

Chapter V

Chimney Boards
"To Hide ye Fireplace"

Painted Floors
"In Plano and Perspective"

To close the fireplace opening during the summer months when heat was not needed, chimney (or fire) boards were in common use during the eighteenth and the first half of the nineteenth centuries. They were either made of wide boards held together on the reverse by stout battens, or of canvas stretched over a light pine frame. Made especially for the individual fireplace, they fitted exactly inside the surrounding woodwork (Fig. 22). There were various methods of holding them upright. Sometimes a wide molding was attached to the bottom which gave them a backward tilt and insured their not falling forward when set in place; occasionally a little turnbuckle, manipulated by a small brass handle, fitted into a channel in the fireplace molding. The most frequent device, however, was to cut two slots in the lower edge to allow the fronts of the andirons to rest outside, on the hearth. Their tops, when snugly set against the board, helped to prevent it from falling forward. When parlor stoves supplanted fireplaces a hole was often cut in the fireboard for the pipe, with unfortunate disregard for the decoration which it damaged.

One of the earliest and most interesting American references to fireboards is to be found in the Letter Book of John Custis of Williamsburg, Virginia. Under date of April 10, 1723, Mr. Custis made the following request:

Get me two pieces of as good painting as you can procure. It is to put in ye summer before my chimneys to hide ye fire place. Let them bee some good flowers in potts of various kinds and whatever fancy else you think fitt; the bigness of each chimney is the one 4 feet 4 inches high, & 4 feet almost 4 inches wide, ye other 4 feet 5 inches wide and 4 feet 3 inches & ¾ high. Done on canvas this is the exact dimensions of ye chimneys. I send this early that the painter may have time to do them well and the colors time to dry. . . . I had much rather have none than have daubing.[1]

Chimney boards fall into two main groups: those made of wood or canvas which have hand-painted designs, and those which were covered with printed wallpaper panels made especially for this purpose in France. As we are discussing primarily painted decoration, we shall consider only the first group. Many ornamental painters included fireboards in their repertoires, and an advertisement of Joseph Kidd of Williamsburg, which appeared in the *Virginia Gazette* in 1769, lists a typical combination of services: "Joseph Kidd, upholsterer in Williamsburg hangs rooms with paper or damask. Undertakes house painting, gilding, glazing, paints floor cloths, chimney boards and signs."

From existing evidence it appears that the fireboard was considered an integral part of the decoration of the room, and that the painter who executed the overmantel, grained the woodwork, or frescoed the walls, might also have been expected to supply a chimney board in harmony with the rest of the decoration. In the Ebenezer Waters house in Sutton, Massachusetts, an old fireboard long stored in the attic was found to fit exactly one of the chamber fireplaces. This board still retains the original brown graining with which the rest of the woodwork was at one time decorated (see Fig. 2), and it may well have been done by the same painter. The Hibbard house in Ithaca, New York (Fig. 137), had a fireboard undoubtedly done at the same time as the frescoed walls.[2] Jonathan D. Poor, a mural artist of the Rufus Porter school, also painted fireboards in much the same manner as his walls. Figure 65 shows a fireboard signed "Jona. D. Poor 1831" which has a background of trees and hills typical of the fresco painter. Although the design, with its superimposed pot of flowers, is confused and too crowded for the finite limitations of a chimney board, it is interesting as being typical of the patterns which Poor and his contemporaries were accustomed to paint upon long stretches of plaster wall.

Landscape scenes similar to those painted on over-

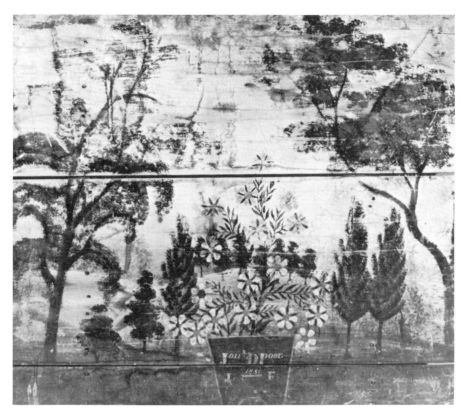

FIG. 65. Fireboard by JONATHAN D. POOR, 1831
Poor was a fresco painter and a nephew of Rufus Porter.
Shelburne Museum, Shelburne, Vermont

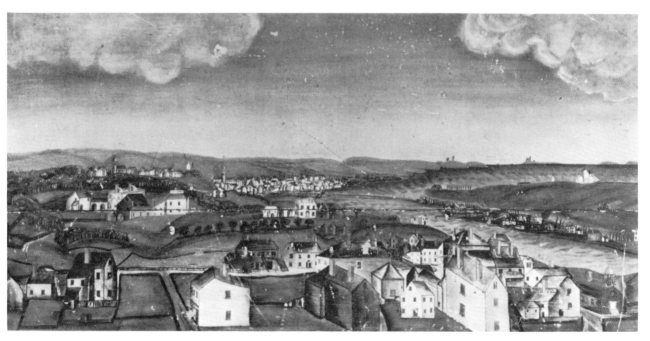

FIG. 66. FIREBOARD from the Vicinity of *Salem, Massachusetts*
An unidentified view, probably by a local painter.
Essex Institute, Salem, Mass.

mantel panels were also done on fireboards, although to a lesser extent. Preserved in the Derby family papers in the Essex Institute, Salem, Massachusetts, is a bill to Mr. John Derby from Robert Cowan, dated Salem, 7 Dec., 1791: "To painting a landscape for a chimney board, 1 pound, 9 shillings, 7 pence." In the same museum is a Salem fireboard which could be the work of Cowan, although there is at present no clue to its history (Fig. 66). Said to be a view in the vicinity of Salem, it is a delightfully detailed composition in what may be called the "American primitive" manner, and study of the houses reveals many interesting architectural features. Two other Salem fireboards may be seen in place in East India Marine Hall of the Peabody Museum, Salem. These were painted by Michele Felice Cornè for the new building on Essex Street into which the East India Marine Society moved in 1804. One of them shows the Canton Factories, or trading posts of the foreign nations in China. The other is a panorama of the harbor and surroundings of Capetown, Africa, painted with Cornè's fine sense of color and perspective, and signed "M. Cornè pinxit, 1804" (Fig. 67). Also said to have come from Salem is a very large board which has old brass handles to facilitate lifting. This painting is a romantic view dated 1790, but the salt marsh banks of the tidal river will be easily recognizable to those familiar with the New England coastline (Fig. 68). Slightly earlier is the rare view on canvas of the John Hancock mansion taken from Boston Common. On the right is the beacon atop Beacon Hill. It was replaced by a monument in 1790 and stood on the site of part of the present State House. This fireboard is traditionally said to have been given by Hancock to the daughter of Samuel Adams on her marriage in 1781 (Fig. 69).

To Winthrop Chandler, painter of overmantels, is credited a fireboard said to represent the Battle of Bunker Hill which was made for his cousin Peter Chandler of Pomfret, Connecticut (Fig. 70). Although many coats of varnish, now darkened with age, obscure some of the details, this is one of the most interesting pictures of the Revolutionary period. The topography of Charlestown is far from accurate; but as no engraving has been found as a source for the view it seems reasonable to accept it as the artist's own idea of the famous battle at which he was almost certainly not present! Horse and foot troops meet in deadly combat in the foreground, supported by a field piece, while the British ships known to have taken part in the engagement, are to be seen at left and right, prominently displaying the Union Jack. Over the fortifications, however, flies a rarely seen flag. This is a combination of the thirteen red and white stripes representing the original colonies, with the union composed of the crosses of Saint George and Saint Andrew, signifying the Crown. This Grand Union Flag was the colonial standard from the beginning of 1776 until June 14, 1777, when the present Stars and Stripes was adopted by a resolution of the Continental Congress.

Although landscapes were in favor for fireboards, miscellaneous subjects were equally popular, to judge from the numbers which have survived. Some were animal pieces, completely original in conception, and so bold or naïve in effect that one cannot help wondering how they were regarded when they were new. In these animal fireboards one gets a distinct impression of the art of the sign painter, whose multiple varieties of lions and other beasts swung above many a road-side tavern. There may also have been other sources of inspiration for these portraits, such as traveling exhibits of unusual quadrupeds which toured the hinterland in the early nineteenth century and caused wonder among the admiring populace. One of these country exhibitions is described in the diary of General Samuel Leighton of Alfred, Maine, on July 3rd and 4th, 1833: "a Caravan of Animals came and put up here. . . . a Convention at the Court house the animals exhibited in my shed . . . & stable 2 Moose rein deer a Caraboo a bear a rackoon . . ."[3] The delightfully stylized rendition which appears in Fig. 71 is known to devotees of American primitive painting as "the bears and pears." The oversized fruit has no relation to nature but will be found similarly depicted in needlework pictures of the mid eighteenth century. This board is believed to have originated in New Hampshire, where a floor by the same artist has recently been found (Fig. 84).

The lion in Figure 72 leaves one in doubt as to whether he is really ferocious or only curious and a little frightened as he peers out from the safety of his virgin forest. This chimney board came originally from the home of Harvey Dresser on Dresser Hill, Charlton, Massachusetts, where it graced the main room of the old coaching inn when the fireplace was not in use. Mention will be found in Chapter IX of some very special decoration done by Dresser in the church in Thompson, Connecticut, in 1817. In view of the fact that he did ornamental painting, it seems likely that he may have painted this fireboard for his own home, and he may have been responsible for some of the overmantels in the vicinity of Sturbridge.

The greater number of fireboards, however, seem to have been decorated with some type of flower arrangement, and these were apparently in demand as early as 1723 when Mr. Custis of Williamsburg wrote: "Let them bee some good flowers in potts of various kinds. . . ." During the eighteenth century the custom of placing a pot of boughs, cut flowers, or flowering plants inside or in front of an unused fireplace was prevalent

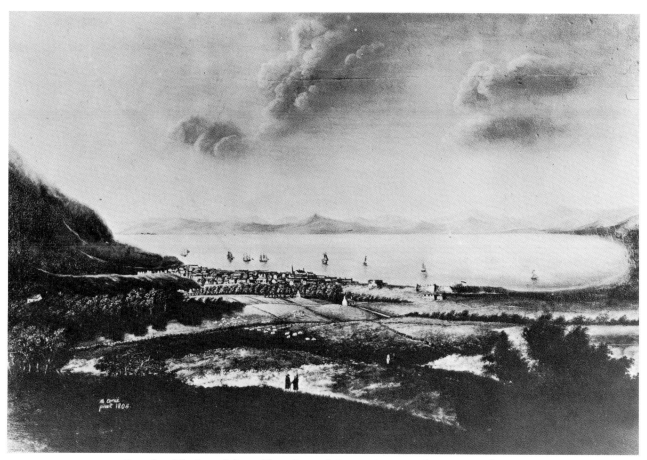

FIG. 67. Fireboard from EAST INDIA MARINE HALL, *Salem, Massachusetts*
View of Capetown, South Africa. By
Michele Felice Cornè. Signed and dated 1804.
Peabody Museum of Salem, Salem, Mass.

FIG. 68. FIREBOARD said to be from
the vicinity of *Salem, Massachusetts*
Fanciful view of a river, dated 1790.
Author's collection

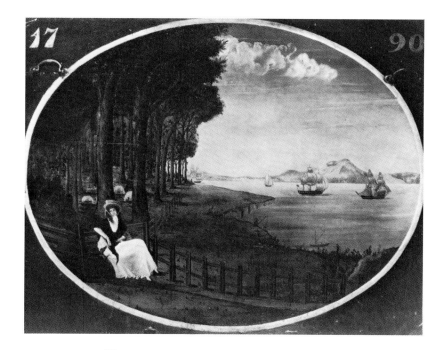

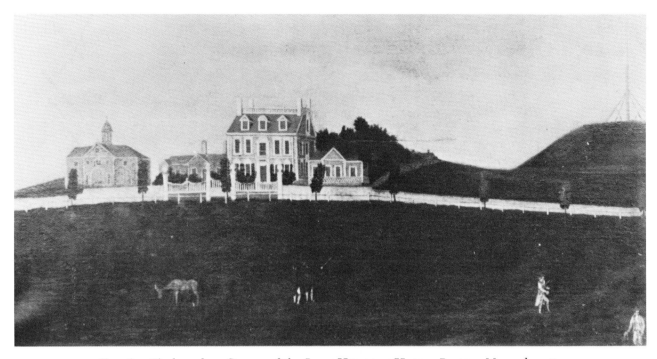

FIG. 69. Fireboard on Canvas of the JOHN HANCOCK HOUSE, *Boston, Massachusetts*
With beacon on Beacon Hill. Given by Hancock as a
wedding gift to the daughter of Samuel Adams in 1781.
Privately owned

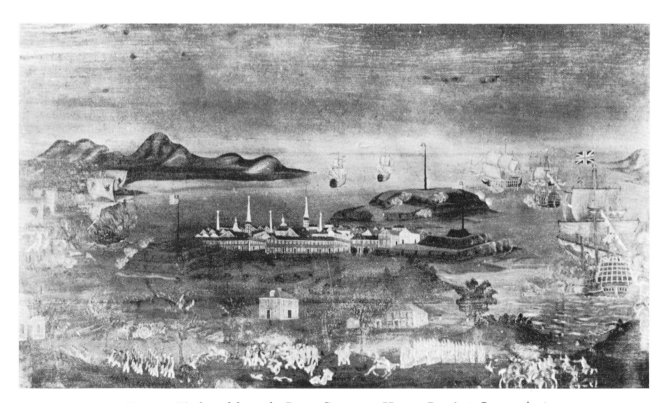

FIG. 70. Fireboard from the PETER CHANDLER HOUSE, *Pomfret, Connecticut*
Thought to be the artist's version of the Battle of
Bunker Hill. Painted by Winthrop Chandler before 1790.
Courtesy Gardiner A. Richardson

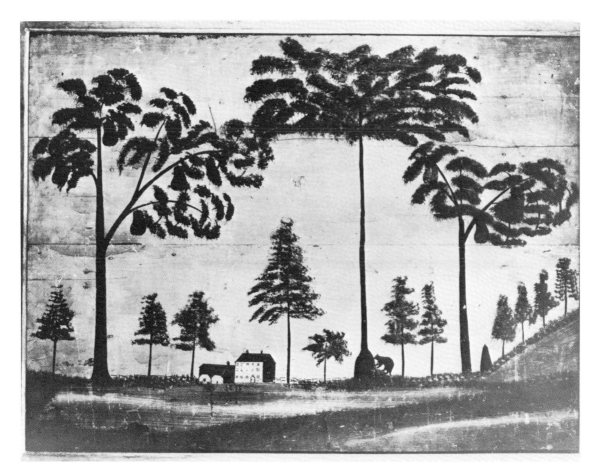

FIG. 71. FIREBOARD Probably from *New Hampshire*

The work of this painter is characterized by the large red pears which hang from the trees. Other examples of his work are to be found in Lisbon, New Hampshire.

New York State Historical Association, Cooperstown, N. Y.

FIG. 72. Fireboard from the
DRESSER TAVERN,
*Dresser Hill, Charlton,
Massachusetts*

This was used to close the fireplace in the summer in the main room of the old coaching inn.

Author's collection

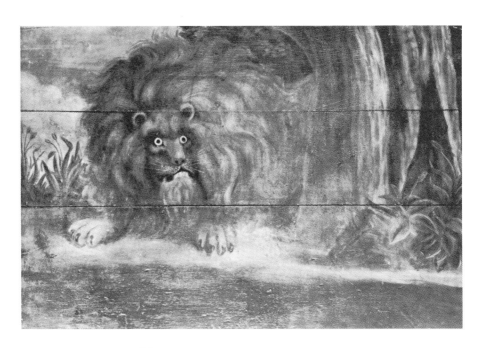

both in England and in the colonies. Josiah Wedgwood, the great English potter, made special receptacles for this purpose and on June 29, 1772, wrote in a letter to his partner Thomas Bentley: "Vases are furniture for a chimney piece, bough pots for a hearth. . . . I think they can never be used one instead of another" (Fig. 73).

Plaster overmantels were sometimes painted with bouquets of posies to suggest floral arrangements, and although they may not have given an entirely realistic impression, they did add gaiety and charm to the focal point of the room (Figs. 104 and 127). Wallpaper, always closely allied with wall painting, also made use of horticultural displays. McClelland's *Historic Wall-Papers* illustrates a handsome eighteenth century chimneyboard with basket of flowers raised on a graduated base. Eventually the following advertisement of Mills and Webb appeared in the *American Mercury*, Hartford, Connecticut, Sept. 23, 1793: "Great variety of paper hangings, handsome pots for chimney pieces with festoon borders."

A comparison of the kinds of containers which were depicted by the wall painters makes a very interesting study, especially with regard to the source of the artists' designs. Urns were perhaps the most popular, some standing on stepped-up bases, such as that in Figure 79, while others, with curving sides and flaring handles, rested on a naturalistic carpet of grass and flowers (Figure 74). These basic forms appear in many media throughout the period of the Classic Revival and are often seen in needlework and Delft pottery of the second half of the eighteenth century, both of which held a prominent place in many American homes.

Like the panel painters, the chimneyboard decorators had certain characteristics of technique and design which can be recognized wherever found. In fact, some of the fireboard painters seem to have evolved what must have been almost stock patterns and to have turned out a number of examples which varied only slightly. A group of these is shown in Figures 75 to 78 in which the vases of leaves will be seen to be very similar, while the borders differ in detail but are obviously intended to simulate pottery titles. In place of the trees, Figure 77 has a border of little landscape vignettes which appears again in Figure 78. The origin of these boards has been very hard to trace, as antiques are taken from one locality to another and it is almost impossible to be sure where they actually originated. The background of Figure 75 might have been Pennsylvania; Figure 76 was purchased in Burlington, Vermont, many years ago and is believed to have been a local piece; Figure 77 has no known history, but Figure 78 was definitely made for a bedroom fireplace in the Ebenezer Waters house in Sutton, Massachusetts. If these histories are correct they would indicate the work of an itinerant who traveled from Pennsylvania to northern Vermont.

Two fireboards obviously by the same decorator have been found in the vicinity of Salem, Massachusetts. That illustrated in Figure 79 was purchased there some years ago. Another, which displays almost the same composition in slightly different coloring, may be seen in the nearby Wenham Historical Society, to which it was given by a local family. A different and perhaps improved type of fireboard appears in Figure 80. Against a background of soft yellow ochre a pot of flowers is painted on a vertical panel in the center of the board. On either side is a set of green slats resembling window blinds. It would appear that this ingenious contrivance was for the purpose of allowing a small amount of draft to escape from the room up the chimney.

Jared Jessup, panel and plaster painter whose work is discussed in detail in Chapter VII, was responsible for the design in Figure 81. This suggests the brick facing of a fireplace opening, against which is set the chimneyboard enframed in stylized black drapes. The gray urn and bright flowers are placed against a variegated background of bluish-green and gray, a combination of color and design which surely could only have been contrived by a rural decorator! This board, however, was a definite part of the decorative scheme of the room for which it was painted in the Ryther house in Bernardston, Massachusetts, and as such it undoubtedly enhanced the entire effect when placed there by the artist, probably in the year 1813, the year in which he dated an overmantel in the nearby Burk Tavern.

How much did one have to pay for a chimneyboard one hundred and fifty years ago? Answers to this sort of question are not always easy to find, and undoubtedly the price varied according to the amount of work and the skill of the artisan. Three documentary references may be cited which give some idea, although it is probable that the work in each case was not entirely comparable. In 1791 Robert Cowan charged John Derby of Salem about $5.75 for painting a landscape on a chimneyboard.[4] In 1809 Gideon Tucker, also of Salem, billed John Archer $5.27 for four chimneyboards. This may have referred only to the making and not to the decorating. Thirteen years later, in 1822, Allen Holcomb, carpenter and decorator of Otsego County, New York, charged $1.00 for painting a fireboard green.[5]

Fireplace Painting

One type of painting which seems to have disappeared entirely from modern usage is fireplace painting, and yet there is definite evidence, both actual and documentary, that hearths and chimney interiors were

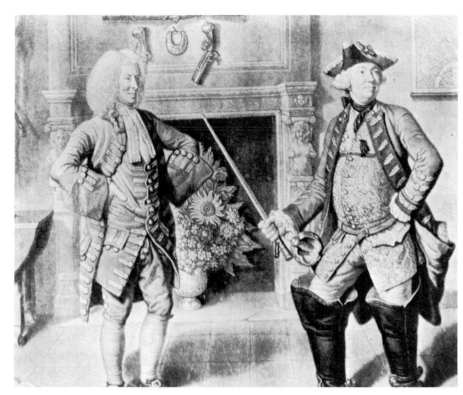

FIG. 73. ENGLISH PRINT by J. H.
Haid after a Painting by
Zoffany, 1765

This print illustrates the custom of
placing a flower arrangement on the
hearth when the fireplace was not
in use. Many chimneyboards car-
ried out this decorative idea.

From a print in the Wythe House,
Colonial Williamsburg, Va.

FIG. 74. Fireboard from the
BANISTER HOUSE, *Brookfield,
Massachusetts*
The hole was cut to permit
the passage of a stove pipe.
Author's collection

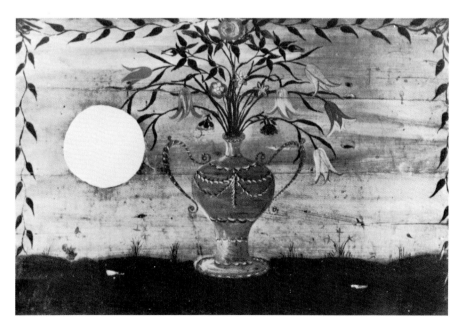

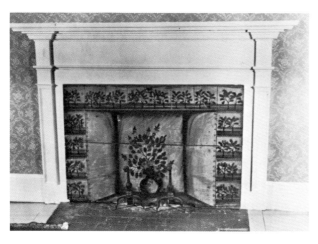

FIG. 75. FIREBOARD of Unknown Origin
Painted in perspective, with border of trees set off in
squares, probably to give the effect of a tile facing.
Author's collection

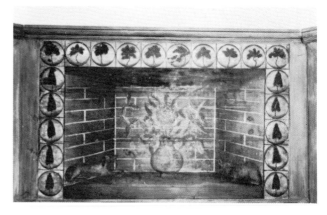

FIG. 76. FIREBOARD Probably from Vicinity of
Shelburne, Vermont
Depicting fireplace interior with a dog and cat lying on
the hearth. Similar arrangement of trees to preceding.
Courtesy Mrs. J. Watson Webb

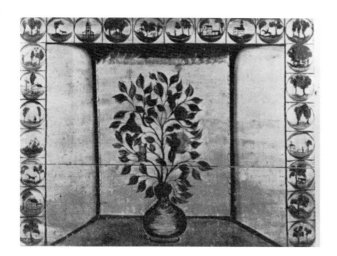

FIG. 77. FIREBOARD of Unknown Origin
Interior and jug of leaves similar to
Fig. 75. Border of landscape vignettes.
Henry Francis du Pont Winterthur Museum,
Winterthur, Del.

FIG. 78. Fireboard from the EBENEZER WATERS HOUSE,
Sutton, Massachusetts
Brick fireplace lining only suggested.
Style of border identical to Fig. 77.
Author's collection

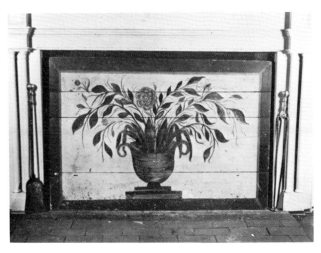

FIG. 79. FIREBOARD from Vicinity of *Salem,
Massachusetts*
Another board by this artist is owned by
the Wenham (Mass.) Historical Society.
Author's collection

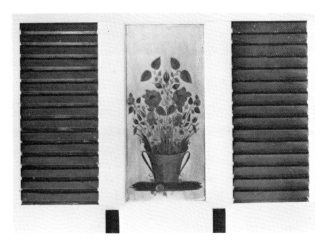

FIG. 80. FIREBOARD from *Salem, Massachusetts*
The slats, reminiscent of window blinds,
appear to have been a special feature.
Author's collection

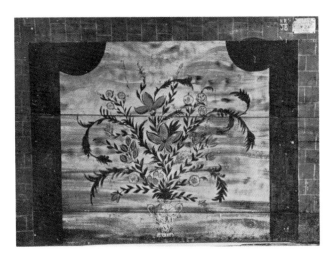

FIG. 81. Fireboard from the RYTHER HOUSE,
Bernardston, Massachusetts
Attributed to Jared Jessup. The fireplace opening is
framed in black, the outer brickwork simulated in paint.
Pocumtuck Valley Memorial Association, Deerfield, Mass.

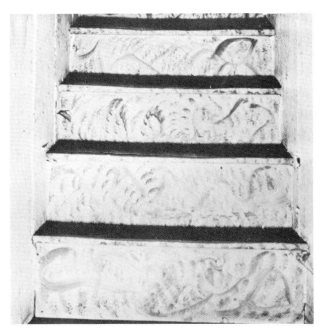

FIG. 82. Back Stairway in the DUTTON HOUSE,
Cavendish, Vermont
Free-hand painted in brown on a gray background. The house
has now been re-erected as part of the Shelburne Museum.
Shelburne Museum, Shelburne, Vt.

often painted during the seventeenth and eighteenth centuries.

Observation of many old houses leads to the conclusion that fireplaces were frequently plastered to preserve the soft bricks from the intense heat of the fire. These plaster linings were whitened, and a wide black band, drawn around the bottom of the fireplace interior, continued the line of the baseboard of the room and minimized the dust of the ashes inside the fireplace opening. The Abraham Browne house in Watertown, Massachusetts, believed to have been built about 1690, has been restored in this manner.[6] Two fireplaces in the Jonathan Cogswell house in Essex, Massachusetts, had been bricked up for a great many years, and when these were opened in 1937 parts of the whitewashed plaster linings were still in place, with black baselines seven inches wide. An item of 46¢ "for whitewashing the chimney" occurs in an Essex account book for the year 1807, and probably refers to whitening the interior of the fireplace. During restoration of the Moses Pierce-Hichborn house, at 29 North Square, Boston, two early eighteenth century fireplaces were uncovered which showed unmistakable evidence of interior painting. The wide black line already referred to may be clearly seen in the kitchen fireplace, with unusual scrolled design at the lower corners of the black-painted smoke-panel pilasters.[7]

Entries for the painting of hearths appear in the account books of Rea and Johnston, a large firm of Boston decorators, shortly after the Revolution.[8] In Salem in 1782 Samuel Blyth billed Elias Hasket Derby "To painting stone hearth, 6 shillings."[9] The old expression "to red up the hearth" which is thought of today in the sense of tidy up, originally meant to add a fresh coat of red paint.

Decorated Floors

Paint played an important part in the decoration of floors before the day of the hooked rug. For those who could not afford the luxury of a carpet, floors and floor cloths were painted in gay and varying patterns in simulation of more costly coverings.

In London in 1739 appeared a small book, now owned by Colonial Williamsburg, with the following intriguing title page: *Various Kinds of Floor Decorations represented both in Plano and Perspective Being useful Designs for Ornamenting the Floors of Halls, Rooms, Summer Houses, etc. in Twenty four Copper Plates. Designed and Engraved by John Carwitham.* Various geometric patterns are shown indicating the styles in favor in England at that date, and similar designs were being used also in the colonies. Two mid eighteenth century travelers have left detailed accounts

of "Browne Hall," built near Danvers, Massachusetts, in 1740. This spacious residence, its porch supported by fifteen-foot Ionic pillars, consisted of two wings connected by "a great hall" designed as an assembly or ball room. From the musicians' gallery one could look down on the handsome floor painted to resemble mosaic.[10]

Floor cloths appear in a number of American portraits (Fig. 112), and their use is attested by many advertisements of the period, some of which claim the American products to be "as neat as any imported from Britain."[11] Although a heavy canvas was frequently used, other materials such as oilcloth are mentioned in early references. Alexander Stenhouse advertised in the *Maryland Gazette* on August 2, 1764: "all Sorts of painted Oil Cloths for Rooms, Passages, and Stairs of various Sizes and Patterns." The Braverter Gray account book contains this recipe: "How To Make Oil Cloth—Take a drying oil, set it over the fire and then desolve Rison in it (or better gum Lac), there must be so much of either as will bring the consistence of a balsom. Then add any colour to it you choose."

In 1760 a "handsome Floor Straw Carpet" was put up for auction in Boston. In 1784 "painted oil cloth for entries or stairs" was imported from Ireland by Francis Wade of Philadelphia. Rea and Johnston painted "floor cloathes" for the best Boston families, which included a plain one with painted border for Charles Sigourney, and another for Doctor Kants "Painted in Cubes." Still another was done in yellow and black diamonds, and in 1772 appears a bill against Colbourn Barrell "to paint 4 yds. canvis, Turkey Fatcheon [fashion] @ 4/6. To ditto yr staircase and entry, 1 pound, 18 shillings." On February 12, 1794 Robert Cowan billed Elias Hasket Derby in the sum of 3 pounds, 8 shillings and 4 pence for painting a carpet measuring twenty yards for an entryway, which must have been for the Benjamin Pickman house at 70 Washington Street, Salem, where Derby lived until he moved into his famous McIntire mansion shortly before his death in 1798.[12] Derby also required carpets in less prominent parts of his estate, as Samuel Blyth in 1782 charged him 3 pounds for "Stamping Carpets in Necessary house & Cupallo."[13]

Simple directions for producing floor cloths were published in 1825 by Rufus Porter, which read as follows:

To Paint In Figures For Carpets Or Borders—Take a sheet of pasteboard or strong paper, and paint thereon with a pencil any flower or figure that would be elegant for a border or carpet figure; then with small gouges and chissels, or a sharp penknife, cut out the figure completely, that it may be represented by apertures cut through the paper. Lay this pattern on the ground intended to receive the figure, whether a floor or painted cloth, and with a stiff smooth brush, paint with a

quick vibrative motion over the whole figure. Then take up the paper and you will have an entire figure on the ground.[14]

The painting of floors was as popular and widespread as the decorating of woodwork and walls, but owing to hard usage only scattered examples remain today. Many are now so worn that their patterns are hardly decipherable, while others have fortunately been preserved under a protective covering of carpet or straw matting. Floors were decorated by the same methods used for woodwork, and we find examples of marbleizing, stenciling, and freehand painting, all dating before 1825. The age of the popular spatter floors of Cape Cod origin has long been a matter of discussion. Esther Stevens Brazer, who made a detailed study of many old floors, believed that they were a mid nineteenth century form of decoration and made this comment in an article written in 1931: "It will doubtless surprise many that, among the numerous types of underfoot decoration that have rewarded my investigation, I have yet to see traces of a really ancient spatter floor. . . . It would be interesting to know whence came this now widely adopted type of floor painting. . . . but if spatter dates prior to 1840, it is strange that we have encountered no earlier traces of it. Personally, I strongly suspect that spatter floors originated in the Victorian era."[15]

In the hallway of The Lindens, built in Danvers, Massachusetts, now removed to Washington, D. C., is a marbleized floor, veined in white on a black background with a fine scroll border. This same treatment appears on the interior of a wall cupboard in the paneled parlor and suggests an eighteenth century date. Also long preserved under modern oilcloth, is decoration on the floor of the upper hall and in several of the bedrooms. Although these borders were done by means of stencils, the patterns are far more intricate than usual, and indicate the work of a decorator of unusual ability and taste. The marbleizing of floors continued to be popular for many years, and examples are accordingly difficult to date with accuracy. Light gray backgrounds with veining or mottling in bluish-black were widely used even during the first half of the nineteenth century, and examples dating as late as 1840 have been observed in Massachusetts and New Hampshire. The same technique was also used on furniture and accessories.

Freehand designs in individual patterns may occasionally be found, but their discovery is a rare event. In the second floor east chamber of the Solomon Smead house in Shelburne, Massachusetts, is a most unusual floor. The colors are gray and black combined in a soft, feathery effect which is set off in segments of irregular form. Another similar floor has been found in a nearby house. The third floor ballroom of the Smead house shows indications of Masonic decoration under a recent coat of paint, and the date 1812, which still remains painted on an end wall, suggests the year in which the decoration may have been done. Some freehand painters made no attempt at a set pattern but simply covered the space with an informal design that looks like modern finger painting (Fig. 82).

In Greenfield Hill, Fairfield, Connecticut, the Zalman Bradley house contains in an upper rear chamber vestiges of a most unusual freehand floor. Although the painting is now extremely worn and has almost disappeared, except around the edges of the room, it must once have been a very effective piece of decoration. Apparently painted originally in salmon pink on a dark ground, the pigment is so heavily applied that the design is raised above the surrounding surface. The reversed-curve border and bold geometric pattern, set off by triple rows of dots, is certainly a simulation of the large patterned carpets of the late eighteenth century (Fig. 83). Ralph Earl painted portraits of the Hubbell family at Greenfield Hill, and in some of his other pictures showed floor coverings whose bold designs resemble this one closely.

Another freehand floor which is unique in my experience is to be found in the Captain Dodge house, built before 1815 on the old County Road in Lisbon, New Hampshire. This remote farmhouse, with its fine view of the surrounding hills, has probably changed little in appearance or surroundings since the day when a traveling decorator stopped and painted floor, fireboard, woodwork, and walls with designs outstanding for their originality. The plaster in both lower and upper hall is colored a deep yellow, and around the doors and corner posts is stenciled a simple border composed of three black lines divided by small red stars, and edged by two lines of dots. Under the ceiling is the simplest of swag borders in gray and red, highlighted in an unusual and effective manner in white. The original color of the woodwork appears to be a clear blue-gray, and the entire stairway is delicately mottled in black on ochre.

It is the floor of the lower left room however, which deserves special mention. Here the wide boards are painted deep cream, their color no doubt having changed in tone over the years through wear and probable applications of old varnish. On each wide board is a series of black, curved brush strokes, varying in length, according to the width of the board, from eight to fourteen inches. Around the edge of the room is the only landscape painting I have ever seen on an old floor (Fig. 84). It varies in width from twenty-nine to thirty-one inches, is painted in natural colors, and consists of mountains, with hastily sketched houses, and one group of three figures having spike headdresses and

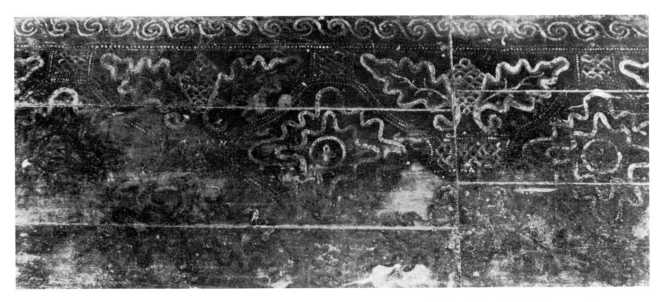

FIG. 83. Free-Hand Floor in the ZALMAN BRADLEY HOUSE, *Greenfield Hill, Fairfield, Connecticut*

Painted in simulation of a woven carpet of the
type which appears in portraits by Ralph Earl.
The embossed design appears originally to have
been painted in salmon pink on a dark ground.

Courtesy Mr. and Mrs. Wentworth Smith
Photograph courtesy Mary Allis

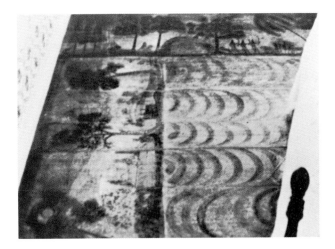

FIG. 84. Free-Hand Floor in the THOMAS DODGE
HOUSE, *Lisbon, New Hampshire*

Curved strokes painted in black, landscape
border of hills and trees. Three figures may
be seen on upper edge. Attributed to the same
painter who did the fireboard in Fig. 71.

Courtesy Mr. and Mrs. Edward Magny

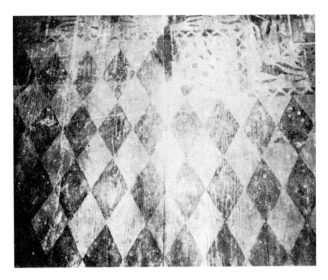

FIG. 85. Stenciled Floor in the STRATTON TAVERN,
Northfield Farms, Massachusetts

Diamonds and tulip border sten-
ciled on the unpainted pine boards.

Courtesy Mrs. Murray Hammond

holding muskets aloft. The most prominent feature of the pattern, however, is the trees; small stiff ones in the background, and large bold ones in the foreground, some of them bending nearly double as if swept by a hurricane. On these trees may be seen the distinguishing mark of this painter, large red fruit resembling giant pears. A fireboard in this same room corresponds with the floor. This depicts a shore scene with a crudely drawn sailing ship and a figure, possibly a South Seas native, brandishing a bow and arrow.[16]

Another floor, probably by this decorator, which has the curved brush strokes but no border, is said to exist in a house at Pearl Lake, Lisbon. A fireboard, undoubtedly by the same hand, is in the Lipman Collection at the New York State Historical Association, Cooperstown, New York, where the artist's stylized primitive technique is seen at its best (Fig. 71).

Floors decorated with stenciled patterns are those most frequently seen. The designs were usually geometric, and varied in workmanship with the ability of the painter. Sometimes an over-all pattern was used; in other cases a decorative border surrounded a center composed of cubes or diamonds. A floor with diamonds painted on the natural pine boards and a border of tulips is in the Stratton Tavern, Northfield Farms, Massachusetts (Fig. 85). This work was probably done by the same decorator who did the wall stenciling in two upper chambers (Figs. 121 and 122).

REFERENCES

[1] The John Custis Letter Book is deposited in the Library of Congress, but the information referred to here was very kindly made available to me by Thomas A. Thorne, William and Mary College, Williamsburg.

[2] Illustrated by Esther Stevens Brazer, "Murals in Upper New York State," *Magazine Antiques*, XLVIII, 3 (Sept. 1945), 148.

[3] Margaret H. Jewell, "Country Life in Maine, a Century Ago Part II," *Old-Time New England*, XXIII, 2 (Oct. 1932), 72.

[4] See note 20, Chap. III.

[5] Account book of Allen Holcomb, 1809-1833. Print Dept., Metropolitan Museum of Art, New York City.

[6] Owned by the Society for the Preservation of New England Antiquities, Boston.

[7] This house is owned by the Moses Pierce-Williams House Association.

[8] These account books which cover the period 1764-1802 may be seen in the Baker Library of the Harvard University School of Business Administration, Cambridge, Massachusetts. See also Mabel M. Swan, "The Johnstons and the Reas-Japanners," *Magazine Antiques*, XLIII, 5 (May 1943), 211-213.

[9] Kimball, *Mr. Samuel McIntire, Carver*, p. 63.

[10] Hamilton, *Gentleman's Progress*, pp. 120, 239. Francis Goelet "Journal," *New-England Historical & Genealogical Register* XXIV (1870), 57. Ezra D. Hines, "Browne Hall," *Essex Institute Historical Collections*, XXXII (1896), 209-210.

[11] Prime, *Arts and Crafts, 1721-1785*, p. 300.

[12] Derby Family Papers, XXXI, 67.

[13] Kimball, *Mr. Samuel McIntire, Carver*, p. 63.

[14] Rufus Porter, *A Select Collection of Valuable and Curious Arts and Interesting Experiments* (Concord, 1826), p. 34.

[15] Esther Stevens Fraser [Brazer], "Some Colonial and Early American Decorative Floors," *Magazine Antiques*, XIX, 4 (April, 1931), 296.

[16] I am indebted to Mrs. Hazel Pickwick of Lisbon for taking me to see this floor. An article by her and Ella Long, "Early Floor Decoration in a New Hampshire Farmhouse," appeared in *The Decorator*, 1, III (Winter, 1948-1949), 14.

Chapter VI

Plaster Painting
"In Oil or Water in a New Taste"

NEW ENGLAND HOUSES during the seventeenth century were finished on the inside with a large amount of wood. Vertical or horizontal boarding with molded edges usually covered at least the fireplace wall, and often the remaining sides of the room. However, the use of plaster gradually increased until by the middle of the eighteenth century it was in general use, except for the chimney breast which continued to be paneled until nearly 1800. Early references, as well as evidence presented by the houses themselves, indicate that most of the walls in the average home were whitewashed until the advent of wallpaper, advertisements for which refer also to the use of whitewash. In 1783 William Poyntell of Philadelphia announced that his low prices for paper hangings would make papering as cheap as whitewash. Joseph Dickinson of Philadelphia was a resourceful merchant whose practical solutions to obviate the difficulties of flies and smoke provide us with an unexpected glimpse of some of the drawbacks of eighteenth century living. He advertised in the *Independent Gazeteer* in 1786: "Flies and smoke opperate to soil paper in common rooms if the grounds are too delicate; to prevent which I have pin grounds that fly marks will not be perceptable upon. Also dark grounds, which the smoke will not considerable effect, in the course of twenty years, at such low prices will eventually be found cheaper than whitewash."[1] Some of the better homes were furnished with wall hangings "many of the rooms being hung with printed Canvas."[2] Such references are not infrequent in eighteenth century documents, although Peter Kalm, who arrived in Philadelphia from Sweden on September 26, 1748 found them virtually unknown in New York City according to his observations: "The walls were whitewashed within, and I did not anywhere see hangings with which the people in this country seem in general to be little acquainted. The walls were quite covered with all sorts of drawings and pictures in small frames."[3] In 1749 Stephen Callow, upholsterer from London, advertised in New York City: "hangs Rooms with Paper or Stuff in the newest Fashion."[4] The only example of an original eighteenth century wall hanging which I have been able to examine came from the Thaxter-Lincoln house in Hingham and gave the impression of being what we would call a heavy burlap.[5] In country towns rooms were frequently whitened for many years after paper had become a matter of course to the city dweller. In June, 1818, Susan Heath of Brookline, Massachusetts, noted in her journal: "Our kitchen and sitting room whitewashed by a Universalist."

Whitewash is still the most satisfactory finish for an early room, because its thin, almost transparent quality enhances the irregularities of old plaster in a way which oil or a modern water base paint do not seem to do. One argument against a standard lime finish for present day interiors has been its propensity to powder and rub off. An old Essex County recipe which has been tested and found impervious either to rubbing or flaking is the following:

2 pecks	Unslacked lime
5 pounds	Rice flour
1 pound	Common glue
5 gallons	Hot Water
(plus what is used for slacking the lime)	

"Slack the lime with hot water. Cover and let stand over night. Make a paste by mixing the rice flour with cold water. Put the glue into a receptacle with twice its volume of cold water. Let stand until dissolved or saturated, then cook without boiling. Mix everything together and stir until well mixed. For outdoor work a quart of rock salt should be dissolved and the wash should be applied warm."

Gradually whitewashed walls disappeared in favor

of wallpaper which began to make its appearance in America by importation early in the eighteenth century. In the inventory of Michael Perry of Boston, stationer and book-seller, was listed in 1700, seven quires and three reams of "painted paper."[6] John Phillips of Boston was advertising "stampt paper in rolls, for to paper rooms" in 1730,[7] but most of the imported paper still came in sheets sold by the quire. Plunket Fleeson of Philadelphia is credited with having been the first manufacturer of American-made papers in 1739. He was followed by John Rugar of New York in 1765, and by others in Boston, Hartford, and elsewhere. Between 1740 and the beginning of the Revolution paper hangings were arriving at the large seaport towns with every ship from London and Paris, and James Birket wrote the following interesting description of Portsmouth, New Hampshire, on August 31, 1750: "The houses that are of Modern Architecture are large & Exceeding neat this Sort is generally 3 Story high & well Sashed and Glazed with the best glass the rooms are well plasterd and many Wainscoted or hung with painted paper from England. . . ."[8] The results were to be far reaching. Itinerant decorators were already preparing to take to the road announcing that they could paint walls in excellent imitation of these papers at a far less price.

Although there is no reason to believe that tinted walls colored with natural pigments could not have been used in colonial America, they do not come to our attention until shortly before the Revolution, when we begin to find them mentioned in newspapers of the period. That the taste of the colonists was influenced by fashions prevailing across the water is suggested by an announcement in the *South Carolina Gazette and Country Journal* of January 21, 1766, which sets forth that one Warwell, painter from London, paints "rooms in oil or water in a new taste." This was probably about the beginning of the demand for plain colored walls which did not last a great length of time; most walls were soon decorated with designs of one sort or another. Thomas Fletcher Dixon advertised in Baltimore that as well as paper hanging he "paints rooms on the wall in an elegant manner," and the following is an interesting list of the colors which he was prepared to apply in 1784: Verditure blue, Prussian blue, pea-green, straw, stone, slate, cream, cloth, and pink.[9] In the following year a notice in the *Pennsylvania Packet* announced: "Plain and ornamental colouring in distemper superbly finished," and in 1792 Hugh Barkley and Patrick O'Meara of Baltimore "bred to the business in Europe" advertised "House-Painting, In the newest European Fashion, either in Distemper or Oil, in a Manner not hitherto practiced here."[10]

From the evidence remaining today it appears that the greater part of our old decorated walls were done in what the early accounts called "distemper." This was a mixture of glue, water, and coloring matter, which was quick and easy to apply, the patterns being removable with water if an error occurred. In a small manuscript notebook kept by George Searle, of Newburyport, 1751-1796, an ornamental painter and a nephew of John Gore of Boston, we find an eighteenth century recipe for:

Green wash for walls 4 Roman vitriol (blue ston), 1 span[ish] whiting. Bruise these together. Put them into an earthen vessell and pour on them some warm rain water. Simmer this over a slow fire for three hours stirring it with a stick. Take it off and let it stand. In 24 hours the ingredients will settle and the water become clear. Pour off the water and it will keep for years ready to mix at pleasure. When wanted it must be mixed with water wherein a small portion of glue has been dissolved, and laid on the walls as many coats as may seem necessary.[11]

Rufus Porter, whose mural painting will be discussed in detail in Chapter IX, published in 1825 a recipe for coloring walls. Of particular interest is his reference to a beautiful rose shade attained by the use of beets. He also mentions yellow ochre and blue as background colors.

Cheap Method of Painting Walls of Rooms. Dissolve ½ pound of common glue in one gallon of water, and mix therewith, Six pounds of Spanish Whiting, To this composition add a small quantity of Yellow Ochre, wet blue, or any other cheap colouring ingredient. Stir these well together:— Then with large brush give the work one or two coats of this composition and it will appear as handsome as oil painting, and equally as handsome if kept dry. Note, If the glue be dissolved in skimmed milk instead of water it will render the paint nearly water proof, and . . . the walls of a room may be painted in figure much in the resemblance of paper hangings, with trifling expense. If the whiting previously be stratified with red beets two or three weeks, it will give the work a beautiful colour without the addition of any other,—a decoction of basswood sprouts may be substituted in place of glue.[12]

Eventually background colors were made up and sold commercially. One paint manufacturer, established in Roxbury, Massachusetts, advertised in the *New England Farmer* for November 4, 1825: "Blue and Green Verditers are used by the paper stainers and for colouring walls of rooms and is a fine water colour sold very low."

Occasionally walls are found which were originally done in oil. Because of its permanency this was more risky for the inexperienced workman to apply, but was more durable against damage from leaks, and could be wiped over with a damp cloth. In *Valuable Secrets in Arts and Trades,* the following directions are given. It

will be seen that the background color is applied dry in this process.

For Painting In Oil On A Wall. You must, when the wall is perfectly dry, give it two or three coats of boiling oil, or more, if necessary, so that the face of the wall may remain greasy, and can soak in no more; then, lay another coat of siccative [*sic*] colours, which is done as follows. Grind some common whitening, or chalk, red ocher, and other sorts of earth, pretty stiff, and lay a coat of it on the wall. When this is very dry, then draw and paint on it whatever you will, observing to mix a little varnish among your colours, that you may not be obliged to varnish them afterwards.[13]

Although the word "fresco" is now generally applied to all types of old wall decoration, particularly the scenic murals, the term as correctly used means painting upon a plaster wall having an especially prepared surface which must be moist upon application of the paint. Directions for this process are given in many of the old English recipe books, but this method does not seem to have been used by the itinerant decorators whose work we are considering here.

REFERENCES

[1] Prime, *Arts and Crafts, 1786-1800*, p. 277.
[2] Birket, *Some Cursory Remarks*, p. 28.
[3] Kalm, *Travels into North America*, p. 457.
[4] Gottesman, *The Arts and Crafts in New York*, p. 134.
[5] A piece of these hangings was owned by the late Chester Burr of Brookline whose father removed it when the house was demolished in 1865. A fragment is also owned by Mrs. S. Randall Lincoln of Hingham, Mass.
[6] McClelland, *Historic Wall-Papers*, p. 238.
[7] *Ibid.*, p. 241.
[8] Birket, *Some Cursory Remarks*, p. 8.
[9] Prime, *Arts and Crafts, 1721-1785*, p. 279.
[10] Prime, *Arts and Crafts, 1786-1800*, p. 302.
[11] This notebook is owned by Charles C. Stockman of Newburyport, who kindly allowed me to copy this recipe.
[12] Rufus Porter, *A Select Collection of Approved, Genuine, Secret and Modern Receipts for the Preparation and Execution of Various Valuable and Curious Arts* . . . (Concord, Mass. Undated), 1st edition, 1825.
[13] *Valuable Secrets*, p. 104.

Chapter VII

Freehand Designs in Repeat Patterns
"That Much Admired Imitation of Stamped Paper"

OWARD THE END of the eighteenth century we begin to find increasing evidence of the work of the itinerant decorator, and designs intended to give the effect of wallpaper were painted directly upon the plaster walls of houses, churches, and taverns throughout New England. Some of the patterns were produced by means of stencils, some were in the form of panoramic scenes, while others were repeat patterns done freehand, all presumably offered at a saving of both time and expense to the prospective owner.

The freehand patterns were not copies from contemporary papers, but the designs were laid out in a similar manner. Bands of swags and tassels were used to gain the effect of wallpaper borders which in turn had derived from festooned valances of fabric. Fabrics were a basic source of design for many early eighteenth century paper hangings, particularly the patterns derived from printed East India "chinces," the importation of which was being advertised in Boston as early as 1711. With the opening of European trade with the Far East, a flood of India cottons began to come into England and France after the establishment of the great East India trading companies in the seventeenth century. Crewel embroidery, which also made use of eastern motifs, was executed by the ladies in many American homes, and these exotic flowers and fruits often appear in modified form in the work of the wall painters, to whom the patterns must have been familiar since childhood. The Ebenezer Gay house in Hingham, Massachusetts, still retains a room painted in almost exact duplication of a crewel design. Although there is no history connected with the painting, it does not give the impression of having been done by a professional decorator. Perhaps a member of the family was responsible for transferring these graceful motifs so successfully from fabric to plaster.

The freehand repeat patterns were done with a variety of designs which makes them still a delight to the eye. Each painter set his personal stamp upon the walls which he decorated, combining his basic patterns, borders, and colors in many ways, but with an individuality which precludes monotonous repetition. Unfortunately, most of the work still remains anonymous, but in addition to isolated examples, four distinct groups of walls by different artists have been recognized, and personal identification is probably only a matter of time.

Connecticut Group

In Windsor, Connecticut, and beyond it in a westerly direction which includes the towns of Farmington, Litchfield, and Washington, are seven houses which may be accepted as the work of one man or of two working together. The colors are strong and inclined to be dark, featuring black, crimson red, and oyster white on gray or dark buff backgrounds. The main designs were drawn on a light gray basic stripe, the color accents then applied, the black strokes being the third operation (Fig. 86). The total result is bold and effective, giving the impression of a rapid but competent craftsman. In the Abiel Griswold house on Pequonnock Avenue in Windsor, a square hipped roof mansion which has seen better days, at least three lower rooms and the front hall were originally decorated. Only the hall now remains unpapered, but memories of scattered flowers and floral sprays rising from handled jars silhouetted in black against a grayish-blue background, suggest the variety of the artist's repertoire. The hall still exhibits its graceful bouquets enclosed in black diamonds on a dark buff ground (Fig. 87). Photographs of one other room taken by the Index of American Design in 1936 before repapering, reveal one of the most unusual painted rooms we have seen (Fig. 88). With the obvious exception of the doors, the entire room is executed in trompe l'oeil, including the paneled wainscote, the simulated wallpaper, and the

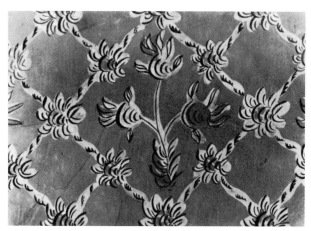

FIG. 86. Detail of Free-Hand Painting in the
TIMOTHY ROOT HOUSE, *Farmington, Connecticut*
Dark gray background. Light gray base-
line with pattern in black and crimson

Courtesy Wilmarth J. Lewis
Photograph National Gallery of Art
Index of American Design
Rendering by Martin Partyka

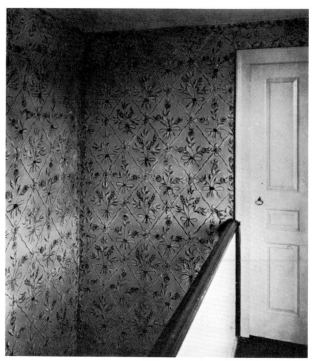

FIG. 87. Front Hall in the ABIEL GRISWOLD HOUSE,
Windsor, Connecticut
Free-hand painting on a buff back-
ground, design in black and gray.

Photograph National Gallery of Art
Index of American Design
Rendering by Michael Lauretano

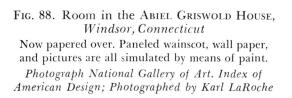

FIG. 88. Room in the ABIEL GRISWOLD HOUSE,
Windsor, Connecticut
Now papered over. Paneled wainscot, wall paper,
and pictures are all simulated by means of paint.

Photograph National Gallery of Art. Index of
American Design; Photographed by Karl LaRoche

small, gold framed pictures, which hang so realistically from rings and handmade nails, and shows to what lengths these artists were prepared to go to create a desired effect. In a house adjacent to the Griswold property the family remembers two upper chambers embellished with freehand flowers, which one may surmise to have been the work of the same decorator. As this second house was built in 1805 it may provide the earliest possible date for this group of paintings.

Proceeding a short distance to the southwestward brings us to the old town of Farmington where the Captain Timothy Root house stands on the tree-shaded main street. Here in the upper northeast chamber we recognize the same hand as in Windsor. On dark gray plaster a similar light gray line forms a background for the designs in black and crimson. Floral sprays are enclosed in alternate rows of diamonds, and a narrow border of flowers surrounds the windows and corner posts, and edges the baseboard and ceiling (Fig. 89). Although the effect is striking, the total result is rather confused owing to an unfortunate crowding of motifs.

Still further west, in Litchfield, are records of three more houses in this group. In the house at present belonging to Philamon J. Hewitt on Northfield Road, there was at one time a ballroom which covered the west side of the upper floor. This has now been partitioned into several small rooms and the walls covered with paper. Built in 1790 as an inn on the stage route from Waterbury to Pittsfield, its ballroom was decorated in the prevailing fashion. Only two fragments of the painting now remain, one on the wall of a closet, which exhibits patterns and borders typical of the rest of the group, and the other a small oval landscape in frame similar to those in the Griswold house.

The Amos Galpin house, built in Litchfield in 1786, had similar painting covered in the 1850's with a layer of newspapers as a basis for wallpaper. When the house was again remodelled in 1912 the paper was removed and the imprint of the hand decoration was found to have been transferred to the backs of the newspapers. Fortunately several pieces were saved and these are now deposited in the Litchfield Historical Society. This wall was also gray, with flowers and vines in black, white, and red. Similar motifs were differently arranged, the decoration resembling that in Farmington, with technique like the Hewitt and Catlin houses.[1]

The Thomas Catlin house on East Chestnut Hill Street, Litchfield, has well preserved painting in the lower northeast room. On a gray background, sprays of flowers and leaves in black, white, and touches of red cover the walls in a graceful pattern which is more pleasing than the set diamonds often employed by this decorator (Fig. 90). Here for the first time we find rec-ord of a landscape used not to imitate a small picture hung upon the wall, but painted on the plaster above the fireplace in the manner of an overmantel panel (Fig. 91). This painting shows that the popularity of overmantel landscapes persisted into the nineteenth century, despite the disappearance of wood paneling as an architectural feature.[2] The drawing was obviously by the same hand as the vignettes in the Griswold house (Fig. 88); the woodwork in this room appears originally to have been grained in red, which must have made a striking combination with the dark gray patterned walls.

The home of Joel and Lemon Stone, built in Washington, Connecticut, in 1772, may be a somewhat earlier example of the work of this same decorator. Local tradition avers that one brother was a Patriot and one a Tory, and that during the Revolution each had symbols of his own sentiments painted on the walls of his respective part of the house. Nothing can be seen today of any British motifs, but in an upper chamber, on a soft buff background, the artist outdid himself in creating designs which are new to his repertory as we know it. A dado is composed of red arches, supported on columns painted to suggest masonry, which contain a variety of figures, some apparently mythological in type. The classic arch is found in contemporary wallpaper, and we shall see it used in different forms by other freehand painters. Inside a black and white wreath, reminiscent of that in Windsor, are an alternating stag and eagle, the outlines of which are done by means of stencils, while the accents are touched in freehand. Thirteen stars surround the eagle's head above which are lettered the provocative words: "Federal Union." Just when these walls, which are illustrated in *Early American Wall Paintings,* were painted it is impossible to say, probably some years at least after the close of the Federal period which they appear to memorialize. The presence of a Prussian eagle painted between the windows does not help to clarify the situation, but one feels that at least part of the decoration of this room had some special significance, and was not composed of stock patterns such as we have seen elsewhere.

Jessup Group

The second group of freehand walls is contained in houses found both in Connecticut and Massachusetts. A few years ago the restoration of the Warham Williams house in Northford, Connecticut, revealed decorative painting which was to become a key for the designs of one artist and the means of identifying at least eight other walls on which he appears to have worked (Fig. 92). These are scattered from Stonington, on the southeasterly shore of Connecticut, to Bernardston,

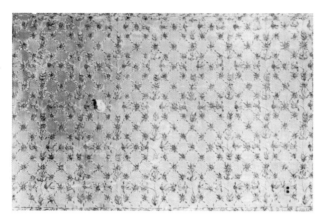

FIG. 89. Wall in the TIMOTHY ROOT HOUSE,
Farmington, Connecticut
Free-hand painting in black and crimson on gray.

*Photograph National Gallery of Art. Index
of American Design; Rendering by Ray Holden*

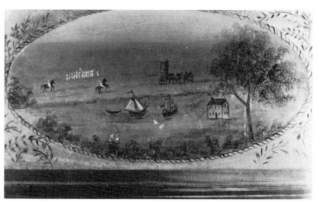

FIG. 91. Overmantel on Plaster from THOMAS CATLIN
HOUSE, *Litchfield, Connecticut*
Now disappeared. Note similarity between
this primitive landscape and those in Fig. 88.

*Courtesy William L. Warren; Photograph Na-
tional Gallery of Art. Index of American
Design; Photographed by Henry Sheeczko*

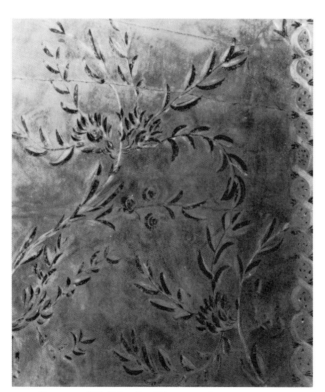

FIG. 90. Wall in the THOMAS CATLIN HOUSE,
Litchfield, Connecticut
Free-hand painting on gray back-
ground. Design in black, white, and red.

*Courtesy William L. Warren; Photograph Na-
tional Gallery of Art. Index of
American Design; Rendering by Martin Partyka*

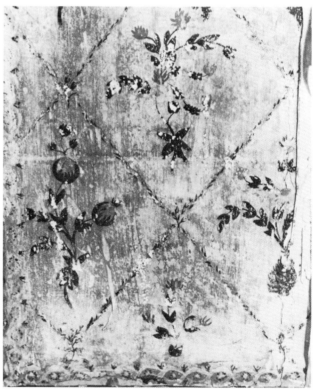

FIG. 92. Detail from a Wall in the WARHAM
WILLIAMS HOUSE, *Northford, Connecticut*
By Jared Jessup. Background blue, flowers red, with leaves
blackish-green and touches of blue and mustard yellow.

*Courtesy Mr. and Mrs. Victor Schaeffer
Photograph courtesy Clarence W. Brazer*

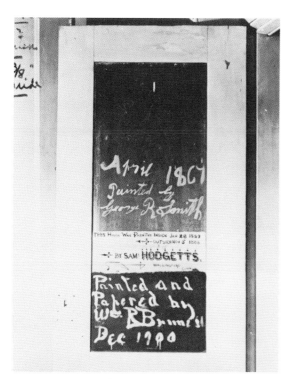

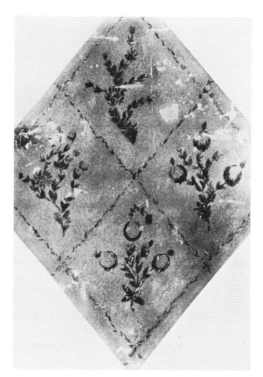

FIG. 93. Back of Closet Door in the WARHAM WILLIAMS HOUSE, *Northford, Connecticut*
With painters' signatures. The name *J. Jessup, Oct. 5, 1809,* appears in blue paint on the center of the upper panel.
Courtesy Mr. and Mrs. Victor Schaeffer
Photograph courtesy Clarence W. Brazer

FIG. 94. Detail of Painting in the BENEJAH STONE HOUSE, *North Guilford, Connecticut*
Attributed to Jared Jessup. Background blue, flower sprays in rose and dark green.
Courtesy Mr. and Mrs. Donaldson Clark
Photograph National Gallery of Art. Index of American Design; Rendering by Michael Lauretano

Massachusetts, almost on the Vermont border. While some of these walls have been known for a long time, others have been more recently discovered, and the whole group is here attributed for the first time to Jared Jessup and a group of assistants, itinerant painters of the early nineteenth century.

The fortuitous circumstance which led to the identification of Jessup was the finding of a list of names on the back of a closet door in the decorated room of the Williams house. There each painter has left a unique record of the year when he worked in the house (Fig. 93). The earliest signature is that of E. Jones, which is lettered in blue, with the date 1792. The second inscription, in a shade of blue more closely resembling that found on the plaster background, is "J. Jessup, Oct. 5, 1809." Subsequent painting was performed by George Smith in 1867, and by Sam Hodgetts of Wallingford who did the interior on January 26, 1889. In 1900 the room was papered and the decorated walls disappeared from sight until renovation a few years ago brought them again to light.

Because the year 1809 coincides closely with the date

of another wall which may be ascribed to the decorator of the Williams house, and because Jessup is known to have been a resident of the neighboring town of Guilford from 1802 to 1804, he, rather than the unidentified E. Jones, has been accepted as the painter of these walls.

This mansion was originally the parsonage in the northern part of the town of Wallingford. It was built in 1750, and with its large central chimney and handsomely carved doorway is an outstanding example of colonial architecture. After the death of Parson Williams in 1788 the house was purchased by his successor, the Reverend Matthew Noyes, who came from a wealthy and prominent family in Lyme. It was during his occupancy that the second floor chamber was painted, and as Jessup worked also in Lyme, it is easy to see how he probably became known to the Reverend Mr. Noyes.

The room in Northford exhibits several details which are characteristic of Jessup's work. The background must originally have been a rather bright blue on which are drawn black diamonds formed by a run-

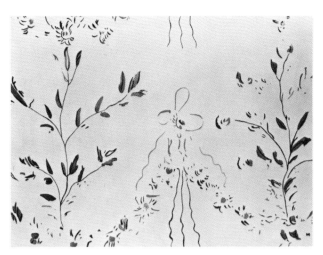

FIG. 95. Detail from Front Stair Wall, 76 WATER
STREET, *Stonington, Connecticut*
Attributed to the Jessup group. Only the outlines
of the design are left. Background in light buff,
colors originally bright blue and vermilion.
*Courtesy Mr. and Mrs. Herbert Hale Corbin; Photograph
National Gallery of Art; Index of American Design;
Rendering by Michael Lauretano*

ning vine of small feather-like leaves exhibiting
touches of putty color. Within each diamond is a vary-
ing flower spray in red, blue, and mustard-yellow, the
leaves painted solidly in dark blackish-green. Framing
each panel of plaster is a border design which is typical
not only of Jessup's work, but of other freehand paint-
ers, and of stencilers also. One may see similar inter-
laced ribbon borders on a number of other walls.

One would hope to find traces of Jessup's painting in
Guilford, as here he was married to Lucretia Chitten-
den on March 14, 1802, and here two daughters were
born in 1803 and 1804. Family records indicate that
Jessup was probably born in Easthampton, Long Is-
land, removing to Richmond, Massachusetts, with his
parents sometime before 1800. Six months after the
birth of their second child Mrs. Jessup died in Guil-
ford, and it may have been at that time that Jared be-
gan his itinerant painting career.[3]

In the lower northwest room of the Benejah Stone
house on Long Hill Road, North Guilford, a design
has been discovered under wallpaper which very
closely resembles that found in Northford, having the
same blue background with pattern of diamonds and
flower sprays (Fig. 94). In the lower southwest room
remains were also found of another decorated wall,
with small diamonds and trellises of roses on a light
ground, but the condition was so poor that it was im-
possible to save it.

In the Colonel Smith house, built about 1788 at 76
Water Street, Stonington, we find for the first time the

familiar Jessup technique coupled with other motifs
and methods which suggest that here he was not work-
ing alone. We shall recognize these new designs, com-
bined with Jessup flower sprays, in several other houses
in Massachusetts and Connecticut. In Stonington, for
the first time also, appears an overmantel landscape of
a type so individual that it cannot be mistaken when
met elsewhere (Fig. 110). Like those in Windsor and
Litchfield, these scenes seem much less accomplished
than the wall painting which accompanies them, but
they serve as unmistakable links in the decoration of
the seven houses in which they appear. Over a finely
carved mantelpiece, enframed by fluted pilasters and a
dentiled cornice, is a primitive view of an estate with
mansion house, outbuildings, and gardens of fruit and
flowers, laid out in meticulous detail. The buildings
are painted yellow with red roofs and doors, and the
windows are indicated by the application of small
black dots. No perspective is attempted, but the scene
is built up on succeeding levels like a needlework pic-
ture, set off by hedges and trees. We shall see these bent
poplar trees and undulating hedgerows in all of the
Jessup landscapes. It will be noticed that poplar trees
are a conspicuous feature of many panel and wall
paintings. George C. Mason says in his *Reminiscences
of Newport* that the Lombardy poplar was introduced
into this country in 1784 by William Hamilton and
was highly thought of during the late eighteenth cen-
tury, later losing its first popularity. This allusion may
explain its general use by the wall painters. Cutting
across the top of the picture is an unexpected band of
mustard-yellow overlaid with a profusion of floral
swags, and one gains the impression that this wall was
almost in the nature of a sample, the artist displaying
all his borders, patterns, and motifs in a veritable
patchwork of color and design.

In the front entry, on the wall which goes up the
winding staircase, is the remnant of a pattern which
has been reconstructed in the Index rendering in Fig.
95. The painting, now almost disappeared, was origi-
nally done in Prussian blue and vermilion on a pale
cream ground, and the pattern was composed of a se-
ries of large horizontal swags spaced from stairs to ceil-
ing and caught at each apex with a stylized bowknot
having three long ends. A vertical running vine was
interspersed between the bowknots. The fine, spidery
effect of these designs exhibits brushwork quite differ-
ent from that of Jessup's robust foliage as seen in the
parlor (Fig. 96).

We find a similar technique displayed, however, in a
dado detail in the Waid-Tinker house in Old Lyme in
which we can recognize an interlaced border almost
identical with that in the signed room at Northford
(Fig. 97). In this house, therefore, may probably be

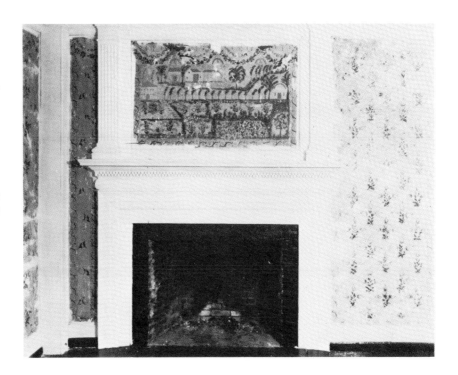

FIG. 96. Wall in 76 WATER STREET, *Stonington, Connecticut*

Attributed to Jared Jessup, the background is blue, flower sprays in rose and dark green. A wide band under the cornice has a background of mustard yellow which contrasts oddly with the rest of the wall.

Courtesy Mr. and Mrs. Herbert Hale Corbin; Photograph National Gallery of Art. Index of American Design Rendering by John Collins

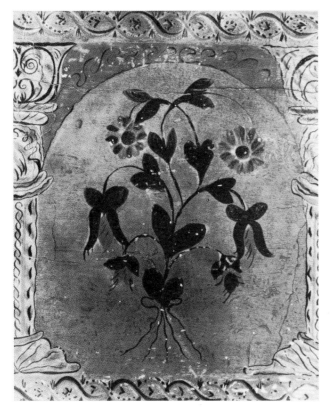

FIG. 97. Detail from Plaster Dado of the WAID-TINKER HOUSE, *Old Lyme, Connecticut*

Now papered over. Note similarity of interlaced border to that in Fig. 92.

Attributed to Jessup group. *Courtesy Walter McGee Photograph National Gallery of Art Index of American Design. Rendering by Martin Partyka*

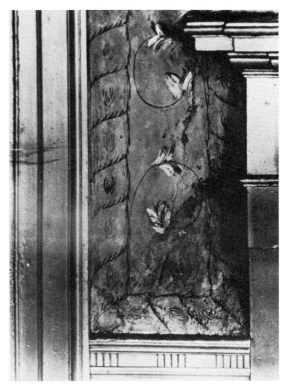

FIG. 98. Detail of Fireplace Wall in the RICHARD ARMS HOUSE, *Deerfield, Massachusetts*

Now painted over. This border is also found in the Asa Stebbins house, Deerfield.

Courtesy Mr. and Mrs. Richard P. Arms Photograph Society for the Preservation of New England Antiquities, Boston, Mass.

seen the work of both Jessup and a co-worker or assistant. The lower northwest room of the Waid-Tinker house contained the most numerous and varied freehand designs which have as yet come to light, but unfortunately they have now been covered with paper due to smoke damage from a recent fire. Luckily, an excellent record has been preserved in the form of renderings by the Index of American Design, and they are illustrated in Allen's *Early American Wall Paintings*.[4] Over a fine mantel, enframed in handsome carving, was the best example yet discovered of a Jessup-type landscape (Fig. 56). This view of a village set on the usual vertical plane was done on the wood paneling, and displayed more careful painting than any of his executions on plaster. One feels that the artist took unusual pains over this commission, which was no doubt more remunerative than some on which he obviously expended less time and trouble. A unique feature of this room was two large designs on opposite walls, one composed of a shield bearing the name "W A I D," and the other a triple circle enclosing an eagle with striped shield, surmounted by a ribbon bearing the name "Weston Brockway." In the Waid-Tinker house we find Jessup using a dado composed of arches framing in each niche a spray of flowers terminating in a bowknot. This bowknot appears in the hall in Stonington, and in two houses in Deerfield, Massachusetts.

Another house in Old Lyme, the Wattrous-Beckwith gambrel-roofed cottage on Sill Lane, has a Jessup landscape in the lower west room. The center of the picture has been retouched in oil where a hole was cut for a stove pipe. Here also, according to the owner, there was further wall painting, "a lovely climbing rose design, and all the woodwork had a three or four inch band outlining it in the blue which turns green with age, and the design on that was Easter lilies." Although it is probable that Jessup and his group decorated many more walls in Connecticut, we do not recognize their designs again until we reach the upper part of the Connecticut Valley.

On the main street of the old town of Deerfield three houses have an interesting combination of motifs, some of which we have met before and others which are new.

Entering the town from the south, one sees immediately on the right the venerable Arms house which stands on property granted to John and Edward Allen of Suffield, Connecticut, in 1685. After several changes of ownership, the house in 1811 was sold by the Childs family to Jonathan Arms for his son, J. Lyman Arms, and it seems probable that the wall paintings were done about this time. In the lower southeast room on a buff background black diamonds are formed by feathery leaves in the Jessup manner, having rosettes

at the apexes, and enclosing sprays of ball-like flowers painted in two shades of red. Under the ceiling line is a border of looped garlands of leaves and rosettes in blue and black, and in the center of each swag is the familiar bowknot with long ends. Over the mantel, painted on the plaster in an octagon, is a harbor scene which closely resembles those in Figs. 100 and 101. Beside the mantel was originally a border we have never seen elsewhere except in Deerfield (Fig. 98). Although this pattern is totally unlike any of the Connecticut work, it links this painting with that in the nearby Asa Stebbins house, while similar bowknots and landscapes were found both in Stonington and Lyme. Across the hall in the southwest room was another design which has now almost disappeared. This presents a problem in attribution because the technique is quite different from that heretofore used by these artists. On a pale pink background, the white design, a large all-over pattern, is outlined in black with touches of red and blue. The border, however, is one used in Stonington!

Recently the wallpaper in the front hall of the Arms house was removed, and the walls sized preparatory to repapering. When this was done several pairs of letters, well-formed in old script about five inches high, appeared on the surface of the plaster, apparently brought out by the sizing. They seem to have been done in a white distemper which resembles that used in the designs of the southwest room. The initials, F S, A H, W B do not coincide with any known owners or occupants of the house, and it is probable that they were put on by some casual visitor and have no especial significance. Nevertheless one cannot help feeling that they could signify the group of decorators who worked here. If so, J J is not among them, which might indicate that Jared himself did not work on this particular job. There is little doubt, however, that the painting in Deerfield and Bernardston was done by some members of the Jessup group.

Continuing down the main street we reach the Frary house, where the small south entry contains all that remains of the artist's work, although an old account speaks of another room with blue wall and oval panel depicting a ship in full sail.[5] The pattern of leaves and flowers in the side entry has been repainted in unfamiliar shades of brown and orange on a strong pink ground, but the technique and design will be found almost repeated in a room in Bernardston.

In the neat brick house built in 1799 by Asa Stebbins one may still see the parlor walls colored a soft rose pink, one of the rare examples of a plain surface which never received further embellishment. In the rear south room the wall is also pink, but the border found in the Arms house (Fig. 98) is laid on a blue band, and surrounds each window and door. Under

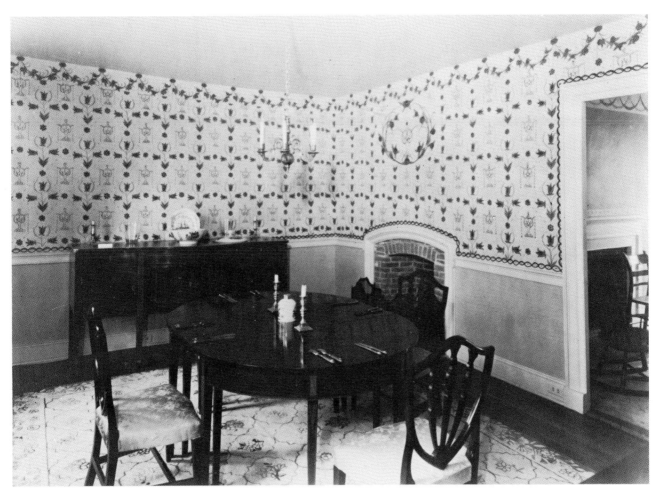

FIG. 99. Room in the Asa Stebbins House, *Deerfield, Massachusetts*
This room is a careful reconstruction of the original designs. Buff background with tulips
and urns in olive green, red, blue, and black. *Courtesy Mr. and Mrs. Henry N. Flynt*

the ceiling is a swag and bowknot border in black and red, and this room happens to illustrate to perfection an advertisement which appeared in a Baltimore newspaper of 1796: "Laying plain grounds in distemper with plain or festoon borders."[6]

The rear north room is completely painted in a striking pattern unlike any we have seen before (Fig. 99), although the horizontal rows of urns are reminiscent in style and arrangement of the parlor of the Waid-Tinker house in Lyme. The background is buff, the design outlined in black, and the colors are olive green, rust, blue, and black. These designs were so far gone after the removal of wallpaper that repainting was unavoidable, but this has been accomplished with great care and a sample of the wall has been left as found to show what remained of the original pattern and colors.[7]

In Bernardston, fifteen miles north of Deerfield, there were at one time several houses with painted walls. The Moses Scott house, built about 1750 on the old Northfield Road, had three stenciled rooms, of which the artist is unidentified. The Aldrich house, near the lime kiln site, and a house opposite the Burk Tavern are both mentioned in the *History of Bernardston* by Lucy Cutler Kellogg, as having had painted decoration of the Jessup type.

The Burk Tavern, however, kept by Major John Burk in 1763, contained an overmantel landscape panel which was removed some years ago and is now preserved in Memorial Hall, Deerfield (Fig. 100). This view (in the center of which a hole has been cut for a stovepipe) is very similar to that in the Arms house which was done on plaster. A few small figures enliven the scene, and a commodious inn occupies the upper left corner of the composition beside which is a signboard seemingly lettered "Hotel Tenny, 1813." The cluster of houses at the water's edge is painted gray, brown, yellow, and brick color with black windows and

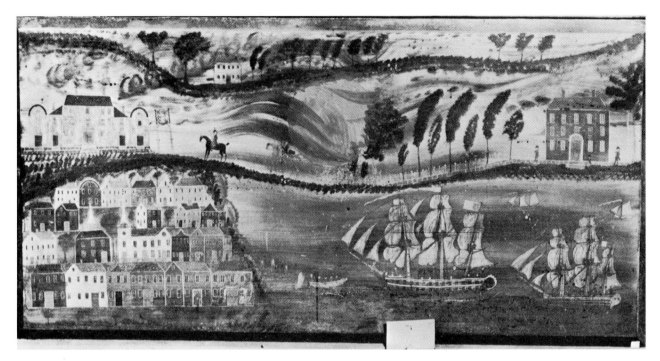

FIG. 100. Overmantel from the BURK TAVERN, *Bernardston, Massachusetts*
Now in Memorial Hall, Deerfield. Attributed to Jared Jessup. Compare with overmantels in Figs. 56, 101, and 110.
Pocumtuck Valley Memorial Association, Deerfield, Mass.

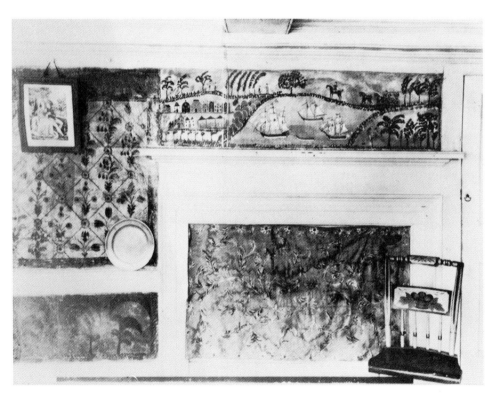

FIG. 101. Fireplace Wall in the RYTHER HOUSE, *Bernardston, Massachusetts*
Wall painting and overmantel on plaster typical of the work of the Jessup group.
*Courtesy Fred Donaldson; Photograph Society for the
Preservation of New England Antiquities,* Boston, Mass.

white trim. The ships fly American flags. The panel is enframed by its original woodwork of which the bevel is black, and the bead at its outer edge is the same dark yellowish-brown used to depict the tavern in the picture. The Burk Tavern sign, now also on exhibit in Memorial Hall, is in the shape of a shield, painted with the appropriate symbols of a decanter and glasses.

Still standing in Bernardston is the Ryther house which contains one room with painted decoration (Fig. 101). In the northeast lower parlor, on a buff ground, are the familiar black diamonds enclosing sprays of flowers and berries. The latter are to be found also in Stonington and Lyme, and do not appear to my knowledge in the work of any other decorator. Beneath the ceiling is a frieze of drapes and tassels, and the dado is composed of arches and windblown trees. Over the mantel the landscape repeats almost the same composition found in the Arms house and the Burk Tavern, with the addition of a delightful coach and four. From this fireplace came the chimneyboard now in Memorial Hall, which was painted as part of the decoration of the room (Fig. 81) and almost matches a plaster panel between two of the windows. It is this panel and fireboard which so closely resemble the design in the entry of the Frary house in Deerfield.

There has long been a tradition in Deerfield and Bernardston concerning the identity of the artist who did these walls, and the date, 1813, which appears on the inn signboard of the Burk Tavern panel, has been taken to indicate the year in which the painting was done. If this surmise is correct, Jessup traveled northward along the Connecticut Valley during the four years from 1809 to 1813. At the present time no further examples have been found of his work, the explanation of which is given as follows in the *History of Bernardston:* "A man came from parts unknown, doing the work in payment for board. He was here as far as can be learned for some months. One day men arrived from the east part of the state of New York, some say from Albany, departing with this man as their prisoner, and it was always supposed that he was arrested as a spy, the War of 1812 being then in progress." This explanation has been accepted as a fact, and the artist is always referred to locally as "the British spy." No substantiation has been found for this tale, either in the known biographical data about the Jessup family, or in the files of the State Library at Albany, and it is more likely that he moved on, perhaps to other occupations, in the manner of the true itinerant.

In summarizing the work of Jessup as compared with that of other freehand artists, we should note his unmistakable landscapes composed of sharply defined levels. Their total lack of perspective is probably not an unsuccessful attempt at realism, but rather a technique which derives quite simply from the stylized designs of eighteenth century needlework pictures (Fig. 24). We have found no stenciled motifs in any Jessup designs, nor have we seen decorated floors or grained woodwork in any of the houses where he worked, although the background of the Ryther house fireboard is variegated in the manner of the woodwork painter. The patterns and methods of painting vary considerably from house to house, and either his style developed and his repertoire of patterns expanded, or, as seems more likely, he worked in company with other men, possibly apprentices. For his plaster backgrounds he used blue, rose, buff, and gray, and although the greater part of his work is in distemper, he occasionally used oil. We find the latter in the Waid-Tinker house and in some of the Deerfield work. Although the actual designs in the houses which we have described vary considerably, there are in every case several details which link each particular wall to others which have Jessup-group characteristics.

Brush Stroke Group

Houses in Vermont, Massachusetts, and Connecticut are included in the third group of freehand walls. In his use of color, in his handling of the brush, and in the designing of his graceful spacious patterns this unknown decorator was a master craftsman of unusual merit. For the first time on these walls we find the same carefully formed brush strokes with which we are familiar on so-called "country" tin, and these strokes are entirely different from the carelessly effective technique usually employed by the wall painters. This man's work is the only instance so far found which illustrates the overlapping of these two major fields of decorative painting.

On the Millers Falls road in Northfield Farms, Massachusetts, stands an old tavern kept for many years by succeeding generations of the Stratton family. Hezekiah Stratton came from Concord, Massachusetts, to Deerfield in the early eighteenth century, married Elizabeth Hawkes, and removed to Northfield in 1715. His son, Hezekiah, born in 1724, was the first inn keeper in the old house, being succeeded by his son Hezekiah, and eventually by the third tavern keeper Arad, who was born in 1795. There was once an old fashioned garden with phlox, sweet briar, and marigolds, and drinking water was brought from the mountain through wooden pipes into a large round tub in the shed, the bottom of which was covered with white stones. In the center of the tub was a pine staff with branches cut to hold the gourd dippers.[8] One day a wayfarer came to the tavern, and before his departure he had decorated the rear upper chamber at the north end of the ell, added sometime after the building of

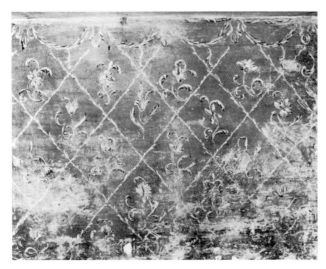

FIG. 102. Wall in the STRATTON TAVERN, *Northfield Farms, Massachusetts*

Background dark gray, design in black with white accents. The strokes are unusually well formed and the sprays are extremely graceful.

Courtesy Mrs. Murray Hammond

the main house. Family tradition maintains that the unknown artist was a Frenchman who had deserted from the armies in the north at the close of the Revolution and had followed the Connecticut River to the vicinity of Deerfield. This theory would date these decorations some twenty-five years earlier than others of comparable type, but it seems more probable that the work was actually done in the vicinity of 1800. The four walls of this room are painted with a background of deep, clear gray upon which, in delicate broken lines, are sketched large diamonds (18 x 16½ inches) in a soft oyster white (Fig. 102). In the center of each diamond is a different flower spray in white, highlighted by carefully formed "tin-painter" strokes of black. Under the ceiling is a simple looped border. The painting is free and rhythmic, suggesting speed combined with unerring skill. The many differing designs are extraordinary in their variety and grace, and the room, when lighted by a westering sun, is arresting in its monochrome artistry.

The Governor Galusha house in Center Shaftsbury, Vermont, has a charming room painted by this same man (Fig. 103). Here an all-over design on an unusual dull green background is painted with the same careful grace. Only the elliptical border enclosing the door casing appears surprisingly amateurish in its unevenness. On the plaster above the fireplace is a decorative overmantel comprising a flower arrangement that springs from a two-handled jar and is reminiscent of the compositions found on fireboards of the early nineteenth century. The broken scroll border which frames

the panel appears elsewhere in the room and is characteristic of this painter (Fig. 104).

In Easton Center, a short distance from Brockton, Massachusetts, stands the Howard Lathrop house, where the partial removal of wallpaper has recently uncovered three rooms and the front hall which fall into the same group. The lower southwest parlor has yellow walls with remains of separate designs now almost obliterated, and the upper southeast chamber has vestiges of painting on the natural plaster. The upper southwest chamber, however, still remains in almost perfect condition (Fig. 111). The background is a deep, rich shade of raspberry pink, upon which large diamonds measuring twenty-nine inches from point to point are outlined by means of small broken strokes in white and black. Within each diamond is a flower spray ten to twelve inches in height, all of which are expertly painted in white, green, vermilion, and sky blue, in shades completely outside the repertoire of the usual wall painter (Fig. 105). The large, uncrowded pattern, together with the brilliant combination of colors, makes these walls both beautiful and unique. A room located just behind this chamber has the same raspberry walls but no evidence of any design. The front entry exhibits a similar rose background with scroll designs made up of short strokes in black and white, the scrolls terminating with several strokes of sky blue. This hall apparently escaped being covered for many years, as a pencil inscription found under the paper near the head of the stairs provides the following information: "Papered July 20, 1893 by Severance for E. Wilbur." Careful scraping reveals that the woodwork in the lower yellow-painted room was a rather dark greenish-blue, and in the room above was a clear medium shade of green, which must have made a striking combination with the raspberry walls.

A short distance southeast of Easton, in the town of Lakeville, the front hallway of the Jennie Sampson house was decorated by this same itinerant. The house has been moved, but an old photograph in the files of the Historic American Buildings Survey shows an all-over pattern with brush strokes similar to those noted before (Fig. 106).

Remnants of painting on a wall in North Canton, Connecticut, known to me only through a rendering in the Index of American Design, prove that the artist worked also in the western part of that state. Although the design is almost obliterated, the same careful brush strokes and border pattern can be recognized as have been seen in Massachusetts and Vermont. Other walls in New England were undoubtedly done by this outstanding craftsman and are perhaps already known by local residents.

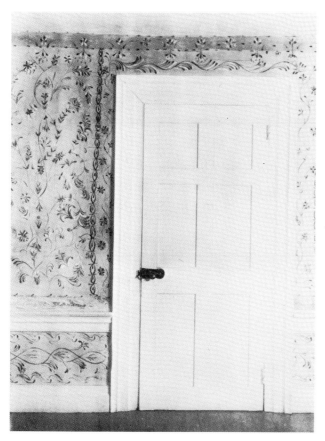

FIG. 103. Wall in the GOVERNOR GALUSHA HOUSE, *Shaftsbury, Vermont*

Soft green background with designs in natural colors and black

Photograph Wilbur Library, University of Vermont
Copyright Herbert Wheaton Congdon

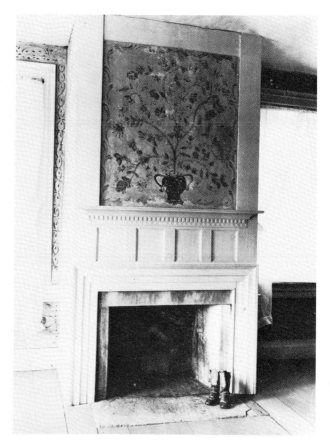

FIG. 104. Overmantel on Plaster GOVERNOR GALUSHA HOUSE, *Shaftsbury, Vermont*

Urn with floral arrangement reminiscent of needlework.

Photograph Wilbur Library, University of Vermont
Copyright Herbert Wheaton Congdon

FIG. 105. Detail of Wall in HOWARD LATHROP HOUSE, *Easton, Massachusetts*

The diamonds are formed of well shaped brush strokes. The tempora on the flower sprays is very thickly applied.

Courtesy William N. Cummings

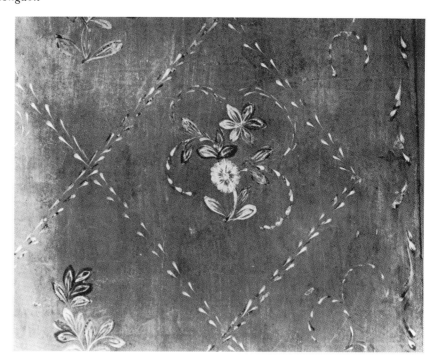

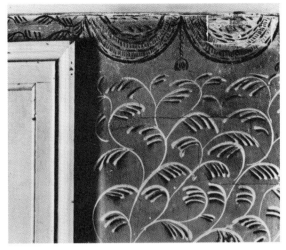

FIG. 106. Small Section of Front Hall in the
JENNIE SAMPSON HOUSE, *Lakeville, Massachusetts*
Now re-erected elsewhere. By the
same hand as Figs. 102, 103, 111.
*Photograph Historic American Buildings
Survey*, Library of Congress, Washington, D. C.

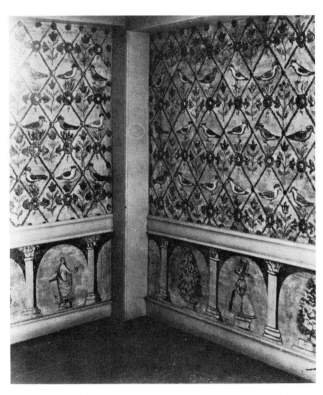

FIG. 108. Wall in RICHARD LORD HOUSE, *Old Lyme,
Connecticut*
Background yellow-buff. Birds have black wings
and red heads, and white or blue breasts. The
arched dado derives from wall paper of the period.
*Courtesy H. W. Gray; Photograph Society
for the Preservation of New England Antiquities,*
Boston, Mass.

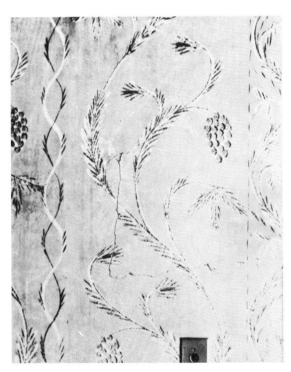

FIG. 107. Section of Front Hall in the REVEREND
SAMUEL FOXCROFT HOUSE, *New Gloucester,
Maine*
Attributed to Phillip Rose. Yellow back-
ground with design in black and white
having touches of red and greenish-blue.
Courtesy Mrs. Isobel S. Fowler
*Photograph from Early American Decora-
tion, Esther Stevens Brazer.*

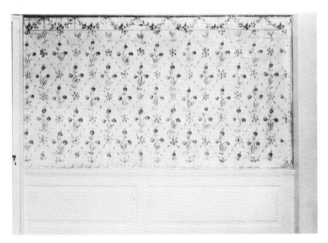

FIG. 109. Section of Wall in the WILCOX HOUSE,
Westfield, Massachusetts
A delicate design on a white background. Flowers in mus-
tard yellow and dull red, with leaves in grayish-green.
*Photograph National Gallery of Art. Index of American
Design; Rendering by Martin Partyka*

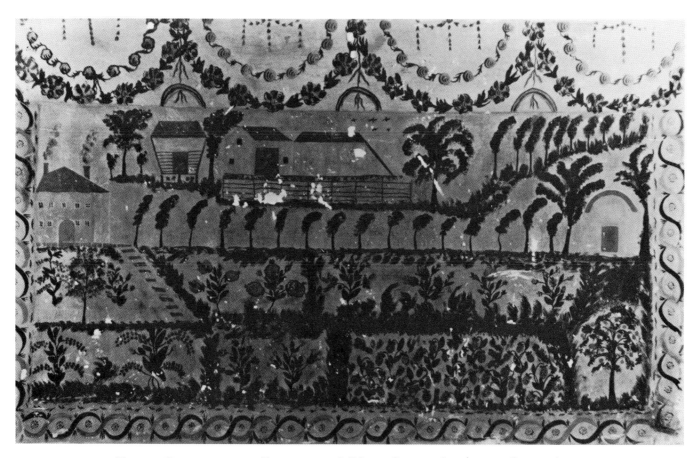

FIG. 110. OVERMANTEL ON PLASTER AT 76 WATER STREET, *Stonington, Connecticut*
Attributed to Jared Jessup. The gardens are laid out in detail with flowers, fruit trees, and berry patch.
Courtesy Mr. and Mrs. H. H. Corbin. Photograph National Gallery of Art. Index of American Design Rendering by J. Collins

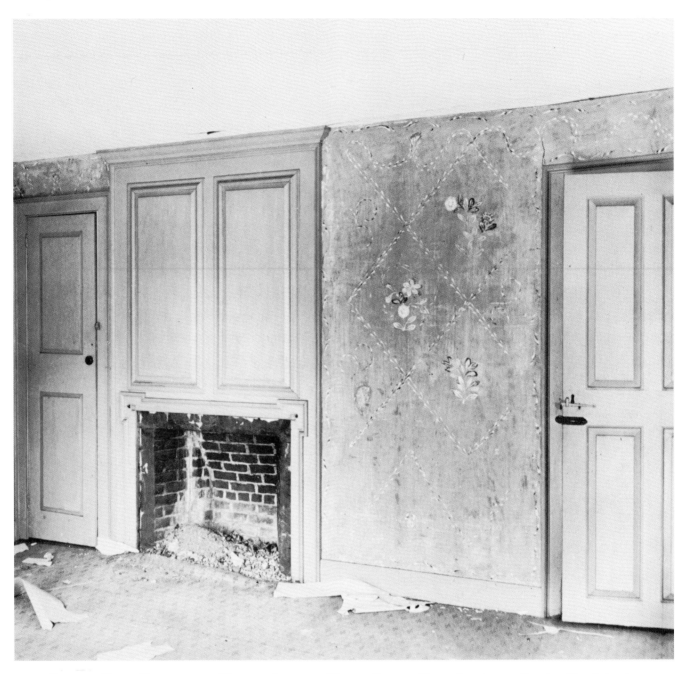

FIG. 111. UPPER ROOM IN THE HOWARD LATHROP HOUSE, *Easton, Massachusetts* *Courtesy Mrs. John Ames*

Maine Group

Still a fourth group of freehand walls has been found in the vicinity of Portland, Maine. These are of special interest because they have been attributed by Esther Stevens Brazer to one Phillip Merrit Rose, a nephew of Paul Revere. He is known to have worked in Portland where he illuminated two family records which commemorated the marriage of Isaac Stevens and Sarah Brackett, and the births of their nine children. There is little biographical data available concerning Phillip Rose, but it appears that he was baptized at the New Brick Church in Boston on July 28, 1771, the son of Edward and Mary (Revere) Rose, who was a sister of Paul Revere. He was in Stevens Plains, Portland, about 1796, where he painted the Stevens family records, and where his sister, Sarah (Rose) Brisco was soon to move with her husband and the three daughters of her sister Mary (Rose) Francis, who were adopted by the Briscos in 1804. Thomas Brisco settled as a tinsmith in Stevens Plains in the early 1800's, and it is possible that he and Rose may have previously conducted a tin shop in Cambridge during the 1790's. An entry in Paul Revere's Day Book indicates that his nephew Rose purchased from him six silver teaspoons in 1794 at the price of 1 pound, 16 shillings. Phillip Rose died in Boston in 1800 and is buried, as is his mother, in Copps Hill Burying Ground.[9]

In the Reverend Samuel Foxcroft house in New Gloucester, Maine, the upper and lower hall and stairway are done in freehand on a soft yellow background (Fig. 107). The stems and leaves are in black laid on a white base, and there are quick touches of iron red on the terminating sprays. Each grape, and the backs of some of the leaves, are mottled in greenish-blue, an effective device which I have not seen in other work. Removal of wallpaper in a small bedroom on the third floor has recently revealed further painting, separate motifs on a gray background, which although done freehand, are executed with such precision that one feels the artist must also have been a stenciler. This impression is borne out also in the hall, where the patterns are graceful but exact. Further painting, said to have consisted of marbleized columns in the corners of the room to the right of the front door, is now unfortunately papered over.

The attribution of this wall to Phillip Rose was made by Mrs. Brazer on circumstantial evidence based on his decorative painting of the family charts in Portland, and the fact that there were Stevens settlers in West Falmouth and New Gloucester, and a shipbuilder by the name of Rose in Yarmouth, three towns where similar wall painting has been found. If her surmise is correct, these are early examples of free-hand painting dating before 1800, the year of Rose's death.

In New England and vicinity are several freehand walls which do not seem to fall into any recognized group, as for instance in the Ephraim Williams house, Ashfield, Massachusetts, which contains three of the most interesting examples I have seen. In two of these rooms a stenciled band of black tulips runs vertically from floor to ceiling, and in the attic chamber a freehand column with entwined rope effect alternates with the vine. A narrow freehand border in black, white, and scarlet outlines the doors, windows, baseboard, and ceiling. In the large northeast chamber, on a background of deep yellow, rows of festoons are arranged in a sort of gothic pattern in black and white, combined with little flame motifs touched with red.[10]

Family tradition states that this painting was done by Lydia Eldredge Williams, born in 1793, who came from her home in Yarmouth on Cape Cod to marry Abel Williams in 1812. Here she lived until the property was sold after the death of her husband in 1854. The fact that these highly original patterns have not been found elsewhere indicates that there may be truth in this story. It is, however, a singular and inexplicable fact that almost the exact tulip stencil found here may be seen on the floor of the small bedroom adjoining the Lafayette room in the Wayside Inn, South Sudbury, Massachusetts, and that closely similar patterns form the border on a floor in the Stratton Tavern, Northfield Farms (Fig. 85) and in the Samuel Lincoln house in Hingham, Massachusetts.[11]

Two distinctive designs are to be found in the Richard Lord house in Old Lyme, Connecticut. In the lower northwest room is a design of diamonds formed of tiny black circles on a buff ground, in the center of which is a row of birds alternating with a row of tulips, highlighted in red and blue (Fig. 108). Below the chair rail is an arched dado divided by Ionic capitals. Alternating within the arches are decorative figures standing on pedestals, and fir trees in pots. The upper hallway of this house has a soft rose background on which diamonds enclose varying sprays of flowers in red, blue, and white. These patterns are strong in coloring and bold in design, making for interest rather than beauty.

In the Wilcox house, Westfield, Connecticut, is another painted room of which a small section has been removed and installed in the New Haven Colony Historical Society, New Haven, Connecticut. Here black diamonds on a white background enclosing repeated floral sprays give a delicate and spidery effect because of the delicacy of the brush strokes (Fig. 109). Touches of red and mustard-yellow were brushed on with apparent haste, while the black accents which give the blossoms shape and form were added over

the color in a second application. The swag border is composed of leaves and flowers in two shades of green, red, and yellow.

Also in the New Haven Colony Historical Society at one time was a section of plaster taken from the Rufus Hitchcock house on Cheshire Green, Connecticut. The panel was of particular interest as the painting in this house is by local tradition attributed to Sylvester Hall, a native of nearby Wallingford. Although no documentary proof has been found to substantiate this claim, there is no reason to doubt the ascription, as Hall advertised as a decorative painter in New Haven in 1804. As this notice from the *Connecticut Herald* is the most detailed advertisement which we have found in New England it is given here almost in its entirety. Although Messers Bartling and Hall were not backward in their claims for unique and superior workmanship, it is fair to presume that the processes enumerated were typical of the work being done by many painter-decorators at the turn of the century.

B. Bartling and S. Hall respectfully inform the gentlemen and ladies of New Haven that they will execute on mahogany furniture of every description, either old or new, that beautiful Chinese Mode of Varnishing and Polishing in a manner that will last for years, and always retain pleasing and beautiful gloss, without the old and laborious method of rubbing and brushing, which not only takes a great deal of the time of the servant, but destroys and racks the strength of the furniture and defaces the natural color of the mahogany. Also that truly elegant French Mode of Varnishing on plain or stamped Paper Hangings, when fixed in rooms, which will secure the colors from fading, cause them to appear brighter, effectually prevent bugs and vermin from collecting in them, and bear washing without injury to the color or gloss. Likewise . . . that much admired imitation of stamped paper, done on the walls of rooms, far superior to the manner commonly practised in this state. Coaches, Chaises, Signs, Windsor and Fancy Chairs, Painted and ornamented in a new and peculiar method, thereby rendering them vastly superior to those executed in the accustomed mode. Toilet Tables, Bed Posts, Window and Bed Cornices and Firescreens, Ornamented in a manner which will render them more elegant and durable than by any means hereto devised. They will also enamel the names of persons on glass, in gold or silver letters, superior to common execution, and at a more reduced price than is at present given. Presuming that one of them is the first person, who, in America, has assayed to perform the above mentioned arts, they flatter themselves, that, from the general satisfaction he has heretofore given in different parts of the United States, they will meet with that encouragement which the Inhabitants of this City are ever ready to accord to native talents when endeavoring to introduce cheaply into use the knowledge of arts which combine utility and elegance.[12]

Biographical data concerning Sylvester Hall are meagre, but it seems likely that he was born in Wallingford on March 13, 1774, and later lived in Winchester, Connecticut. Judging from an old photograph

of the plaster sample from the Hitchcock house, "that much admired imitation of stamped paper, done on the walls of rooms," was freehand decoration of careful and superior workmanship.

We may also deduce from the wording of the advertisement that one of the partners in the new venture had been a traveling decorator. Circumstantial evidence points to its having been Hall, as Bartling apparently made his home in New Haven where he advertised a chaise for sale in 1806. In 1830 Hall appeared as a resident of Burke, Caledonia County, Vermont, where he made a transfer of land in that year. We may accept Sylvester Hall as one of the few wall decorators whom we know by name. He is credited with doing a landscape panel and a freehand wall in the Hitchcock house, and he also advertised vehicles, signs, and furniture. It is tantalizing that the designs on the plaster sample attributed to him do not coincide with known patterns on other walls. Many examples of his work must exist unrecognized today, and it is to be hoped that his name will eventually be connected with some of the unidentified examples of decorative painting which at present remain anonymous.

REFERENCES

[1] For information concerning the Hewitt and Galpin houses I am indebted to William L. Warren of Litchfield, whose investigation of freehand walls in Connecticut resulted in the fine renderings made by the Index of American Design, many of which are used as illustrations in this volume.

[2] This overmantel picture disappeared some years ago due to the exigencies of time and wear, but an old photograph has fortunately preserved its appearance.

[3] What little biographical material has been found on Jared Jessup is in Henry G. Jessup's *Edward Jessup and His Descendants*, and the *Vital Records* of Richmond, Mass. and Guilford, Conn.

[4] Allen, *Early American Wall Paintings*, pp. 56-59.

[5] Kate Sanborn, *Old Time Wall Papers* (New York 1905), p. 44.

[6] Prime, *Arts and Crafts, 1786-1800*, p. 305.

[7] The repainting of these designs and of the stenciling in the ballroom of the Hall tavern in Deerfield (Figs. 99 and 120) was done by Stephen G. Maniatty of Deerfield.

[8] To Mrs. James H. Slade, fifth great-granddaughter of Hezekiah Stratton, I am indebted for the family history given here.

[9] Mrs. Brazer's published references to Phillip Rose will be found in "Zachariah Brackett Stevens," *Magazine Antiques*, XXIX, 3 (March 1936), 98-102, and "Did Paul Revere Make Lace-Edge Trays?" *Magazine Antiques*, XXXI, 2 (Feb. 1937), 76-77. Her personal notes were made available to me through the courtesy of Clarence W. Brazer and of the Esther Stevens Brazer Guild.

[10] See illustrations in Janet Waring, *Early American Stencils on Walls and Furniture*, (New York 1937), Fig. 26. Hereafter referred to as Waring, *Early American Stencils*.

[11] The tulip border detail from the Wayside Inn is illustrated by Esther Stevens Brazer in "Some Colonial and Early American Decorative Floors," *Magazine Antiques*, XIX, 4 (April, 1931), 298. Tulip border in the Samuel Lincoln house illustrated in Brazer, *Early American Decoration*, facing p. 165.

[12] *Connecticut Herald*, New Haven, Conn. Notice inserted on each successive Tuesday from Jan. 10 through March 14, 1804. A file of this newspaper is owned by the New Haven Colony Historical Society.

Chapter VIII

Stenciled Walls

"Imitation of Paper Hangings by a Mechanical Process"

THE ORIGIN OF STENCILED PATTERNS on walls in New England and neighboring states springs from the same wallpaper sources as the freehand designs. Although the stenciler often made use of geometric motifs, while those of the freehand artist were predominantly floral, the border designs were very similar. Wide bands of drapes and swags, combined with tassels and bells, follow the same general style, and the entwined ribbon border, beloved by the freehand painter, appears frequently in stenciling.

It seems probable that stenciled walls first made their appearance toward the end of the eighteenth century, although their period of greatest popularity was apparently between 1815 and 1840. The earliest documentary evidence I personally have seen of this type of decoration is to be found in the portrait of John Phillips by Joseph Steward, painted in 1793 (Fig. 112). A small stenciled border is portrayed around cornice, window, and baseboard, which will be discussed in detail later in this chapter. An advertisement appeared in the *Federal Gazette* of Baltimore on July 29, 1796, which, from the wording, seems to refer to stenciling, and is the earliest printed reference which I have found: "Priest, William, Painter, Interior Work, Painting in imitation of Paperhangings, By a mechanical process, which from its facility, enables the artist to paint a room, staircase, &c. upon lower terms, than it is possible to hang with paper of equal beauty."[1]

The colors found on stenciled walls are distinctive, and usually limited to a few shades, although variations will appear in isolated examples. Yellow ochre was a favorite background, and much of the interior woodwork of the early nineteenth century was also painted in this soft shade which was called "buff." An "ashes of roses" pink, and the natural white plaster are also seen as backgrounds, but the brilliant blue and strong gray of the freehand painters seem not to have been particular favorites of the stencilers. The pattern colors are usually a soft olive green, iron red, dark blue, black, and several shades of yellow. Distemper was the usual medium. It should be remembered that it is only in rare cases that we see the actual colors in which the walls were originally painted, as most of them emerge from under many layers of wallpaper, their patterns dimmed through the action of the paper glue. Others which have never been covered have lost their former brightness through dust or other defacement.

The early years of the nineteenth century brought an increasing use of the stencil on furniture, walls, and floors. The stencils themselves were usually cut out of heavy paper to which successive coats of oil, paint, or shellac had been applied to keep them flat and firm. A margin was left around the design to protect the wall, and it was important to keep the under side free from paint which otherwise might be transferred to the surface being decorated. A stenciling outfit was simple and consisted of a box containing dry colors, long handled round brushes of various sizes, stencils, and tools for measuring and laying out wall spaces. The number and size of the stencils varied according to the desires and ability of the artists, who cut their own patterns. Many effects could be achieved by different combinations of small motifs, and while similar patterns are sometimes found, there is usually a variation which betrays the hand of a different craftsman. Although it is probable that most of the good freehand work was done by professionals, there are persistent traditions which ascribe several stenciled walls to the efforts of amateur members of the family. Some of these designs, however, have been found again in widely separated localities which causes one to speculate on how individual patterns may have been copied, sold, or otherwise passed from one decorator to another.

The names of several wall stencilers have been discovered, and their work identfied by Janet Waring in *Early American Stencils on Walls and Furniture*. The

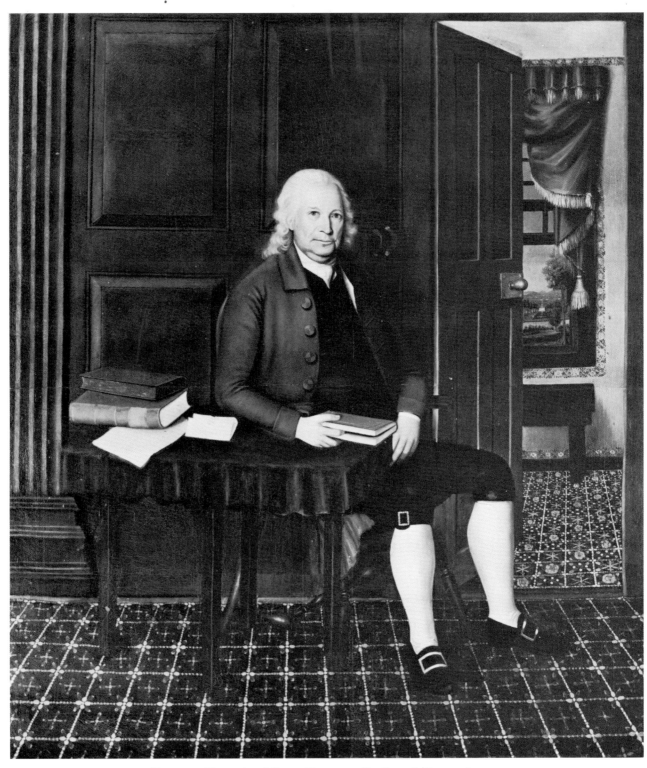

Fig. 112. Portrait of John Phillips. By Joseph Steward, 1793
The floor is covered with painted carpets, and bands
of stenciling decorate the plaster in the rear room.
Courtesy The Trustees of Dartmouth College, Hanover, N. H.

work of other artists may be recognized only by their patterns which can be followed from town to town where they traveled. Moses Eaton, Jr., is the best known of these men, and his painting box, complete with brushes and stencils, was found by Miss Waring and was left by her to The Society for the Preservation of New England Antiquities in Boston.[2] Eaton was born in Hancock, New Hampshire, in 1796, and later moved to Dublin where he is said to have given up his itinerant ways and settled down to farming. Two houses in Dublin and his father's home in Hancock were stenciled with patterns which are contained in his kit.

Emery Rice also stenciled in the vicinity of Hancock at a later date, while Nathaniel Parker, born in North Weare in 1802, is said to have done the walls in the Buchman house in Antrim, New Hampshire. Twenty-two patterns of Henry O. Goodrich, contained in his work box, are illustrated in *Early American Stencils,* and make an interesting comparison to those of Moses Eaton. Goodrich, who died when only twenty years of age, used mostly geometric figures which contain variants of some of the Eaton patterns and borders. The weeping willow was a favorite motif and one finds it with many slight variations, a fact which indicates the cutting of numerous stencils by different artists.

The number of stenciled walls which still remain in New England is amazing, and indicates that this type of decoration was both popular and widespread. Despite the fact that many have disappeared, and others are undoubtedly still hidden beneath wallpaper and paint, a complete survey of those known to exist would fill an entire volume. As stenciling has received rather more attention, both in print and in practice, than other types of wall decoration, no attempt will be made here to cover the entire field. Instead, certain familiar types will be grouped in the hope of clarifying a large and confusing body of designs.

Border Group

In a group of some dozen houses, one or more of which are located in each of five New England states (Rhode Island excepted), is to be found a type of stenciling entirely different from the single motif repeat patterns commonly seen. Apparently the work of one itinerant, the decoration consists almost entirely of dainty borders, occasionally with the addition of an unusual figure on an uncrowded wall space. I believe it is the work of this stenciler that is to be seen in the Phillips portrait painted in 1793 (Fig. 112), which is presumed to show the interior of his Exeter, New Hampshire home; and I also feel that borders of this style constitute the earliest type of wall stenciling, and

pre-date the large geometric patterns of the 1820-1840 period.

The old Manse in Peterborough, New Hampshire, now known as Bleak House, was built in 1797, and six rooms and the front hall were decorated by this man in delicate and subtle patterns. We find there several unusual background colors, such as peach, gray, yellow, and rose which set off the delicate brushwork to perfection. In this house all the walls have been retouched so the original tints cannot be studied as accurately as one might wish, but the patterns themselves have been carefully retained.[3] The Salmon Wood house, built in Hancock, New Hampshire, in 1801 shows among other similar motifs the same looped swags and tassels as in Peterborough, which are shaded to suggest highlights in a manner unusual for the stenciler. We find this border repeated once again in John Leavitt's tavern in Chichester, New Hampshire, of which a likeness of the interior as it appeared in 1824 has been preserved in a small watercolor drawing. This is a rare contemporary picture of a stenciled room of the period (Plate v). In the small leafy band which divides the walls into panels, and in the blue swag and tassel frieze we recognize the hand of the unknown decorator, but the graceful bird which perches on a branch over the fireplace is a motif not yet discovered elsewhere. The painter of this picture, said to represent a visit of Lafayette to Leavitt's tavern in 1824, was one Joseph Warren Leavitt of Chichester, a cousin of Mrs. Sally (Emery) Morse, who is seen industriously sewing with her feet almost in the fire.

That this stenciler traveled through the coastal towns is proved by the discovery of his borders in the King Hooper House in Marblehead, Massachusetts, which correspond with some of those in the Peter Farnum house in Francistown, and in the Salmon Wood house in Hancock. The Jaynes house, also in Marblehead, has border stenciling, and local tradition avers that this work was done in 1791 when the Methodist Church was organized in an upper room by followers of John Wesley. Quarter fans in the Sheraton style are another characteristic of this decorator. They appear in the ballroom of the Governor Franklin Pierce house, built in Hillsboro, New Hampshire in 1804; in the ballroom of the Joslin Tavern, West Townsend, Massachusetts; in the hallway of the Barry house, Kennebunk, Maine; and in an upper chamber of the Ichabod Goodwin house at South Berwick, Maine (Fig. 113). In the Goodwin house the background is tinted a dusty rose, the black border is laid on a band of gray around doors and windows, and the fans have an orange-brown background with black spokes. The same cornice border is found in the Dutton house in Cavendish, Ver-

FIG. 114. DUTTON HOUSE, *Cavendish, Vermont*
Now re-erected at Shelburne Museum. Large geometric design similar to others found in Vermont, and possibly added by a later stenciler than the man who did the borders.
Shelburne Museum, Shelburne, Vt.

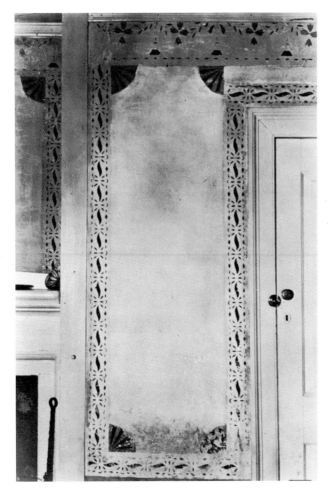

FIG. 113. Wall in the ICHABOD GOODWIN HOUSE, *South Berwick, Maine*
Black border laid on a band of gray with background of soft rose. The quartered fans are typical of the work of this stenciler.
Courtesy Miss Elizabeth Goodwin
Photograph National Gallery of Art.
Index of American Design
Rendering by Mildred E. Bent

mont, and both borders appear together in the Barry house in Kennebunk, Maine.[4]

For generations the old Dutton house, with its long sloping roof, was a landmark on a conspicuous corner of the main street of Cavendish, Vermont. Two chambers and the front hall were stenciled with yellow backgrounds, having borders in black and iron red on white and salmon pink bands. Over the fireplace in the east room may be seen the same festoon border which appears in the Governor Pierce house with a single large design in black and red over the fireplace, which seems entirely out of scale and key with the delicate border patterns of this artisan (Fig. 114). Large geometric figures filling the center of the wall are also to be found

in a rear upper room of the Governor Pierce house in Hillsboro, New Hampshire. In *Early American Wall Stencils* are illustrated similar large designs which appear on walls that have Moses Eaton patterns, or are attributed to Erastus Gates of Plymouth, Vermont. It seems possible, therefore, that as fashions changed during the 1820's, another artist added his touch (and not such an artistic one) to the restrained border compositions of the earlier craftsman.[5] In the same room an unusual line of urns, eight inches in height, and spaced eighteen inches apart, surmounts the baseboards. These are painted in black with details overlaid in white, and the bases are red. Joined by leafy swags, each of which encloses a flower spray, they make a bold and effective decoration against the clear yellow of the walls (Fig. 115). This house has now been removed and re-erected as part of the Shelburne Museum in Shelburne, Vermont. The original sten-

FIG. 115. Upper East Room, DUTTON HOUSE, *Cavendish, Vermont*
Now re-erected at Shelburne Museum. Unusual row of urns stenciled in black and red, with touches of white, against a yellow background. The upper border is composed of black swags with touches of red laid on a white band.
Shelburne Museum, Shelburne, Vt.

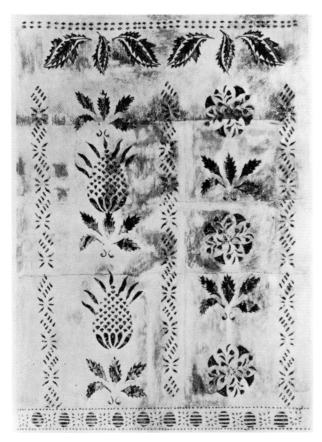

FIG. 116. Section of Wall from the DAVID THOMPSON
HOUSE, *West Kennebunk, Maine*
By Moses Eaton. Design in green and two
shades of red against a grayish plaster. Now
on exhibit at the Tate house, Stroudwater,
Portland, Maine.
National Society of Colonial Dames of America
resident in the State of Me.; Photograph National
Gallery of Art. Index of American Design
Rendering by Mildred E. Bent

ciled overmantel has been preserved, and the remain-
ing walls have been carefully reproduced. A house on
the Boston Post Road, in Guilford, Connecticut, is
said to have been found bearing on a pale blue wall
two of the identical borders which are found in the
Pierce house and in the old Manse at Peterborough.

Patterns of the Moses Eaton Type

As our second group we may take the patterns of
Moses Eaton and other similar designs which are the
type most generally seen in New England and probably
date slightly later than the borders alone. These walls
are usually divided into panels by small geometric or
floral bands, the spaces containing alternating motifs
of single designs. A leaf, arcade, or swag border tops
the walls with a smaller frieze surmounting the base-
board. Fig. 116 shows a section of wall from the David

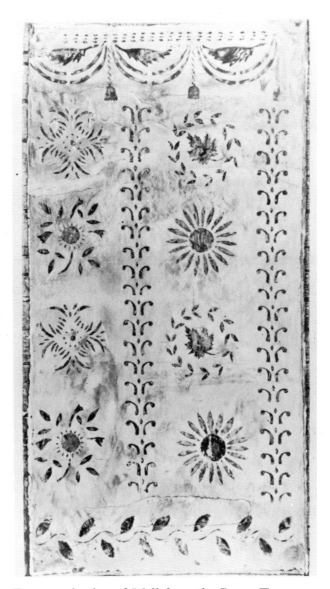

FIG. 117. Section of Wall from the DAVID THOMPSON
HOUSE, *West Kennebunk, Maine*
By Moses Eaton. The stencil for the vertical
band is in Eaton's kit. On exhibit at the
Tate house, Stroudwater, Portland, Maine.
National Society of Colonial Dames of America
resident in the State of Me.; Photograph
National Gallery of Art. Index of American
Design; Rendering by Mildred E. Bent

Thompson house in West Kennebunk, Maine, by
Moses Eaton, made up of designs which are to be found
in his stencil box, and which are typical of his work.
Against a background of grayish plaster Eaton used
green and two shades of red to give variety to his de-
signs, of which the pineapple is one of the handsomest,
and the serrated leaf border one of the most frequently
seen. Another room in the same house shows different
patterns done in the same color range (Fig. 117). When

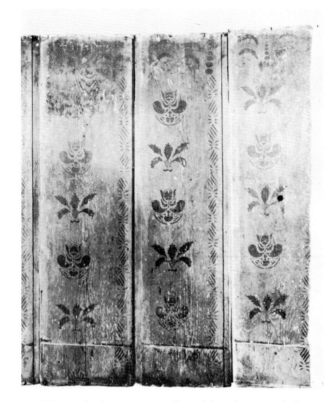

FIG. 118. STAIR-WALL Sheathing from *Athol, Massachusetts*

Moses Eaton's stencils in green and red are applied directly to the unpainted pine boards.

Author's collection

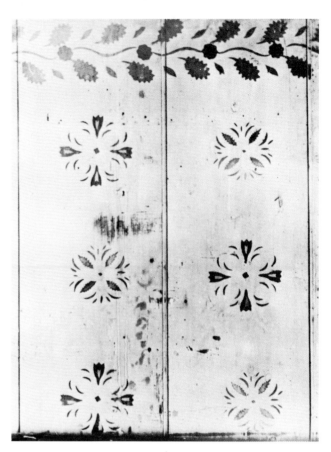

FIG. 119. Beaded Sheathing in the JESSE AYER HOUSE, *Hampstead, New Hampshire*

Eaton-type designs in Chinese red and green touched with yellow.

Photograph Society for the Preservation of New England Antiquities, Boston, Mass.

FIG. 120. Ballroom of the HALL TAVERN, *Charlemont, Massachusetts*

Now re-erected at Deerfield, Massachusetts. Designs of an unknown painter are executed in red and green on a yellow background. A panel of the original plaster may be seen to the right of the door. The rest of the painting was carefully copied from the original after the building was moved.

Photograph courtesy Mr. and Mrs. Henry N. Flynt

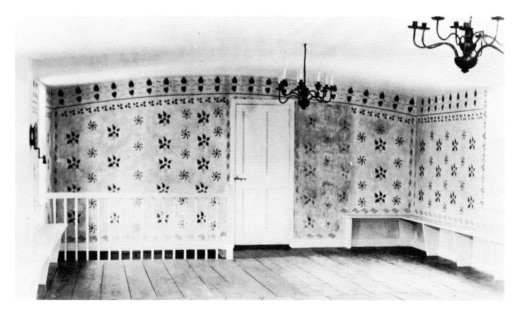

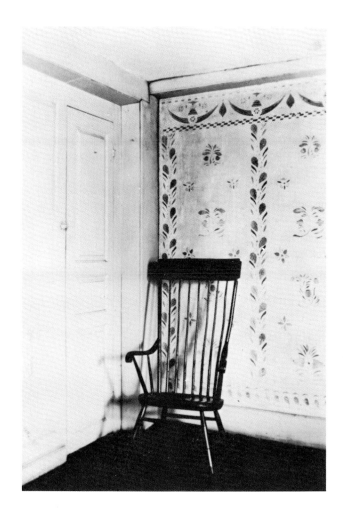

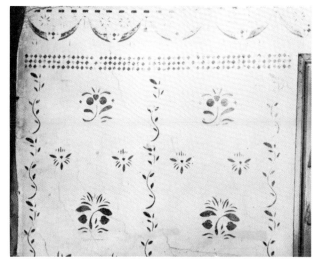

FIG. 122. Detail of Another Room in the
STRATTON TAVERN
Designs by the same artist.
Courtesy Mrs. Murray Hammond

FIG. 121. Upper Room in the STRATTON TAVERN,
Northfield Farms, Massachusetts
Attributed to the traveling artist "Stimp."
Courtesy Mrs. Murray Hammond
Photograph courtesy Mrs. James H. Slade

FIG. 123. Fireplace Wall in
the POMEROY HOUSE,
Somers, Connecticut
Ascribed by tradition to Lu-
cinda Pomeroy. Note the simi-
larity of motifs and upper
border to those in Fig. 121.
*Photograph National Gallery
of Art, Index of American
Design
Rendering by Ray Holden*

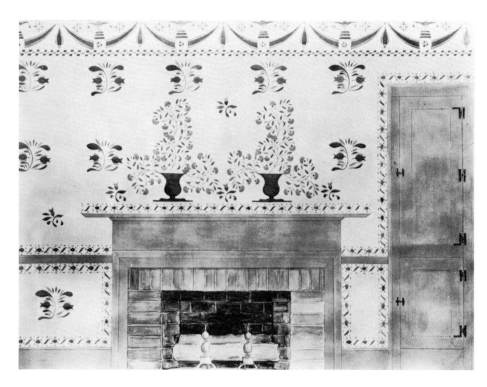

this house was demolished these two sections were removed and are now exhibited in the Tate House in Stroudwater, headquarters of the Maine Society of Colonial Dames. These designs are also to be found in the hall of the Grant house in North Saco, Maine.

From the vicinity of Athol, Massachusetts, comes some very early featheredge sheathing once used to enclose a small flight of stairs. The outlines of the stairends can still be seen on the backs of the wide old boards. At some date long after the original construction, the stenciling was applied directly on the mellow pine finish (Fig. 118). In the Jesse Ayer house in Hampstead, New Hampshire, the designs are used in a room having plaster walls on three sides and beaded sheathing on the fourth wall. The background is a light gray, with designs in red, green, and soft yellow (Fig. 119). The same leaf border and other patterns are also to be found in Upton, Massachusetts, and in Smithfield and Still Water, Rhode Island.

The many Eaton walls extant in New England prove him to have been one of the most prolific of the itinerant stencilers, and his well-worn brushes indicate many hours of expert use.

In Charlemont, Massachusetts, stood until recently a picturesque building known as the Hall Tavern, which was taken down and re-erected in Old Deerfield in 1950. The ballroom, added to the original building in the early years of the nineteenth century, was stenciled in red and green on a sunny yellow background, with woodwork painted in a harmonizing shade of buff (Fig. 120). An adjoining room was embellished with borders only. Although the plaster surface was badly defaced from the application of successive layers of wallpaper, the patterns were plainly visible, and part of the old design was fortunately found under later window casings which showed the paint colors in pristine condition. All the patterns were carefully traced and photographed, and after the re-erection of the building they were repainted on new plaster which was accurately matched in color and texture to the original. One large section of the old wall was moved intact, and this allows an interesting comparison of the old and new work. Although these walls fall into the Eaton group, none of the motifs correspond exactly with any of his known patterns and it is probable that they are by another hand.

Patterns Attributed to "Stimp"

A third group of designs, some of which Miss Waring has attributed to a traveling artist known only by the pseudonym of "Stimp," may be studied under a general heading because of a repetition of several of the figures which are unmistakable in their bold originality. The name "Stimp" is connected by local tradition with the painting of the walls of the Hartwell house, in Washington, Connecticut, about 1830, where the painter is said to have frightened the occupants by an overfondness for strong liquor. Recurring motifs used by this decorator include a swag border with bell, two distinctive leaf borders, and several flower motifs.

We have already mentioned the Stratton Tavern in Northfield Farms, Massachusetts, in connection with a fine freehand room (Fig. 102), and it was both a surprise and a pleasure to find also two rooms of distinctive stenciling (Figs. 121 and 122). It seems unlikely that the same decorator was responsible for all the painting, as no freehand patterns have been noted in any of the other houses where "Stimp" stenciling has been found. The Josiah Sage house in South Sandisfield, Massachusetts, the Oliver Smith house in Tyringham, and the Belden house in New Boston, New Hampshire, are others illustrated by Miss Waring which bear the imprint of the same decorator. The old sign-board of the Stratton Tavern, on exhibit at Memorial Hall in Deerfield, is unusual in having both stenciled and freehand decoration.

In the vicinity of Hartford, Connecticut, are several houses containing walls which appear to be by this same man, while in Somers, Connecticut, just south of the central Massachusetts border, is the Pomeroy house of which an Index of American Design rendering is shown in Fig. 123. Family tradition recounts that the stencils were designed by Lucinda Pomeroy, a daughter of the household, but the similarity of the details to those in the Stratton Tavern, and in other houses of the "Stimp" group, suggests a connection which was more than coincidental. If the work was actually done by her, Lucinda must have seen one of the houses in her neighborhood and carefully copied the designs for her own use.

Various miscellaneous patterns which seem to be one-of-a-kind appear from time to time throughout New England, and suggest that wall stenciling was a popular vocation. Many of the persons who did this work, however, will probably always remain anonymous.

REFERENCES

[1] Prime, *Arts and Crafts 1786-1800*, p. 305.
[2] Photostats have been made of the original Eaton stencils and may be seen at the headquarters of the Society, 141 Cambridge St., Boston. A second set of photostats is in the Print Dept. of the Metropolitan Museum, New York City.
[3] Work now in progress has just uncovered further examples of unrestored stenciling in this house.
[4] Waring, *Early American Stencils*, Figs. 91 and 92.
[5] *Ibid.*, Figs. 79 and 85.

Chapter IX

Figure and Subject Pieces
"Too Many to Enumerate"

JUST HOW EARLY FIGURE PAINTING on plaster walls came into use in America is hard to say, but undoubtedly it was considerably earlier than the advent of the scenic panoramas which flourished during the second quarter of the nineteenth century. Remaining examples seem to date from the mid eighteenth century to the early years of the nineteenth, and one notice which appeared in the *American Mercury*, November 22, 1789, proves that they were popular enough by this date to warrant advertising a variety of designs: "Gilding and painting by Sanford and Walsh, two doors south of the new Meeting House. Portrait, miniature and heraldry painting in all their various branches. Also signs and chaise painting in the most elegant manner equal to any done in America, likewise outside and room painting. Fresco painting upon walls, representing landscapes, favorite hunting pieces, shipping etc., and various other pieces too many to enumerate."

Two years later, in 1791, Anthony Audin, "Painter from Paris," advertised in the *Charleston City* (South Carolina) *Gazette* that he "Takes the liberty to acquaint the public in general, that he . . . decorates apartments in architecture, marine and landscapes, all in the most new and approved taste."[1]

Mention has been made in Chapter I of the Chinoiserie wall paintings enframed in bolection moldings which were found under later woodwork in the parlor of the Vernon house in Newport, Rhode Island (Fig. 8). These appear to have been patterned after embossed leather panels, in a style popular in England during the late seventeenth and early eighteenth centuries, although probably not used here until a somewhat later date. Nevertheless, they have a decidedly pre-Revolutionary flavor, and appear to be among the earliest plaster decorations found in New England.

Others of a different type but similar in period may be seen on the hallway of the McPhaedris-Warner house in Portsmouth, New Hampshire, a three-story brick mansion built by Captain Archibald McPhaedris in 1716. The decorations consist of a series of pictures in the lower hall and on the stairway, representing different incidents, and their existence was not suspected until some ninety years ago when they emerged from under four layers of wallpaper. These are not arranged in a continuous panorama, but consist of separately treated subject pieces in a manner which we believe to be typical of the earlier examples of plaster painting. One scene shows a lady spinning, while a dog protects her from an attacking eagle grasping a chicken in its talons. Above this picture is a scriptural scene showing Abraham with upraised sword about to sacrifice Isaac in the presence of the admonishing angel, while a classic urn flames in the foreground (Fig. 124). On the wall across the stairway is a figure mounted on a prancing steed, which, from the letter "P" surmounted by a coronet painted on his holster, is probably intended to represent Sir William Pepperrell, hero of the capture of Louisburg in 1745. He was the first native-born American to have a baronetcy conferred upon him by a British monarch (Fig. 125).

Paintings of quite a different type are found on the wall of the stair landing in the Warner house. Above the window is painted a rounded canopy, at either side of which are looped drapes which hang over the heads of two large Indians (Fig. 124). These figures represent two of the five Mohawk chieftains whom Colonel Peter Schuyler took to England early in 1710. After the failure of an English expedition against the French in Canada, Schuyler, who was Indian Commissioner of New York, decided to insure the loyalty of the Indians to England by taking the Chiefs of the Five Nations to London where they were granted a special audience with Queen Anne, received much hospitality from the nobility, and were subjects of lively curiosity to the British populace. This event was also of great interest in the colonies, where it was felt that Schuyler's efforts to

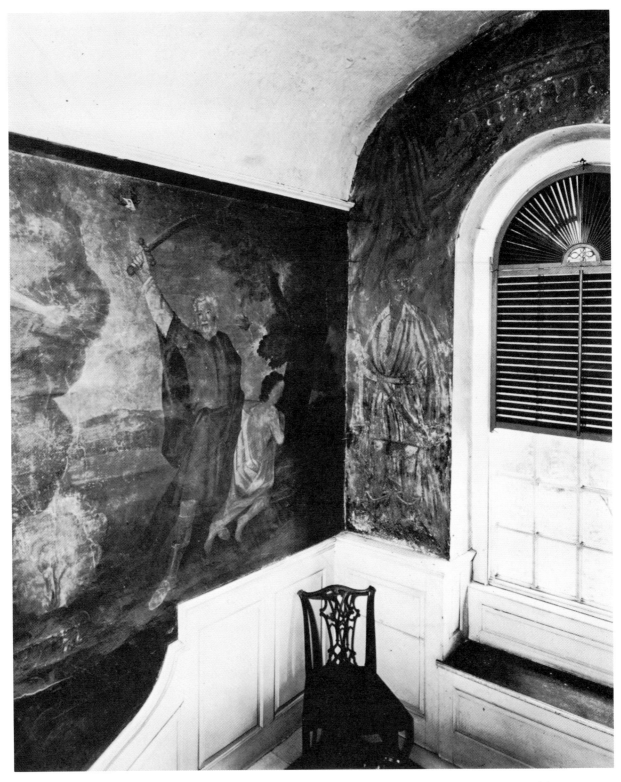

FIG. 124. Hallway of the MCPHAEDRIS-WARNER HOUSE, *Portsmouth, New Hampshire*
Abraham about to sacrifice Isaac. At left of window may be seen a representation of
one of the Mohawk chieftains taken to England by Colonel Peter Schuyler in 1710.
*The Warner House Association, Portsmouth, New Hampshire; Photograph
Society for the Preservation of New England Antiquities,* Boston, Mass.

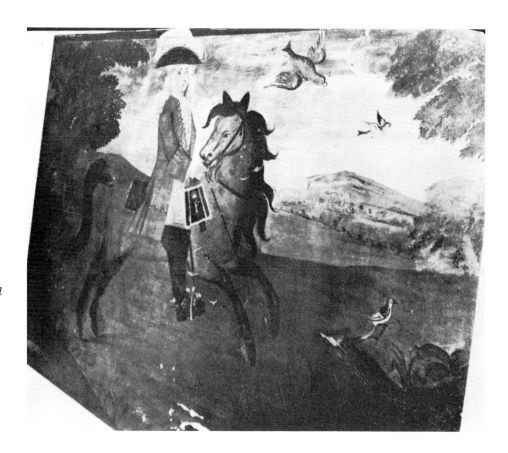

FIG. 125 Hallway of the
McPhaedris-Warner
House
Probably intended to rep-
resent Sir William Pep-
perrell, hero of the cap-
ture of Louisburg in 1745.
*The Warner House Associa-
tion, Portsmouth, New
Hampshire
Photograph Society for the
Preservation of New England
Antiquities,* Boston, Mass.

FIG. 126. Wall Painting
in *Fitchburg, Massachusetts*
By J. H. Warner, 1840.
Painted red drapes with elabo-
rate tasselled edging decorate
the top of each picture.
*Courtesy Mr. and Mrs.
Charles Howard; Photograph
courtesy Fitchburg Art Center,*
Fitchburg, Mass.

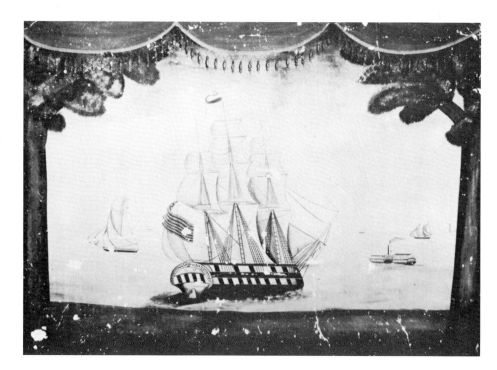

cement British and Indian friendship had been successful. The two figures in the Warner house are based, with some minor changes, on mezzotints after original portraits painted in London by Verelst in 1710. The colors are dark reds and browns, heavily lined with black. The chieftain on the left is Etow Oh Koam, King of the River Nation, Turtle Tribe; that on the right is John, King of the Generethgarich, Wolf Tribe. Although there is no means of ascertaining the date of these paintings, it seems probable that they were done soon after the building of the house in 1716, when popular interest in the event was still evident. The other wall paintings would appear to be by a different hand, dating perhaps in the third quarter of the century, and may well have been the work of the same decorator who did the fine marbleizing on the dining room paneling. While other architectural painting in Portsmouth and Kittery has been noted elsewhere in this book, none of it appears to be comparable to any found in the Warner house, although one would expect to find other examples by the same artists in this vicinity.

Colonial mansions were not the only homes to display painted scenes. Houses with the simplest of exteriors will often surprise one by harboring pictorial decorations of unsuspected merit. In a small cottage on Pritchard Street, Fitchburg, Massachusetts, one room exhibits nineteenth century paintings of a type unrecognized elsewhere. Each wall space is filled with a different subject. These include a knight in armor, an antlered stag confronted by a rattlesnake, and a writing box supporting a dish of fruit. One wall shows a large ship under full sail with a lighthouse and side-wheel steamer in the background (Fig. 126). Over the mantel is a still life composition of books and urns of flowers in the center of which is a scroll bearing the name of the artist, J. H. Warner, and the date August 1840 (Fig. 127). All the pieces are painted with such boldness and vigor that we would like to know more of the artist and to see further examples of his work.

The Drew-Blanchard house on Cove Street in the old seaport town of Duxbury, Massachusetts, has a small entry typical of the Cape Cod cottage, with stairway winding up against a large central chimney. Painted on a blue background at the head of the stairs is a large and striking eagle with outspread wings, measuring almost six feet in length (Fig. 128). This is a conventional representation of the national symbol, holding arrows and olive branch and displaying the well-known motto on a ribbon held in its beak. Competently drawn in shades of brown, it is undoubtedly the work of a ship's painter. Many men did fancy painting of this sort in the small towns along the New England coast. It was a specialized branch of the ornamental field, and was much in demand from 1775 to 1850, while mari-

time commerce was at its height. In 1792 Robert Cowan of Salem billed Elias Hasket Derby 18 shillings for "ornamenting part of the ship Grand Turk, sturn [stern]."[2] In 1831, in Bath, Maine, William M. Prior, a rising young artist, advertised in the *Maine Inquirer*: "Lettering of every description, imitation carved work for vessels, trail boards and stearn mouldings painted in bold style."

Not everyone who lived on the coast, however, wanted ship decorations in his home. In Groton, Connecticut, just outside New London, a large medallion of a horse having delightfully uncertain anatomy occupied the center of one wall. This measured four feet in diameter and was done in distemper in blue, brown, and green (Fig. 129).

One artist who is reported as having traveled through New Haven about the year 1805 is said to have been asked by the occupants of the Ephraim Baldwin house in Woodbridge if he would paint the recent Battle of Trafalgar, presumably as it appeared in his own imagination. This he did, placing it above the fireplace in the ballroom over the ell, and surrounding it with a black painted border. Although much defaced, it is still a striking composition, with a group of ships of the line in extremely close formation on the left. In the foreground two boatsful of men fire at one another in close and deadly combat, and on the right the sterns of three imposing ships were originally drawn in careful detail. The British Jack flies proudly on all the vessels save one which shows the tri-color of France.

"Deception Pieces"

Some other wall paintings of the early nineteenth century fall into a special category which we might call "painting with intent to deceive," or architectural trompe l'oeil. This technique in a more sophisticated form had been widely practiced in Europe for several centuries. In 1560 the Barbaro brothers built the Villa Maser, situated forty miles northwest of Venice, Italy. Palladio designed the stately mansion, while Veronese, the great Venetian painter, adorned its walls with murals in "deception painting" which he carried to its highest degree. Figures peep into the rooms through simulated doorways, and from a painted balcony under the decorated ceiling, a charming representation of the owner's wife looks down on the scene below.[3] The architectural deceptions which appeared in America in the early 1800's were simple and naïve manifestations of the European tradition, but show the originality of the country painter, and an interesting and little-known phase of American interior decoration.

Again it was the ornamental painters south of New York, many of whom had come direct from London or Paris, who led the way in advertising the newest Eu-

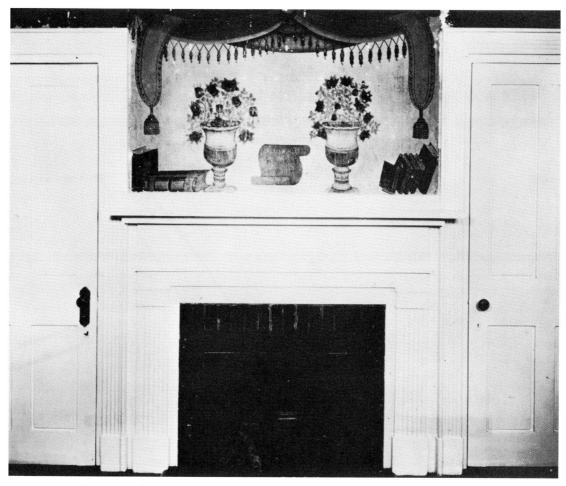

FIG. 127. OVERMANTEL Decoration on Plaster, *Fitchburg, Massachusetts*
Signed and dated on scroll *Painted by J. H. Warner, Aug. 1840.*
Courtesy Mr. and Mrs. Charles Howard; Photograph Courtesy Fitchburg Art Center,
Fitchburg, Mass.

FIG. 128. Plaster Painting in Upper Hall, DREW-BLANCHARD HOUSE, *Duxbury, Massachusetts*
Probably done by a local ship's painter.
Courtesy Dr. Dwight Fowler
Photograph courtesy Winsor White

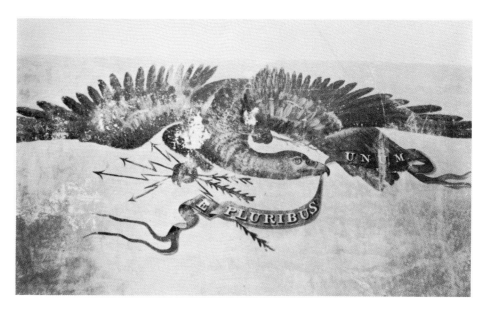

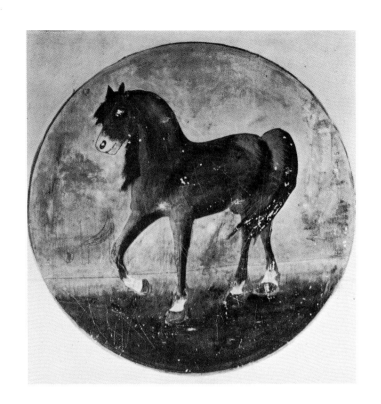

FIG. 129. PLASTER PAINTING from *Groton, Connecticut*
This medallion, measuring four feet, occupied the center of one wall.
Photograph National Gallery of Art.
Index of American Design
Photograph by Karl La Roche

FIG. 130. OVERMANTEL PICTURE on Plaster, *Worthington Ridge, Berlin, Connecticut*
Rings, hooks, nails, and molded gold frame, all are cleverly simulated by paint. The view is foreign, and was probably inspired by an engraving.
Courtesy Mr. and Mrs. R. C. Merwin
Photograph National Gallery of Art.
Index of American Design
Photographed by Karl La Roche

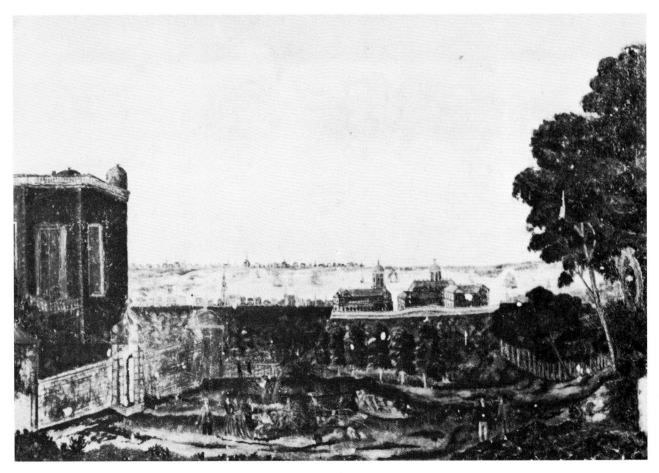

ropean styles. In 1771 John Winter announced in the *Pennsylvania Chronicle:* "Painting the inside of houses to represent stucco, fret or carved work."[4] In 1792 one Beaucort, Member of the Academy of Painting, Sculpture, and Civil and Naval Architecture of Bourdeaus [*sic*], stated in the *General Advertiser* of January 3rd that "He understands the art of ornamenting, in the newest style and taste, apartments, by painting to imitate either architecture, baso-relievos, flowers, or the arabesque style."[5] Other decorators advertised simply "deception pieces." In Charleston, South Carolina, "Deceptive Temples, Triumphal Arches, Obelisks, Statues &c, for Groves or Gardens"[6] were painted to simulate buildings and statuary.

Wallpaper also followed the fashion for trompe l'oeil. In 1769 Plunket Fleeson, American paper manufacturer, anounced that he made "papier-mâché, or raised paper mouldings for hangings, in imitation of carving, either coloured or gilt."[7] In 1814 Joseph Dufour of Paris brought out his scenic paper "The French in Egypt," representing the victory of the French over the Turks at Mataria on March 20, 1800. One of the most interesting things about the design is the white balustrade at the bottom of each strip of paper, which gives one the impression of seeing the colorful panorama from a raised balcony.[8]

In New England deception painting, if not as opulent as in the south, was equally unusual. It is an amusing coincidence that in the Villa Maser framed landscapes hanging from simulated hooks were painted over the doorways of one of the bedrooms. Two hundred and fifty years later a decorator in a small Connecticut town conceived the same idea, and proceeded to put it to good effect in at least three houses in Berlin, Connecticut. In a square old mansion on Worthington Ridge one sees on entering the parlor a landscape enclosed in a heavy gold molding, apparently hanging from rings supported by handmade nails (Fig. 130). Close inspection is needed to prove that this is not a framed picture on canvas. The scene, which includes figures strolling in a walled garden, with imposing buildings and a seaport town in the background, may have been inspired by a scenic paper or a foreign engraving.[9] A dainty freehand border was found around the windows and under the cornice in the same room, which consisted of diamonds in greenish-blue enclosing sprays of rosebuds in shades of pink. Above the diamonds was a pale blue band, with a horizontal stripe below in dark blue, on which was a linear design in black. A looped border was also found in the hall but was not preserved. Another house in the town had bucolic landscapes in oval frames painted on the wall, the only remains of which now is a photo in the Index of American Design, and several other homes were

evidently decorated in the same manner. Berlin was a center for much activity during the 1820's, when women of the neighborhood were in great demand for the expert painting of tinware. The name of one general painter is also found in the annals of the town, one Hiram Mygatt, who is termed an "ornamental carriage painter." He was born in 1795, married Anna Booth on July 13, 1823, and died in Berlin on October 20, 1831. These wall decorations, however, probably date from the 1790's and are by an unknown hand.

The Abiel Griswold house in Windsor, Connecticut, has already been mentioned in Chapter VII, and the room illustrated in Fig. 88 was entirely decorated by the clever use of paint, which simulated wallpaper, wainscot, and pictures in an otherwise plain interior. In 1793 James Morrison informed his friends in the *Maryland Journal* that he was prepared to do "Wall Painting, mock Pannelling to imitate Wainscot . . . in the neatest manner."[10] It is therefore interesting to find a room which actually illustrates "mock pannelling," quite a bit of which was done, and to which we shall refer again later in this chapter.

Public meeting places such as churches, taverns, ballrooms, and Masonic halls were frequently the objects of special attention by the traveling artist, and it is in such buildings that some of the most unusual painted decoration has been found. Much of this falls into the class of deceptive painting, particularly in the churches and Masonic meeting rooms where especial enrichment of an otherwise plain interior was desired. The *History of Windham County* gives an account of the new church built in Thompson Village, dedicated in 1817 to take the place of the old one damaged in the great gale of September 25, 1815. Elias Carter had charge of the work which he carried out in accordance with the plans presented by Ithiel Town. "Harvey Dresser of Charlton, furnished the painting below the lofty pulpit, which so artfully simulated a stairway with curtained drapery that it was a perpetual wonder to children that Mr. Dow did not make use of it." The substitution of a painted stairway for an actual flight may be explained by the fact that the subscribers to the new church agreed that a sum not to exceed $6,000.00 should be expended on the building.[11]

High up on the Sheepscot River in Maine is the small settlement of Head Tide, a part of the town of Alna. It is now a tiny community of early white painted houses, in one of which was born the poet Edwin Arlington Robinson. Once, however, it was a prosperous center of lumber and grist mills and of ship building activity. The trim church of 1838 with its Revere bell is a delightful example of Victorian Gothic architecture with pointed windows and square steeple. Inside has been preserved without visible change a painted interior of

unusual interest. The old slip pews are grained in bird's-eye maple with mahoganized rails. The gallery pillars, pulpit platform, and stairs are marbleized, and the frame of the long pulpit bench is mahogany-painted in excellent imitation of the Empire woodwork of its period. The most striking feature, however, appears on first sight to be a tall window with conventional drapery placed behind the pulpit. Closer observation reveals that within an actual wooden frame a cleverly simulated window with white cross bars and small panes is painted on the flat plaster wall. Red draperies bordered with embroidered gold edging are realistically looped up to real brass tie-backs attached to the casings. Behind the window panes green slat blinds are painted closed to complete the illusion, which when the colors were fresh and new must have been a veritable "deception piece."[12]

In Hampton Falls, New Hampshire, the Unitarian-Congregational Church, built circa 1832, contains an entirely different type of architectural ornamentation. There a plain interior has been skillfully embellished with simulated wall panels composed of moldings drawn in delicate shades of gray and oyster white. The wall in the rear of the choir loft is painted with a decorative design embodying a lyre with scrolls and foliage, while the ceiling also exhibits intricate brush work painted to imitate plaster. In this little edifice the skill of an unknown decorator transformed the bare interior into a place of dignified beauty for its congregation. Saint John's Church in Portsmouth, New Hampshire, exhibits rather more elaborate painting of simulated panels, cornice, and moldings, but was probably not by the same artist, who is said to have been one Daniel Shepard of Salem.

Unfortunately, local records are usually unrevealing concerning the identity of the men who were responsible for this type of work, but occasionally a pertinent reference will be found. Benjamin J. Severance of Northfield, Massachusetts, advertised in 1823: "painting of Meeting houses with internal ornaments."[13] From only a limited investigation of churches built in New England during the first half of the nineteenth century, it appears that a complete survey of these little Greek Revival buildings from the point of view of painted "internal ornament" would be a valuable and rewarding study.

Masonic Meeting Places

Some unusual painted decoration consisting of Masonic symbols was used in the meeting rooms of many of the early Masonic Lodges. While much of this work has unfortunately disappeared, some interesting descriptions of such rooms are worth noting, and a few examples still survive.

In *The Centennial, One Hundredth Anniversary of the Most Worshipful Grand Lodge of Connecticut*, are descriptions of several decorated Lodge rooms in that state. King Solomon's Lodge, Woodbury, met from 1797 to 1824 in "a new hall prepared for its use in the house of widow Damaris Gilchrist, which was subsequently used as a ballroom to Kelley's Hotel. Tradition says it was fitted up in magnificent style. Upon the ceiling were delineated the 'starry decked heavens,' with the all-seeing eye, and other Masonic emblems." Eastern Star Lodge, No. 44 of Lebanon, chartered October 17, 1798, held its meetings until its removal to Windham in 1809 in an old house in the vicinity of Goshen. Part of this was fitted up by Joseph Metcalf as a Lodge room which ran the entire length of the second story. "The walls are painted with curious birds of extremely variegated plumage, sitting in a tangle of vines which nearly cover the white background. Here and there is a scene, presumably scriptural. Just below the ceiling is a painted curtain festooned with cord and tassel." A wooden tablet, three by four feet, was over the mantel, painted with various Masonic symbols. This was purchased (before 1890) by E. Goldsworthy of Providence and exhibited at the Freemason's Repository.[14]

One Masonic meeting place still in a good state of preservation stands on U.S. Route 20 in the locality now known as New Lebanon, New York, just west of Pittsfield, Massachusetts. Unity Lodge, described by Jean Lipman in the *Magazine Antiques* for May, 1949, was chartered September 15, 1788. One of the earliest lodges in New York State, it is still active as Unity No. 9. In the gambrel-roofed house where meetings were held from 1795 to 1850, the Lodge room occupies the entire third floor. Elisha Gilbert built the mansion in 1794 and undertook to provide a meeting place for his Masonic brothers, toward which, according to tradition, the Lodge agreed to pay $800.00. The four walls of the long room are painted with a sky blue background and designs in buff and brown (Fig. 131). Among the designs are King Solomon's Temple, the Mosaic Tablets, the Beehive, and other symbols. Over the fireplace at the end of the room is a tall panel showing a globe supported by a column between draped curtains. The decoration is said to have been done by a wagon painter named Mason, soon after the house was built, although an early nineteenth century date seems more likely on the basis of style. Probably originally executed in tempora, it was restored in oil in 1890. The domed ceiling, once embellished with a Starry Canopy surrounding an All-Seeing Eye, was in too poor condition to preserve.

In Shelburne, Massachusetts, on Bardwell's Ferry Road (once the old highway to Albany), stands a three-story brick mansion built by Solomon Smead in the

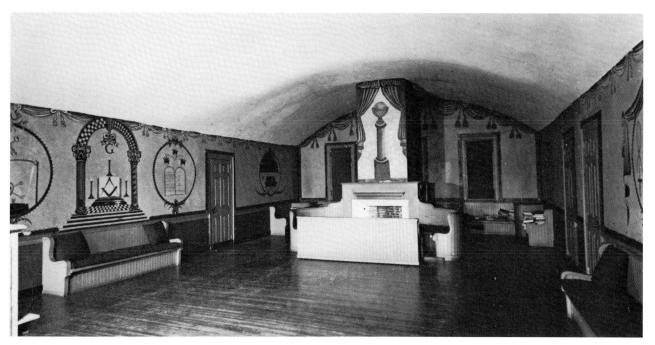

FIG. 131. Masonic Meeting Room in the ELISHA GILBERT HOUSE, *New Lebanon, New York*
Unity Lodge No. 9 met here from 1795 to 1850. The domed
ceiling was also once embellished with Masonic symbols.
Photograph courtesy Jean Lipman

FIG. 132. Masonic
Decoration on Plaster in
Original Ballroom, FULLER
TAVERN, *Berlin,
Connecticut*
Before restoration. The
frame, ring, and handmade
nail are cleverly simulated.
*Courtesy Dr. Dwight E.
Wilson
Photograph National Gallery
of Art. Index of American
Design
Rendering by Martin Partyka
and Michael Lauretano*

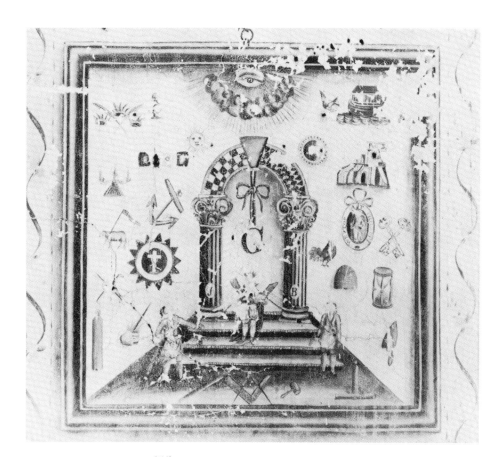

early nineteenth century. The third floor contains a vaulted ballroom which still retains its original box seats and fiddler's bench. Despite a modern coat of yellow calsomine, the room so strongly bespeaks the vanished presence of onetime decoration, that the owner kindly allowed us to do a slight amount of circumspect investigation. At the northerly end of the room, the date 1812 appears in an oval which has escaped the recent renovation. Here we scraped a small area of the plaster wall and found beneath the present paint indications of a deep blue undercoat which may have been intended to represent the Night Sky. On the center of the south wall a sunburst in red and blue appeared on a blue ground, and we felt that further investigation would probably reveal still other symbols of Masonic origin. Further evidence of the presence of a decorator in this house is shown by a fine freehand painted floor in one of the upper chambers. As a matter of fact, in Northfield, Massachusetts, only a few miles from Shelburne, lived Benjamin J. Severance, ornamental painter who advertised in 1823 in the *Franklin Herald and Public Advertiser* that "he will execute house painting, sign and ornamental painting in all their branches, Masonic painting, designs for Masonic and other diplomas."

In Bradford, New Hampshire, stands the Joshua Eaton house with stenciled walls, and also scenic frescoes ascribed to Rufus Porter. The decoration has been described and pictured by its owner in the *Magazine Antiques* for July, 1948. It is traditionally believed that the first Masonic meeting in the neighborhood was held in the frescoed room in 1818; and in a landscape composition over the mantelpiece the square and compass are incorporated as part of the design.

In the old Fuller Tavern at the south end of the town of Berlin, Connecticut, is another composition by the same artist who did the "deception piece" over the mantel in the house on Worthington Ridge (Fig. 130). This now appears between two windows in a rear east bedroom which was the end of the original ballroom before the space was partitioned to make modern accommodations. A varied assortment of Masonic symbols makes up the composition, which is framed in a simulated black and yellow molding suspended by a painted ring from a sturdy hand-hammered painted nail (Fig. 132). The symbols are executed in blue, green, brown, and red on a buff ground, the whole picture having been recently retouched in oil by a local painter. In this tavern the Berlin Masonic Lodge was chartered on October 13, 1791, and it is believed that the room was decorated some few years after that date. Here also a graceful freehand vine of rosebuds surrounds the windows and tops the walls.

When paper was recently removed from the walls of the upper northwest chamber of the General Salem Towne house in Charlton, Massachusetts, scenic murals were discovered on the plaster consisting of tall pine trees outlined against a background of rolling hills. The painting was expertly done in oil. A Masonic Lodge was chartered in Charlton in 1796 of which General Towne was a prominent member, and he offered the large front room in his newly erected mansion to be used as a meeting place. The ceiling of this room was appropriately decorated, according to an old account, with a sprinkling of golden stars surrounding the All-Seeing Eye.[15]

In Allen's *Early American Wall Paintings* are description and illustrations of painting in the Hubbard house, which was built on the Hartford Turnpike in Cromwell, Connecticut, in 1794. This building was used as a tavern from 1808 to 1833. The ballroom is stenciled, and over the fireplace in another room a stenciled urn holding leaves and berries is surmounted by the Masonic square and compass painted in blue and green on a white background.

Other early meeting rooms said to contain painted Masonic symbols are Eureka Lodge, Portsmouth, and the Masonic Lodge in Warren, both in Rhode Island; the old inn at Cheshire, Massachusetts; and lodges in Woodbury, Connecticut, and Aurora, New York.[16]

REFERENCES

[1] Prime, *Arts and Crafts, 1786-1800*, p. 301.

[2] Derby Family Papers, XXXI, 51.

[3] Description and photographs of the Villa Maser appeared in *Life Magazine* for July 24, 1950.

[4] Prime, *Arts and Crafts, 1721-1785*, p. 14.

[5] Prime, *Arts and Crafts, 1786-1800*, p. 3.

[6] Prime, *Arts and Crafts, 1721-1785*, p. 13.

[7] McClelland, *Historic Wall-Papers*, p. 245.

[8] *Ibid.*, p. 306. Another interesting example of wall paper trompe l'oeil was Dufour's venetian blind printed in pale green on a black ground, illustrated, p. 197.

[9] Architectural wall papers, complete with simulated wood carving and framed landscapes, were popular during the late eighteenth century. One with a scene after Vernet is illustrated in McClelland's *Historic Wall-Papers*, p. 225.

[10] Prime, *Arts and Crafts, 1786-1800*, p. 305.

[11] Ellen D. Larned, *History of Windham County, Connecticut*, II, *1760-1880* (Worcester, 1880), 440.

[12] For full description and illustrations of the church at Head Tide see Frank Chouteau Brown, "The Congregational Church at Head Tide, Maine," *Old-Time New England*, XXX, 3 (Jan. 1940), 95-100.

[13] *Franklin Herald and Public Advertiser*, Greenfield, Mass., Sept. 9, 1823.

[14] Joseph K. Wheeler, ed., *The Centennial* (Hartford, 1890), p. 309. A copy of this book is owned by the New Haven Colony Historical Society.

[15] The Towne house is eventually to be re-erected at Old Sturbridge Village.

[16] For information concerning the Masonic Lodges at Portsmouth and Warren, Rhode Island, I am indebted to John Perkins Brown; at Cheshire, Mass. to Mr. and Mrs. Edward D. Andrews. Photographs of the interiors of the Lodge rooms in Woodbury, Conn. and Aurora, New York are in the Historic American Buildings Survey, Library of Congress, Washington, D. C.

Chapter X

Scenic Panoramas
"Not in Perfect Imitation of Anything"

URING THE EARLY nineteenth century scenic wallpapers, engraved in France from wood blocks, made their appearance in America. They were sent across the ocean in small sheets which were numbered, and eventually assembled by means of a chart. Intended to cover the entire room in a continuous scene without repetition, they were generally used above a chair rail or dado. Here again the traveling artist offered a substitute in the form of painted decoration to those who could not easily procure the expensive French imports, and panoramas on plaster walls still adorn a number of houses in New England and neighboring states.

We have already given in Chapter III details of the career of Michele Felice Cornè who came to Salem, Massachusetts, in 1799 in the Derby ship *Mount Vernon*. As well as overmantel landscapes, fireboards, and ship pictures, Cornè did some outstanding scenic frescoes in Salem and elsewhere. Like his landscapes and marines his murals cannot be classed as primitive Americana in the manner of most of the wall painters, but are executed with the practised hand of the competent professional decorator.

On the grounds of the Essex Institute in Salem stands a small building which was originally the cupola of the Pickman-Derby-Brookhouse mansion at 70 Washington Street. This house was purchased by Elias Hasket Derby from Benjamin Pickman, Senior, in 1782. On the inside plaster of the domed roof is painted a marine panorama, said to represent the fleet of Derby ships. This is accepted as the work of Cornè, and is well worth a visit (Fig. 133). At 393 Essex Street are some fine scenic panoramas by Cornè which are illustrated in *Early American Wall Paintings*. These were not painted on the plaster itself, but on thin paper applied directly to the walls. The effect, however, is of fresco rather than wallpaper.[1]

Cornè left Salem about 1807 and sojourned for a few

years in Boston where it is said he executed murals in the John Hancock and other mansions. During 1812-1815 he did a fine group of scenes in the Sullivan Dorr house in Providence, Rhode Island, and these he painted directly on the plaster. The panoramas cover the walls of the parlor and the upper and lower halls (Fig. 134). They comprise the romantic Italian scenery with which Cornè was familiar, and which was popular on the early nineteenth century French papers from which he undoubtedly derived inspiration.[2] Cornè took up residence in Newport, Rhode Island, in 1822 where he lived until his death in 1845, but it is a disappointing fact that little of the work which he did there survives.

In the Redwood Library, however, are several small sketches by him of figure groups obviously intended to be used in wall designs. The outlines of the drawings are formed by a series of tiny perforations making a type of stencil or transfer. Powdered charcoal was the medium usually dusted through such holes; it formed an outline on the plaster which could either be drawn, or filled in with color. By this means a large composition could be accomplished much more quickly and easily than when painted entirely freehand. This technique also resulted in a design less stiff than that produced by a hollow-cut stencil. One of these groups of figures, somewhat smaller in size, may be recognized in one of the murals in the Sullivan Dorr house[3] (Fig. 135).

Deerfield, Massachusetts, was a center of activity for several different decorators during the early years of the nineteenth century. Although their names are not to be found in any written history of the town, examples of their work remain to prove that the residents loved pattern and color and welcomed the traveling artist. Two examples of scenic frescoes are recorded, one of which, in the lower northwest room of the Allen house, disappeared some time ago. Another is in the

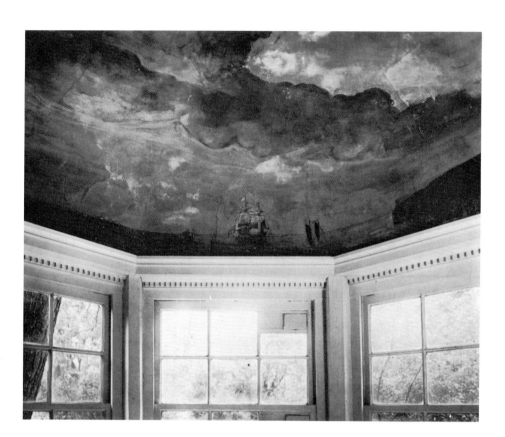

FIG. 133. Plaster Ceiling of
the Cupola of the PICKMAN-
DERBY-BROOKHOUSE HOUSE,
Salem, Massachusetts

No longer standing. Cupola
preserved at the Essex Insti-
tute, painting of the Derby
ships attributed to Cornè.

Essex Institute, Salem, Mass.
*Photograph Society for the
Preservation of New England
Antiquities*, Boston, Mass.

FIG. 134. Wall Painting in
the SULLIVAN-DORR HOUSE,
Providence, Rhode Island

By M. F. Cornè. Note the
elaborately marbled dados.
View is of the Bay of Naples.

*Photograph The
Magazine Antiques*

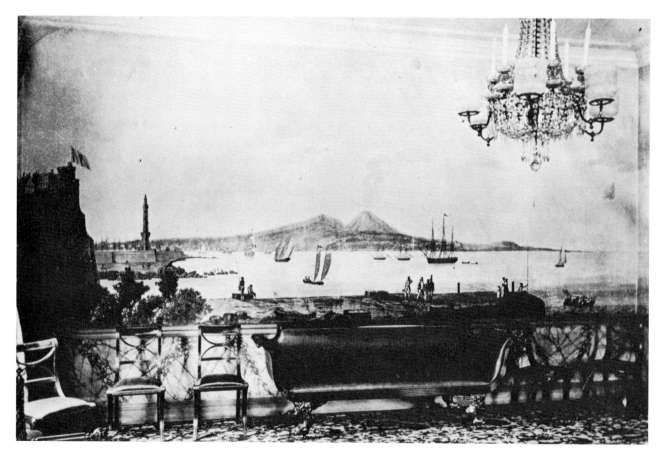

FIG. 135. DRAWING IN INK of a Group of Figures for use in a Wall Painting
By M. F. Cornè. The figures are outlined by tiny perforations making a type of stencil. This group is slightly larger than that used in one of the murals in the Sullivan-Dorr house; see Fig. 134.
Redwood Library, Newport, R. I.

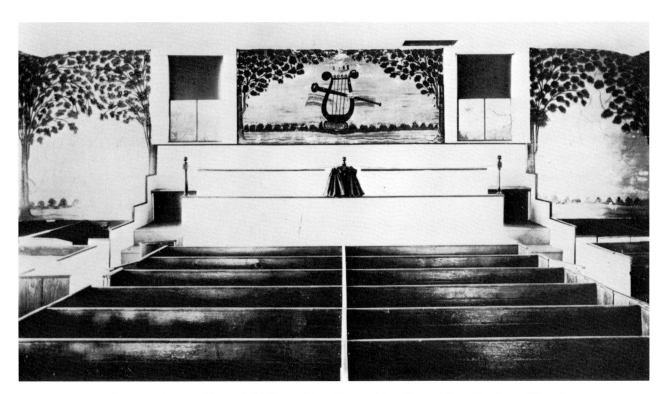

FIG. 136. TOWN HALL, *Middleton, New Hampshire.* Upper Floor Used as a Church
Painting by John Avery, 1841.
Photograph Society for the Preservation of New England Antiquities, Boston, Mass.

front entry of the old Saxton Tavern, opposite the Frary house, which is now owned by Deerfield Academy. These scenes are nearly obliterated owing to many repaperings, but an article published thirty-five years ago describes a large waterfall with drinking stag on the side wall of the stairway, with lakes and distant mountains above.[4] A dado under the upper windows has palm branches in the form of looped garlands with red roses or pomegranates in the center of each. This motif appears to be unique in combination with a landscape fresco, and suggests the hand of a man who also did freehand repeat patterns with conventionalized swag borders.

In New Hampshire there are traces of scenic murals by several different artists. In Loudon two houses have overmantel pictures painted on plaster depicting country river scenes. The hallway of one is painted with romantic motifs among which is a large castle reminiscent of the schoolgirl art of the first half of the nineteenth century.

The *History of the Town of Candia* gives an account of a young man named Stephen Badger who is said to have come to Candia from Amesbury, Massachusetts, in 1825. He painted landscapes containing mountains, lakes, figures, and animals, including a sea serpent gliding over the water which may have been occasioned by a similar legendary reptile which appeared off Gloucester, Massachusetts, in 1817 and again in 1819. Badger taught the art of mural painting to another Candia resident, one Asa Fitts, who painted two rooms in the home of his brother-in-law with bright unshaded trees of equal height.[5]

Work of John Avery

In the vicinity of Wolfeboro, New Hampshire, are several buildings which contain the work of John Avery who was born in Deerfield, New Hampshire, in 1790. After his marriage in Meredith to Hannah Prescott, the couple moved to South Wolfeboro, where John and his brother Charles were both engaged in the painting business.

In the Hersey-Whitten house in the township of Tuftonboro, the front entry and stairhall and the lower southwest room are frescoed but were later covered with wallpaper which is still in the process of removal. Above the chair rail in the south-west room are large-scale, boldly painted scenes comprising a village green surrounded by houses and a church, set behind a high iron fence. Figures and animals abound, including an enormous bird perched on a branch eating cherries. Under the rail different scenes are set off by scrolls, quite different in style from the work of other decorators. In the front entry a freehand border of grapes and vines frames the door, and on the wall fac-

ing the stairs a man in a blue and buff uniform, with scroll in hand, rides a dapple gray horse, while his aide follows deferentially in the background. The colors are still remarkably fresh and bright, and the general effect is both striking and decorative, although the execution is decidedly primitive. The scrolls and flourishes, which remind one of contemporary penmanship, substantiate a date in the vicinity of 1840 which is ascribed locally to these murals. Presumably Avery also did graining, as it appears in at least two of the buildings which contain his frescoes. In the Whitten house the floors of the painted room and entry are marbled with black veining on a gray background, and the stairs are decorated with an attractive pattern which simulates a painted carpet.

Among several other houses in the neighborhood painted by Avery is the old Chamberlain Inn in Brookfield, where the hall is Avery's work; another house is in Wolfeboro and was pictured in the *Magazine Antiques* for June 1938.[6] Still a third is the Stoddard-Gilman house on the road from Wolfeboro to Sanbornville which stands in a commanding position overlooking Wentworth Lake. On this tract of land Governor John Wentworth, prior to the Revolution, built an incredible summer estate in the wilderness, and the Gilman house is said to have been erected by him in 1780 as an academy building. The lower southwest room is decorated by Avery with murals which resemble those in the Whitten house. A large building of fanciful turreted architecture is so reminiscent of similar structures which appear in the schoolgirl pictures of the 1830's and 40's that the derivation of both may be easily discerned in the current art instruction books which flooded the market at that time. On another wall of this room Avery has forsaken decorative fancy in favor of unexpected realism by depicting a building bearing the inscription: "Concord State House." One wall where the old fireplace was removed has been repainted in recent years to conform to the rest of the room.[7]

At "Four Corners" in the little town of Middleton, New Hampshire, stood at one time two buildings decorated by Avery. One of these was the Scates-Shapley Tavern which was built in the late eighteenth century and destroyed by fire in 1929. The walls of the staircase hall were painted with the branching trees and conical hills typical of Avery's work.[8]

Near the site of the Tavern stands a small building, which was moved a short distance to its present position some years ago. At that time a new lower floor was constructed to serve as a town hall, which raised the interior of the old church to a position on the second floor. Here, still in good condition, are some of the most interesting of Avery's murals. Around the sides

of the large room, which still retains its unpainted pews, are tall, leafy trees reaching from floor to ceiling without the distraction of animals or figures which the artist may have deemed unsuitable for a place of worship. At the east end two short flights of steps, grained in gray with an original design resembling pea pods, lead up to a low platform which supports the simple pulpit. On the plaster wall behind the pulpit, so arranged that they enframe the preacher, are handsomely painted red draperies with tassels gracefully looped around simulated metal tiebacks. The wall at the opposite end of the room is embellished with a large lyre and trumpet placed against a staff of musical notes. Above this is the date 1841[9] (Fig. 136). A self-portrait of John Avery, painted on a wood panel, is owned by the Old Home Association and hangs in a house near the church. It shows a young man in a black coat with high collar and ruffled stock, and is framed in a mottled molding probably made by the artist himself.

Vermont has a well-known example of frescoing in the Captain Dan Mather house at Marlboro, where the central hall and lower southeast room are painted with landscapes. These are crudely done with slight attempt at perspective and show no buildings or figures of special interest.[10] "Pen work" scrolls similar to those used by Avery are reminiscent of those seen on painted tinware, and suggest a period between 1830 and 1850 for these murals. Upstairs three bedrooms are nicely stenciled in red, green, blue, and a strong yellow on a pink background, in familiar patterns which may be the work of Moses Eaton. In any case, it seems improbable that they are by the same man who did the frescoes. Of considerable interest is the graining found in the frescoed room, probably done by the same decorator. The baseboard is marbleized in a large irregular design, bluish-gray on white, and the door panels and dado are mahogany-grained in a fine feather pattern.

Outside of New England similar frescoes are occasionally found. In the Hibbard house in Ithaca, New York, an unusual group of murals by an unknown artist was discovered in the early 1890's when wallpaper was removed from the parlor walls. They were photographed at that time, and although they were again covered with paper, they have been described and illustrated in an article by Esther Stevens Brazer in the September, 1945 issue of the *Magazine Antiques*.[11] On one wall the artist presumably depicted Vesuvius in process of eruption, accompanied by clouds of black smoke and lava streaming down the mountainside on the defenseless town below. In other parts of the room the Erie Canal figures prominently (Fig. 137), which indicates the probability that the painting was done shortly after the opening of the waterway in 1825.

In Woodford County, Kentucky, about fifteen miles west of Lexington, are three houses containing murals which are attributed to one Alfred Cohen, a native of southern France who emigrated with his two brothers from Marseilles probably in the early 1830's. Done in oil on plaster, the rural scenes make a most interesting comparison between the work of this French artist and New England frescoes of the same period. One fourteen-foot panel in the parlor of the General James McConnell house, Versaille, Kentucky, is topped by a familiar wide border of red drapery swags on a gray background. Rectangular panels below the chair rail are marbleized in shades of tan. The views are a combination of ancient and contemporary architecture juxtaposed with the wall painter's usual happy disregard for uniformity or perspective. The general effect, however, is very similar to some of the New England wall paintings, in which the buildings are European in style.[12]

Rufus Porter and His Followers

By far the largest number of scenic murals painted in New England during the first half of the nineteenth century, however, were done by a man who in every respect lives up to our idea of the typical Yankee jack-of-all-trades. For much of the following information I am indebted to Jean Lipman who has done extensive research on the life and work of Rufus Porter.[13]

Rufus, son of Tyler and Abigail (Johnston) Porter, was born on May 1, 1792, in West Boxford, and after his first eleven years spent in this small Massachusetts community he moved with his family to Flintstown, now Baldwin, Maine. Thereafter he did not permanently settle down for any length of time during the ninety-two years of his long life. His only formal schooling, after the elementary years, was six months spent at Fryeburg Academy during parts of 1804 and 1805, after which he eventually found his way to Portland. There for a time in 1810 and 1811 he became a house and sign painter, until he left this trade to join the militia in West Boxford during the War of 1812.

As a house painter in the early years of the nineteenth century, young Porter learned the rudiments of many types of decorating, and the fact that stenciling, graining, and marbleizing all appear at one time or another in the houses which contain his frescoes indicates that he was a typical painter-decorator of his day. He went further, however, and during the 1820's perfected a technique for "Painting of Walls of Rooms" which he practiced throughout New England, thereby producing the fine scenic panoramas which may still be seen in many old homes in Massachusetts, New Hampshire, and Maine. Traveling by stage coach and on foot he journeyed south as far as Baltimore in 1819 and 1820, where he painted portraits, cut silhouettes,

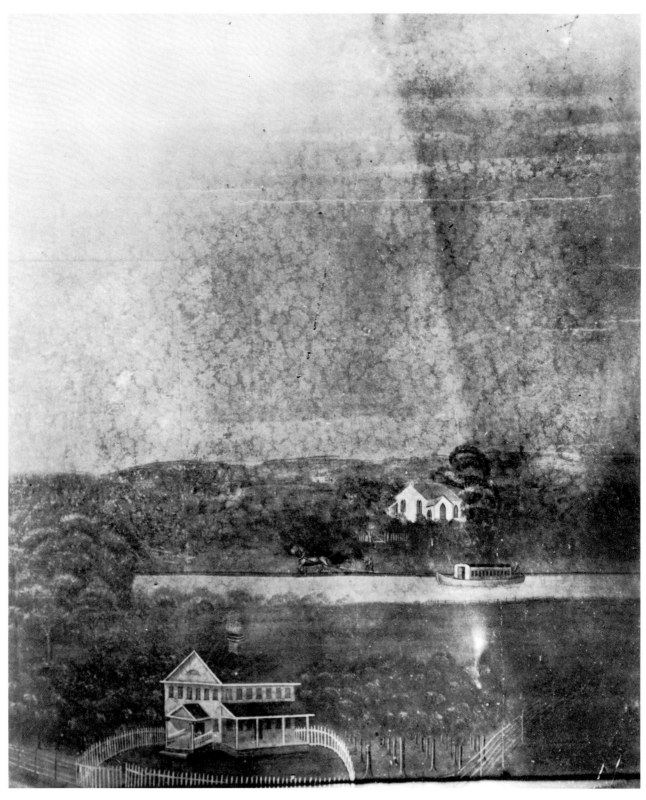

FIG. 137. Parlor of the HENRY HIBBARD HOUSE, *Ithaca, New York*
Painted with frescoes some of which depict Niagara Falls, The Erie
Canal and Mount Vesuvius. Probably painted soon after 1825.
Photograph The Magazine Antiques

and thereafter intermittently produced various ingenious inventions which varied from a camera obscura to small working models of an airship.

In 1825 Porter published in Concord, Massachusetts, a small book whose title page reads as follows: *A Select Collection of Approved, Genuine, Secret and Modern Receipts for the Preparation and Execution of Various Valuable and Curious Arts as Practised by the Best Artists of the Present Age.* There were at least five more printings of the book in Concord, New Hampshire, before the end of 1826 with some additions and deletions, and the title was changed to *A Select Collection of Valuable and Curious Arts and Interesting Experiments.*[14] Here, in addition to many ingenious recipes for such things as "To change the colour of a horse from white to black" and "To Kindle a fire under Water," Porter gave his first set of directions for "Landscape Painting on Walls of Rooms." He was to amplify these in later articles in the *New York Mechanic* and the *Scientific American,* both of which he edited and published in 1841-42 and 1845-47, respectively.[15]

Scenic panoramas of the sort which Porter began to paint in 1824 had begun to be fashionable in America in the early nineteenth century in the form of imported French wallpapers. It has been estimated by Nancy McClelland in *Historic Wall-Papers* that over two hundred examples of this period are still to be found in this country, and it seems plausible that Porter's introduction to this type of wall treatment came on a visit to one or another of the houses in or near the seaport towns where he may have traveled. The well-known "Captain Cook" paper was printed in France by Dufour and described by its maker in a booklet issued in 1804-05, and there is a set in the old Ruel-Williams house in Augusta, Maine. Another famous paper which might have been seen by a traveler in Maine was the "Monuments of Paris," issued in 1815, of which a set is recorded in Bucksport. The "Bay of Naples," 1815-1820, was used in South Berwick and Kennebunk, as well as in towns in Vermont, New Hampshire, and Massachusetts.

The manufacture of American-made papers was also going on apace, and some scenic papers featuring American views were made in this country in the early nineteenth century. In 1813 Moses Grant, Junior, advertised in Boston: "Fancy Landscape Paper Hangings . . . have just completed additional figures of the present fashionable Hangings for Rooms, obviating the objection of too much sameness, by introduction of a variety of views. The Design, Paper, Colours and Labour are American."[16] Special scenic papers for hat boxes became popular at this time, some of which depicted on a small scale scenes not unlike those used by Porter. One such box, covered with a paper undoubtedly issued in celebration of the opening of the Erie Canal in 1825, shows the environs of the canal with the caption "Grand Canal." Tall poplar trees closely resembling those used by the mural painters are used with decorative effect. On another bandbox, of which a rendering is owned by the Index of American Design, houses of the Porter type sit atop rolling hills with similar spreading trees placed in the foreground. Even the large squirrels beloved by Porter appear on bandbox papers.

If the use of scenic panoramas for walls of rooms was introduced to New England by means of imported paper hangings, it remained for Rufus Porter to adapt the fashion to the use and taste of the average man. While wealthy folk in cities could afford imported luxuries, they were both prohibitive in price, and otherwise unsuitable, for many rural interiors. Insisting that "if there were a competent supply of artists who could accommodate the public with this kind of painting, it would nearly supersede the use of paper hangings,"[17] Porter set out in 1824 on a tour of New England which was to continue intermittently for twenty years, and to leave in its wake scores of houses whose spontaneous designs and fresh colors still gladden the eye after more than a century. Painting with a technique far superior to most of his contemporaries, he did not try to inject into his murals the exotic foreign flavor of the wallpapers from France. Instead he chose with unerring taste to paint the walls of New England farmhouses with American scenes. Discarding the imaginative quality of the panel painters, he simplified his designs until his patterns have the direct appeal of a wood cut. Yet they are for the most part composite pictures rather than literal views of a given locality. In his series of seven articles on "Landscape Paintings on Walls of Rooms" which appeared in 1846 in Volume I of the *Scientific American,* he makes an interesting statement regarding his views on this point: "In finishing up scenery, it is neither necessary nor expedient, in all cases, to imitate nature. There are a great variety of beautiful designs, which are easily and quickly produced with the brush, and which excel nature itself in picturesque brilliancy, and richly embellish the work, though not in perfect imitation of anything."[18]

One is led to believe from his writings that Porter was both a dexterous and speedy workman, and his walls betray both sureness and vigor. He knew all the tricks of the trade, of which the following note from the *Scientific American* is an amusing sidelight:

If there appears any break, or imperfect match between the sections [of a mural], he has only to build a tree or bush over it. So in regard to any defect in the ground painting on any

part of the walls, a ready remedy is always found in trees, bushes or clouds. . . . We have seen an artist in this branch paint the entire walls of a parlor, with all the several distances, and a variety of fancy scenery, palaces, villages, mills, vessels &c., and a beautiful set of shade trees on the foreground, and finish the same complete in less than five hours.[19]

This last observation undoubtedly referred to the artist himself!

There is some evidence that Porter made a trading voyage to Hawaii and the northwest coast between 1817 and 1819, and it is possible that the influences of that voyage may be discerned in the tropical foliage, exotic trees, and smoking volcanoes which appear in some of his frescoes. Similar details, however, were used by other mural painters and they were prominent features of the foreign wallpapers which adorned some of the parlors with which he must have been familiar. The "Bay of Naples," for instance, with its smoking Vesuvius, was to be found in several houses in New Hampshire and Maine.

In 1824 Rufus Porter was thirty-two years old. He had been married for nine years to Eunice Twombly of Portland, Maine, and had had four sons, two of them twins. From this time until her death in 1848 his wife lived in Billerica, Massachusetts, which town was Porter's legal residence for twenty years, although he only seems to have appeared there during intermittent pauses in his travels. Having tried his hand at various types of decorating, including house, sign, sleigh, and drum painting, as well as the taking of likenesses and the cutting of silhouettes, he now embarked upon the phase of his varied career by which he was to be remembered long after his numerous inventions had been lost in obscurity. The greater part of his murals are believed to date between 1825 and 1840, when his interest veered for a time to journalism, and he began to edit and publish the *New York Mechanic, Scientific American,* and *Scientific Mechanic.* During these fifteen years, however, and for a short time in the 1840's, he is credited with having painted several hundred houses with landscape panoramas.

In a number of towns in a radius of about thirty-five miles of Nashua, on the Massachusetts and New Hampshire borders, Porter presumably did a group of houses some of which still retain their decorated walls. On the main street of Townsend Harbor the old Reed house, built soon after 1800, contained two rooms by Porter. The lower northeast room was papered over many years ago, but the upper northwest chamber glows with the original fresco colors which are in an exceptionally fine state of preservation. No border is used at the cornice line, nor is there any dado. The familiar rolling hills are dotted here and there with

the foresquare houses which he loved to draw. A steamboat with alert pilot plies the waters between an island and the mainland, while on a nearby hill a man holding the hand of a child watches through a spy glass a sailing ship approaching the shore. His dog sits on his haunches beside him. The background of these walls is white, with strong lemon yellow and green predominating in the design. Here, as in other of Porter's murals, one forgets the essential confinements of a room and senses the freedom of looking into the actual out-of-doors. Also in this house many of the door panels are finely grained in crotch and swirl patterns, and the mantel in the landscape room is stippled or sponged in dark green.

Porter's use of the stencil is a characteristic seldom found in mural landscapes, but he used it to good effect, and his own directions for wall stenciling within his compositions are as follows:

In painting the pictures of steamboats, ships, and other vessels, it is convenient to have a variety of outline drawings of vessels of various kinds, sizes, and positions, on paper: the back sides of these papers are to be brushed over with dry venetian red; then by placing one of the papers against the wall, and tracing the outlines with a pointed piece of iron, bone, or wood, a copy thereof is transferred to the wall ready for coloring. The painting of houses, arbors, villages &c., is greatly facilitated by means of stencils.[20]

We see this put into practice in a number of cases including the drawing of the large squirrels in the trees from the murals of the Prescott Tavern, East Jaffrey, New Hampshire, saved when the building was demolished and now installed in the Goyette Museum, Peterborough, New Hampshire.

On a narrow dirt road in the southeastern corner of the township of New Ipswich, New Hampshire, stand a handful of old houses at least two of which were decorated by Porter. The land in this vicinity had been owned by John Melvin before 1770, but by the early nineteenth century it had passed into the hands of the Davis family. More recently occupied by Solomon Russell, this farmhouse still retains three landscape-painted rooms on the second floor. The upper southwest chamber has over the fireplace a large building identical with those which appear in the Prescott Tavern and in the Craigin house in Greenfield, New Hampshire, and is done by means of a stencil (Fig. 138). A typical Porter touch is the round-faced sun which hangs over the building. The use of a stenciled band to top his scenic frescoes seems to be original with Porter, and the designs of these borders are entirely different from any used by other stencilers. Under the chair rail appear his favorite volcano and other scenes of hills and houses, done entirely in shades of gray in what he called Chiaro Oscuro and described

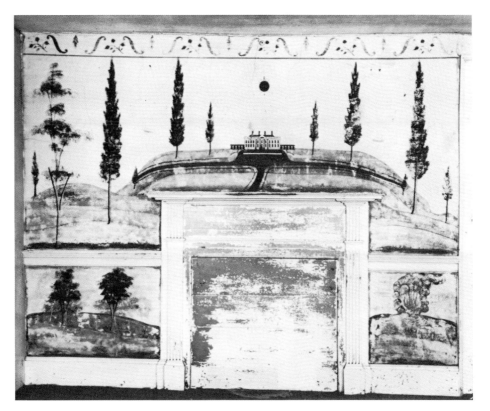

FIG. 138. Upper Chamber of the DAVIS-RUSSELL HOUSE, *New Ipswich, New Hampshire*

By Rufus Porter. The upper border and building are both stenciled, the latter being used in at least two other murals. The scenes above the chair rail are in full color, the dado is done in gray monochrome. Painted circa 1825.

Courtesy Mrs. James Downes

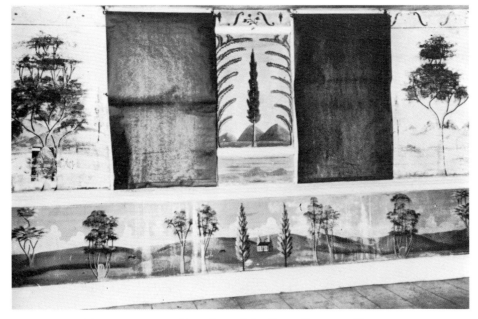

FIG. 139. Front Chamber of the DAVIS-RUSSELL HOUSE

By Rufus Porter. The compact, early nineteenth century house is a typical feature of these murals.

Courtesy Mrs. James Downes

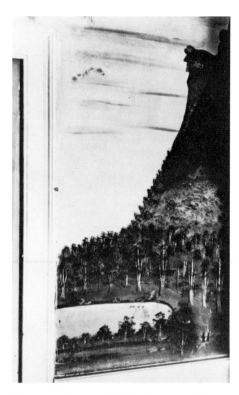

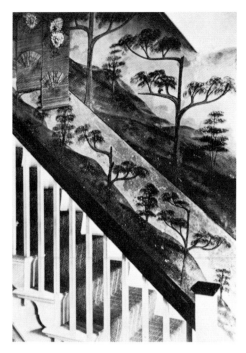

FIG. 140. Lower Hall, CRAIGIN HOUSE,
Greenfield, New Hampshire
By Rufus Porter. View of the Old Man
of the Mountain, Franconia Notch.
*Courtesy Mr. and Mrs. John G. Tracy
Photograph Society for the Preserva-
tion of New England Antiquities,*
Boston, Mass.

FIG. 141. Stairway, CRAIGIN HOUSE
By Rufus Porter. The upper scene is
painted in natural colors. The lower, in-
tended to suggest a dado, is in gray mono-
chrome. Note early method of outlining
the tree trunks and branches. Circa 1825.
*Courtesy Mr. and Mrs. John G. Tracy
Photograph Society for the Preservation
of New England Antiquities,* Boston, Mass.

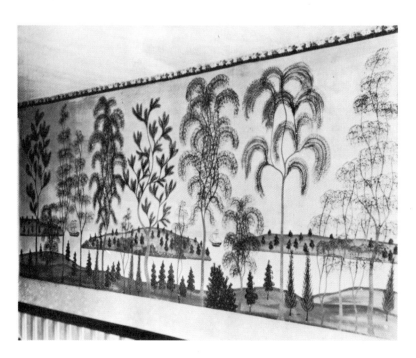

FIG. 142. Hallway,
CUSHMAN TAVERN, *Webster
Corner, Maine*
By Orison Wood, a fol-
lower of the Porter school.
Painted about 1830.
*Photograph courtesy
Henry F. du Pont*

as follows: "light and shade painting on walls, consists of representation of all the variety of landscape scenes with only one color, and the various shades between that color and white." He made good use of this effective device in a number of instances where he used a full color palette above the chair rail (Fig. 139). The rear northwest chamber illustrates several typical Porter characteristics; the feathery vine, straight poplars, and tree branches edged with a heavy dark line. One floor is marbled in gray and white. The drawing and perspective in this group of walls is much inferior to the fine work of the later signed Porter murals, which suggests the possibility of another hand, perhaps that of Nathan Thayer of Hollis, New Hampshire.

In the Gardner-Davis house across the fields a lower room showed until recently the result of Porter's handiwork, and in the adjacent town of Mason he also apparently received several commissions. In a house built in 1822 for Asher Tarbell, the parlor was decorated with landscapes now covered with paper, and the Joseph Saunders house on Saunders Hill had a lower frescoed room. In the Jonathan Batchelder house in Mason a lower room was also decorated, while upstairs yellow was used as a background for stenciled bands of tulips around doors and windows. The border is identical with that in the Solomon Russell house.[21]

Directly north of New Ipswich in the town of Greenfield, New Hampshire, Porter did some of his most interesting work on the walls of the Craigin house built in 1804 on the Wilton Road. In the lower hall of this fine brick mansion are views which appear to be unique in the Porter repertoire; the "Old Man of the Mountain" at Franconia Notch (Fig. 140) and a large panorama which is said to represent Quebec, but is probably a fanciful view. On the staircase wall is a panorama of trees and hills painted on two levels, a rather confusing effect, but one intended to suggest a dado. This lower strip is painted in gray monochrome with the scene above in colors (Fig. 141).

Porter decorated a group of houses in Massachusetts in the towns of Harvard, Groveland, Amesbury, and Georgetown, the tradition in Georgetown being that the murals were done in 1832. Six years later he did the walls in the Colburn house in Westwood, which are signed R. Porter, and S. T. Porter, with the date 1838. The signature S. T. Porter apparently referred to the artist's eldest son, Stephen Twombly, who was born in Portsmouth, New Hampshire, in 1816. Walls signed R. Porter have been found in the Emerson house in Wakefield, and in the "Shaker Glen House" in Woburn, Massachusetts.

In Massachusetts Porter painted in a wide perimeter around Boston, but in New Hampshire the greater part of his work seems to have been in the southwestern half of the state, from New Ipswich and Mason on the southern boundary, through East Jaffrey, Greenfield, Hancock, Lyme, and North Haverhill. In Maine he worked in many places, including Portland, Hollis Center, Buxton, Winthrop, and several towns within a fifty mile radius of Fryeburg, where he had attended the academy in his youth.

It seems obvious that Porter did not always work alone; in fact it is well established that there were several men who worked independently, or as his assistants, in a style which resembled his in general effect. Several walls of Porter-type have been found which are signed by, or attributed by local tradition, to other men. It seems fair to presume, therefore, that he gave instruction, and that his pupils sometimes worked together, and at other times assisted him.

Orison Wood is credited about 1830 with doing several houses in the vicinity of Lewiston, Maine. He was "a painter by trade" who had learned plaster painting from his father, who in turn had been employed as a young man by an Italian who had peddled plaster ornaments. Wood was not merely a copyist; his murals have individual style and originality, although definitely based on Porter originals (Fig. 142).

In the Priest house, Groton, Massachusetts, is a typical view of water and islands in which the name J. D. Poor is lettered on a small steamboat in the foreground. Jonathan D. Poor was Porter's nephew, the son of his sister Ruth, who had married Jonathan Poor of Baldwin, Maine, soon after 1801. From the many houses still existing which can be attributed to Poor, it is evident that he was very active between 1830 and 1840 in Chesterville, Farmington, Mt. Vernon, Fairbanks, Fayette, Bethel, and other towns in Maine. His designs closely resemble Porter's in both style and content, and it is said that he received about $10.00 per room. A fireboard signed by him is shown in Fig. 65. Nathan Thayer of Hollis is also credited by family tradition with having painted the walls of the Priest house in Groton, frescoes in a house in "Abbot Village", Andover, and those in the Coburn Tavern in East Pepperell. Thayer taught school in Hollis in winter, painted murals in summer, and is said to have decorated many houses before his death in 1830. If the information obtained from his great granddaughter is correct, and he was the decorator of many houses in this vicinity, his subject matter and painting technique must have resembled those of Porter to an astonishing degree. Possibly further investigation might indicate that other walls which bear the characteristics of Porter's so-called early period should be re-assigned to Nathan Thayer.[22]

Another name which occurs in connection with

murals of the Porter type near Parsonfield, Maine, is that of "Paine," who seems to have used an uprooted tree as a sort of signature. The signatures of E. V. Bennett and A. N. Gilbert both appear on walls in Winthrop, Maine.

After 1845 Rufus Porter gave up painting and turned his attention to journalism and to his aerial navigation project which he had worked at intermittently since 1820. This, with its detailed plans for a flying machine, was far ahead of its time. He was active with this and other inventions, until the very end of his life, when at the age of ninety-two he died suddenly at the home of his son in West Haven, Connecticut, on August 13, 1884.

The end of Porter's active career in 1845 virtually marked the close of decorative wall painting in New England. Thereafter machine-printed paper superseded the brush of the old-time craftsman, and the era of the itinerant wall painter was ended.

REFERENCES

[1] These panoramas are in the Lindell-Andrews-Perkins house, and are illustrated by Allen, *Early American Wall Paintings*, pp. 31-35.

[2] Many good illustrations of these murals appear in Allen's *Early American Wall Paintings*, pp. 36-45.

[3] For a fuller discussion of these sketches see Katherine McCook Knox, "A Note on Michel Felice Cornè," *Magazine Antiques*, LVII, 6 (June, 1950), 450-451.

[4] Margaret C. Whiting, "Old Time Mural and Floor Decorations in Deerfield and Vicinity," *History and Proceedings of the Pocumtuck Valley Memorial Association*, 5, VI (Annual Meeting 1915), 272-281.

[5] J. Bailey Moore, *History of the Town of Candia, N. H.* (Manchester, N. H., 1893), p. 371.

[6] *Magazine Antiques*, XXXIII, 6 (June, 1938), 308.

[7] For biographical data on John Avery, and for photographs of some of his mural painting see Meeting in Print, mimeographed paper of the Wakefield-Brookfield Historical Society, Wakefield, N. H. Winters of 1949 and 1950.

[8] For illustrations of these walls see Albert C. MacLellan, "The Scates-Shapley Tavern, Middleton, N. H., . . .," *Old-Time New England*, XX, 3 (Jan. 1930), 135-139.

[9] Edward B. Allen, "The Frescoed Walls of the Meeting House at Middleton, N. H.," *loc. cit.*, pp. 129-133.

[10] Illustrated in Allen's *Early American Wall Paintings*, pp. 66-70.

[11] "Murals in Upper New York State," *Magazine Antiques*, XLVIII, 3 (Sept., 1945), 148-149.

[12] Clay Lancaster, "Primitive Mural Painter of Kentucky: Alfred Cohen," *American Collector*, XVII, 11 (December, 1948), 5.

[13] Jean Lipman, "Rufus Porter Yankee Wall Painter," *Art in America*, XXXVIII, 3 (Oct. 1950), *passim*.

[14] Further information about Porter, and details concerning the various editions of *Curious Arts*, may be found in Mary Hale Auer, "Rufus Porter," *The Decorator*, 1, V (April 1951), 13. Copies of several different editions are owned by the New Hampshire State Library and the New Hampshire Historical Society, Concord, N. H.

[15] Porter's directions for wall painting taken from *Curious Arts* have been reprinted in Brazer's *Early American Decoration*, p. 44, and in Lipman's "Rufus Porter Yankee Wall Painter," *Art in America*, XXXVIII, 3 (Oct. 1950), 148-149, 151, 152-153.

[16] McClelland, *Historic Wall-Papers*, p. 270.

[17] Porter, "The Art of Painting," *Scientific American*, 30, I (April 9, 1846).

[18] *Scientific American*, March 26, 1846.

[19] *Ibid.*, April 9, 1846.

[20] *Ibid.*, March 12, 1846.

[21] For information in connection with the Mason and New Ipswich houses I am indebted to T. A. Eaton, Greenville, New Hampshire.

[22] Information concerning Nathan Thayer and his painting was given to me by his great granddaughter, Mrs. W. B. Goodwin, of Lowell.

Chapter XI

More Examples of Varied Kind

"Executed in a grand and Rural manner and at the most reasonable rates"

WHEN THE FIRST EDITION OF *American Decorative Wall Painting* was issued in 1952, it was believed that the publication of this pioneering effort would stimulate interest in, and a search for, additional examples of painting on plaster and wood. This hope has been realized, and some new discoveries made by homeowners, antiquarians, and graduate students have appeared in print and been augmented by the encouraging support of collectors, museums, and local historical societies. Only rarely today is paneling automatically scraped to the bare wood, or wallpaper carelessly removed with little regard for the original plaster finish below. What remains of our heritage of painted decoration is, therefore, far more appreciated and protected than it was twenty years ago.

Additional examples of the work of different painters have now come to light and may be grouped together for a more comprehensive study of their individual styles. On the other hand, still relatively few traveling decorators are known by name, although several houses in one area, or others stretched along old highways of travel, clearly indicate the routes of their activity.

A paneled room-end with overmantel landscape has recently appeared, from under layers of later paint, in a house at Grosvenordale, Connecticut. The composition proves it to be yet another subject in a previously recognized group, two of which are illustrated in Figures 16 and 17. A stylistic reappraisal of this decorator's work now suggests the probability that the hunting scene in Figure 31 (and two others found in the same house) were also by his hand. Only by studying and comparing a number of examples do such conclusions become apparent, proving that while subject matter may differ radically, each artist's basic technique is usually recognizable.

Since 1952 several hitherto unknown New England overmantels have appeared. A most significant development has been the discovery of original sources of design for some of them, and for others previously recorded. When the initial study of overmantels was made, a majority of the pictures were presumed to be the artists' own concepts, occasionally painted "from nature" but more often decoratively composed to fill a given architectural space. For example, Figure 31 illustrates an engraving after a painting by the English sporting artist James Seymour from which the hunting panel in Figure 32 derived. This particular episode "In Full Chase" was especially popular in America. With three other scenes in the same set, it was printed on a wallpaper hung in the Moffatt-Ladd house in Portsmouth, New Hampshire, about 1763.[1] Another panel exhibiting a fox hunting scene came from a house in East Douglas, Massachusetts, no longer standing (Fig. 143). Although obviously painted by a different artist, it also was based on the same engraving. It is interesting to compare two quite dissimilar interpretations of the same basic source. "Hunting pieces under glass" were one of the many kinds of prints imported and sold at vendue in America during the second half of the eighteenth century, and indicate how local artisan-painters obtained access to English prototypes.

Interest in the fine marbleized paneling from the Joseph Pitkin house of East Hartford, Connecticut (Fig. 4), has been considerably enhanced by discovery of two overmantels which were originally associated with it (Fig. 144). Reunited with their surrounding woodwork shortly after the first edition of this book went to press in 1952, it soon became obvious that the Pitkin panels are attributable to the same itinerant who painted the boarding in South Farms, Connecticut (Fig. 54), and did many similar landscapes

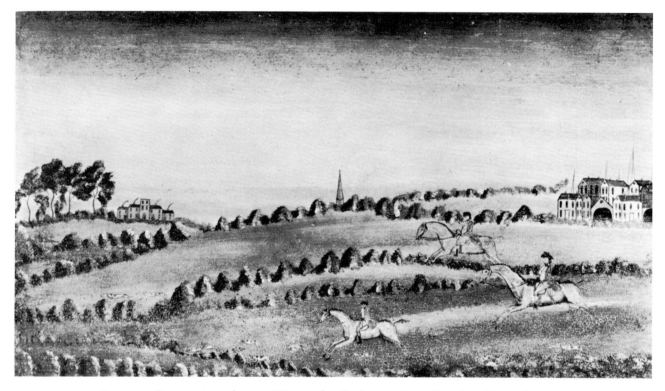

FIG. 143. OVERMANTEL from a WALLIS family house, *East Douglas, Massachusetts*
Based on an engraving after a painting by James Seymour.
Author's collection

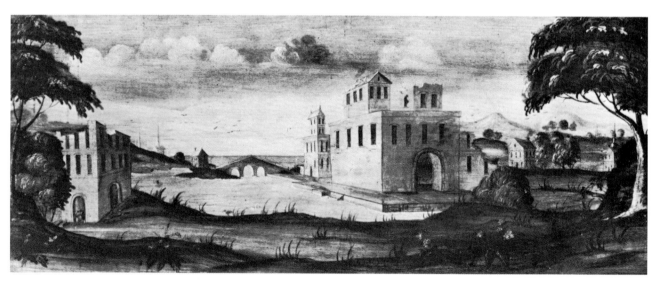

FIG. 144. OVERMANTEL from the JOSEPH PITKIN HOUSE, *East Hartford, Connecticut*
Wadsworth Atheneum, Hartford, Conn.

in Hingham, Massachusetts (Figs. 35 and 36). It was formerly suggested that the artist was John Hazlitt, a resident of Hingham, but in view of the similar panels since recognized in Connecticut, his authorship now appears unlikely. All the known panels in this widely separated group depict buildings exhibiting a decidedly European flavor, and it seems certain that they too were inspired by engravings.

A second overmantel scene almost identical to that in the Seth Wetmore house in Middletown, Connecticut (Fig. 55), may now be found in the south wing of the Burbanks-Phelps-Hathaway-Fuller house in Suffield, Connecticut. The wing was moved from an unknown location and probably added to the main house prior to 1794. When, some years ago, a panel was discovered in the attic, it was adapted to fit its present position above the fireplace at the far end of this small room. Classical landscapes of similar type could have been suggested to New Englanders by mid eighteenth century English wallpapers such as those installed in the Van Rensselaer manor house in Al-

bany, New York, or the Jeremiah Lee Mansion in Marblehead, Massachusetts, during the 1760's. Or they could have derived from plates taken after Pannini or Claude Lorrain and others. *The Boston News-Letter* for July 8, 1773, advertised "A set of very handsome Prints, neatly framed and glazed, engraved from original Paintings by Claud Lorrain." After making the Grand Tour, as some Americans did even before the Revolution, architectural subjects became fashionable as decoration in American as well as English homes.

An overmantel in the Alexander King house, Suffield, Connecticut (Fig. 53), was once believed to represent a nearby view on the Connecticut River. In 1953 Edward Croft-Murray, Keeper of Prints at the British Museum, recognized a similarity between the Connecticut view and a mid eighteenth century engraving of the River Thames near London, entitled "A View of Richmond Hill up the River" (Fig. 145). François Vivares (1709–1780) was the engraver. A native of France who spent most of his life in England, he became an eminent landscape engraver specializing

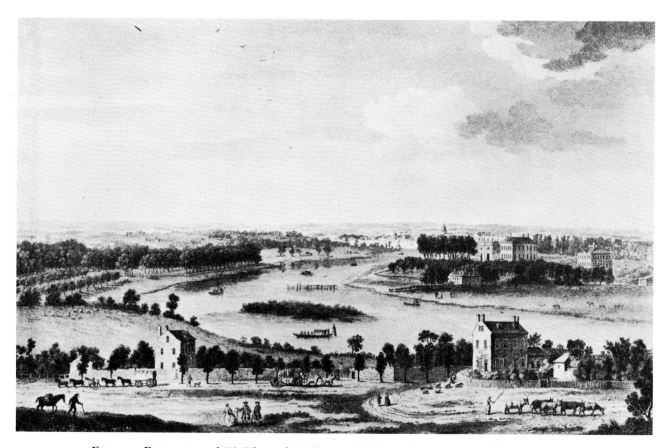

FIG. 145. ENGRAVING of "A View of Richmond Hill, . . ." by François Vivares (c. 1749)
Source of design for an overmantel in the Alexander King house, Suffield, Connecticut (FIG. 53).
Author's collection

in panoramic views of this type. The original painting was by Antonio Jolli (1700–1777), a pupil of Pannini, follower of Canaletto, and a well-known designer of scenery for the London opera. Comparison of the Suffield panel with the English prototype shows how the unknown American artist simplified and rearranged the basic composition yet retained the salient features of the original. Engravings by Vivares were available in Colonial America and were advertised for sale in New York City, along with many other articles, in the *New-York Journal or the General Advertizer* on March 16, 1775, as follows: "MINSHULL'S LOOKING GLASS STORE, Removed from Smith street to Hanover-square (opposite Mr. Goelet's the sign of the Golden Key) has for sale . . . Engravings by Strange, Wollet, Vivare's & other eminent masters . . ." A portrait believed to be Timothy Swan, owned by the American

Antiquarian Society and also painted in Suffield, is attributed to the same artist as the Alexander King house overmantel, and certain characteristics of the engraver's style (such as the curious form of the tree shadows) are repeated in both pictures.

At least two overmantels from outside of New England are based on early book illustrations which are more difficult to discover than the better-known engravings. A very strange panel in the Metropolitan Museum entitled "Landscape with Wayside Crosses," from an unidentified house near Morgantown, Pennsylvania, is referred to briefly on page 62 (Fig. 146). This somber composition is a careful rendering of a small illustration in William Salmon's *Polygraphice or the Arts of Drawing, Engraving . . .* published in London in 1685 (Fig. 147). This book was one of the earliest English art instructors to be used in Colonial

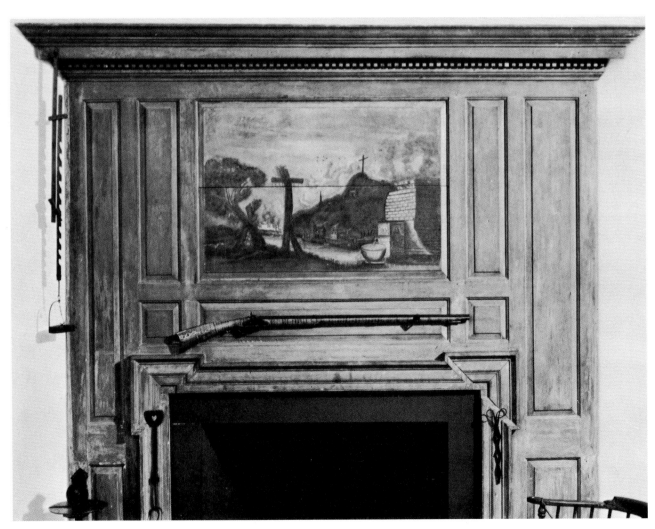

FIG. 146. OVERMANTEL in chimney breast from a house near *Morgantown, Pennsylvania*
The Metropolitan Museum of Art, New York, N.Y.

America. It includes directions "to extend or contract a Picture keeping the proportions," which was accomplished by dividing the original illustration into a useful number of squares that could then be enlarged or contracted and painted, like the pieces of a picture puzzle, to produce the size required. This method must have been successfully followed many times in adapting small designs to the much larger proportions of fireboards or overmantel pictures.

Another overmantel from Pennsylvania displays many of the same characteristics as does a far less accomplished example from Massachusetts (Figs. 19 and 63). The two widely separated artists changed certain details, but the topography of the right bank of the river, and the group of people feeding swans, indicate a common source of design. The panel in Figure 63 is a fairly close copy (with minor figure changes) of an illustration entitled "The Serpentine River and Grotto in Stow Gardens" which appeared in the third edition of the popular book *A New Display of the Beauties of England,* published in London in 1776 (Fig. 148). At the far end of the Serpentine appears the famous grotto which was illustrated in 1750 in *The Beauties of Stow,* by George Bickham, London. Bickham was an engraver and drawing master to the Academy at Greenwich, and he described the building as the most charming Grotto that imagination could form, entirely built of shells of mother-of-pearl and full of mirrors by which the prospect of the gardens, and of one's own person, were infinitely multiplied. The small Temple of Contemplation can be seen at the right. The Gothick Temple at Stow is represented in at least one early nineteenth century American schoolgirl watercolor (now in the Abby Aldrich Rockefeller Folk Art Collection at Williamsburg, Virginia). At the close of

the eighteenth century this great English country estate contained elaborate follies and ornamental gardens comprising some four hundred acres, but long before that the gardens were on view at certain times to the public. Excellent guidebooks by B. Seeley, with informative descriptions and good illustrations, were newly issued from time to time and were conveniently available to visitors at the New Inn near the south entrance to the estate. Separate black-and-white and colored engravings in sets were also obtainable. Such unexpected sources, borrowed in the eighteenth century by both professional and amateur artists, were not as remote as they might appear today. This is shown by a notice in *The Boston News-Letter* for April 23, 1762: "Just imported in the Pitt Pacquet and to be sold at the London Book Store, Boston . . . Large and splendid views of some of the most remarkable Places in North America; and of the most magnificat Palaces and Gardens in England." Whether American owners were aware of the derivations of their overmantel views presents an interesting speculation.

In the old John Mason house, adjacent to the Connecticut River in Cornish, New Hampshire, was found the overmantel with handsome bolection surround which appears in Figure 149. While it is tempting to identify this scene as some nearby stretch of the Connecticut River, the locale appears to be imaginary, unless it might be related to an illustration, "View from the Terrace of Oatlands, Surrey," to be found in the publication *A New Display of the Beauties of England* already mentioned. Similarity of style definitely connects the painting with two overmantels in the Thomas Murdock house built some twenty miles upriver in Norwich, Vermont. In the upper southwest chamber a fine paneled chimney breast incorporates a

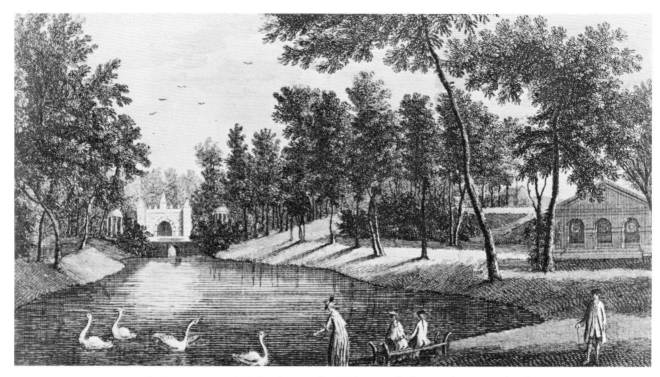

FIG. 148. ENGRAVING of "The Serpentine River and Grotto in Stow Gardens"
This illustration from Vol. I of *A New Display of the Beauties
of England*, London, 1776, is the source of design for FIG. 63.
Photograph Society for the Preservation of New England Antiquities, Boston, Mass.

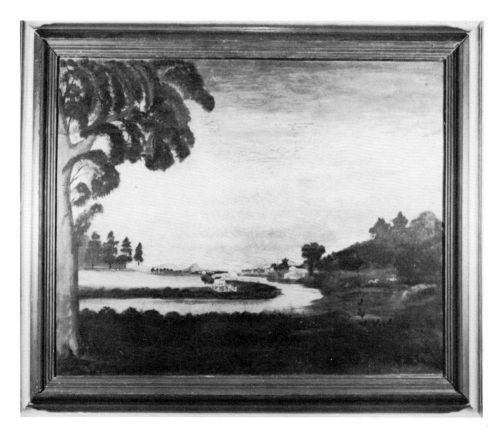

FIG. 149. OVERMANTEL from
the JOHN MASON HOUSE,
Cornish, New Hampshire
Author's collection

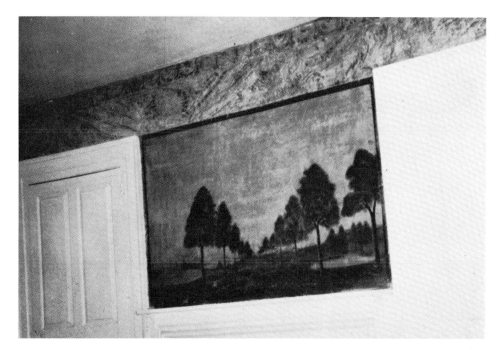

FIG. 150. OVERMANTEL picture on plaster in the THOMAS MURDOCK HOUSE, *Norwich, Vermont* Attributed to the same artist shown in FIG. 149. *Courtesy Mrs. Charles Pierce*

landscape of unusual design having a house and surrounding fence that resemble those shown in the distance in the Mason panel. Another overmantel scene, in the northwest chamber, displays tall trees and extensive buildings, but it is painted directly on the plaster wall which suggests a transitional date, near the turn of the nineteenth century. This picture is framed by a black line and is surmounted by a frieze composed of freely painted feather and' peacock-eye graining, scroddled in shades of blue, red, brown, and green. Above this curious decoration is a crude swag-and-tassel border reminiscent of those seen on later freehand walls (Fig. 150).

In Figure 45 is seen a panel from an unknown location that bears a close resemblance to two others of similar design found since 1952 and apparently derived from the same engraved source (Figs. 151 and 152). Although each artist has altered the composition of the left side of his picture, the basic pattern of hills, river, and boats remains the same. Figure 151 is painted with unusual clarity and fine color, and the dead tree in the foreground (which also is present in Figure 45) serves to accentuate the picturesque elements of nature so much admired in the late eighteenth century.

Reference has been made in previous chapters to painted decoration found in West Sutton, Massachusetts. Two overmantels (originally framed in grained and marbleized paneling), a fireboard, and records of a ceiling with stenciled compass points indicate the probability that more than one decorator worked at different times in the Ebenezer Waters house. In the

nearby Waters-Phelps house a fireboard and freehand-painted wall were set off by handsomely grained wood trim, the style of which was repeated in the 1793 Le Barron house on Main Street, where it was combined with a fine early wallpaper.[2] There also, in a lower front room, the remains of an overmantel landscape, with hills and a cluster of small houses, was uncovered a few years ago.

In the house built circa 1769 by General Samuel McClellan in South Woodstock, Connecticut—long known as the Arnold Inn—the general's brother-in-law, Winthrop Chandler, painted two trompe l'oeil shelves of calfbound books on a panel above the fireplace in the lower south front room. Removed from its original location, and cleaned to reveal the clarity of the exceptional design, this unique piece is now in the collection of the Shelburne Museum (Fig. 153). When the eighteenth century chimney breast was dismantled to remove the overmantel, a second painting, executed on a thin coating of plaster directly on the chimney bricks, was unexpectedly revealed. The scene, surmounting a row of simulated fireplace tiles, is framed at either side by two painted curtains attached by loops to a rod, or pole, above. Although lacking in perspective, the picture conveys the impression of a window view showing the Arnold Inn itself surrounded by other houses, gardens, and human figures. The plaster dado in this room, on which only fragments of the painting now remain, exhibits a running fox and an arrogant lion, both of large size. In the adjoining west room, another painting on plaster has

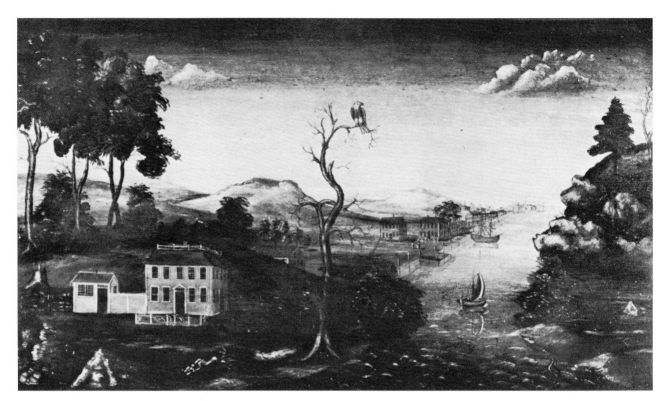

FIG. 151. OVERMANTEL from the HEARD HOUSE, *Wayland, Massachusetts*
Privately owned

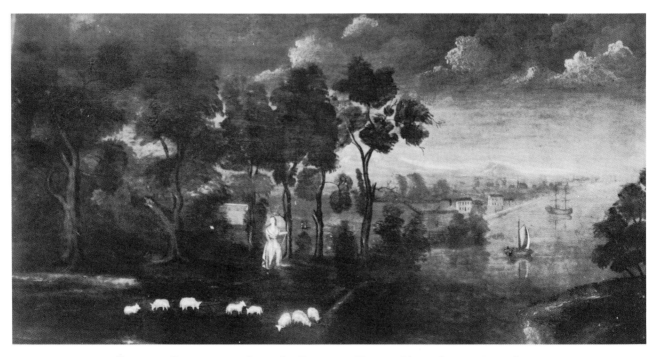

FIG. 152. OVERMANTEL from the BALDWIN HOUSE, *Shrewsbury, Massachusetts*
Courtesy Mrs. Eveleth Hill and Mrs. John W. Lasell

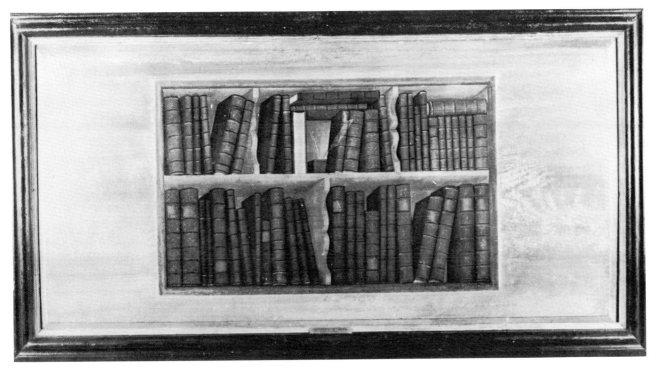

FIG. 153. OVERMANTEL from the SAMUEL MCCLELLAN HOUSE, *South Woodstock, Connecticut*
By Winthrop Chandler.
Courtesy Webb Gallery of American Art, Shelburne Museum, Shelburne, Vt.

recently been discovered, again behind original panel-ing. This features an oversized horned owl and a boy swinging from a tree, amidst a country setting. One wonders if these primitive scenes were painted as pre-liminary decoration before the finished paneling was installed, and if so, how long they were exposed to view. An overmantel from Framingham, Massachu-setts, is noted on page 133 and illustrated in Plate VI.

Two outstanding examples of painted woodwork in New York and North Carolina deserve particular men-tion. A tremendously long overmantel panel, ninety inches in length, shows the Martin Van Bergen farm near Leeds, Greene County, New York, with house, outbuildings, and farm activities as they appeared in 1729. The panel was painted for this small Dutch house, but in the nineteenth century was moved to another family home nearby. It is now in the collec-tion of the New York State Historical Association at Cooperstown. From the long-demolished Alexander Shaw house, about three miles from Wagram, Scotland County, North Carolina, came a fine painted room now installed in the Abby Aldrich Rockefeller Folk Art Collection, Williamsburg, Virginia, and is to be seen in Plate VII. The interior is entirely wood-sheathed, with painted dado and mantel. The frieze is composed

of a decorative border from which depends a band of large swags and tassels, and there is a picture entitled "Vue of New York," extending over the mantel. The unidentified artist's signature, "I. Scott, Aug. 17, 1836," is inscribed above a doorway. This room can be con-sidered a unique example of signed painted decoration of this type in the southern states.

Fireboards in many styles still continue to turn up, having been stored away in cellar or attic following the advent of the parlor stove. More informal than re-lated overmantels, and much less traditional in feeling, fireboards usually exhibit individual designs chosen by the artist or owner. A few, however, derive from en-graved sources, of which the lion illustrated in Figure 72 is an amusing example. This ferocious beast began his pictorial existence as the British lion peering out from behind Britannia's skirts in an American print titled "Let the Weapons of War Perish," which was published by the small firm of Shelton and Kensett on March 1, 1815, in Cheshire, Connecticut (Fig. 154).

One characteristic of many fireboards is the wide-spread use of borders painted to suggest Delft fireplace tiles. Borders created by individual painters varied greatly and included motifs enclosed in both circles and squares. A number featured trees of odd kinds and

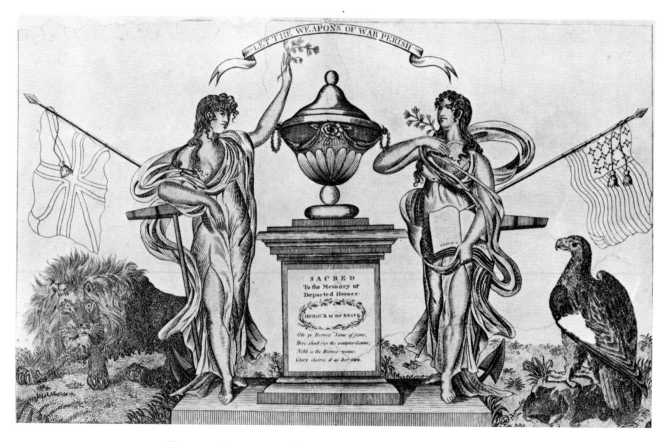

FIG. 154. ENGRAVING of "Let the Weapons of War Perish"
Published by Shelton and Kensett, March 1, 1815. The
lion is the source of design for the fireboard in FIG. 72.
Author's collection

shapes (Figs. 75 and 76); others displayed ingenuous little scenes of houses, animals, and figures (Figs. 77, 78, and 155). While it is obvious that the inspiration for these borders arose from eighteenth century fireplace surrounds, it is interesting to observe that nineteenth century decorators perpetuated the tradition, adapting rather than copying architectural precedent.

A fireboard from the Waters-Phelps house in West Sutton, Massachusetts, is illustrated in Figure 156. This piece with its stylized banding, prim flower arrangement, and shadowed fireplace opening has a close affinity to some very unusual decoration found in the small, early Sproat-Ward house in Lakeville, Massachusetts, where, in an upper chamber, a marbleized bolection molding frames an overmantel panel with two similar floral arrangements (Fig. 157). The walls are composed of horizontal sheathing, the lower section of which is painted dark brown to resemble a dado. Above, under the cornice, is a series of large, bold, freehand swags in shades of gray. Between the swags hang long red-and-black tassels supported on red

cords which depend from looped bowknots painted on the cornice above. A well-designed stenciled floor completes the decoration of this interesting room.

Fireboards of marine subjects are relatively rare but a particularly spirited example appears in Plate VIII. On close inspection, rows of tiny black dots prove to be seamen perched aloft on the yardarms, furling sail in a choppy sea.

A fireboard attributed to Charles Codman of Portland, Maine, represents East Cove in Portland veiled in a rosy tinted light (Fig. 158). Although Codman's work is now associated with landscapes influenced by the romantic aspects of the Hudson River School, he began his career about 1825 as an ornamental painter of clock faces, fire buckets, fireboards, and walls. This board, with its delicate gold stenciling on a black background, was painted for the Deering mansion in Portland, of which the contents were dispersed at auction and the house demolished some years ago.

An architectural fireboard of more sophisticated design, incorporating cleverly simulated moldings and

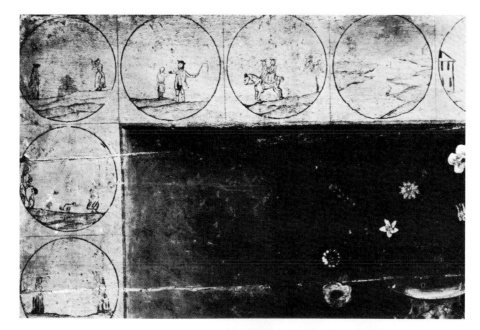

FIG. 155. Detail of a FIREBOARD
Border suggests early
Delft tiles.
Privately owned

FIG. 156. FIREBOARD from the
WATERS-PHELPS HOUSE,
West Sutton, Massachusetts
Actual knots in the wood
are accentuated by painting.
*Abby Aldrich Rockefeller
Folk Art Collection,
Williamsburg, Va.*

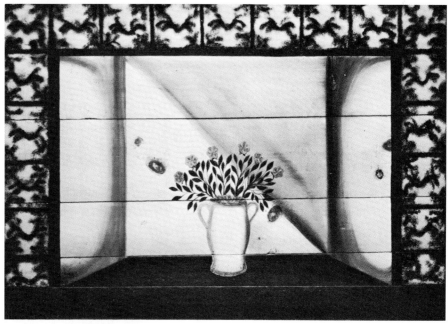

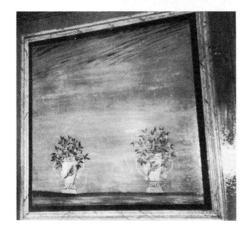

FIG. 157. OVERMANTEL from
the SPROAT-WARD HOUSE,
Lakeville, Massachusetts
Compare FIG. 156.
Courtesy A. L. Van Lenten

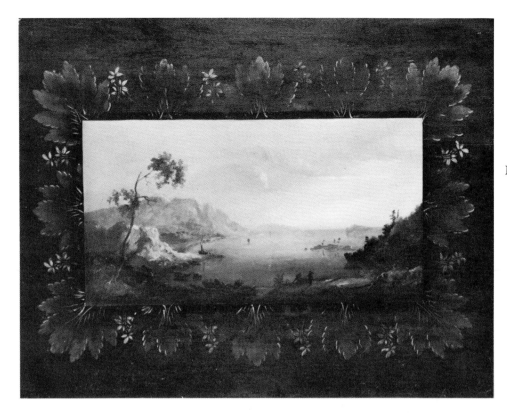

FIG. 158. FIREBOARD of East Cove, *Portland, Maine*
Attributed to
Charles Codman.
Fruitlands Museum,
Harvard, Mass.

FIG. 159. GOTHIC FIREBOARD
With simulated
architectural moldings.
Privately owned

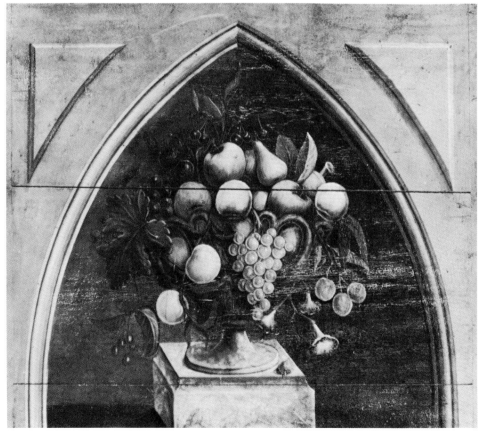

· 140 ·

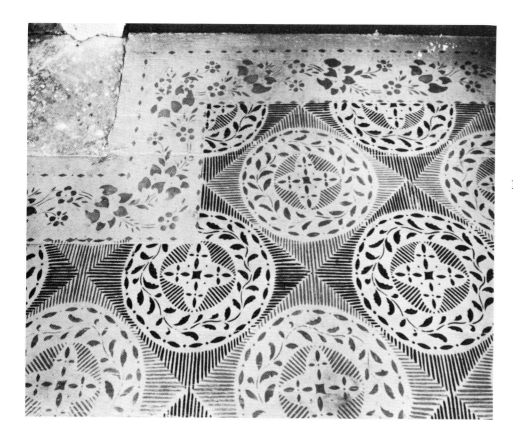

corner pieces, was no doubt designed especially for a drawing room of nineteenth century Gothic character (Fig. 159). The colorful vase of fruit and flowers standing on a traditional marble plinth betrays the hand of an experienced artisan-painter.

The Edward Durant house on Waverly Avenue, Newton, Massachusetts, was built as a tavern in 1734. After it changed ownership in the 1790's, the floors of four rooms and the hallway were stenciled in extremely handsome patterns employing five colors—Indian red, yellow ochre, verdigris green, white, and black (Fig. 160). The all-over designs are large and very intricate, the main units being composed of delicate central motifs framed by various combinations of circles and squares. In each room is a different border pattern. As this decorator's work had not been found elsewhere, it is gratifying to have heard of a similar floor in Carlisle, Massachusetts, which has fortunately been well preserved under a protecting rug.

Another floor of completely different character may date from the eighteenth century. It is represented by several small pieces now preserved in the Essex Institute, Salem, Massachusetts. These fragments were unexpectedly revealed under later boarding when the Pickman-Derby-Brookhouse cupola was dismantled during the summer of 1971 (Fig. 133). Small geometric designs painted in a bright shade of orange-coral are closely spaced in alternating rows against a clear blue-gray background. The Salem house from which the cupola came was purchased by Elias Hasket Derby from the widow of Benjamin Pickman on April 29, 1782. During the following July a bill from Samuel Blyth, Painter (preserved in the Essex Institute's *Derby Papers*) charged Mr. Derby for "Gilding Cupallo Ball, 4–16–0," and for "Painting 78 yds in Cupallo, 3–4–0." It could be possible, therefore, that this gay little design is a rare survival of Blyth's 1782 floor.

Some interesting painted decoration came to light several years ago in the Whitaker-Clary house, built circa 1810–1815 in New Salem, Massachusetts. In addition to striking early wallpaper and stenciled plaster walls, decoration of the parlor floor combines oval motifs separated by groups of smaller diamonds. This stenciled pattern, with an added border at the edge, was also used to good effect to imitate a fabric carpet running over treads and risers on the steep front stairs (Fig. 161). The design, much worn with age, was restored in 1969, and still fulfills its intended purpose. Another floor dating to the second quarter of the nineteenth century is painted in simulation of a woven carpet, and came from the Humphreys house, formerly located at 59 Humphreys Street, Dorchester, Massachusetts. It is illustrated in Plate XI.

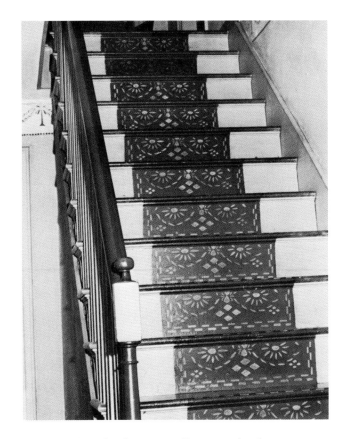

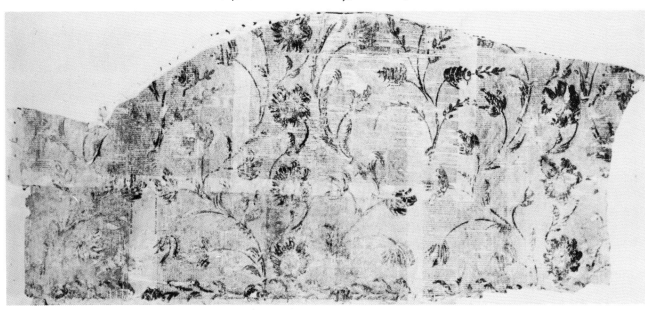

FIG. 161. STENCILED PATTERNS in the
WHITAKER-CLARY HOUSE, *New Salem, Massachusetts*
Simulation of a woven stair runner.
This design is also found on parlor floor.
Swift River Valley Historical Society, New Salem, Mass.

FIG. 163. Detail of FREEHAND PAINTING in the
JOHN BALL HOUSE, *Hollis, New Hampshire*
Attributed to the decorator of the *Connecticut Group.*
Courtesy Mrs. Francis A. Schultz

FIG. 162. FREEHAND PAINTED WALL in the AMOS GALPIN HOUSE, *Litchfield, Connecticut*
Early designs offset on newspaper lining for later wallpaper.
Litchfield Historical Society, Litchfield, Conn.

· 142 ·

Occasionally a newly found example of freehand painted walls is recorded under the *Connecticut Group* (p. 83). In the Dr. Daniel Sheldon house on North Street, Litchfield, in two halls and a stairway, a familiar pattern of diamonds formed by vines and leaves is broken by rosettes at the apex of the diamonds. Unfamiliar but most interesting motifs, consisting of a large urn and a sun with face, alternate within the diamonds. Found under wallpaper during renovations, the designs were badly faded but still discernible. Sometimes paper, if carefully removed, can clearly preserve original patterns that have virtually disappeared from the surface of a painted wall. Sheets of newspaper applied as lining for later wallpaper from the walls of the Amos Galpin house in Litchfield (mentioned on page 85) are shown in Figure 162 to illustrate a case in point. Benjamin Tallmadge bought the Thomas Sheldon house in Litchfield in 1784 and subsequently it was embellished by the same decorator. Only a small section of his work is now visible below the ceiling in the upstairs hall.[3] The work of this painter has also been recognized on Long Island, where designs in the Sherwood-Jayne house, Setauket, and Sayrelands in Bridgehampton (both owned by the Society for the Preservation of Long Island Antiquities) can be identified with patterns found in the various Connecticut houses noted.

Since investigation first began on the *Connecticut Group,* several similar examples of freehand decoration have been found in the small township of Hollis, New Hampshire. There, in at least five old houses, is decorative painting so reminiscent of the various Connecticut examples that the work of the same itinerant seems unmistakable. In the lower northwest room of the John Ball house, a diamond enclosing leafy sprays having distinctive ball-like blossoms is painted in black on a buff background (Fig. 163). A very similar design adorns a lower front room of the Poole house on Dow Road. The Samuel Cummings house also displays diamonds with the same ball-like blossoms, but there is an additional motif of compact round blossoms and leaves comparable to those seen in the Red House in Washington, Connecticut.[4] Some of these designs were initially painted in white with the black strokes and red centers superimposed, and completed with a final wash of clear light blue. In the Josiah Conant house, finished in 1806, is a decorated floor of the same design found on the walls of the Cummings house, but only portions around the edges are still clear.

In 1959 and 1960 two new examples of the *Brush Stroke Group* of freehand painting (p. 93) were discovered in central Massachusetts. Combined with already familiar pomegranates, scrolls, and vines, these designs add a new dimension to this decorator's work by the inclusion of several inimitable birds—an owl, a long-tailed pheasant, a flying duck, and a boldly feathered eagle. In the Williams Inn, Sunderland, two lower rooms were originally finished in horizontal sheathing—one having wallpaper pasted to the boards and the other being painted with scrolls, flowers, and an occasional large bird in black and white on a gray background (Fig. 164).[5] A few miles west in Conway, Massachusetts, in the Captain Thomas French house, built circa 1770–1790 on Baptist Hill Road, this artist's work is again apparent in two chambers and the upper entry (Fig. 165). Here, however, bright red and mustard-yellow backgrounds effectively set off the graceful scrolls and flower sprays seen before in the Stratton Tavern of Northfield Farms, Massachusetts (Fig. 102). A wooden doomed-top box has recently been found which is certainly the product of this decorator with his typical birds and floral sprays. Lined with a Haverhill, Massachusetts, newspaper, dated June, 1806, the box and its painting both probably date to this early period. The stair hall of the Jennie Sampson house (p. 94), built in Lakeville, Massachusetts, but now removed to Chatham on Cape Cod, is signed "M N T 1803." These initials may yet provide a definite clue to the identity of the *Brush Stroke* painter. At Hoag's Corner, just over the New York State line in a region which was developed after 1760 by settlers from Rhode Island, Connecticut, and Dutchess County, New York, the Wunderling house formerly had an upper hall with freehand patterns that placed the decoration within the *Brush Stroke Group.* This emphasizes the westward travel of many New England craftsmen in the wake of settlers migrating to New York, Ohio, and other newly opened territories. Other isolated examples of freehand repeat-patterns by various unknown artists have been uncovered during recent years but are perhaps not of sufficient significance to record in this limited space.

It is heartening to note that additional examples of stenciled walls are continually coming to light in American homes. While there are too many to list in this chapter, a few instances are of special interest. In the *Border Group* (p. 101), this decorator's work has been recognized in a number of New Hampshire towns, including the Tavern in Gilmanton, and the Fitzwilliam Inn and the Locke house in Fitzwilliam. A house on Clough's Hill in Loudon includes, between two front windows, a stenciled bird similar to that seen in the watercolor showing the interior of John Leavitt's tavern (Pl. V) in Chichester. In Newington, New Hampshire, a new feature consisting of pairs of facing silhouette portraits, is introduced into the border frieze. Several houses in the vicinity of Dighton, Massachusetts, a house in Putnam, Connecticut, and walls in the Nathan Ballou house in Lincoln, Rhode

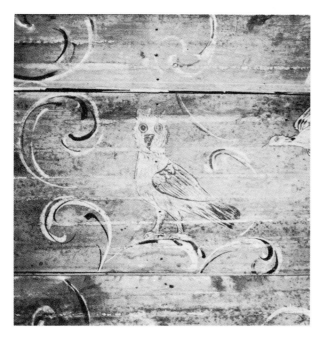

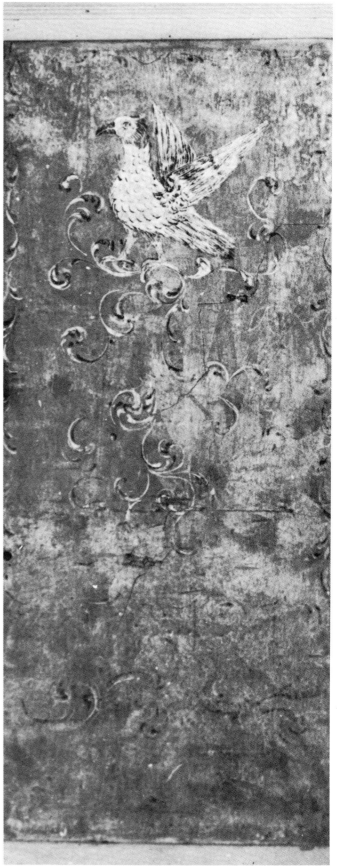

FIG. 164. WALL PAINTING from the
WILLIAMS INN, *Sunderland, Massachusetts*
Detail from sheathed room attributed
to the *Brush Stroke* decorator
Author's collection

FIG. 165. PLASTER WALL in the
CAPTAIN THOMAS FRENCH HOUSE
Conway, Massachusetts
Attributed to the *Brush Stroke* decorator.
*Photograph Society for the Preservation
of New England Antiquities*, Boston, Mass.

FIG. 166. FRESCO in the parlor of the
DAN MATHER HOUSE, *Marlboro, Vermont*
Photograph Allen Collection, Society for the Preservation of New England Antiquities, Boston, Mass.

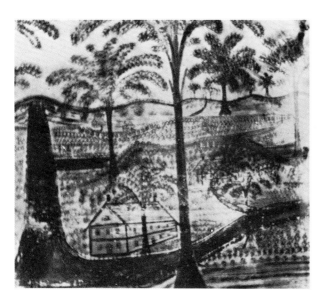

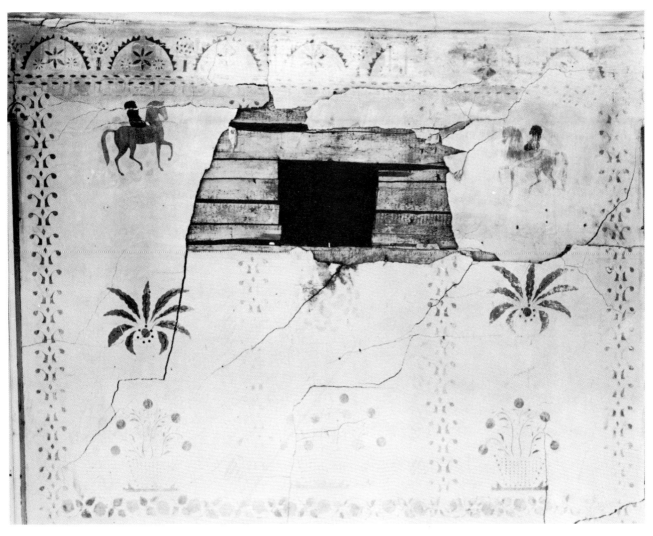

FIG. 167. Detail of OVERMANTEL in the MATHER HOUSE, *Marlboro, Vermont*
Having prancing horses combined with patterns by Moses Eaton.
Photograph Waring Collection, Society for the Preservation of New England Antiquities, Boston, Mass.

Island (which closely resemble those in the ballroom of the Governor Pierce house, Hillsboro, New Hampshire) prove that this fine stenciler traveled widely.

Patterns of the Moses Eaton Type (p. 103) are still being found as old wallpapers are removed. In the Dan Mather house, Marlboro, Vermont, said to have been built about 1820, stenciling by Moses Eaton, combined with naïve freehand landscapes by an unknown hand, were described and illustrated in Allen's *Early American Wall Paintings.* These decorations have now formed the basis of comparison for a small group of other walls situated in the three northern states. Large trees in the Mather entrance hall have drooping branches done with a distinctive sponged technique (Fig. 166). They are rooted in strongly lined horizontal

planes and occasionally overhang houses primitively drawn only in outline. These elements are characteristic of this decorator's work, as are also stenciled horses, which in the Mather house are prancing on a wall of Eaton stenciling (Fig. 167).

Almost certainly by the same two artists are walls in a small upper chamber of the Burgess house in Sebec, Maine. There Eaton's patterns are surmounted on the sloping eaves by a long row of alternating large and small trees done freehand in shades of strong dark green. Stenciled horses with grooms, and the same lined groundwork are also seen here, although no buildings appear in this panorama. A third house in Falmouth, Maine, also exhibits Eaton patterns combined with an overmantel design wherein silhouettes of prancing

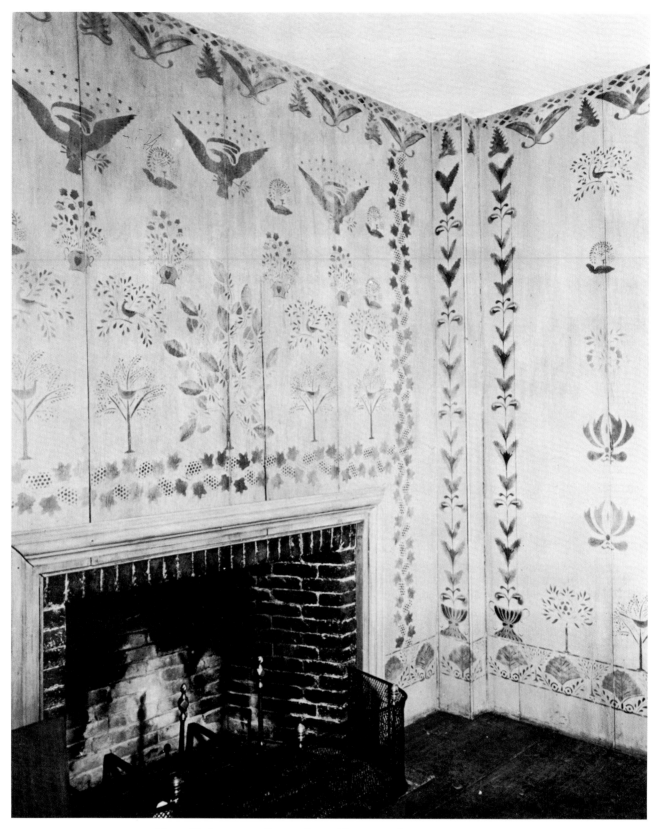

FIG. 168. STENCILED ROOM from *Chenango County, New York*
With vertical designs typical of others found in New York State.
Shelburne Museum, Shelburne, Vt.

· 146 ·

horses, although minus riders, appear to match those used in the Mather house. From Holderness, New Hampshire, comes a small wooden fireboard on which the characteristically outlined house and spongy drooping trees form definite links with this interesting landscape and stencil group, about which local legends still persist concerning "two young men who traveled and worked together" about 1830. While these panoramas are in a style vaguely reminiscent of the work of Rufus Porter, they are noticeably cruder in both design and execution, and are far more limited in variety of subject matter than were Porter's competently painted frescoes (Pl. IX).

As the second quarter of the nineteenth century progressed, New England stencilers tried their luck westward over the New York border, and Eaton patterns were found some years ago in an abandoned house near Stephentown, Rensselaer County. A few miles north in Berlin, New York, a room in the Craib house, stenciled with red and green flower and leaf sprays, and a frieze of green pine trees, is one of the very few examples which is signed with the painter's name—"J. H. De Forest, Pittsfield, 1833." This inscription is written within a rectangle between two of the designs, and could refer to towns of this name either in Massachusetts or New York State, although the patterns are not particularly reminiscent of those found in the New England area. The only name so far discovered corresponding to this signature is that of one John Hancock De Forest, 1776–1839, who married Dorothea Woodward in 1811, and whose forebears lived in Connecticut in the eighteenth century.

In the Bump Tavern, built in Ashland, Greene County, New York, the upper hall, ballroom, and two bedrooms were found to be decorated with stencils by "Stimp" (p. 106) when the building was restored following its removal to the property of the New York State Historical Association in 1952. A section of wall in unrestored condition is preserved for study beneath a wallboard panel at the top of the front stairs.

For the most part, the many stenciled patterns that have been found throughout New York State during the last twenty years are quite individual in design, although echoes of Eaton's motifs are often present. One of the richest interiors was discovered in a small, boarded-up house on a back road in Columbus, Chenango County (since re-erected at Shelburne Museum) where the matched boarding of two lower rooms displayed a great variety of designs, some resembling those of Moses Eaton, in which an eagle in profile is a prominent feature (Fig. 168). Similar stenciling attributed to the same hand has been identified in at least two other buildings, one of which, the Bonnell

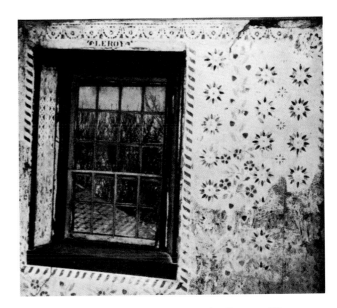

FIG. 169. STENCILED WALL in the DRAKE HOUSE, *Walworth, New York*
With name "LEROY" stenciled above the window.
Photograph Rochester Museum of Arts and Sciences, Rochester, N.Y.

house, is located on Whig Corners Road, near Cherry Valley, New York.

Two other houses in upper New York State exhibit painted decoration by a mysterious artist who signed his walls "LEROY." In the Drake house, Atlantic Avenue, Walworth, just east of Rochester, many rooms of good stenciling were uncovered in 1953. Over the window in the upper east room appeared the name "LEROY" (Fig. 169). Although a town of this name is situated not far away, no reference to this itinerant has yet been discovered. Some fifty miles southeast of Rochester near Pen Yan, in an old tavern on the former stagecoach route between Bath and Geneva, scenic frescoes of large trees with birds and prancing horses were unearthed from beneath four layers of wallpaper, and were said to have borne in two places the inscription "D. LEROY painter" before they were again covered in April, 1959.[6]

In 1841, Dr. Jacob Maentel, a German-born farmer-artist, painted in Poseyville, Indiana, a watercolor portrait of Mrs. Rebecca Jaquis. This small picture is of great documentary interest because, like Plate V, it shows a rare contemporary view of a stenciled interior (Pl. X). Seated in a Windsor arm chair, Mrs. Jaquis poses against a blue stenciled wall, the three border designs of which may be recognized as Moses Eaton patterns.

Wherever early Masonic meeting rooms are still identifiable, investigation below modern wall finishes

usually reveals painted Masonic symbols. The former ballroom of the Stapleton house in Treadwell, New York, ten miles from Oneonta, is said to have been used by the Aurora Lodge in 1810, and a sunburst in red and blue-black forms the central ceiling motif. Other ceiling and overmantel sunbursts, combined with a delicate, wide lacy swag-and-tassel border, result in a painted interior of great distinction. Figure 131 illustrates a Masonic meeting room in the Elisha Gilbert house, New Lebanon, New York, just west of Pittsfield, Massachusetts. Since this building was photographed, a second room displaying almost identical symbols, obviously by the same artist, has been rediscovered in the old Hall Tavern in Cheshire, Massachusetts. Striking portraits of the tavern keeper and his wife seated at a window of the house in 1808 are owned by the Abby Aldrich Rockefeller Folk Art Collection.

The subject of the plaster overmantel picture in Worthington Ridge, Connecticut (Fig. 130), has now been recognized as a view, undoubtedly from an engraving, of the twin towers of Greenwich Hospital, London, taken from Greenwich Hill, with the old observatory rising at the left.

Many strange and bizarre subject pieces have been covered in recent years, among them a volcano with tropical scenery as background for a snake fighting a tiger in Windham, Vermont. In nearby Londonderry, a legendary character identified as John or Thomas Powers is believed to have painted a pair of Napoleonic figures with lion, coupled with a room-length mural that includes a gory battle between a silver stallion and a crouching tiger, apparently inspired by the famous picture "The Frightened Horse," by the eminent eighteenth century English artist, George Stubbs.

In a small gambrel-roofed cottage on Weston Road, Waltham, Massachusetts, a lower room exhibits an extraordinary series of murals that depict fantastic figures and scenes for which no prototypes are now recognizable, although there must once have been artistic or literary sources of design. A gnomelike man and child, a figure hanging from a gibbet, a grotesque Angel Gabriel with outsized horn, a hunter aiming at a flock of large birds in a tree, and an Indian with upraised bow and arrow are among the images, all painted in an exaggerated and childlike manner reminiscent of characters in a fairy tale. Although carefully photographed by the Museum of Fine Arts, Boston, in 1966, the dark colors and worn condition of the plaster surface make reproduction here impossible.

Since primary information was published in *American Decorative Wall Painting* concerning murals by John Avery in Wolfeboro, New Hampshire, and vicinity (p. 120), an article has been written for *Yankee* magazine of December, 1970, which illustrates in color Avery's work in the previously mentioned Chamberlain Inn, Rust house, and Hersey-Whitten house in Tuftonboro, where a painted stair carpet is an added feature of decoration. These walls with their bold yet fanciful buildings and scenes prove that Avery was a colorful and imaginative decorator.

From a tumbled-down house in Deansboro, Oneida County, New York, came two panels of fresco on plaster which were saved from destruction by Mrs. J. Watson Webb and are now in the collection of Shelburne Museum. One represents a river with paddlewheel steamer, embellished at the lower edge with a band of well-executed leafy-vine stenciling. The second panel, however, appears to be unique in presenting Jean François Gravelet, the popular circus performer known as "Blondin," during his famous exploit of crossing the Niagara River a short distance below the Falls, on a tightrope in 1859 (Fig. 170). An oil painting of this feat, similar in many details, is in the collection of the New-York Historical Society.

In the Carroll and Bosc houses, Springfield, Otsego County, New York, and more recently fifteen miles away in the parlor of the old Pinney Tavern in Middlefield, lively and imaginative murals have been

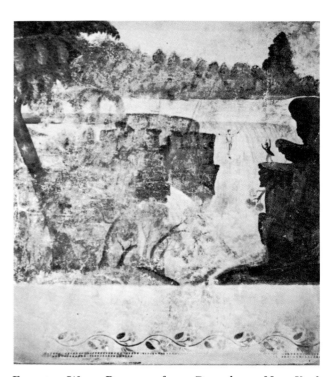

FIG. 170. WALL PAINTING from *Deansboro, New York* Believed to portray "Blondin" crossing the Niagara River in 1859. His tightrope is no longer visible.
Shelburne Museum, Shelburne, Vt.

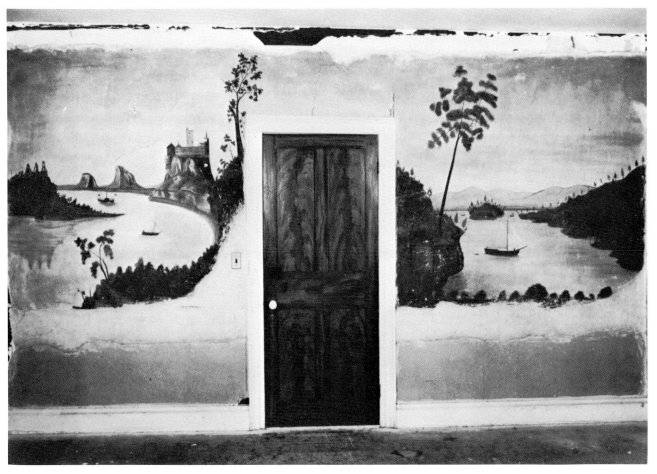

FIG. 171. MURAL in the parlor of the JOSHUA PINNEY TAVERN, *Middlefield,*
New York
Photograph New York State Historical Association,
Cooperstown, N.Y.

found, incorporating jagged rocks, torrential water-falls, spiky trees, and rivers with boats and romantic castles (Fig. 171). Whether or not these frescoes are all by the same hand, and they may well be, they illustrate typical examples of taste in the second quarter of the nineteenth century, when bold and picturesque murals painted in strong shades of green and brown were in popular demand.

In the Carroll house, itself once a turnpike tavern, the painted walls in the stair hall were signed by William Price in 1831. In 1957 the plaster in the lower and upper halls was removed and installed in the Henry Francis du Pont Winterthur Museum (Pl. XII), while other rooms were prepared for exhibit at the the New York State Historical Association.

Further examples of American wall painting will undoubtedly be found as time goes on. It is also to be

hoped that additional names of decorators whose work is described and illustrated here, will eventually be determined and recorded in print.

REFERENCES

1 A sample of the yellow background wallpaper and the four hunting prints originally a part of it are exhibited in the Moffatt-Ladd house, Portsmouth, N.H.

2 A piece of this colorful wallpaper is in the collection of Old Sturbridge Village, Sturbridge, Mass.

3 I am greatly indebted to William L. Warren for recent information concerning these Litchfield houses, and to Shirley Spaulding De Voe for slides and notes documenting many painted interiors.

4 Designs on the walls of the Red House are illustrated in Allen's *Early American Wall Paintings,* pp. 49–50.

5 This wall is now installed in the Museum of the Society for the Preservation of New England Antiquities, Boston, Mass.

6 Photographs and information about various examples of painted decoration in New York State are on file at the New York State Historical Association, Cooperstown, N.Y.

Appendices

BIOGRAPHICAL LIST OF PAINTERS

PANEL AND FIREBOARD PAINTERS

WINTHROP CHANDLER, 1747-1790

Son of William and Jemima (Bradbury) Chandler of Woodstock, Connecticut. Chandler is said to have begun his career as a house painter, but upon occasion also did carving, gilding, illustrating, and drafting, as well as portrait and landscape painting. His earliest known portraits of the Reverend and Mrs. Ebenezer Devotion of Scotland, Connecticut, are dated May 8, 1770. Chandler married Mary Gleason of Dudley, Massachusetts, in 1772, by whom he had seven children. He lived for five years in Worcester, Massachusetts. At the end of his life, after the death of his wife, he returned to Woodstock where he died impoverished on July 29, 1790. Chandler was perhaps one of the few painters of his type who was not an itinerant. He appears to have done all his work for friends or relatives in the vicinity of his home. Seven overmantels and one fireboard, as well as portraits and landscapes, have so far been attributed to him.

MICHELE FELICE CORNÈ, 1751-1845

Born on the island of Elba, and drafted into the army to resist a French attack on Naples, Cornè in 1799 was only too happy to escape his enforced military service and accept free passage to America on the ship *Mount Vernon*. In the family of her owner, Elias Haskett Derby, he lived for a time in Salem, and there he began his painting career. This included many pictures of Salem ships, a few portraits of local people, landscapes on canvas, and during the War of 1812 a group of paintings of famous naval engagements which were included as engraved illustrations in Abel Bowen's *Naval Monument*. In 1810 his name appears in the Boston Directory as of 61 Middle Street, where he lived until 1822 when he moved to Newport, Rhode Island. There he died on July 10, 1845. Cornè did wall frescoes (see list of Wall Painters), and while in Salem executed for the East India Marine Society two fireboards dated 1804, and a panel of Salem Harbor made for the entrance door of the Society's room in the Pickman Building. To him also are attributed four overmantel paintings on wood of scenery in the Italian manner, and two canvas overmantels from Oak Hill, Peabody, now in the Museum of Fine Arts, Boston.

ROBERT COWAN, 1762-1846

Robert Cowan was born in Scotland but came to Salem, Massachusetts, before 1782, in which year he married Elizabeth Stewart, also of Scotland. According to the Vital Records, seven children were born to them in Salem. One son, James, was lost at sea from the Brig *Hector* out of Trinidad with Captain Jonathan Bickford in 1807. On September 7, 1791, Robert Cowan, designated as "painter," purchased a seventeenth century house which stood on the easterly corner of Beckford Street, the westerly end of which he used for his home until he disposed of the property in 1837. When the street was widened by the city in 1846 the old house disappeared. Cowan did many types of ornamental painting for the Derby family of which records are contained in the Derby papers in the Essex Institute. Included among these is a receipted bill for "painting a landscape for a chimney board" in 1791.

JONATHAN WELCH EDES, 1751-

Jonathan Welch Edes was the son of William and Rebecca (Hawkins) Edes of the well-known Charlestown family, of which Benjamin Edes the printer was also a member. He received his middle name from his paternal grandmother, Susannah Welch, who was married to his grandfather, Edward Edes, by Cotton Mather in 1714. Jonathan W. was born on February 1, 1751/2, and when he was twenty-one years old his mother, "Rebecca Edes Senior," deeded to her son Jonathan Welch Edes, Painter, Pew 67 in the New North Church. On September 12, 1776, he married Susannah Barrett, and a manuscript genealogy of the Edes Family in the New England Historic Genealogical Society says that he served as a Captain in the Revolutionary War. By 1790 his first wife had died and he had apparently moved to Waltham, as on August 9 of that year he was married in Waltham by Doctor Cushing to Nancy Welsh of Newton. On May 1, 1793, "Jonathan Welch Edes, Painter" and his wife Nancy sold land and buildings near Sudbury Street, Boston, which had belonged to her mother, the late Mrs. Elizabeth Welsh. In March, 1796, the Watertown Town Meeting "Voted to grant Jonathan W. Edes in full of his account, 7 pounds." Two articles in the *Waltham Free Press*, under dates of September 27 and November 25, 1863, credit Edes with having painted two overmantel panels while living in Waltham, one for the home of Josiah Sanderson, now demolished. In 1789 he painted on an overmantel a view of Boston Light, which was engraved by S. Hill and published in the *Massachusetts Magazine* for February of that year, and in 1793 did a sketch of Eden Vale

in Waltham, with view of John Boyce's paper mill, which also appeared in the *Massachusetts Magazine*. In 1798 he appears as a painter living in Wing's Lane, Boston, and is listed in the Directories thereafter until 1803, after which date no further information about him has been found.

SYLVESTER HALL, 1774-

For biographical note see list of Wall Painters. Local tradition credits to Hall the overmantel panel from the Rufus Hitchcock house in Cheshire, Connecticut, which now hangs in the Public Library of the Town. Another panel, possibly by the same artist, is owned by the Fairfield (Connecticut) Historical Society.

JOHN HAZLITT, 1767-1837

John Hazlitt was born in Marshfield, England, the son of the Reverend William Hazlitt, a Unitarian clergyman, and the brother of William, the essayist. John sailed with his family for America from Cork, Ireland on April 3, 1783. After a year's sojourn in Philadelphia and elsewhere (the Reverend William Hazlitt being an itinerant preacher), the family traveled north to Weymouth, Massachusetts, in August 1784. They remained in Massachusetts until August 1787 when they sailed back to England. John is said to have received no training previous to his stay in America, and it is surprising that he did such good work at the age of only eighteen years. A miniature by him of his father was bequeathed to the Wampatuck Club, and a portrait of Doctor Ebenezer Gay is owned in Hingham. After his return to England he exhibited many times in the Royal Academy and died in Stockport May 16, 1837. The attribution of the Thaxter house panels to Hazlitt is a local one, and rests on their superior technique, English subject matter, and the fact that no others by the same hand have been found outside of Hingham.

JOHN HOLLIMAN

The date and place of John Holliman's birth and death have not been ascertained, but his marriage to Susanna Pretice on May 1, 1722 is recorded in Salem, Massachusetts, where nine children were born between 1723 and 1740. Holliman followed two professions, that of gravestone cutter and of decorative painter. Examples of his stone carving exist in Beverly, Massachusetts, on the gravestone of Joanna Herrick, and in Marblehead where he was paid ten pounds by the estate of John Conant for gravestones in 1746. The Diary of the Reverend William Bentley records a visit to the Dudley Woodbridge house, Water and Vine Streets, Salem, where he was taken many years after Holliman's death to see the artist's beautifully colored variegated painting on the paneling of the "great southeast room" and chamber above. In 1742 Holliman bought a lot of land on Beacon Hill in Boston which he mortgaged back to the seller for the whole amount. In 1744 his name appears in the records of the Brattle Street Church, he having transferred his membership from the Church in Salem, a fact which suggests that he had taken up residence in Boston. Original cedar-graining in the Richard Derby house, Salem, and similar decoration in Essex and Gloucester, Massachusetts, may be examples of his work.

DOCTOR RUFUS HATHEWAY, 1770-1822

The place of Rufus Hatheway's birth is uncertain (probably Freetown, Massachusetts), but he was married to Judith Winsor of Duxbury on December 10, 1795 by Doctor John Allyn. It is said that he fell in love with her while painting her portrait, but that his father-in-law, Joshua Winsor, a prominent merchant of Duxbury, persuaded him to take up the practice of medicine, which he considered a more suitable profession for the husband of his daughter. His portraits of local Duxbury people painted in the 1790's indicate that Hatheway was probably self-taught, but his ability to portray character, and his liking for decorative accessories, give his pictures strong individuality. One landscape on canvas is known to be his work, and one overmantel panel from the old John Peterson house in Duxbury has always been ascribed to him.

JARED JESSUP

For biographical note see list of Wall Painters. Although Jared Jessup is known primarily for his freehand wall painting, two landscape panels by him have been found, one in Old Lyme, Connecticut, and one in Bernardston, Massachusetts. These are recognizable by their great similarity to the plaster overmantel paintings which accompany several of his decorated walls.

JONATHAN D. POOR

For biographical note see list of Wall Painters. Jonathan D. Poor was a fresco painter and nephew of Rufus Porter, but he decorated at least one fireboard which is signed with his name and dated 1831.

PAINTERS OF FREEHAND REPEAT PATTERNS

B. BARTLING

The only evidence we have of B. Bartling as a wall painter consists of an advertisement dated 1804 for general decorating, in which his name is coupled with that of S. Hall (See below). At this period he apparently made his home in New Haven, Connecticut, as the *Connecticut Herald* of November 18, 1806, carried a notice of a chaise and harness for sale, with instructions to "enquire of B. Bartling."

S. HALL, 1774-

Probably the son of David and Ruth Hall, although four Sylvesters listed in the Wallingford and Cheshire, Connecticut, Vital Records between 1778 and 1785 create considerable confusion. In 1795, when he was twenty-one years old, 25 pounds was deducted from his share in his father's will, "on account of his learning a trade." This was probably painting and decorating. He lived for a time at least in Winchester, Connecticut, as two daughters were born there in 1800 and 1802, and he was granted land by his brother as "of Winchester." During the early months of 1804 he and B. Bartling ran a repeated advertisement in the *Connecticut Herald* in which they solicited business in general decorating which included executing "that much admired imitation of stamped paper, done on the walls of rooms. . . ." A panel of plaster said to be by Hall from the Rufus Hitchcock house in Cheshire shows a freehand top border of leaves, with an interlaced border edging windows and chair rail. A landscape panel from this house is also ascribed to him. The wording of the newspaper advertisement suggests that Hall was a traveling decorator, and in 1830 he is recorded in a deed of land as being "of Burke, Caledonia County, Vermont."

JARED JESSUP

John Jessup is thought to have moved from Wethersfield, Connecticut, to Southampton, Long Island, about 1644, where his great grandson Nathan (or Nathaniel) married Hannah Tarbell of Easthampton, and where their son Jared was probably born sometime during the Revolutionary period. Some years before 1800 they removed to Richmond, Massachusetts, a small town near Pittsfield which was incorporated in 1765, and settled in greater part by families from Long Island, and from Guilford, Connecticut. On March 14, 1802, Jared married Lucretia Chittenden in Guilford, where she had been born in 1772. Two children were born there, Lucretia in 1803 and Hannah in 1804. Mrs. Jessup died in Guilford on August 11, 1804, six months after the birth of her second child, and it seems likely that little Hannah was sent up to make her home with her grandparents in Richmond, as she died and was buried there in 1846. It was perhaps after the death of his wife that Jared began his career as a traveling painter. Walls in Guilford, Stonington, and Old Lyme may be recognized as his by similarity of certain details to a room in the Warham-Williams house, Northford, Connecticut, on the closet door of which he signed his name and the date October 5, 1809. Farther up the Connecticut Valley, in Deerfield and Bernardston, Massachusetts, is another group of walls by the same artist, where on an overmantel panel from the Burk Tavern, the date 1813 appears on a tavern sign. An old tradition in the neighborhood avers that the unknown decorator was a British spy in the War of 1812 who was apprehended while at work in Bernardston and taken away to Albany. No other walls by him have in fact been found, but investigation has provided no corroboration for this tale. From the variety of brush strokes and patterns found on the walls attributed to Jessup it seems likely that he had one or more assistants, or worked as one of a group of decorators.

PHILLIP MERRIT ROSE, 1771-1800

On March 21, 1765 Paul Revere's sister Mary married Edward Rose, said to have been an English ship master who died at sea presumably prior to 1779, when his widow married Edward Lawson. She was again a widow at the time of the 1790 census but married Alexander Baker on March 6, 1791. Contained in the records of the New Brick Church in Boston are the baptismal entries of three of her children: Mary, 1766, who married Caleb Francis, and died in 1804; Sarah, 1769, who married Thomas Brisco and went to live in Stevens Plains, Portland; and Phillip Merrit, July 28, 1771. Phillip may have kept a tin shop in Cambridge with his brother-in-law, Thomas Brisco. He ordered six silver teaspoons from his uncle, Paul Revere, in 1794. About 1796 he was in Stevens Plains, where he painted two family records for Isaac and Sarah (Brackett) Stevens, and may have painted walls in New Gloucester, West Falmouth, and Yarmouth. He died in Boston in 1800 and is buried with his mother in Copps Hill Burying Ground.

PAINTERS OF SCENIC FRESCOES AND SUBJECT PIECES

*Data on painters of the Porter School which are marked * are taken from "Rufus Porter" by Jean Lipman*

JOHN AVERY, 1790-

John Avery was born in Deerfield, New Hampshire in 1790. He later moved to Meredith where he married Hannah Prescott, and finally came to live in South Wolfeboro. Several of John's sons, Elbridge, John W., and Charles were also painters, the last decorating bedroom sets with scrolls and flowers. John Avery painted many murals in the vicinity of Wolfeboro, using distinctive designs of trees, buildings, animals, and figures. A wall in the Middleton Church is dated 1841. His portrait painted on a wood panel is inscribed on the back: "John Avery Sr." and is owned by the Old Home Association of Middleton.

STEPHEN BADGER

According to local tradition Stephen Badger arrived in the town of Candia, New Hampshire, as a young man from Amesbury, Massachusetts, in 1825. He painted rooms in several houses in the town with landscapes in water color, which had the mountains, lakes, figures, and animals which were popular at the time. In the home of Samuel Fitts he drew an ocean with ship in full sail and an immense sea serpent gliding over the water nearby. This was probably the result of the tremendous interest caused by a supposed sea serpent seen at Gloucester, Massachusetts, in 1817. It is said that Badger taught the art of wall painting to a neighbor, Asa Fitts, who painted two chambers in the home of his brother-in-law, Joshua Lane, which had trees of equal height painted with no shading. One large stump was realistically drawn with the woodsman's axe stuck in it, its handle extended horizontally. Some distance west, in Stoddard, another mural by Badger existed in 1942 in poor condition.

*E. V. BENNETT

No biographical information found. His signature appears on a fresco of Rufus Porter type in the Frank Hanson house in Winthrop, Maine.

MICHELE FELICE CORNÈ, 1751-1845

Biographical details appeared under "Panel and Fireboard Painters." Although Cornè painted fireboards and overmantels, he is better known for the scenic frescoes which he sometimes painted on paper and applied to the walls, and at other times executed directly on the plaster. In Salem he decorated with a marine panorama the inside of the cupola of the Pickman-Derby house, and also painted the walls of the hall in the Lindell-Andrews house at 393 Essex Street with scenes of rivers and mountains. After moving to Boston he is said to have decorated the Hancock mansion, and in Providence, Rhode Island, he did the halls and parlor of the Sullivan-Dorr house with many different views including the Bay of Naples and other Italian scenes.

JOHN DOW, 1772-1862

John Dow was born in August, 1772, on what is now known as Quaker Farm, South Road, Kensington, New Hampshire, a descendant of an old Quaker family in the town. Although his ancestors and some of his family are buried in the Friends Cemetery at Seabrook, his friends objected to his being buried there, feeling that he was not sufficiently "coöperative," so his body lies in a field near his home. His stone has been moved, and in 1950 rested in a thicket of trees at the end of the field to the east of the house. It bears the following inscription: "John Dow Esq., died Nov. 7, 1862. age 92 years 3 mos." He was a farmer and a great hunter and is said to have painted for pleasure all his life. He painted a pair of oxen on two barn doors of the farm at the bottom

of the hill to the west of his house. On the plaster wall beside the fireplace in a house across the road, which has now been taken down, he painted a goose on a pink background. He decorated the panel over his own kitchen fireplace with a hunting scene in a sort of *découpage,* part of which may still be seen. In later life he did a series of water color drawings for a small neighbor, Walter Sawyer.

HARVEY DRESSER, 1789-1835

The son of Major Moses Dresser, he was born on Dresser Hill, Charlton, Massachusetts. He began his career as a painter, and in 1815 to 1817 painted a staircase with red drapery beside the pulpit of the church in Thompson, Connecticut, which was so realistic that the children wondered why the minister did not use it. A fireboard from the old Dresser home is in existence and may have been done by him. He eventually went into the business of manufacturing furniture, carts, and sleighs, harness and iron work, and ran two country variety stores. In 1831 he purchased and operated a large cotton mill known as the "Dresser Manufacturing Company" at Southbridge, and became one of the most influential men of the town. He died February 8, 1835 at the age of forty-six. An engraving of him is in *Historical Collections* by Holmes Ammidown.

*E. J. GILBERT

His stenciled signature has been found in two places on the walls of the Knowlton house in Winthrop, Maine, where his designs are similar to those used by Rufus Porter, but his style and coloring are somewhat different.

*JONATHAN D. POOR

A nephew of Rufus Porter, Jonathan was the son of Jonathan and Ruth (Porter) Poor of Baldwin, later Sebago, Maine. It is thought that he may have been the young relative "Joe" who traveled as Porter's portrait painting assistant in 1823. From 1830 to 1840 he apparently did many murals in the Porter manner, receiving, it is said, about $10.00 for each room. Family records state that he was living in Vienna, Maine, in 1833 where he is credited with doing several houses. The name J. D. Poor is lettered on a side-wheel steamboat in a fresco in the Donald L. Priest house, Groton, Massachusetts, and the Norton house in East Baldwin, Maine, has a fresco initialed J.D.P. and dated 1840.

*RUFUS PORTER, 1792-1884

Born in West Boxford, Massachusetts, he moved to Maine with his family in 1801, and thereafter traveled almost continuously during his long life. He was an inventor and journalist as well as a painter, and founded the *Scientific American* in 1845. In 1815 he married Eunice Twombly of Portland, who brought up a large family of children in Billerica, Massachusetts, where she lived during her husband's many absences from 1823 until her death in 1848. Porter began itinerant portrait painting in 1816 which he carried on throughout New England and as far south as Virginia, trying also landscape painting and the cutting of silhouettes. In 1824, however, he turned his attention to scenic murals which proved both popular and successful, and many houses decorated by him are still to be found in Massachusetts, Maine, and New Hampshire. After 1845 he appears to have given up painting in favor of his experiments and his writing, which included *A Select Collection of Valuable and Curious*

Arts and Interesting Experiments, the first edition of which appeared in 1825. He died on August 13, 1884 while on a visit to his son in New Haven, Connecticut.

*STEPHEN TWOMBLY PORTER, 1816-1850

Son of Rufus and Eunice (Twombly) Porter, Stephen was born in Portland, Maine. Little is known about him except that in the Colburn house, Westwood, Massachusetts, his name, S. T. Porter, is signed above that of his father, with the date 1838. He was also a partner in publishing the *American Mechanic* in 1841-1842. He died in Billerica on October 6, 1850.

SANFORD AND WALSH

There is no biographical information about these men, and knowledge of them as wall painters rests on an advertisement which appeared in the *American Mercury,* on November 16, 1789. At their shop, which was located two doors south of the North Meeting House in Hartford, Connecticut, they did gilding and general decorating which included heraldry, portraits, miniatures, signs, and chaises. They also did "outside and room painting," the latter consisting of scenic frescoes of hunting, shipping, and many other subjects.

NATHAN THAYER, 1781-1830

Born on July 6th at Milford, New Hampshire, he removed to Hollis in 1798 and married Hannah Jewett in 1807. He taught school during the winter months for thirty years and was a member of the School Committee, Justice of the Peace, and Representative to the General Court. In 1825 he married for a second time Mary Jewett, sister of his first wife. During the summers he is said to have painted murals in many towns in southern New Hampshire and vicinity, including Groton, Andover, and East Pepperell, employing a style which has heretofore been regarded as that of Rufus Porter's early period. He died on October 21, 1830.

*J. H. WARNER

This name and the date Aug. 1840 are inscribed on a scroll over the mantelpiece in a house at 183 Pritchard Street, Fitchburg, Massachusetts. Each wall of the room exhibits a different scene, all done with boldness and brilliance. If Warner was an itinerant it is to be hoped that further examples of his work will be found.

*ORISON WOOD, 1811-1842

His home was in Auburn, Maine, and in the Wood genealogy he is listed as "a painter by trade." His father, Solomon, was a painter of plaster ornaments, an art he had learned from an Italian in Boston. Wood did wall frescoes after the Porter manner, and several houses in Lewiston, West Auburn, and Webster Corner, were done by him about 1830.

WALL STENCILERS
The following names are taken from
Early American Stencils on Walls and Furniture
by Janet Waring

MOSES EATON, 1796-

His father, Moses, Senior, was descended from early settlers of Dedham, Massachusetts. He fought in the Revolutionary War and later moved to Hancock, New Hampshire,

where his son was born. Moses, Junior, lived much of his life in nearby Dublin, settling in the part of the town now known as Harrisville. It is said that after his marriage he turned to farming, but the many walls in Massachusetts, New Hampshire, and Maine which bear his stenciled patterns indicate that he was the most prolific itinerant wall painter in New England. His stencil kit is preserved in the museum of The Society for the Preservation of New England Antiquities, Boston.

HENRY O. GOODRICH, 1814-1834

His name is known only through an old box of wall stencils which was found in the attic of the Goodrich house at Not-

tingham, near Deerfield, New Hampshire. His gravestone in the family burying-ground at the rear of the house supplied the dates of his birth and death.

NATHANIEL PARKER, 1802-

He was born in North Weare, New Hampshire. The stenciling in the Buchman house in Antrim is said to be his work.

EMERY RICE

He plied his trade in the vicinity of Hancock, New Hampshire. A set of stencils was found in the home of his son, one of them being similar to a stencil found in the Eaton kit.

CHECKLIST OF PICTORIAL PANELS

The checklist is arranged in the following manner: original location of panels; brief description; measurements to the nearest inch, height preceding width; name of artists if identified (these must necessarily be provisional attributions as only one signed panel has been recorded); present location, or name of owner; where illustrated if known to the author.

MASSACHUSETTS

BERNARDSTON, *Burk Tavern*

Town and harbor with two ships. Tavern at left dark yellowish-brown. Houses: gray, brown, yellow, and brick color. Windows black, muntins and trim white. Men wear square-crowned hats and tail coats. Ships fly American flags. 32 x 66. JARED JESSUP. Memorial Hall, Deerfield, Mass. Illus. Fig. 104.

BOSTON, *Clark-Frankland house,* Cor. Garden Court and Prince St. Now demolished

View of the mansion with two figures standing at left. Red brick with white trim and green door. Muntins white. 16 x 26. On loan by the Bostonian Society to the Society for the Preservation of New England Antiquities, Boston. Illus. Fig. 30.

Wall panel. Inn with mounted rider surmounted by the Hubbard shield suspended by bowknots of red ribbon. Inn brown with reddish roof, casement windows. 63 x 31. Maine Historical Society, Portland, Me. Illus. Fig. 29.

Wall panel. House standing on cliff above a river, two figures below, one in tricorne hat and red coat. 63 x 26. Location as above. Illus. Allen, *Early American Wall Paintings.*

Wall panel. River with man and girl on bank. Shield of the Saltonstall family. Owned in 1926 by Mrs. Frederick Gay, Brookline, Mass. Illus. as above.

Wall panel. Castle with cow in foreground. Shield of the Clark family. Ownership and illus. as above.

BROOKFIELD, *Banister house,* Fiskdale Road

Large hip-roofed house with carriage sheds and two barns. Bevel shaded green. House and sheds light yellow with white trim. One barn pumpkin color, one gray. Men wear high crowned hats, knee breeches, and cutaway coats. Women wear high plumed hats of the 1790's. 34 x 50. Mr. and Mrs. B. K. Little, Brookline, Mass. Illus. Fig. 25.

CHELSEA (Now Revere), *House near old First Church,* Beach St.

Boston Light with pilot rowing out to a ship. Set in origi-

nal woodwork painted dark red. 28 x 81. Signed and dated, JONA W. EDES, 1789. Mr. and Mrs. B. K. Little, Brookline, Mass. Illus. Fig. 32.

DUXBURY, *John Peterson house,* Powder Point. Now demolished

Pair of peacocks with tails crossed looking back at one another, against a bluish-green background. Set in original stiles and rails. 27 x 54. DR. RUFUS HATHEWAY. Rev. Abbott Peterson, Duxbury, Mass. Illus. Fig. 36.

FRAMINGHAM, *Peter Clays house,* 657 Salem End Road

View of a small town. Houses and a church, with shipping in the distance, are grouped between rising hills on either side, which are set off by hedgerows. Most of the houses are cream with pinkish-brown windows. Three houses are brown, vermilion, and dark green. One has a red door. 26 x 53. Original location.

FRAMINGHAM, Location of house unknown. Now demolished

Three large stags silhouetted against the sky. Based on a traditional motif. 15 x 61. WAMSCOUN, an Indian. Edward Atkinson, Columbus, Ohio. Illus. Fig. 26.

FRANKLIN, Perhaps from William Makepeace house, Unionville

Hunters and dogs galloping over a rolling countryside. Based on an engraving after the English painter James Seymour. 22 x 58. Mr. and Mrs. B. K. Little, Brookline, Mass. Illus. Fig. 34.

Wall panel. Figures hunting and shooting on a country estate having two large gateposts. 25 x 53. Museum of Art, Rhode Island School of Design, Providence, R. I.

Wall panel. Landscape with large group of buildings and small figures in foreground. 27 x 43. Col. and Mrs. Edgar W. Garbisch, New York City, N. Y.

HINGHAM, *John Thaxter house*

Seventeen raised panels on the fireplace wall of the original "hall." Landscapes with buildings of English type, one a walled castle. Panels differ in size. Entire woodwork measures 10' 8" x 7' 3". JOHN HAZLITT. Original location. Illus. Fig. 39.

HINGHAM, *Thaxter-Lincoln house,* now demolished

Three wall panels with English landscapes similar to above. Two, 6 x 19. One, 16 x 29. JOHN HAZLITT. Mrs. S. Randall Lincoln, Hingham, Mass.

Wall panel. Landscape surrounding a bay with a three-masted ship under sail. Birds in the sky. 13 x 19. JOHN HAZLITT. Hingham Historical Society.

Wall panel. Two houses with outbuildings. 17 x 30. JOHN HAZLITT. Mr. and Mrs. B. K. Little, Brookline, Mass. Illus. Fig. 38.

Wall panel. Three turreted castles set in a rolling landscape. Grisaille with bevel in rose. 10 x 29. JOHN HAZLITT. Formerly Chester Burr, Brookline, Mass.

Wall panel. Stream with bridge joining a church and crenelated tower. Grisaille with pink bevel. 27 x 15. JOHN HAZLITT. Formerly Francis H. Lincoln, Hingham, Mass.

IPSWICH, *Caldwell house,* near Town Wharf. Now demolished

Fishing station at Great Neck with many boats; one appears to fly the British flag. Little Neck appears on right with a flock of sheep. 18 x 58. Ipswich Historical Society.

MARBLEHEAD, *Jeremiah Lee Mansion*

Biblical scene "Esther before Ahasuerus" is said to have been painted on the panel over the fireplace in the Banquet Room. This has now disappeared and its whereabouts is unknown.

NEWBURYPORT, *The Rev. John Lowell house*

Seven ministers seated around a long table with candles, clay pipes, and writing equipment. Arch overhead with Latin inscription. Left side of picture composed of landscape with six swans. 31 x 42. Elmwood, Cambridge, Mass., former home of James Russell Lowell. Illus. Fig. 47.

OXFORD, *House unidentified*

River with church and houses on left. At right group of men and women feeding swans. Houses are brown, yellow, red, and green. Church has quoined corners and cock weathervane. 30 x 54. Worcester Art Museum, Worcester, Mass. Illus. Fig. 21.

OXFORD (North), *Joshua Merriam house*

View of a town near a harbor with three ships. Houses: white, brown, and red. Many outbuildings with black, arch-topped doors. Group of large figures at right, men and women in late 18th century costume. Negro peddler with pack and stick. 17 x 54. Worcester Historical Society, Worcester, Mass. Detail illus. Fig. 20.

PEABODY, *Oak Hill*

Dining room. On canvas. Group of figures based on a painting by William Redmore Bigg, R.A., entitled "Saturday Evening." Original exhibited at the Royal Academy, London, in 1792. 50 x 48. MICHELE FELICE CORNÈ. Museum of Fine Arts, Boston, Mass. Illus. Fig. 42.

Drawing room. On canvas. Group of figures after a painting by William Redmore Bigg, R.A., entitled "Sunday Morning." Original exhibited at the Royal Academy in 1793. 48 x 52. MICHELE FELICE CORNÈ. Museum of Fine Arts, Boston, Mass. Illus. Edwin J. Hipkiss, *Three McIntire Rooms from Peabody, Mass.* (Museum of Fine Arts, Boston, 1931).

PETERSHAM, *John Chandler house*

Large city on banks of a river, with block buildings, many churches, and frame houses, painted pink, gray, and blue, with white trim and black doors. 27 x 45. WINTHROP CHANDLER. Original location. Illus. *Art in America,* April 1947.

SALEM, *Simon Forrester house,* 120 Derby St.

Italian landscape with houses, a church, and ships in bay surrounded by distant hills. Figures of men and women in foreground. Vine and flower border painted freehand. 27 x 65. MICHELE FELICE CORNÈ. Mrs. Francis B. Crowninshield, Marblehead, Mass. Illus. Fig. 43.

Italian landscape with river spanned by arched bridge, houses, a church, and many round stone towers. Two men conversing and traveller with pack over shoulder. 27 x 45. MICHELE FELICE CORNÈ. Essex Institute, Salem, Mass.

SALEM, *Rooms of the Salem East India Marine Society,* Essex St.

Over-door panel. View supposed to represent Salem Harbor with ship *Mount Vernon.* Figure of a woman at left. A scroll lettered "East India Marine Hall" was added in 1825. 16 x 40. Signed and dated, M. CORNÈ, 1805. Peabody Museum, Salem, Mass. Illus. Allen, *Early American Wall Paintings.*

SALEM, *house unidentified*

River with bridge and ships, surrounded by distant hills. Man with bundle on a stick walking in foreground. Exceptionally fine coloring. 27 x 65. MICHELE FELICE CORNÈ. Mr. and Mrs. B. K. Little, Brookline, Mass. Illus. Fig. 44.

SALEM, *George Hodges house,* Essex St.

On canvas. Probably Winter Island. Two bridges crossing an inlet. Houses and outbuildings on distant right. Many boats on bay in background. Mr. and Mrs. George H. Shattuck, Marion, Mass. Illus. Fig. 41.

SHREWSBURY, *Baldwin house.* Now demolished

Shepherdess and sheep among trees at left. River and two boats at right, with houses along a road on the bank. 24 x 49. Mrs. Eveleth Hill, Shrewsbury, Mass.

SHREWSBURY, *Artemus Ward house*

Local tradition avers that an overmantel landscape once existed in the lower center room, but the fireplace wall has been altered and no signs of paneling now remain.

SOUTHBRIDGE, *John Ammidown house,* West Dudley Road

View of a town with hills in distant background. Houses cream, with brown roofs and windows. Church has cock weathervane. No figures. 33 x 55. Original location. Illus. Fig. 17.

SPRINGFIELD, *Reuben Bliss house.* Now demolished

A pond with lady sitting on bank. Cluster of houses on far shore and Conn. Valley hills on either side. Four large birds in sky. 35 x 73. United States National Museum, Washington, D. C.

STURBRIDGE, *Moses Marcy house.* Now demolished

Man in militia uniform standing behind a table and drinking from a long-stemmed wine glass. On the table a creamware bowl, clay pipe, and book. A dog sits under the table. In background a ship on river, and gambrel-roofed house painted light buff with white trim. Front door is red with green trim. 41 x 27. Old Sturbridge Village, Sturbridge, Mass. Illus. Fig. 22.

STURBRIDGE, *Perez Walker house,* Walker Pond. Now demolished

Large town of closely built white houses with hill rising

steeply on left and masts of many ships at dock in distance. Woman and soldier in uniform at lower right. 39 x 45. Old Sturbridge Village, Sturbridge, Mass. Illus. Fig. 19.

STURBRIDGE, *Damon Nichols house,* near Charlton line. Now demolished

Bay with ships. At left a town with two churches. Houses red and white, some with red roofs. 43 x 58. Mr. and Mrs. B. K. Little, Brookline, Mass. Illus. Fig. 18.

SUTTON (West), *Ebenezer Waters house*

Parlor. Winding river, thickly wooded. House at left light brown with white trim and black pedimented door. In foreground five horsemen with tricorne hats, some in uniform. One a negro with a red turban. Man carrying a stick, with double pack over shoulder, accompanied by a dog. 20 x 58. WINTHROP CHANDLER. Original location. Illus. *Art in America,* April 1948.

Upper Chamber. Broad river with rows of brick buildings on right and frame houses on left. A fort in foreground. Houses painted light yellow, pink, and green, with white trim. 18 x 47. WINTHROP CHANDLER. Original location. Illus. Fig. 3.

TAUNTON, *Porter Inn,* south side of the Green. Now demolished

Buildings on the north side of Taunton Green. These include the Court House and McWhorten's Inn. Others have been identified. 30 x 48. Old Colony Historical Society, Taunton, Mass.

WESTBOROUGH, House said to have stood at corner of Main and West Sts. Now demolished

Large square mansion with open sheds and terminal buildings framed by avenue of poplars. At left two riders and a hound chase an antlered stag toward a man and woman standing at right. Henry Francis du Pont Winterthur Museum, Winterthur, Delaware.

WORCESTER, *The Rev. Joseph Wheeler house,* Main St., opposite Court Hill. Now demolished

Wheeler house and store in center with neighboring houses, sheltered by a long row of palm trees. At far right a cluster of houses painted vermilion, blue, brown, pink, gray, and cream. Large house has pedimented door, dentiled cornice, and quoined corners, and is portrayed accurately. 22 x 58. Charles Aiken, Wellesley, Mass. Illus. Fig. 23.

NEW HAMPSHIRE

EXETER, *Gardiner-Gilman house*

River with large white mansion house on road in foreground. On far shore a town with houses painted red, white, and gray. There are two churches with steeples and two taverns with hanging signboards. A party of men and women comes down the street preparatory to embarking in a barge for a ship nearby. 28 x 48. Traditionally ascribed to a guest named Van Cortland. Gilman Garrison house, Exeter, N. H. Illus. Fig. 49.

EXETER, *house unidentified*

Eagle holding United States shield, with arrows and olive branch. Large tree at either end of panel against a soft blue background. Above the eagle's head are seven stars. At each corner of the panel is a black painted square enclosing a small conventional design. The whole was apparently originally enframed in a molding having crossetted corners.

35 x 63. Old Sturbridge Village, Sturbridge, Mass. Illus. Fig. 50.

HENNIKER, *Ocean-Born Mary House*

United States Seal with eagle, shield, and laurel wreath, surmounted by sixteen stars. Painted in shades of gray. The design was restored some years ago owing to water damage. Original location. Illus. John Mead Howells, *The Architectural Heritage of the Merrimac.*

PORTSMOUTH, *Capt. Robert Parker house,* Islington St. Now demolished

House standing on the left bank of a river. Fields with several large trees at right. Col. and Mrs. Edgar W. Garbisch, New York City, N. Y.

VERMONT

JERICHO, *Governor Chittenden house.*

Eagle with shield, arrows, and olive branch. Beneath the eagle a pine tree, at left a Liberty Cap, at right the American flag with sixteen stars. In the background a row of hills. Original location. Illus. Fig. 51.

NORTH MONTPELIER, *Rich Tavern*

Highly stylized group of public buildings. Almost indistinguishable owing to old varnish. Original location.

MAINE

KITTERY, *John Bray house.*

Large bay surrounded by hills with two fortifications. Full rigged ship in bay with a boat being rowed toward shore. 25 x 60. Hanging in John Bray house, Kittery.

RHODE ISLAND

NEWPORT, *Phillips house,* Mill St. Now demolished

View of Newport harbor. Fort George on Goat Island in the foreground, flying the British jack. Shipping in the harbor, with the town of Newport in the background. 27 x 61. Lewis G. Morris, Newport. Illus. Fig. 63.

View of old stone mill with surrounding houses and Bannister family ships in distance. Said to have been an overmantel in a Mill Street house. 16 x 21. Traditionally attributed to Gilbert Stuart. Lawrence P. Tower, Newport. Illus. as frontispiece of Philip Ainsworth Means, *Newport Tower.*

NEWPORT, *Quaker Tom Robinson house,* 64 Washington St.

Chimney wall of upper chamber consists of eight raised panels with similar designs. On large panel is a wavy horizon line with small and large trees in greenish-gray. Streaks of red and green in the sky. Two red fires smoke at either end. Part of woodwork still uncovered. Large panel 25 x 56. Original location. (A harbor scene was found on an overmantel in a lower room of this house.)

NEWPORT, Four panels showing harbor and battle scenes are reported to have been taken out of an old house which was demolished in 1925, but these are now unlocated.

SAUNDERSTOWN, *Rowland Robinson house*

At left two riders and four dogs gallop after a stag. Five large trees are silhouetted against a rose and blue sky. A large exotic bird sits on a branch. 35 x 55. Original location. Illus. Fig. 62.

CONNECTICUT

BROOKLYN, *Allen house.* Destroyed by fire

Rolling country with many trees. A large mountain lion sits on a branch of tree in center, while a deer runs below. This panel was destroyed when the house burned some years ago. Illus. Allen, *Early American Wall Paintings.*

BROOKLYN, *Coles-Searle Tavern*

Flat plain with small trees and three large trees whose tops are not shown in the painting. A white horse stands behind left tree with hunter shooting as his dog chases a deer. A lion and a bear stand nearby. 18 x 70. Metropolitan Museum of Art, New York City, N. Y. Illus. Fig. 52.

Another panel was located in a house on the Village Green, but this has been removed and its whereabouts is unknown.

CANTERBURY, *Palmer house*

Mansion house with dependent wings and other buildings situated beside a bay. A ship off shore and a lighthouse opposite. A steepled church nestles in the hills. The panel is framed by a draped curtain which is looped in the center by a tasseled cord. Original location. Illus. Allen, *Early American Wall Paintings.*

CHESHIRE, *Rufus Hitchcock house.* Cheshire Green

View of church and two houses supposed to represent Cheshire Green. Locally attributed to SYLVESTER HALL. Cheshire Public Library. Illus. Allen, *Early American Wall Paintings.*

DEEP RIVER, *House on Union St.*

A bay with sailing ships, and lighthouse on a spit of land. A boat with men rowing pulls away from ship, in center, which flies the American flag. On left shore is an ox cart, and one man is chopping wood while another piles it. 20 x 51. Mr. and Mrs. B. K. Little, Brookline, Mass.

FAIRFIELD, *Elisha T. Mills house?* Now demolished

On the left a gray gambrel-roofed house with white trim, having a blue door. At right two red barns. Said to represent a scene in Fairfield, possibly the Beers house. 24 x 41. Fairfield Historical Society. Illus. Fig. 61.

LEBANON, *Welles house*

Landscape painted on the central panel of a room-end. Reference to this overmantel will be found in J. Frederick Kelly's *Early Domestic Architecture of Connecticut.* Original location.

LYME, *Waid-Tinker house*

Three lines of houses placed on horizontal planes with no attempt at perspective. Window panes suggested by black dots. A tavern with sign is lettered S. L. Inn, and another "Jin Shop." JARED JESSUP. Original location. Now painted over owing to smoke damage after a fire. Illus. Fig. 59.

MIDDLETOWN, *Seth Wetmore house,* Meriden Rd.

At the right a classic ruin in front of which is a man in a tricorne hat and knee breeches and a lady in a red dress and blue apron. Nearby is a group of peasants and two cows. In the distance is an arched bridge, a church, and other buildings on the bank of a river. Probably based on an engraving or an imported wall paper. The surrounding woodwork retains its original cedar-graining and green marbleizing. 37 x 75. Original location. Illus. Fig. 58.

MIDDLETOWN, *house in South Farms district*

Group of wall panels, landscapes, and marines painted on inner surface of the outer boarding. These were apparently placed above and below a chair rail and were surrounded by heavy moldings. Now papered over. Original location. Illus. Fig. 57.

NORTHFORD, *Tyler-Harrison house*

Group of houses on the shore of a small bay, painted blue, buff, dark green, and cream. Roofs and many doors red. A number of small figures including man with two-wheeled cart. Heavy trees in background with horses climbing a steep hill. 27 x 30. Miss Ethel Wellman, Northford. Illus. Fig. 60.

SCOTLAND, *Elisha Hurlbut house*

A winding stream flanked by high hills with two large trees in foreground. A gray mansion house with white trim on left, and a red house with outbuildings in gray and brown on right. In the foreground a group of men, horses, and riders. Bevel in dark red. 44 x 61. WINTHROP CHANDLER. Mr. and Mrs. B. K. Little, Brookline, Mass. Illus. Fig. 53.

SOUTH WOODSTOCK, *Gen. Samuel McClellan house* (Arnold Inn)

Two shelves of calf-bound books separated by shaped partitions. The books have red labels now almost indistinguishable owing to old varnish. There are an ink well and two quill pens on the upper shelf. 19 x 35. WINTHROP CHANDLER. Original location. Illus. *Art In America,* April 1947.

SUFFIELD, *Alexander King house*

View of a wide river (probably the Connecticut), with flat countryside and hills in the distant background. In the foreground a black coach with yellow wheels and postilion rider. There is a coat-of-arms on side of coach. 37 x 62. Original location. Illus. Fig. 56.

ORIGINAL LOCATION UNCERTAIN

VICINITY OF BOYLSTON, Massachusetts

Wooded scene with many large trees interspersed with small trees and bushes. In the foreground a hound chases a fox which follows a stag. 41 x 58. Arthur Knight, Shrewsbury, Mass.

VICINITY OF ENFIELD, Massachusetts

Lemon yellow hip-roofed house with central chimney. Front door green surmounted by a transom. Ell and shed dark gray. Hill with trees in background and a brilliant rose and blue sky. 19 x 26. Mr. and Mrs. B. K. Little, Brookline, Mass.

VICINITY OF MARBLEHEAD, Massachusetts

Street scene in a seaport town. Shipping and sailors at left. Houses painted red and brown with red and green roofs. Several taverns and many figures and vehicles in street. Church has Gothic windows. 18 x 24. "Beauport," Eastern Point, Gloucester, Mass. Illus. Fig. 46.

VICINITY OF MARBLEHEAD, Massachusetts

Hunting scene with five riders and a large pack of hounds. This painting is a close copy of an engraving by B. Baron, London, after a painting by John Wootton entitled "The Going out in the Morning." 27 x 70. Jeremiah Lee Mansion, Marblehead, Mass.

VICINITY OF NEWBURYPORT, Massachusetts

Two white houses with outbuildings under a large tree at extreme left. Low hills in background. Bevel soft greenish-blue. 23 x 47. Mr. and Mrs. B. K. Little, Brookline, Mass.

VICINITY OF NEWBURYPORT, Massachusetts

Rolling hills with small trees in right foreground. At left a river opening out into a broad expanse of water. In center a ship and a sloop firing at one another. Several other boats nearby. One ship flies red British jack, the other has unrecognizable red flags. At lower right corner is a large urn of flowers. 35 x 44. Creek Club, Locust Valley, Long Island. Illus. *The Antiquarian*, April 1929.

SALEM, Massachusetts?

Said to represent the Island of Mauritius (Isle of France), but appears to be a fanciful scene with ship sailing by a walled fortress. A small house with two groups of well drawn figures in the foreground. 41 x 83. MICHELE FELICE CORNÈ. Mr. and Mrs. Lammot du Pont Copeland. Greenville, Delaware.

NEW HAMPSHIRE

Hunting scene with four riders and two hounds pursuing a hare. In the foreground a huntsman with pole. This figure appears in many of the needlework pictures and English hunting prints of the mid eighteenth century. 31 x 75. Mr. and Mrs. Lammot du Pont Copeland, Greenville, Delaware.

VICINITY OF POMFRET, Connecticut

View of houses and trees with a river and an island in the background. A brown and red house with white trim. At left a hound chases a fox who is chasing a rabbit. 31 x 62. WINTHROP CHANDLER. Ben Grosvenor Inn, Pomfret, Connecticut. Illus. Fig. 55.

VICINITY OF WOODSTOCK, Connecticut

View of a square, hip-roofed house with central chimney, painted gray with white trim, surrounded by rolling country and cultivated fields. Two riders pass on the road; one accompanied by two hounds leads a black saddled horse. 27 x 34. WINTHROP CHANDLER. Mrs. Joseph H. Chadbourne, Hampton, Connecticut. Illus. *Art In America*, April 1948.

ORIGIN UNKNOWN

Farmyard scene. Hip-roofed house on left. In foreground five large fowl: a turkey, three chickens, and a hen. 15 x 35. Edward Ford, Marshfield, Mass.

ORIGIN UNKNOWN

River scene with rolling country at left. A two-story house at left with man and woman holding a parasol strolling in front. In foreground a hound scenting a rabbit which hides behind a rock. A row of frame buildings borders the river in the distance, and a heron stands at the water's edge. Reverse of panel is lettered: "Painted by an Englishman near the year 1776 afterwards being covered with white paint, was removed gently by L.W.B. and Mary H. Hughes. 1854 &/57." 33 x 64. Mr. and Mrs. B. K. Little, Brookline, Mass. Illus. Fig. 48.

ORIGIN UNKNOWN

Large house on far bank of a river which runs in foreground. Man fishing on bank with basket and two fish beside him. Two men row a boat and a woman in a wide skirt and large brimmed hat sits on the river bank. 21 x 51. Creek Club, Locust Valley, Long Island.

OUTSIDE NEW ENGLAND

WARWICK, New York, *Daniel Burt house,* Forester St.

The chimney wall is composed of sixteen small panels, seven of which are over the fireplace. The landscape is painted on the center horizontal panel of this arrangement. Two hills on either side slope down to the center with water in the background. Men row out to a ship, near which is a whale. On the headland at left is perched a large eagle with outspread wings. The family who built this house came from Connecticut. 13 x 30. Original location. Warwick Historical Society.

VICINITY OF LANSDALE, Pennsylvania

Group of large figures feeding swans at the edge of a small pond or river. Several fanciful buildings nearby. Women in side paniers and fichus and men in knee breeches and tricorne hats of the mid eighteenth century. An old man sits with one leg up on a carrying bench. Entirely painted in grisaille. May be derived from an engraved source. 32 x 55. Mr. and Mrs. B. K. Little, Brookline, Mass. Illus. Fig. 66.

LEBANON COUNTY, Pennsylvania

View of a river with large cross in foreground and a high hill surmounted by a cross in background. At right a stone cistern with water pouring into a large basin. This is a copy of Plate XXI in William Salmon's *Polygraphice*, published in London in 1685. 32 x 47. Metropolitan Museum of Art, New York City, N. Y.

FRIENDSHIP, Anne Arundel Co., Maryland, *Holly Hill*

In upper chamber. View of an island. There is a turreted castle on the shore from which flies the British flag. Set in original marbled woodwork. 29 x 58. Illus. Fig. 6.

In dining room. Ship flying the British jack coming into port. Two men are waiting on the shore in front of a house with a high wall. 14 x 78. Illus. *Maryland Historical Society Magazine*, Dec. 1946.

Over door into dining room. Stone tower on the edge of a bay. 9 x 12. Capt. and Mrs. Hugh P. LeClair, Friendship, Maryland. Illus. *Maryland Historical Society Magazine*, Dec. 1946.

YARMOUTH, Kent County, Maryland, *Spencer Hall*

Ship building scene on Gray's Inn Creek, on the west side of the Chester River, below Rock Hall. Two ships in process of construction, and many boats on river, seven flying English flags. 27 x 106. Maryland Historical Society, Baltimore, Md. Illus. *Maryland History Notes*, May 1943.

KING GEORGE COUNTY, Virginia, *Marmion*

Paneled room with original painted decoration. Background color grayish-green. Columns and cornice marbleized in black on brown. Dado boldly marbled. Overmantel and wall panels painted with scenes in foreign manner, intermingled with vases or cornucopias of flowers and bits of rococo detail. Overmantel 30 x 28. Vertical wall panels 62 x 30. Metropolitan Museum of Art, New York City, N. Y. Illus. Allen, *Early American Wall Paintings*.

RICHMOND COUNTY, Virginia, *Morattico*
Overmantel and two flanking panels enframed in bolection moldings with original marbleizing. Center panel shows a large and ornate mansion with formal gardens and a river and town in the background. 19 x 91. Two side panels have birds and water fowl. 19 x 27. Henry Francis du Pont Winterthur Museum, Winterthur, Delaware. Illus. Fig. 67.

MOUNT VERNON, Virginia, *Mount Vernon*
On canvas. Rural landscape ordered from England by George Washington in a letter dated April 15, 1757. He specified "a Neat Landscape after Claude Lorrain . . .

£3.15.6" Original location, West Parlor. Illus. Thomas Tileston Waterman, *The Mansions of Virginia.*

MOUNT VERNON, Virginia, *Woodlawn Plantation*
Panel under window on front stairway. Seascape with sailing ship and lighthouse. 20 x 52. Woodlawn Plantation, Mount Vernon, Virginia.

WILMINGTON, North Carolina
Complete room with original paint in a combination of gray, red, and brown. The overmantel shows a harbor scene with ships off shore and a row of houses in the immediate background. Tom Darst, Pinehurst, N. C.

CHECKLIST OF ADDITIONAL PICTORIAL PANELS

MASSACHUSETTS
BRIDGEWATER, *Gurney house,* Green Street
Coastal view with buildings, including latticework summerhouse and ship moored offshore, in foreground. Village and hills in background. Overall misty effect blending into maroon band above, on which "smoke ring" clouds float, dark red bevel. 35 x 44. Mr. and Mrs. B. K. Little, Brookline, Mass. Illus. Catalogue *Land and Seascapes,* Abby Aldrich Rockefeller Folk Art Collection, Williamsburg, Va., 1969.

EAST DOUGLAS, *Wallis house,* Reservoir Road. Now demolished
Three horsemen with hounds pursue a fox shown in the field at upper left. Based on an engraving after the English painter, James Seymour. 23 x 43. Mr. and Mrs. B. K. Little, Brookline, Mass. Illus. Fig. 147.

LYNN, *House unidentified*
River scene, with long arched bridge, round crenellated tower and two houses beyond. A number of small figures are engaged in fishing, hunting, and boating. Lynn Historical Society, Lynn, Mass.

SUTTON, *Le Barron house,* Main Street
Between two hills lies a village of small houses and a church, painted generally in soft greens and dark blues without perspective. A large animal, birds, and two hunters with fox appear in foreground. 36 x 56. Original location.

WAYLAND, *Heard house*
Yellow hip-roofed mansion in left foreground with hound chasing a rabbit. A large bird perches on a dead tree rising in front of river scene with buildings and hills in the background. Painted in dark rich colors. 29 x 50. Panel now privately owned. Illus. Fig. 155.

CONNECTICUT
EAST HARTFORD, *Joseph Pitkin house*
Norman-style monastic buildings set in a gray-green landscape, with seaport and other buildings in background. 15 x 37. Wadsworth Atheneum, Hartford, Conn. Illus. Fig. 148.

Overmantel. Two large buildings with river between in style of similar panels found in Hingham, Mass. Wadsworth Atheneum, Hartford, Conn. Illus. *The Connecticut Antiquarian,* June, 1964.

GROSVENORDALE, *House unidentified*
A small town, with two churches and houses painted in white, buff, and pink, framed by a number of large trees on both sides. 20 x 55. Nathan Liverant and Son, Colchester, Conn.

NEW HAMPSHIRE
CORNISH, *John Mason house*
View of a winding river with hill on right, distant mountains in background, and a house with fenced garden at the left. 49 x 59. Mr. and Mrs. B. K. Little, Brookline, Mass. Illus. Fig. 149.

VERMONT
NORWICH, *Murdock-Pierce house*
A pond with small boat lies at right. To the left is a large two-gabled house surrounded by a post and rail fence similar to that in the John Mason house in Cornish, N.H. At far left is a two-story garden house with a conical roof. 44 x 64. Original location.

OUTSIDE NEW ENGLAND
LEEDS, New York *Martin Van Bergen farm*
A 1729 view of the stone house and outbuildings, including the family, other figures, and a number of farm animals. 18 x 90. New York State Historical Association, Cooperstown, N.Y. Illus. *The Magazine Antiques,* November, 1968.

WAGRAM, North Carolina, *Alexander Shaw house.* Now demolished
Complete sheathed room with original painted decoration. Overmantel picture of "Vue of New-York" (24 x 81½) perhaps based on an engraving depicting the Great Conflagration of 1835. Abby Aldrich Rockefeller Folk Art Collection, Williamsburg, Va. Illus. Plate VII.

SELECTIVE BIBLIOGRAPHY

WOODWORK PAINTING

House Painting—General

Bentley, William, *The Diary of William Bentley, D.D.*, 4 Vols., The Essex Institute, Salem, Massachusetts, 1905-1914.

Birket, James, *Some Cursory Remarks In His Voyage To North America 1750-1751*, Yale University Press, New Haven, 1916.

Bridenbaugh, Carl, ed., *Gentleman's Progress, The Itinerarium of Dr. Alexander Hamilton 1744*, The University of North Carolina Press, Chapel Hill, 1948.

Coburn, Frederick W., "The Johnstons of Boston," *Art In America*, XXI, (Nos. 1 and 4—December 1932 and October 1933).

Copley, John Singleton, *Letters and Papers of John Singleton Copley and Henry Pelham 1739-1776*, The Massachusetts Historical Society *Collections*, Vol. LXXI, Boston, 1914.

Custis, John, Letter Book of John Custis, 1717-1741, (Manuscript), The Library of Congress, Washington, D. C.

Dwight, Timothy, *Travels In New England and New York*, William Baynes and Son, and Ogle, Duncan, & Company, London, 1823.

Halsey, R. T. H. and Cornelius, Charles O., *A Handbook of the American Wing*, The Metropolitan Museum of Art, New York City, 1926.

Holcomb, Allen, Account Book of Allen Holcomb, 1809-1833, (Manuscript), The Metropolitan Museum of Art, New York City.

Jourdain, Margaret, *English Interior Decoration, 1500-1830*, B. T. Batsford, London, 1950.

Kalm, Peter, *Travels Into North America*, contained in *A General Collection of the Best and Most Interesting Voyages and Travels in All Parts of the World*, John Pinkerton, London, 1812.

Rea and Johnston, Account Books of Rea and Johnston, 1764-1802, Boston, Baker Library, Harvard University School of Business Administration, Cambridge, Massachusetts, (Manuscript).

Sewall, Samuel, *Diary of Samuel Sewall 1674-1729*, The Massachusetts Historical Society *Collections*, Vols. V-VII, Boston, 1878-1882.

Recipes and Methods

Anon., *Valuable Secrets Concerning Arts and Trades*, Norwich, 1795.

Brazer, Esther Stevens, *Early American Decoration*, The Pond-Ekberg Company, Springfield, 1940.

Claiborne, Herbert A., *Some Paint Colors from Four Eighteenth-Century Virginia Houses*, The Walpole Society Note Book, 1948.

[Dossie, Robert], *The Handmaid to the Arts*, J. Nourse, London, 1764.

Fessenden, Thomas G., ed., *New England Farmer and Horticultural Journal*, John B. Russell, Boston, 1823-1828 (Newspaper).

Gray, Braverter, Day Book of Braverter Gray, 1805-1807, (Manuscript) Privately Owned.

Hodgson, Mrs. Willoughby, "The Art of Japanning," *Magazine Antiques*, II, (August 1922).

Parker, John, *A Treatise of Japaning and Varnishing*, Oxford, 1688.

Porter, Rufus, *A Select Collection of Valuable and Curious Arts and Interesting Experiments*, Concord, New Hampshire, 1826.

Porter, Rufus, ed., *Scientific American*, Vol. I, New York City, 1845-1846 (Newspaper).

Price, E. L., "The Art of Lacquering," *Magazine Antiques*, XXII, (November 1932).

Sheldon, Marjorie Ward, *The Interior Paint of the Campbell-Whittlesey House, 1835-1836*, The Society for the Preservation of Landmarks in Western New York, Rochester, 1949.

Smith, John, *The Art of Painting in Oil*, Daniel Browne, London, 1753.

Swan, Mabel M., "The Johnstons and the Reas—Japanners," *Magazine Antiques*, XLIII, (May 1943).

White, J., *Arts Treasury of Rarities and Curious Inventions*, 5th edition, London, 1770.

Graining and Marbleizing

Anon., *A Handbook for the Exhibition Buildings of Colonial Williamsburg, Incorporated*, Williamsburg, 1936.

Appleton, William Sumner, "Report of the Corresponding Secretary," *Old-Time New England* (Society for the Preservation of New England Antiquities), XXXII, (April 1942).

Brown, Frank Chouteau, "The Congregational Church at Head Tide, Maine," *Old-Time New England*, XX, (January 1930).

Downing, Antoinette Forrester, *Early Homes of Rhode Island*, Garrett and Massie, Inc., Richmond, 1937.

Hinchman, Lydia S., "The Maria Mitchell House and Memorial, Nantucket, Mass.," *Old-Time New England*, XVI (January 1926).

Keyes, Homer Eaton, ed., "A Notebook and a Quest," *Magazine Antiques*, XXXII, (July 1937).

Trowbridge, Bertha Chadwick, *Old Houses of Connecticut*, Yale University Press, New Haven, 1923.

Winchester, Alice, "The Meeting House at Sandown," *Magazine Antiques*, XLVIII, (December 1945).

Floors

Carwitham, John, *Various Kinds of Floor Decorations Represented Both in Plano and Perspective*, John Bowles, London, 1739.

Fraser [Brazer], Esther Stevens, "Some Colonial and Early American Decorative Floors," *Magazine Antiques*, XIX, (April 1931).

Hinchman, Lydia S., "The Maria Mitchell House and Memorial, Nantucket, Mass.," *Old-Time New England*, XVI, (January 1926).

Hines, Ezra D., "Browne Hall, Folly Hill, Danvers," *Essex Institute Historical Collections*, XXXII, (1896).

Keyes, Homer Eaton, ed., "The Renaissance of the Lindens," *Magazine Antiques*, XXXIII (February 1938).

Little, Nina Fletcher, "An Unusual Painting," *Magazine Antiques*, XLIII, (May 1943).

Long, Ella and Pickwick, Hazel, "Early Floor Decoration in a New Hampshire Farmhouse," *The Decorator, Journal of the Esther Stevens Brazer Guild of the Historical Society of Early American Decoration, Inc.*, III, (Winter 1948-1949).

Pictorial Panels

Allen, Edward B., *Early American Wall Paintings 1710-1850*, Yale University Press, New Haven, Connecticut, 1926.

Ammidown, L. E., "The Southbridge of Our Ancestors," *Leaflets of the Quinabaug Historical Society*, I, Southbridge, Massachusetts.

Burroughs, Alan, "An Early Overmantel," *Art in America*, XXIX, (Oct. 1941).

Cornelius, Charles O., "Paneling from Belle Mead, New Jersey," *Bulletin of the Metropolitan Museum of Art*, (January 1926).

Fiennes, Celia, *Through England On A Side Saddle in the Time of William and Mary*, The Leadenhall Press, London, 1888.

Finberg, A. J., ed., "A Painted Room of the Seventeenth Century," *Third Annual Volume of The Walpole Society*, University Press, Oxford, 1914.

Howells, John Mead, *The Architectural Heritage of the Merrimac*, Architectural Book Publishing Company, New York City, 1941.

Karr, Louise, "A Council of Ministers," *Magazine Antiques*, XI, (January 1927).

Little, Nina Fletcher, "Winthrop Chandler, Limner of Windham County, Connecticut," *Art in America*, XXXV, (April 1947).

Little, Nina Fletcher, "Recently Discovered Paintings by Winthrop Chandler," *Art in America*, XXXVI, (April 1948).

Lloyd, Nathaniel, *A History of the English House* . . . , William Helburn Inc., New York City, 1931.

Morse, John T., *Memoir of Henry Lee*, Little, Brown and Company, Boston, 1905.

Waltham Free Press, (Newspaper), Waltham, Massachusetts, September 1864.

Waterman, Thomas Tileston, *The Mansions of Virginia*, The University of North Carolina Press, Chapel Hill, 1945.

Sources of Panel Designs

Bowen, Helen, "The Fishing Lady and Boston Common," *Magazine Antiques*, IV, (August 1923).

Cabot, Nancy Graves, "The Fishing Lady and Boston Common," *Magazine Antiques*, XL, (July 1941).

Cabot, Nancy Graves, "Engravings and Embroideries," *Magazine Antiques*, XL, (December 1941).

Cabot, Nancy Graves, "Engravings as Pattern Sources," *Magazine Antiques*, LVIII, (December 1950).

Crunden, John, *Convenient and Ornamental Architecture*, London, 1770.

Knox, Thomas, "Boston Light House," *Massachusetts Magazine*, I, (February 1789).

Langley, Batty, *The City and Country Builder's and Workman's Treasury of Designs*, Printed for S. Harding, London, 1756.

Pain, William and James, *Pain's British Palladio or the Builder's General Assistant*, Printed for I. and J. Taylor, London, 1793.

Watson, A. E. J., ed., "Old Sporting Prints," *The Badminton Magazine of Sports and Pastimes*, V, 1897.

Newspaper References

Dow, George Francis, *The Arts & Crafts in Early New England*, The Wayside Press, Topsfield, Massachusetts, 1927.

Essex Journal and New Hampshire Packet, Newburyport, Massachusetts, October 28, 1789.

Fessenden, Thomas G., ed., *New England Farmer and Horticultural Journal*, John B. Russell, Boston, Massachusetts, 1823-1828.

Gottesman, Rita Susswein, *The Arts and Crafts in New York*, New York Historical Society *Collections*, New York City, 1938.

Porter, Rufus, ed., *Scientific American*, Vol. I, New York City, 1845-1846.

Prime, Alfred Coxe, *The Arts and Crafts in Philadelphia, Maryland, and South Carolina, 1721-1800*, 2 Vols., The Walpole Society, 1929-1932.

Waltham Free Press, Waltham, Massachusetts, September 1864.

Biographical

Bolton, Theodore, "John Hazlitt—Portrait Painter," *The Essex Institute Historical Collections*, LVI, (1920).

Dresser, Louisa, "Christian Gullager . . . ," *Art in America*, XXXVII, (July 1949).

Edes, Henry Herbert, Descendants of John Edes of Charlestown, Massachusetts, The New England Historic Genealogical Society, Boston (Manuscript).

Forbes, Harriet Merrifield, *Gravestones of Early New England* . . . , Houghton Mifflin Company, Boston, 1927.

Jessup, H. G., *Edward Jessup and His Descendants*, John Wilson and Son, Cambridge, Massachusetts, 1887.

Kimball, Fiske, *Mr. Samuel McIntire, Carver, The Architect of Salem*, The Southworth-Anthoensen Press, Portland, Maine, 1940.

Sawitzky, William, *Ralph Earl, 1751-1801*, (Catalogue), The Whitney Museum of American Art, New York City, 1945.

PLASTER PAINTING

General

Allen, Edward B., *Early American Wall Paintings 1710-1850*, Yale University Press, New Haven, Connecticut, 1926.

Brazer, Esther Stevens, *Early American Decoration*, The Pond-Ekberg Company, Springfield, 1940.

McClelland, Nancy, *Historic Wall-Papers*, J. B. Lippincott Company, London and Philadelphia, 1924.

Prime, Alfred Coxe, *The Arts and Crafts in Philadelphia, Maryland, and South Carolina, 1721-1800*, 2 Vols., The Walpole Society, 1929-1932.

Recipes and Methods

Fessenden, Thomas G., ed., *The New England Farmer and Horticultural Journal,* John B. Russell, Boston, 1823-1828 (Newspaper).

Porter, Rufus, *A Select Collection of Valuable and Curious Arts and Interesting Experiments,* Concord, New Hampshire, 1826.

Porter, Rufus, ed., *Scientific American,* Vol. I, New York City, 1845-1846 (Newspaper).

Searle, George, Memorandum Book and Roll of Arms of George Searle, Newburyport, Massachusetts, 1773-1796, (Manuscript), Privately Owned.

Freehand Repeat Patterns

Brazer, Esther Stevens, "Signed and Dated, A Painted Wall in Connecticut," *Magazine Antiques,* XLVIII, (September 1945).

Congdon, Herbert Wheaton, *Old Vermont Houses,* Stephen Daye Press, Brattleboro, Vermont, 1940.

Fraser [Brazer], Esther Stevens, "Zachariah Bracket Stevens," *Magazine Antiques,* XXIX (March 1936).

Fraser [Brazer], Esther Stevens, "Did Paul Revere Make Lace-Edge Trays?," *Magazine Antiques,* XXXI, (February 1937).

Stenciled Patterns

Little, Nina Fletcher, "An Unusual Painting," *Magazine Antiques,* XLIII, (May 1943).

Morson, William Taylor, "Another Old New England Farmhouse Restored," *Magazine Antiques,* LIV, (July 1948).

Waring, Janet, *Early American Stencils on Walls and Furniture,* William R. Scott, Inc., New York City, 1937.

Panoramas and Subject Pieces

Allen, Edward B., "Some American Historic Frescoes," *Magazine Antiques,* XIV, (July 1928).

Allen, Edward B., "The Frescoed Walls of the Meeting House at Middleton, New Hampshire," *Old-Time New England,* XX, (January 1930).

Ammidown, L. E., "The Southbridge of Our Ancestors," *Leaflets of the Quinabaug Historical Society,* I, Southbridge, Massachusetts.

Auer, Mary Hale, "Rufus Porter," *The Decorator,* V, (April 1951).

Brazer, Esther Stevens, "Murals in Upper New York State," *Magazine Antiques,* XLVIII, (September 1945).

Brown, Frank Chouteau, "The Congregational Church at Head Tide, Maine," *Old-Time New England,* XXX, (January 1940).

Howells, John Mead, *The Architectural Heritage of the Merrimac,* Architectural Book Publishing Company, New York City, 1941.

Karr, Louise, "Old Westwood Murals," *Magazine Antiques,* IX, (April 1926).

Karr, Louise, "Painted Walls and Panels," *The Antiquarian,* (August 1925).

Keyes, Homer Eaton, ed., "A Summer Home in Wolfeboro, New Hampshire," *Magazine Antiques,* XXXIII, (June 1938).

Knox, Katherine McCook, "A Note on Michele Cornè," *Magazine Antiques,* LVII, (June 1950).

Lancaster, Clay, "Primitive Mural Painter of Kentucky: Alfred Cohen," *American Collector,* XVII, 11 (Dec. 1948), 6.

Larned, Ellen D., *History of Windham County, Connecticut,* Vol. II, Charles Hamilton, Worcester, 1880.

Lipman, Jean, "Rufus Porter—Yankee Wall Painter," *Art in America,* XXXVIII, (October 1950).

MacLellan, Albert C., "The Scates-Shapley Tavern, Middletown, New Hampshire, With an Account of Its Destruction by Fire," *Old-Time New England,* XX, (January 1930).

Meeting In Print, (Reference material on the mural painting of John Avery), Publication of the Wakefield-Brookfield Historical Society, Wakefield, New Hampshire, Winters of 1949 and 1950.

Morson, William Taylor, "Another Old New England Farmhouse Restored," *Magazine Antiques,* LIV, (July 1948).

Moore, J. Bailey, *History of the Town of Candia,* [New Hampshire], George W. Brown, Manchester, New Hampshire, 1893.

Swan, Mabel M., and Karr, Louise, "Early Marine Painters of Salem," *Magazine Antiques,* XXXVIII, (August 1940).

Winchester, Alice, "A Painted Wall," *Magazine Antiques,* XLIX, (May 1946).

Masonic Designs

Lipman, Jean, "An Early Masonic Meeting Place," *Magazine Antiques,* LV, (May 1949).

Morson, William Taylor, "Another Old New England Farmhouse Restored," *Magazine Antiques,* LIV, (July 1948).

Wheeler, Joseph K., *The Centennial of the Most Worshipful Grand Lodge of Connecticut,* New Haven, 1890.

Newspaper References

The Connecticut Herald, New Haven, January 10, 1804.

The American Mercury, Hartford, November 16, 1789.

Prime, Alfred Coxe, *The Arts and Crafts in Philadelphia, Maryland, and South Carolina, 1721-1800,* 2 Vols., The Walpole Society, 1929-1932.

Index